EDVARD MUNCH

PSYCHE, SYMBOL AND EXPRESSION

EDITED BY JEFFERY HOWE

BOSTON COLLEGE McMULLEN MUSEUM OF ART

Distributed by the University of Chicago Press

This publication is issued in conjunction with the exhibition
Edvard Munch: Psyche, Symbol and Expression
at the Charles S. and Isabella V. McMullen Museum of Art, Boston College.

February 5 to May 20, 2001

The exhibition is organized by the McMullen Museum of Art.

Principal Curator:
Jeffery Howe

Co-Curators:
Claude Cernuschi
Scott T. Cummings
Katherine Nahum
Vanessa Rumble
Stephen Schloesser, S.J.

This exhibition and catalog are underwritten by Boston College and
the Patrons of the McMullen Museum with additional support from Per Arneberg and
the Andrew E. and G. Norman Wigeland Fund of the American-Scandinavian Foundation.
Scandinavian Airlines System provided assistance with transportation.

Distributed by the University of Chicago Press
Exhibition and publication coordination by Thea Keith-Lucas
Copyediting by Naomi Rosenberg, Thea Keith-Lucas and Lisabeth Buchelt
Produced by the Office of Marketing and Communications at Boston College
and the McMullen Museum of Art
Catalog design by Julia Sedykh Design
Printed and bound in Singapore by Eurasia Press

CONTENTS

NANCY NETZER

This exhibition owes its origin to Anna-Elizabeth Arneberg, an undergraduate at Boston College, who, after viewing an exhibition of contemporary Irish art, wandered into the McMullen Museum office to speak with our curator Alston Conley. She inquired whether the Museum had ever considered mounting an exhibition of Edvard Munch, who had been a friend of her Norwegian grandfather, Arnstein Arneberg (no. **69**), an architect in Oslo. Later her father Per Arneberg, who had assembled a collection of Munch's work for the Fram Trust and had devoted many years of creative study to his country's most famous artist, offered to help the McMullen organize this exhibition. We gathered a group of professors from the faculty who specialize in the art and culture of northern Europe of the late nineteenth and early twentieth centuries to generate new questions an exhibition might pose of Munch's works. These professors then selected works to embody in vivid form the points they wished to make. We were encouraged from the start by the positive response from institutions and private collectors to our requests for loans. In particular, our colleagues in Norway have been extraordinary in their generosity, lending works of the utmost rarity, most of which have never before been displayed on this side of the Atlantic. We are especially pleased to show *View from Balcony, Aasgaardstrand* (no. **18**) which was discovered recently in the wall of Munch's studio in Aasgaardstrand and brought to our attention by Per Arneberg.

From this modest beginning developed *Edvard Munch: Psyche, Symbol and Expression,* the most comprehensive exhibition of Munch's work in America since *Edvard Munch: Symbol and Image* was shown at the National Gallery in Washington in 1978. The subject is a daunting one, especially as so many exhibitions and books have been devoted to this artist. The present exhibition, however, marks the first time that a broadly interdisciplinary view of his work has been attempted on such a large scale. The mission of this project, from its inception, was to focus on several key themes that dominated the intellectual and cultural life around the turn of the last century. The examination of Munch's artistic oeuvre in this light has led to reappraisals of a number of familiar—as well as a few unfamiliar—works.

The entire undertaking of exhibition and catalog could not have been achieved without the tireless work of the curators and museum staff. The chief curator of this exhibition was Professor Jeffery Howe of the Fine Arts department at Boston College. His knowledge of the field and wise judgment have informed his editing of this book to great advantage. Each of the co-curators from various departments, Professors Claude Cernuschi (Fine Arts), Scott Cummings (Theater), Katherine Nahum (Fine Arts), Vanessa Rumble (Philosophy), and Stephen Schloesser, S.J. (History) charted a new avenue of research for his/her essay. Our debt to the curators is enormous, and we thank them for welcoming Edvard Munch, a demanding, if fascinating, companion, into their lives for the past year and a half.

Other faculty, especially John Michalczyk (Fine Arts), Mark O'Connor (Honors Program), and Lawrence Wolff (History) aided their endeavor. The circle of those involved in the exhibition has extended in numerous directions and drawn on the expertise and generosity of many beyond our cam-

pus. Special thanks are due colleagues at several other institutions: Arne Eggum, Petra Pettersen, Marianne Kemble, and Karen Lerteim (Munch Museum); Marit Lange, Ernst Haverkamp and Torill Bjordal (National Gallery, Oslo); Lisbeth Weltzin (Borre Kommune); George Goldner, Colta Ives, Lisa Yeung, and Mary Doherty (Metropolitan Museum of Art); Malcolm Rogers, Sue Reed, George Shackelford, Patricia Loiko, Kim Pashko, Patrick Murphy, and Christopher Atkins (Museum of Fine Arts, Boston); James Cuno, Jerry Cohn, Maureen Donovan, and Ada Bortoluzzi (Harvard University Art Museums); Jane Blaffer Owen, James Clifton and Celia Cullen Martin (Sarah Campbell Blaffer Foundation); Sarah Epstein, Krista Hoffpauir and Vivi Spicer (Epstein Foundation); Nancy Hall-Duncan (Bruce Museum); as well as Akka Arneberg, Anders Bjork, Dag Kleven, Aldis Browne, Andrew Rose, Ian MacKenzie, Anne-Ruth and Jan Klein, Tore Maehle, Paal Smith-Kielland, Einar Tore Ulving, Christoph Adamski, Jonathan Yuen, Susan Cleary, and Peter Nahum. We also extend special thanks to Professor Crystal Tiala (Theater) for the reconstruction (in the exhibition) of Munch's stage set for Ibsen's *Ghosts* and to Daniel Brunet, an undergraduate at Boston College, for the biographical chronology in this volume.

The staff of the McMullen Museum and others from across the University have been deeply involved at various stages with this project. In particular, our curator Alston Conley designed and, with his crew, installed the exhibition; our exhibition coordinator Thea Keith-Lucas played an invaluable role in the production of the catalog and in the exhibition's overall organization, and our administrator, Helen Swartz coordinated all efforts. We are grateful as well to Steven Vedder and Gary Gilbert for photography, to Naomi Rosenberg for copy editing of the text, to Lisabeth Buchelt and Emily Hankle for proofreading text, to Rosanne Pellegrini for publicity, and to the members of our Development office, especially Gemma Dorsey, who aided our funding efforts. In designing the catalog Julia Sedykh has created an expressionist work in itself.

Such an ambitious project could not have been attempted were it not for the generosity of the administration of Boston College. We especially thank president William P. Leahy, S.J., academic vice-president John J. Neuhauser, associate dean of faculties Patricia DeLeeuw, dean of arts and sciences Joseph Quinn, and assistant to the president Rose Mary Donahue. Very generous support was provided by the Patrons of the McMullen Museum chaired by C. Michael Daley. Additional support came from Per Arneberg and from the Andrew E. and G. Norman Wiegand Fund of the American-Scandinavian Foundation, New York. Scandinavian Airlines System (SAS) provided assistance with transportation.

Finally, we wish to thank Per Arneberg, who buttressed our dreams from their inception. His infectious enthusiasm and optimism inspired this new vision of Edvard Munch's work. We hope that this book will serve as a lasting tribute to him and all mentioned above who contributed so much to its realization.

EDVARD MUNCH:
PSYCHE, SYMBOL AND EXPRESSION

JEFFERY HOWE

Courage comes in many forms. In the popular imagination, Norway evokes images of fjords and Vikings, untamed nature and intrepid explorers. Compared to these heroic figures, a modern artist, particularly one as open about his anxieties as Edvard Munch, may seem to be overly fragile and sensitive — decadent, even. Yet Munch faced his fears directly, and rendered their likenesses on canvas. Neither his life nor his art was all gloom and *angst,* in any case; his portraits bear witness to a wide circle of friends, and his paintings of the Norwegian landscape capture the beauty and Romantic spirit of the Nordic setting. Appropriately enough, one of Norway's most intrepid explorers, Fridtjof Nansen, who journeyed to the North Pole in 1893 in a wooden ship, owned Munch's *Starry Night* painting of 1893 (Getty Museum, Los Angeles).[1] Unlike the arctic explorer, however, Munch had no need to journey to remote regions of the earth to discover new worlds; in 1894, Franz Servaes observed that Munch carried his "inner Tahiti" within him.[2]

Edvard Munch (1863–1944) was the first Scandinavian visual artist to earn an international reputation during the explosion of creativity in the late nineteenth and early twentieth centuries that has been called the "Scandinavian Renaissance." His haunting image of *The Scream* (paintings in 1893, lithograph in 1895, no. **7**) has become an emblem of modern anxiety, and may now be the most frequently reproduced work of art in the world. Yet there is much more to Munch's art than this single strident note. Munch, productive for more than six decades, became a major portraitist and landscape painter, as well as an exacting explorer of human passions, including universal themes of love, death and spiritual seeking.

Associating Munch with spirituality may seem unusual, but in the aftermath of Impressionism, he strove, as did the Dutch Vincent van Gogh and the French Paul Gauguin, to make his personal emotions and spiritual longings the focus of his art. Although the religious dimension of his works is sometimes overlooked, Munch insisted that "in all my work people will see that I am a doubter, but I never deny or mock religion."[3] Even his controversial works such as *Madonna,* or *Loving Woman,* of 1895 (nos. **54** and **55**) are sincere representations of his personal attempt to understand the sacred quality of life and the fundamental mystery of existence. Essays by Stephen Schloesser, S.J., and Jeffery Howe in this catalog will address this paradox. A profoundly ambitious artist, Munch sought no less than to express the fundamental themes of life as lived in the modern world, and to portray these themes in an authentic, powerful style that would lay the groundwork for modern Expressionism.

Munch never hid his private pain, but believed that suffering nourished his art:

I do not believe in an art which has not forced its way out through man's need to open his heart.
All art, literature, as well as music must be brought about with our heart blood.
Art is our heart blood.[4]

This aesthetic doctrine is embodied in a number of works, but especially the woodcut *The Flower of Pain* of 1898 (no. **12**).[5]

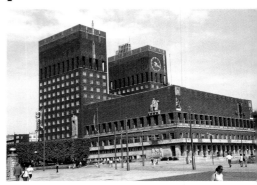

Numerous tragedies, beginning with the death of his mother in 1868 when Munch was only five, followed by the deaths of his sister Sophie in 1877 and his brother Andreas in 1895, and the mental breakdowns of his sister Laura in the 1890s, shaped his life and his art. As Munch noted, "Sickness and insanity and death were the black angels that hovered over my cradle and have since followed me throughout my life."[6] Yet he transcended these losses (Katherine Nahum's essay provides an eloquent examination of the impact of these events). The painting *Interior with the Artist's Father and Sister* of 1884–85 (no. **63**), the earliest painting in our exhibition, shows that Munch has already mastered all the stylistic innovations of Realism and Impressionism. Seen from psychological and social points of view, this intimate portrait underscores his attachments to his family and his own lived experience.

Munch's first artistic activities began when he was a child. Munch manifested a love of drawing at an early age, and was encouraged by his aunt, Karen Bjølstad, who looked after his family following the death of his mother. Munch began his formal artistic training at the Royal School of Design in Kristiania (Oslo) in 1880, leaving the school after two years. He began participating in public exhibitions in 1883. In 1885, the successful painter Frits Thaulow (1847–1906), a distant relative who often supported young artists, provided funds for Munch to take a three week trip to Antwerp and Paris. This was his first direct contact with the international art world. His art developed quickly, and in 1889, Munch was given first one-man exhibition held in Norway.

Munch came to maturity in the 1880s, a period of radical change and experimentation in art and society. His art more frequently addressed personal issues than political matters, but questions of national identity were inescapable at this time. Norway struggled for independence throughout the nineteenth century. The country had separated from Denmark in 1814, but was still joined to Sweden. The parliamentary system was introduced in 1884, loosening ties to the Swedish crown. Calls for full independence became increasingly insistent throughout the century, and Norway finally became independent from Sweden in 1905. The city of Kristiania, which had been named for Danish King Christian IV in the seventeenth century, reverted to its medieval name of Oslo in 1925. Themes of national identity were particularly prominent in Munch's murals for the Aula of the University of Oslo (1909–12). *The Sun* (no. **81**) is an important study for these murals. Munch hoped to continue producing works for the public sphere with murals for the new town hall of Oslo (1916–1950, fig. **1**), designed by the architects Magnus Poulsen and Arnstein Arneberg (no. **69**). Munch's portrait of Arneberg is one of his many images of fellow artists. Arneberg also drew designs for the studio Munch planned to build at his home in Ekely. Although the commission for the town hall never materialized, Munch's art shifted from the private sphere of his inner emotions to include new social themes with images of laborers. His series of street workers in the late 1910s and early 1920s dates from this period (no. **72**).

At the height of the Scandinavian Renaissance, the Norwegians Henrik Ibsen (1828–1906; no. **58**) and Bjørnsterne Bjørnson (1832–1910), winner of the Nobel prize for literature in 1903, and the Swede August Strindberg (1849–1912; no. **67**) reshaped modern theater, introducing new standards of realism and a new intimate scale of theatrical presentation. The multifaceted relationship of Henrik Ibsen and Munch is discussed in essays by Scott Cummings and Crystal Tiala in this catalog. They focus particularly on Munch and Max Reinhardt's collaboration on a production of Ibsen's *Ghosts* in 1906. Another essay, by Vanessa Rumble, discusses Munch, Ibsen and Søren Kierkegaard in terms of their moral and spiritual conscience. In poetry, writers close to Munch such as the Norwegian Sigbjørn Obstfelder (1866–1900) and the Dane Emanuel Goldstein (1862–1921) experimented with the new modes of Symbolist poetry that they discovered in France and Germany. The Norwegian novelist Knut Hamsun

1
Arnstein Arneberg and Magnus Poulsen, Town Hall, Oslo, 1916–1950.

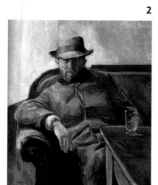

(1859–1952), winner of the Nobel Prize for literature in 1920, explored subjective states of mind in his writings. The most influential philosophers in Scandinavia in the nineteenth century were the Dane Søren Kierkegaard (1813–1855), and the Germans Arthur Schopenhauer (1788–1860) and Friedrich Nietzsche (1844–1900). The new evolutionary principles of Charles Darwin (1809–1882) also left an indelible imprint on Scandinavian thought at this time.

THE KRISTIANIA BOHEMIA

Social and cultural rebelliousness flourished among the young intellectuals and artists in Kristiania in the 1880s. They valued independent thought above all, and demanded freedom and non-conformity in social and artistic practice. They came to be known as the Kristiania Bohemians, and their "Nine Commandments" were published in their journal *Impressionisten* in 1889; one should note that the word "Impressionist" still connoted social as well as artistic revolution:[7]

1. *Thou shalt write thy life.*
2. *Thou shalt sever thy family roots.*
3. *Thou canst not treat thy parents harshly enough.*
4. *Thou shalt not touch thy neighbour for less than five kroner.*
5. *Thou shalt hate and despise all such peasants as Bjørnsterne Bjørnson.*
6. *Thou shalt never wear celluloid cuffs.*
7. *Thou shalt never cease from causing scandal at the Christiania Theatre.*
8. *Thou shalt never show remorse.*
9. *Thou shalt take thy life.*

The new intellectual currents swirled with ideas of free love, anarchism, Darwinism, pessimism, and atheism. One of the most prominent leaders of the youthful free-thinkers was Hans Jaeger (1854–1910), whose novel *From the Kristiania Bohemia (Fra Kristiania-Bohêmen)* of 1885 outraged the establishment. The novel was banned, and its author sentenced to several months in prison. To keep Jaeger company in his prison cell, Munch gave him an early version of the picture called *Loving Woman* or *Madonna.*[8] One of Munch's finest early portraits is his *Portrait of Hans Jaeger*, National Gallery, Oslo, 1889 (fig. **2**), a tribute to the man who had became something of a substitute father. Jaeger's novel *Sick Love (Syk Kjaerlihet,* 1893) delineates the free-love society that he envisioned, and its experiments in Kristiania. Munch himself was drawn into a socially rebellious affair with a married woman, Milly Thaulow, whom he referred to as "Mrs. Heiberg" in his letters and journals. For the romantic young artist, this was a critical relationship, and he was devastated when she broke it off. These early experiences left a permanent mark on Munch; he continued to paint and repaint scenes of the Bohemians, and especially Hans Jaeger, for the next fifty years. Jaeger's themes were echoed twenty years later in Munch's unpublished novel titled "The City of Free Love."[9]

Christian Krohg (1852–1925), was another leading figure among the Kristiania Bohemians and the editor of the journal *Impressionisten*. He was a bit older than Munch, and gave direction to him and several other artists who shared a studio near the Norwegian parliament building in the mid-1880s. Krohg also wrote a book that scandalized official Kristiania, attacking the official hypocrisy and exploitation that permitted legalized prostitution and condemned free love. His novel *Albertine*, published in 1886, told the story of an innocent young woman who was forced into prostitution by the police after being caught in a round-up of prostitutes, who were required to undergo regular check-ups

2
Edvard Munch, *Portrait of the Author Hans Jaeger,* oil on canvas, 1889. National Gallery, Oslo.

for venereal disease. Although the novel spoke out for honesty and condemned corruption, it was also censored and Krohg was fined. Krohg escaped prison, perhaps by virtue of his prominent family and his own legal training.[10] After the suppression of the novel, Krohg painted the celebrated life-size large canvas depicting *Albertine in the Police Doctor's Waiting Room,* now in the National Gallery, Oslo, 1885–87 (fig. **3**). Munch later intimated that he had painted one of the prostitutes in the picture, an assertion later denied by Krohg.[11] The relationship between Munch and Krohg was complex. Although Munch downplayed Krohg's influence on him, Krohg's painting of *The Sick Girl* of 1880–81 (fig. **4**) was clearly the model for Munch's paintings and prints of *The Sick Child* (no. **9**), and Krohg supported Munch's art. Sickness was a popular theme for Realist artists; Munch referred to these early years as his "pillow period."[12] Krohg owned the first version of Munch's *Sick Child,* but later exchanged it for *Starry Night* (1893) so that Munch could sell it to a collector. A few years later, Munch traded again with Krohg

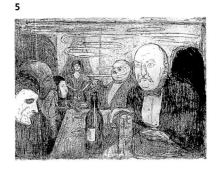

so that he could sell *Starry Night* to Fridtjof Nansen.[13] Krohg, who had lived in Germany for several years in the 1870s, also introduced Munch to the art of Max Klinger and other international artists, which helped broaden his understanding, and would influence him in his evolution from Realism to Symbolism.[14]

Krohg's wife, Oda Lasson Krohg (1860–1935), was also a talented painter, and a conspicuous figure in the bohemian scene. Munch's etching *Kristiania-Bohemia II* (fig. **5**) shows her at the end of the table in a bohemian gathering. Her image is based on Krohg's own *Portrait of Oda Krohg,* National Gallery, Oslo, 1888 (fig. **6**). Gathered at this table are Munch, Krohg, Gunnar Heiberg, who was involved in a triangular relationship with Oda and Christian Krohg, and Oda's first husband in the foreground at right. Munch gathered much material for his later images of *Jealousy II* (no. **29**) and the *Dance of Life* in these early years in Kristiania.

Although Realism and Impressionism defined modern art in Norway in the 1880s, and Munch began his career as a Realist, he soon criticized the movement for its obsession with the superficial:

A great wave swept over the world—Realism. Nothing existed which could not be demonstrated or explained by means of physics or chemistry—painting and literature consisted solely of things that could be seen by the eye or heard by the ear—it was concerned only with the external shell of Nature.[15]

Munch came to agree with the new current of Symbolist artists and writers, who distrusted reality as perceived through the senses, and sought other avenues of knowledge. The Symbolists demanded an art that was faithful to psychological realities as well. As Munch noted: "Nature is not only what is visible to the eye—it also shows the inner images of the soul—the images on the back side of the eyes."[16] Elaborating on his dissatisfaction with the limits of Realism and Naturalism, Munch said:

Inspiration is thought—Naturalism is craft . . . salvation shall come from Symbolism. By that I mean an art where the artist submits reality to his rule, which places mood and thought above everything and only uses reality as a symbol . . .[17]

Munch's passion for inner truths ultimately led him to create a new mode of expression that would lead to the Expressionist style.

NEW ARTISTIC HORIZONS

Foreign travel broadened Munch's artistic horizons, and he soon became an international figure. His new style and themes were too revolutionary for the conservative Norwegian critics in the 1890s; his art frequently baffled them. His first trip to Paris in 1885 provided a taste of international modern art movements; a longer stay in 1889–1890, when he wrote his Saint-Cloud Manifesto, was more decisive. It was at this time that he moved beyond Impressionism and discovered Symbolist painting and poetry. The young Danish poet Emanuel Goldstein, who shared a room with Munch in Saint-Cloud, helped introduce him to new literary currents.

If Paris opened his eyes to new artistic possibilities, Berlin mounted his first highly publicized exhibition in 1892. The show, however, was closed by official order after just one week. With the ensuing scandal came a not entirely unwelcome notoriety. As often happens, scandal provided the occasion for celebrity. Munch stayed in Berlin for the next three years, and linked up with a new group of avant-garde artists and writers who frequented the café *Zum Schwarzen Ferkel* (The Black Piglet) from 1892 to 1896. This café on a corner of the street Unter den Linden received its nickname from August Strindberg, who, in the dark of night, mistook a hanging wineskin for a piglet.[18] Munch's new friends included the Polish author Stanislaw Przybyszewski (1868–1927), his Norwegian wife Dagny Juel Przybyszewska (1867–1901), the Swedish dramatist August Strindberg (1849–1912), the Norwegian playwright Gunnar Heiberg (1857–1929), the Danish author Holger Drachmann (1846–1908), the Norwegian art historian Jens Thiis (1870–1942), the German poet Richard Dehmel (1863–1920), the Swedish writer Adolf Paul (1863–1943) and the German author Franz Servaes (1862–1947). Munch's art became the rallying point for the establishment of a new modernist movement in the German capital. Claude Cernuschi's essay in this catalog examines how this German experience affected Munch's art, and how Munch influenced the new generation of Expressionists in the twentieth century.

In late 1895, Munch followed Strindberg to Paris, where his interest in Symbolist literature was deepened. In Parisian cafés and salons, the artist met with the leading figures of the movement:

Strindberg joined in, and our circle consisted of friends of Gauguin, who was in Tahiti, plus van Gogh — There were also some friends of the now dead Verlaine and of Mallarmé; also people from the Mercure de France Circle — Merrill, too, came there. — For a time Oscar Wilde attended — Mollard in Rue Vercingétorix.[19]

Munch executed a much-admired portrait of Stéphane Mallarmé (no. **68**) in 1896. *Death in the Sickroom* (no. **10**) and other works show the influence of Maurice Maeterlinck's *L'Intruse (The Intruder)* of 1891, a play which characterizes death as a nocturnal intruder who steals upon an anxiously waiting family.

MUNCH AND WOMEN

Depictions of women are among Munch's best-known images; they are distinguished by an unaccustomed honesty about sexuality and the relations between men and women. Indeed, along with artists

such as Auguste Rodin, Munch was a leader in the new frankness that would become a hallmark of modernist art.[20] Personal fears and anxieties, and a determination to dedicate his life to his art, however, strained Munch's relationships with women:

I have always put my art before everything else. Often I felt that women would stand in the way of my art. I decided at an early age never to marry. Because of the tendency towards insanity inherited from my mother and father I have always felt that it would be a crime for me to embark on marriage.[21]

Munch feared that romantic attachments might subvert his individuality. He subscribed to the stereotypes of gender differences that so strongly marked the *fin-de-siècle:*

The difference between men and women is as great as between round and straight lines. A man living exclusively for his woman loses something of his own characteristics—becomes slippery and round. He can no longer be trusted. But a woman, under the same circumstances, becomes rounder and more feminine.[22]

Images such as *Ashes II* (1899, no. **28**), *Vampire* (1895/1902, nos. **40** and **41**) and *Jealousy II* (1896, no. **29**) are perhaps too easily characterized as misogynistic, considering their complexity. The recent exhibition catalog *Munch and Women, Image and Myth* by Patricia Berman and Jane Nimmen is a thoughtful analysis of the image that has been constructed for Munch.

Looking deeper into Munch's art, we find an abundance of sensitive and positive images of women. Munch particularly valued his relationships with his female family members, beginning with his mother, his sisters Inger (1868–1952) and Laura (1867–1926), and his aunt Karen Bjølstad (1839–1931), who became his surrogate mother. Recent scholarship suggests that Asta Nørregaard (1853–1933), a female artist and a distant cousin of Munch's friend Harald Nørregaard, may have been a mentor for the artist. She painted a portrait of Munch in 1885.[23]

Other striking examples of strong and independent women with whom Munch had meaningful, if not romantic, relationships include Oda Lasson Krohg (1860–1935), who was a leading figure of the Kristiania Bohemia, and Dagny Juell Przybyszewska (1867–1901), who was a key figure in the Berlin bohemian circle which gathered at the café *Zum Schwarzen Ferkel* in Berlin.[24] Munch's own experiences with free love ended in pain for him, beginning with his long affair with Milly Thaulow, the wife of Carl Thaulow (brother of Frits Thaulow). This early love affair may be the source of his paintings and prints of *The Voice (Summer Night)* (1893, nos. **16**, **18B** and **19**), and is perhaps also related to the images of *Attraction* and *Separation,* and *The Kiss on the Shore* (no. **17**). Munch also had a long and stormy relationship with Tulla (Matilde) Larsen (1869–1942) in the last years of the nineteenth century and the first years of the twentieth century. This affair almost ended in disaster when they struggled over her gun, and a bullet nearly severed the artist's ring finger.[25] This episode may have colored Munch's relationship with the beautiful English violinist, Eva Mudocci (Evangeline Muddock, c. 1883–1953). Munch's portrait of her in *The Brooch,* which Munch first titled *Madonna*[26] (1903, no. **65**) is one of his most beautiful portraits. Mudocci later wrote of this image:

He wanted to paint a perfect portrait of me, but each time he began on an oil painting he destroyed it, because he was not happy with it. He had more success with the lithographs, and the stones that he used were sent up to our room in the Hotel Sans Souci in Berlin. One of these, the so-called Madonna [The Brooch], *was accompanied by a note that said "Here is the stone that fell from my heart." He*

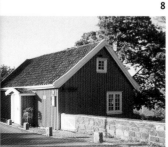

did that picture and also the one of Bella (Edwards) and me [The Violin Concert] *in the same room. He also did a third one of two heads—his and mine—called* Salome. *It was that title which caused our only row.*[27]

The long flowing hair in *The Brooch* resembles that of the woman in the paintings and prints of the *Madonna* (nos. **54** and **55**). Munch seems to have associated the long, flowing, Pre-Raphaelite hair with the image of the Madonna. The confusion of titles also echoes the chaos of his romantic attachments at this time.

Munch maintained positive and respectful relationships with other women even during this trying period. He painted a portrait of Aase Nørregaard (1868–1908), the wife of his friend Harald Nørregaard in 1895 (no. **64**), at the height of his associations with Symbolist and Decadent artists and writers, including unrepentant misogynists such as Strindberg. Ignoring the biases of his comrades, Munch wrote to Aase in a warm and confessional tone:

The happy, glowing state of marriage may suit many people, not least you and Nørregaard. You have preserved your youth as in a sealed jar . . . that is all very fine, but why should all the furies of Hell descend on a poor painter because he has the misfortune not to be able to marry—but he has only managed to steal a small caress.[28]

Munch was apparently a favorite guest of the Nørregaards', and he enjoyed talking with them. Sarah Epstein interviewed Aase's daughters about his working method:

For several weeks he had Aase Nørregaard dress up in her formal black gown every day. He would then simply chat with her. When she accused him at last of doing this as a ruse to have a chance for conversation, he said no, he was studying her for the painting. He then produced the portrait without once looking at her.[29]

Aase Nørregaard died of pneumonia in 1908. Depression over her death, and the loss of other friends within a short time, may have contributed to Munch's breakdown and hospitalization in Copenhagen later that year.[30]

THE REFUGE OF ART: MUNCH'S STUDIOS

Munch's art not only grew from pain, but provided solace as well. The studio was the refuge in which Munch created his deeply personal images; one can trace the outline of Munch's career by following the sequence of his studios. In 1882, after leaving the Royal School of Design, Munch rented a studio with a group of other young artists on Karl Johan Street in Oslo, near the *Storting* (Parliament). He painted his first mature pictures here. The studio was in the busy center of the capital, near the Grand Hotel, which he frequented with the other Kristiania Bohemians (fig. **7**).

In 1889 he began spending summers in the seacoast town of Aasgaardstrand; in 1897 he bought a small house there which also served as his studio (fig. **8**). The cottage, which Munch called "The House of Fortune", is now a museum.[31] Aasgaardstrand was the setting for his early romantic affairs and disappointments; the rocky coast of the fjord is seen in his paintings and prints of *Melancholy* (no. **13**). A large house near the hotel (fig. **9**), with a pair of linden trees in the yard, appears in many paintings and

7
Karl-Johan Street, Oslo.

8
Munch's house, Aasgaardstrand.

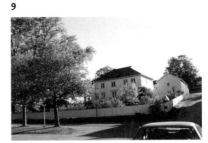

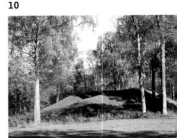

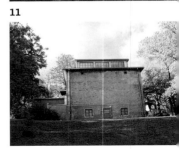

prints, including *Three Girls on a Bridge* (no. **78**) and the *Red Virginia Creeper* (no. **74**). The house takes on a personality, and at times seems almost haunted. It can also be seen in the background of the *View from Balcony, Aasgaardstrand* (no. **18A**), directly opposite of the brooding figure of Munch's sister Inger, who stands wrapped in a shawl against the autumn chill. Inger and her shawl are mirrored by the house wrapped in its extraordinary vine.

The nearby Borre woods, which were noted for their Viking graves (fig. **10**), may have provided the background for his paintings of *The Voice (Summer Night),* 1893 (no. **16**). Munch called the path to Borre from Aasgaardstrand the "fairy tale path", a tribute, perhaps, to the magical quality of this forest and sea, and the way it affected his romantic liaisons.[32] A quotation associated with *The Voice (Summer Night)* (nos. **19** and **18B**) captures the mystery of the night and illicit love:

I was walking out there on the greyish-white beach — This is where I first acquired a knowledge of the new world — that of love — Young and innocent — straight out of a monastery-like home — alone among my friends not to have been introduced to this mystery — Never before felt the intoxicating power of a kiss. . . .

Here I learned the power of two eyes that grow as large as globes close to me — emitting invisible threads which would steal into my blood — my heart

Here I learned the strange and wonderful music of the voice — one moment tender — the next teasing, then provocative. . . .[33]

Love and emotion transformed the world for Munch, and visual reality served only as a starting point for his images.

In the 1890s, Munch spent much time abroad. After working in Berlin from 1892–95, he visited Paris in 1896, where his work was shown in the new gallery owned by Siegfried Bing, L'Art Nouveau, which gave its name to the artistic movement.[34] In 1902, he stayed with Dr. Max Linde in Lübeck. Between 1904 and 1908, Munch frequently traveled back to Berlin. In 1907, he began a prolonged stay at the north sea town of Warnemünde, where he painted bathers and sea scenes. In 1908–09, he sought treatment at Dr. Daniel Jacobsen's clinic in Copenhagen for a nervous breakdown and severe alcoholism. While Munch was there, the king of Denmark conferred the Knighthood of the Order of Saint Olav upon him. On his recovery, Munch returned to Norway, but stayed some distance from Oslo, preferring to set up his studio first in the coastal village of Kragerø in 1909, and then across the fjord in Hvitsten in 1910. Here he painted the landscape *Fra Hvitsten: Landscape with Oslo Fjord* (1912–15, no. **76**). He hired retired fishermen to pose for his studies for the Aula murals, and to help him with the large canvases he needed for paintings such as *The Sun,* 1912 (no. **81**). The Aula murals were unveiled in 1916.

In 1916, Munch bought a property in Ekely, just outside Oslo, where he built several studios over the years. This was to be his final home until his death in 1944. Today, only his winter studio survives (fig. **11**). It was in Ekely that he painted the *Winter Landscape* of 1919 (no. **83**), the *Starry Night* of 1922–24 (no. **82**) and many other works. Munch plumbed the depths of his inner self in these Nordic scenes, treating the landscape as a mystical mirror to his emotions. A great cosmopolitan, Munch traveled to many other places, including southern France, Italy, and Prague over the years, but it is in Norway that his art was forged, and in Norway that he returned to live out the last decades of his life. The meaning and appeal of his art is, however, universal.

9
House, Aasgaardstrand.

10
Borre woods, near Aasgaardstrand.

11
Munch's winter studio, Ekely.

1 Louise Lippincott, *Edvard Munch. Starry Night*, Malibu, CA: Getty Museum Studies on Art, 1988, p. 66ff. Nansen took paintings of Norwegian landscapes by Eilif Petersen, Erik Werenskiold and others with him on this voyage.

2 Franz Servaes, in *Das Werk des Edvard Munch*, Stanislaw Przybyszewski, editor, Berlin: S. Fischer, 1894, p. 37ff.: "Im gegensatz zu allen diesen Leuten (von Stuck, Hofmann, Liebermann, Gauguin) steht, obwohl im innersten Kern mit ihnen verwandt, Eduard Munch, der Norweger. Er braucht nicht Bauern und nicht Kentauren und nicht Paradiesesknaben die Primitivität der Menschennatur zu erblicken un zu durchleben. Er trägt sein eigenes Tahiti in sich, und so schreitet er mit nachtwandlerischer Sicherheit durch unser verworrenes Culturleben, ganzlich unbeirrt, im Besizt seiner durchaus culturlosen Parsifal-Natur. Der reine Thor in der Malere — das ist Eduard Munch."

3 Munch, Manuscript OKK 2734; quoted by Ragna Stang, *Edvard Munch*, New York: Abbeville Press, 1977, p. 120.

4 Munch, Manuscript N 29; quoted in Arne Eggum, *Edvard Munch: Symbols and Images*, catalog of exhibition, Washington, DC: National Gallery, 1978, p. 154.

5 Bodil Ottesen, "The Flower of Pain: How a Friendship Engendered Edvard Munch's Predominant Artistic Metaphors," *Gazette des Beaux-Arts*, ser. 6, 124, October 1994, pp. 149–158.

6 Edvard Munch; quoted by Stang, *Edvard Munch*, p. 31.

7 "Bohembud" (commandments for the Bohemians), *Impressionisten*, No. 8, February 1889; quoted by Stang, *Edvard Munch*, p. 52.

8 This painting, called *Hulda*, is now lost; see Reinhold Heller, *Munch: His Life and Work*, Chicago: University of Chicago Press, 1984, p. 38.

9 The text is translated in Arne Eggum, *Alpha and Omega*, catalog of exhibition, Oslo: Munch Museum, 1981.

10 Roy Asbjörn Boe, "Edvard Munch: His Life and Work from 1880 to 1920," unpublished Ph.D. dissertation, New York University, 1971, p. 51.

11 Kirk Varnedoe, "Christian Krohg and Edvard Munch," *Arts Magazine*, April 1979, pp. 88–95; Krohg's denial of Munch's participation is cited on p. 90.

12 Munch used the phrase "pillow period" to Jens Thiis: "As far as the sick child is concerned I might tell you that this was a time which I refer to as the 'pillow period.' There were many painters who painted sick children against a pillow — but it was after all not the subject that made my sick child.

"No, in sick child and 'Spring' no other influence was possible than that which of itself wells forth from my home. These pictures were my childhood and my home. He who really knew the conditions in my home — would understand that there could be no other outside influence than that which might have had importance as midwifery. — One might as well say that the midwife had influenced the child. — This was during the pillow era. The sick bed era, the bed era and the comforter era, let it go at that. But I insist that there hardly was one of those painters who in such a way had lived through his subject to the last cry of pain as I did in my sick child. For it wasn't just I who sat there, it was all my loved ones." Manuscript N 45; quoted in Eggum, *Edvard Munch: Symbols and Images*, p. 146.

13 Patricia Berman and Jane van Nimmen, *Munch and Women, Image and Myth*, Alexandria, VA: Art Services International, 1997, p. 45.

14 Marit Lange, "Max Klinger og Norge," *Kunst og Kultur* (Norway), vol. 80, pt. 1, 1997, pp. 2–40.

15 Edvard Munch, 1892, Violet Book, Manuscript OKK 1760; quoted by Stang, *Edvard Munch*, p. 79.

16 Edvard Munch, 1907–1908, quoted in Herschel Chipp, editor, *Theories of Modern Art*, Berkeley and Los Angeles: University of California Press, 1969, p. 114.

17 Quoted in Eggum, *Edvard Munch: Symbols and Images*, p. 131.

18 Reidar Dittman, *Eros and Psyche. Strindberg and Munch in the 1890s*, Ann Arbor, MI: UMI Research Press, 1982, p. 79. See also Reinhold Heller, "'Das schwarze Ferkel' and the Institution of an Avant-Garde in Berlin, 1892–1895," in *Künstlerische Austausch = Artistic Exchange: Akten des XXVIII. Internationalen Kongresses für Kunstgeschichte, Berlin, 15.–20. Juli 1992*, Berlin: Akademie Verlag, 1993, pp. 509–19.

19 Edvard Munch, Manuscript N 222; quoted in Arne Eggum, *Munch and Photography*, New Haven and London: Yale University Press, 1989, p. 67.

20 See Albert Elsen, *Origins of Modern Sculpture: Pioneers and Premises*, New York: G. Braziller, [1974], pp. 22–24.

21 Edvard Munch, quoted by Stang, *Edvard Munch*, p. 174.

22 Rolf E. Stenersen, *Edvard Munch, Close-Up of a Genius* [1944], Oslo: Sem & Stenersen AS, 1994, p. 63.

23 Berman and van Nimmen, *Munch and Women, Image and Myth*, p. 15.

24 Berman and van Nimmen, *Munch and Women, Image and Myth*, p. 31.

25 For the episode of Tulla Larsen and the gun, see Stang, *Edvard Munch*, pp. 172–174.

26 Elizabeth Prelinger and Michael Parke-Taylor, *The Symbolist Prints of Edvard Munch*, New Haven and London: Yale University Press, 1996, pp. 206–209.

27 Eva Mudocci to W. Stabell; quoted by Stang, *Edvard Munch*, p. 178.

28 Edvard Munch to Sigurd Høst; quoted by Stang, *Edvard Munch*, p. 178.

29 Sarah G. Epstein, *The Prints of Edvard Munch. Mirror of His Life*, Oberlin, OH: Allen Memorial Art Museum, 1983, p. 123.

30 Berman and van Nimmen, *Munch and Women, Image and Myth*, p. 46.

31 Epstein, *The Prints of Edvard Munch. Mirror of His Life*, p. 69ff.

32 Lippincott, *Edvard Munch. Starry Night*, p. 39.

33 Quoted in *Edvard Munch: The Frieze of Life*, Mara-Helen Wood, editor, London: National Gallery Publications, 1992, p. 59.

34 Gabriel P. Weisberg, "S. Bing, Edvard Munch and l'Art Nouveau," *Arts Magazine*, 1986, vol. 61, no. 1, pp. 58–64.

THE SCANDINAVIAN CONSCIENCE:
KIERKEGAARD, IBSEN, AND MUNCH

VANESSA RUMBLE

Edvard Munch presents us with unforgettable images of Scandinavia. *The Voice (Summer Night)* conjures up the spell of midsummer nights in which the sun scarcely sets (no. **16**). A certain suspense, at times attractive, at times disquieting, marks many of the images in Munch's Frieze of Life. The force of Munch's art, like the appeal of Scandinavian summer evenings he loved, derives from the haunting awareness of life's urgency against the backdrop of long winters and death. Munch's description of his last Christmas together with his mother, celebrated when he had just turned five, offers the same troubling proximity of light and darkness:

There were many white lights shining all the way to the top of the Christmas tree—some were dripping. It was shining in all the colors of light, but mostly in red and yellow and green. It was a sea of light so intense that one almost could not see. The air was hot and smelled intensely of burned spruce and smoke. Supported by a pillow in her back, she sat silent and pale on the sofa in a deep black silk dress. . . .[1]

When Laura Munch died of consumption several days later, she left five children behind, the oldest six years old.

Edvard Munch's portrayals of Norwegian life and landscape become visual equivalents for a certain psychic terrain, one in which loss and anxiety are prominent. If Munch's most recognizable work, *The Scream* (no. **7**), brings his viewers to reflect on conflicts that only an adult could name, we should nevertheless note that the figure's face and gestures, the round eyes and upraised hands, appear also in *The Dead Mother* (no. **11**). Munch's powerful depictions of Eros and the seemingly inevitable progression from attraction to jealousy, disillusionment, and despair, trigger recurring thoughts of the little wild-haired child, wide-eyed with loss. It is widely recognized that the losses of Munch's childhood are reflected in the quality of his later erotic attachments and his relation to and portrayal of the natural world. Munch's work, like the writings of his predecessors in Scandinavian letters, the Danish philosopher Søren Kierkegaard and the Norwegian playwright Henrik Ibsen, explore what Kierkegaard would call, problematically, hereditary sin. Kierkegaard, Ibsen, and Munch call into question the possibility of real moral freedom. To what degree do severe losses limit our ability to respond appropriately and whole-heartedly to the complex responsibilities that face us? All three thinkers express the tragic potential in our checkered moral pedigree: the uncertain intersection of nature and freedom in which we all come into being as moral subjects, and our very mixed presuppositions for doing so. Munch, like Ibsen and Kierkegaard, was preoccupied by the way in which the misfortunes and misdeeds of individuals can echo in generation after generation.

Why Scandinavia produced such compelling portraits of the human situation, drawn to and often divided by nature and duty, remains a mystery. One may conjecture that the significant family tragedies

that marked the childhoods of Kierkegaard, Ibsen, and Munch may have made them especially aware of the gap between the ruthlessness of need and the claims of conscience. Morality and inclination find no easy meeting place in their works. One may also wonder, more speculatively, whether this tension may be traced back to an earlier crisis, when Christian teachings brought by Frankish missionaries and merchants met the pagan culture of Vikings. How were the claims of Rome received by Norse souls so used to the urgent rhythms of life, rhythms potentially as threatening as they were gratifying to those led by them? Kierkegaard, Ibsen, and Munch, coming on the scene roughly one thousand years after this encounter, offer varied perspectives on the way in which human freedom and the claims upon it have been appropriated and expressed in the Scandinavian conscience.

Søren Kierkegaard (1813–55) sought to find a religious expression for our "entangled freedom" that would retain a reference to individual experience. Brought up in a home marked by the pietism of his father's west Jutland roots, the young Kierkegaard was introduced to the story of Christ in a way which would underscore the disparity between the worldly happiness of the natural man and the innocent suffering of Christ. Kierkegaard describes his father's memorable instruction:

Imagine a child, and then delight this child by showing it some of those artistically insignificant but for children very valuable pictures one buys in the shops. This man with the look of the leader, with a waving plume on his hat, and riding a snorting steed at the head of thousands upon thousands whom you do not see, his hand stretched out in command . . .—this is the emperor, the one and only Napoleon. —This man here is dressed as a hunter; he is leaning on his bow and looking straight ahead with a look so piercing, so steady, and yet so concerned. It is William Tell. . . . —And in the same way and to the child's unspeakable delight you show the child several pictures. Then you come to a picture that you have deliberately placed among the others; it portrays one crucified. The child will not immediately . . . understand this picture; he will ask what it means, why is he hanging on such a tree. . . . Then tell the child that this crucified one is the Savior of the world. . . . Tell him that this crucified man was the most loving person who ever lived. . . . [T]he child, the first time he hears it, will become anxious and afraid for his parents and the world and himself.[2]

Not surprisingly, the young Kierkegaard railed in his journals against the oppression and impoverishment he saw in the Christian world view:

Almost everywhere that the Christian occupies himself with what is to come, there is punishment, devastation, ruin, eternal torment and suffering before his eyes. In this respect the Christian's imagination is exuberant and wayward, but when it comes to describing the bliss of the faithful and chosen one, it is proportionately meager. . . . [I write this] not to criticize the Christians . . . but to caution everybody who is still not tightly laced in this kind of a spiritual corset from imprudently entering into such a thing, to protect him against such narrow-chested, asthmatic representations.[3]

This sense of the Christian world-view as somehow claustrophobic, as excluding earthly pleasure and the best of pagan culture, becomes an enduring conviction of both Ibsen and Munch. Kierkegaard's rebellion, however, was short-lived. Though he, to the end of his life, claimed that unredeemed human nature is hostile to the demands of Christianity, he came to believe that only the existence of a transcendent God can bring genuine freedom to human life. Only the belief in such transcendence, which renders "all things possible," releases people from the constraints of finitude and worldly probability, allowing them to breathe.[4] Kierkegaard's journey to this conclusion was, however, no simple one.

In 1841, at the age of twenty-seven, Søren Kierkegaard broke off his engagement to the seventeen-year-old Regine Olsen. Though he was by all accounts devoted to the vivacious and personable Regine, Kierkegaard had begun to fear that he could not make her happy. It was never clear to Kierkegaard himself whether the difficulty lay in his melancholy, his sense of complicity in his father's guilt,[5] the restless need to cultivate his own genius, or the belief that marriage would conflict with a personal religious calling. In any case, less than a month after having defended his master's thesis in theology at the University of Copenhagen, the young Kierkegaard found himself suddenly a social outcast in his provincial Copenhagen, and his journals show him struggling to vindicate himself and to recover a sense of identity and mission. He did not wait long. Though his unhappy relationship with Regine left an unmistakable mark on his writings, it also solidified his vocation: "She made me a poet." The broken engagement itself became an emblem of the human situation, of the manner in which: (1) freedom interrupts the repose of the human in nature and (2) the misuse of that freedom jeopardizes the relation between human and divine. These two themes are intertwined throughout Kierkegaard's writings. The first motif unites his thought with that of Ibsen and Munch, while reflections concerning the relation of human to divine, unmediated by the realm of nature, are seldom broached by Ibsen and Munch. Kierkegaard's work allows us to see how the psychological and religious concern with human freedom overlap and inform one another.

In *Fear and Trembling* (1843), Kierkegaard advocates an understanding of faith as sharply divorced from all social obligation and incapable of recognition by others. Not surprisingly, Kierkegaard defends the claim that some religious obligations lie wholly beyond the realm of social norms. He searches for religious heroes who, like himself, have defied propriety: Abraham's willingness to sacrifice Isaac is singled out as a paradigmatic case of faith's inability to communicate to, or vindicate itself before, a secular audience. At the same time, he betrays his lingering doubts as to the coherence of a self whose fundamental inclinations are so at odds with social expectation. If the individual's nature is so incommensurable with social forms, is this rooted in individual fault, social corruption, or divine retribution of some sort? Shakespeare's Richard III makes a telling appearance in a work ostensibly concerned with obligation to the divine will: "I [have been] cheated of feature by dissembling Nature, deformed, unfinished, sent before my time into this breathing world, scarce half made up, and that so lamely and unfashionably that dogs bark at me as I halt by them."[6] In spite of Kierkegaard's will to believe in a deity who can reconcile nature and morality, as well as the desires of the heart and the claims of community, the fear remains that the worlds of desire and obligation are so incompatible that they cannot communicate with one another, the claims of the one unrecognizable to the other. What sort of deity would countenance such a situation? While Kierkegaard stops short of outright defiance, his reflections on Richard III's dilemma show him unwilling to explain away the conflict between human nature and moral obligation as either: (1) ultimately subordinate to an inscrutable religious duty and hence dismissible, (2) ascribable solely to nature, and by extension to its Creator, or (3) attributable exclusively to the perversity of the human will. "For what love for God it takes to be willing to let oneself be healed when from the very beginning one in all innocence has been botched, from the very beginning has been a damaged specimen of a human being!"[7] Here, human freedom is clearly assigned the task of "allowing itself to be healed." Nevertheless, belief in grace in a world so inexplicably fragmented would surely require the "leap" beyond rationality of which Kierkegaard wrote, and life in such a world would, he knew, offer no illumination of the meaning behind the sacrifice.

Kierkegaard returns to the problem of the relation between freedom and nature in the following year, with the drafting of his brilliant and problematic *The Concept of Anxiety*. Shifting abruptly from his earlier concern with religious duty to "the Absolute," Kierkegaard frames a question so decisive for

Ibsen and later Munch: how does freedom emerge in human existence? Final resolutions prove elusive, of course, but Kierkegaard succeeds in communicating the anxiety, the ambivalence, and the all-but-inevitable self-deception that accompanies freedom in its genesis. More than any other work, *The Concept of Anxiety* is insistent in its presentation of the human being as a contingent, embodied, historical, and sexual being. The issue that remained largely implicit in *Fear and Trembling*—how a person can assume responsibility for a nature not of his or her choosing—comes to the fore. Kierkegaard struggles with the problem of what he calls hereditary sin *(Arvesynd):* what are we to make of a freedom whose extent can not be determined and whose existence cannot be dismissed? In *The Concept of Anxiety,* his response seems to be one that anticipates that of Ibsen and Munch—namely, the recognition of a *lack* of self-knowledge almost sublime in extent. Anxiety signals the restless point of intersection between freedom and nature, the shifting boundary between innocence and culpable freedom:

Anxiety is the dizziness of freedom, which emerges when the spirit wants to posit the synthesis and freedom looks down into its own possibility, laying hold of finiteness to support itself. Freedom succumbs in this dizziness. . . . In that very moment everything is changed, and freedom, when it again rises, sees that it is guilty. Between these two moments lies the leap, which no science has explained and which no science can explain. He who becomes guilty in anxiety becomes as ambiguously guilty as it is possible to become.[8]

Late in life, Kierkegaard began to abandon this sublime bracketing of identity. In *The Sickness unto Death,* Anti-Climacus, the most Christian of Kierkegaard's pseudonyms, argues that our lack of self-knowledge lies ultimately in the defiance of the Creator. This defiance is no longer accessible to consciousness, as it is long since hidden in the folds of sin and time. On this interpretation, it is no longer finitude but individual fault that stands in the way of a transparent self-knowledge. The ambiguity that, in *The Concept of Anxiety,* was said to veil the descent into guilt becomes, in *The Sickness unto Death,* a willed ignorance. Kierkegaard was well aware that there could be no empirical proof of this claim; indeed, he argued that the extent of human sin could not be arrived at by any human solely through introspection. Rather, "man has to learn what sin is by a revelation from God; sin is not a matter of a person's not having understood what is right but of his being unwilling to understand it, of his not willing what is right."[9] Divine revelation assigns the human will primacy over adverse nature and circumstance, firmly locating culpability within the individual.

While Kierkegaard's prosperous childhood home was filled with a foreboding sense of the imminence of divine judgment, Henrik Ibsen's boyhood home in Skien was marked by life-draining poverty and misfortune. At age seven, he saw his father overtaken by sudden financial difficulties, followed by the auctioning of the family's main residence, warehouses, boathouses, and personal belongings. They moved to a former summer residence outside the town, and in this relative isolation Henrik watched the slow disintegration of his parents' hopes. As Ibsen's biographer succinctly reports: "Financial ruin has been known to alter a man's character for the better. It was not so with Knud Ibsen [Henrik's father]."[10] Lively and forceful in better times, Henrik's father became domineering and brutal, and the vitality of the family was lost. The Ibsen children became the unwilling witnesses of this slowly evolving tragedy. An autobiographical fragment, written by Ibsen in 1881, provides vivid descriptions of his earliest memories. Signs of prosperity and optimism abound in the sketch; we see the young Ibsen's delight in the sights and sounds of his native Skien, not least in "balls, dinner parties and musical gatherings [that] followed each other in rapid succession."[11] Tellingly, the sketch terminates abruptly in his seventh year. In Ibsen's adult life, it was only through his plays that he could endure the return to "the

everyday anguish of family life."[12] In his final years, Henrik Ibsen repeatedly took up the idea of making the journey to his birthplace, but the impulse would invariably falter, with Ibsen concluding, "It is not easy to go to Skien."[13]

Ibsen's dramas, like Munch's paintings, bring psychic suffering into a disconcerting proximity to the viewer. The two artists captured the vertiginous effect of psychic distress—the overwhelming quality of prolonged despair, its capacity to alter the shape of daily life. The suffocating sadness of Ibsen's childhood home, revisited countless times in his dramas, anticipate Munch's paintings and prints of death chamber scenes. By the time he writes *Little Eyolf,* toward the close of his productive life, Ibsen is able to produce dialogue in which hardly a line fails to underline the inevitability of his character's misery. The reader reels as the underlying determinants of what seemed a redeemable, if bleak, situation are unveiled, successively blocking off any prospects for a hopeful outcome. The noose tightens slowly and relentlessly in the course of Ibsen's middle and late plays *(Rosmersholm, Hedda Gabler, John Gabriel Borkman, The Master Builder, Little Eyolf,* and *When We Dead Awaken).* The vanishing of the protagonists' possibilities for happiness is the decisive action of these plays. Edvard Munch is said to have called Ibsen's *John Gabriel Borkman* "the best winter landscape in Norwegian art."[14] Ibsen himself locates the landscape more precisely as "the interior of a human soul in which love has died."[15] Ibsen's dramas are lasting monuments to this "Ice Church" of the soul.[16]

Though Ibsen claimed to have "read little of Kierkegaard and understood less," his companions in early adulthood report a shared enthusiasm for Kierkegaard, and Ibsen would later hear the ideas of the Dane expounded by his mother-in-law, Magdelene Thoresen.[17] It is difficult to ignore the echoes of the philosopher in the proclamations of a would-be existentialist hero like Ibsen's Brand: "To be wholly oneself! But how, with the weight of one's inheritance of sin?"[18] In Ibsen's work, the weight of this inheritance often appears in the form of a return of repressed desires and humiliations. In contrast to Kierkegaard's belief in the ultimately willed character of our fate, Ibsen's tragic sensibility leads him to dismiss such clear-cut resolutions. Kierkegaard's insistence on sin's willed ignorance is countered by Ibsen's depiction of the involuntary, self-protective movements of a soul under attack. The wild duck, Old Ekdal tells us in Ibsen's drama of 1884, dives, when wounded, deep into protective waters, fastening itself, in the mud and debris of the sea-floor, to twigs and tangled roots: "Goes without saying. Always do that, wild ducks. Plunge to the bottom—as deep as they can get, old chap—bite themselves fast in the weeds and the tangle—and all the other damn mess down there. And they never come up again."[19] Old Ekdal's hunt for the wild duck becomes a metaphor for young Werle's zealous hunt for family secrets. The wild duck is finally flushed from its hiding place, but it does not come to the surface alive. The family secrets that emerge at Werle's insistence do so prematurely (at least from the point of view of those who from the beginning had most needed obscurity's protective camouflage), with tragic results. Young Hedvig does not survive Hjalmer Ekdal's doubts as to her paternity.

Ibsen's depiction of the domain we today would call unconscious is often signaled by reference to the sea, to untamed creatures, or to the wild nature of Norway's north country. Ibsen's gestures toward this domain, and his compelling representation of its power, recall the dilemma posed by Kierkegaard: Can creatures subjected to the compulsion of forces so incompletely understood nevertheless be free? Though Ibsen does not burden his characters with an unqualified autonomy, neither does he release them from their responsibility and guilt. Here the moral, and sometimes the specifically Christian, dimension of Ibsen's heritage meets the pagan. In the words of Julian the Apostate in *Emperor and Galilean,* "Whoever has once been in His power can never completely free himself from it."[20] Equally impossible, however, is the task of fully domesticating the pagan striving for survival and domination. As a mature writer, Ibsen increasingly erodes the ground for happy compromise between moral or reli-

gious ideals and untamed desires; he rejects, too, any possibility of skirting the conflict. In consequence, Ibsen's dramas culminate in the impossibility of movement. If his protagonists seem at times enervated and imprisoned by the demands of conscience or of social propriety, the playwright offers no vision of facile emancipation. The primal demands of the unconscious, urgent and unscrupulous, can corner and checkmate with pitiless speed, and more surely than any moral code.

Only rarely in Ibsen's work does the confrontation of passion and propriety yield a happy result. More often the main characters, like the protagonists of *Rosmersholm,* are granted too little insight, too late. When, at the outset of the play, the housekeeper at Rosmersholm alludes to the white horses that she sees, the viewer registers the ominous note but doubts their capacity to overwhelm the idealism of John Rosmer and the directness and strength of Rebecca West. Rosmer, a former pastor turned unbeliever, lives in the home of his ancestors, a remote manor long viewed by the community as "a stronghold of order and morality—of respect and reverence for everything that is accepted and upheld by the best elements in . . . society."[21] Rebecca West, an outsider from the north, was introduced to Rosmer and his wife Beata by the latter's brother, and she managed the affairs of the house during Beata's final illness. As the play opens, Miss West is living alone with Rosmer on the estate, following the death of his wife. The two plan to work to reverse what they perceive as the grim and life-denying legacy of Rosmer's ancestors, both at the manor and in the surrounding community. In the end, however, it is the ancestral conscience that wins over the spirits of both Rosmer and Rebecca. In a confession memorable for its shattering honesty, Rebecca retraces the steps by which she led Rosmer's childless wife to suspect that she, Rebecca, might be pregnant by him. Beata was seized with suicidal despair, and she acted upon it. Rebecca evaded acknowledgment of her role in her death. The tragically belated moral courage of both Rosmer and Rebecca West only highlights its utter futility. "Enslaved . . . to a law which [she] had not previously recognized,"[22] the moral law and religious traditions of her host's forebears, Rebecca must face a devastating self-knowledge. Without the "radical and ruthless" passion that previously drove her actions, Rebecca is mired in a guilt that she lacks the resources to escape. Without the assurance of a moral basis for their lives, Rosmer and Rebecca are at the mercy of the white horses of Rosmersholm, and their promise of oblivion. As the play concludes, they follow Beata's steps into the millrace.

Even when Ibsen vouchsafes the viewer a happy ending, as he does in *The Lady from the Sea,* the security of the compromise reached between passion and *Sittlichkeit* (societal norms) is singularly vulnerable. No natural harmony is posited between the claims of morality and the exigencies of nature. When Dr. Wangel sets his restive wife Ellida free to choose between remaining in her marriage to him or following her former lover, the Stranger from the sea, Ellida is able to shake free of her captivation by the Stranger. The play seems to culminate in an Apollonian victory, but the restored union of Ellida and Wangel is not entirely convincing. Wangel was drawn by his wife's elusiveness, the inaccessibility of her untamed spirit. She, in turn, had accepted the security of his home without becoming a true participant in the family's life. M. C. Bradbrook captures the irony of the ending: "Prudence, wisdom, and sanity are on Wangel's side, yet the Stranger is an emissary from the hidden sources of power, and there is a contradiction at the basis of the play. The poetic vision, which should control and focus all the dramatic action, is, instead, set in opposition to it."[23] The happy ending does not encompass the very element that Ibsen saw as indispensable and inescapable, those passions that have not submitted to the settled order of things.

While Ibsen's characters must face the disruptive claims of "inner trolls," Munch's art focuses on the individual's confrontation with his or her natural limits. Death and sexuality confront the self with its boundaries. Ibsen's preoccupation with inner conflicts gives way to Munch's fascination with the

subject's attempt to maintain its integrity in the face of what is perceived as other. Kierkegaard's description of the spirit's anxiety in the face of sexuality is apropos: "In the moment of conception, spirit is furthest away, and therefore the anxiety is greatest. . . . Why this anxiety? It is because spirit cannot participate in the culmination of the erotic. It cannot express itself in the erotic. It feels a stranger."[24] Like Kierkegaard, Munch views sexuality's encroachment on the subject's self-conscious sovereignty as a threat to the coherence of the self. Death, like sexuality, poses the question of whether anything personal escapes the grip of nature.

For Munch, as we know, this question had been posed to him all too vividly by his mother's early death. Munch himself contracted tuberculosis in his early adolescence, and his older sister Sophie, from whom he had been inseparable since his mother's death, succumbed to the disease when Edvard was fourteen. During the time of his own illness, Munch later recorded in his notes, the adults caring for him sought to conceal from him his own blood-soaked handkerchiefs.[25] Munch's monumental work, *The Sick Child,* which he reworked in different media for the next thirty-five years, depicts his dying sister (no. **9**). The painting reveals the extent of the loss and the mystery that had not been concealed from either Edvard or his sister.

By 1885, when Munch began working on *The Sick Child,* he had already established a reputation for himself as a rising star among young Norwegian painters, and he had received encouragement and financial assistance from the leading Norwegian representatives of Naturalism and Impressionism, Fritz Thaulow and Christian Krohg. Painting the death of his sister defined his independent direction as an artist in much the same way as the event itself defined Munch as a man. Towards the end of his career, when Munch posed for a photographer in one of his studios at Ekely, *The Sick Child* was propped up against the wall next to him, a token of the work's priority in his art and life.

In the painting, Sophie is represented in profile, gazing over the bowed head of her aunt Karen Bjølstad, who cared for her during her illness. Munch describes in his memoirs the terrible exhaustion of his sister, and the weak hands with which she clasped her bedclothes. In the painting, however, she is alert, her head bowed neither in supplication nor helplessness. The child looks past not only her aunt but also the viewer, who might be eager to reassure the child, as her own father did, of our shared mortality, and to be somehow exonerated by her. For the viewer can only witness, not heal.

The child's presence, with the shadow of a halo in the background, is majestic. She crowns the suffering of the scene. And the suffering, we may imagine, was formidable. Karen Bjølstad had devoted herself to raising her dead sister's children. The death of Sophie can only have been a heart-rending reminder of her inability to fully compensate for the loss of their mother, leaving the children fragile and exposed to illness. Munch noted his own tendency to view the painting with eyes partially closed, and he incorporates the mark of his lashes on some versions of the scene. In so doing, the silent presence of the fourteen-year-old boy who must endure the slow death of his sister and relive the loss of his mother is imprinted on the canvas. Sophie herself sits with open eyes. She does not shrink from what she sees; nor does the adult Munch who paints her. The sunlight pours over her.

The German philosopher Immanuel Kant claimed that if one were able to survey the violence of nature without actually being subject to its force, one would experience a mixture of simultaneous pleasure and pain that he designated the sublime.[26] On Kant's account, the pain arose from one's awareness of the frailty of one's physical existence, while the pleasure reflected one's consciousness of a moral vocation that transcended physical vulnerability. He famously divided the human being into a physical aspect, governed by natural laws, and an immaterial one, capable of moral autonomy. In so doing, Kant tamed the classical Romantic vision of the sublime as the confrontation of the human individual with an all-engulfing nature, within and without. While Kant isolated the realms of physical and spiritual and designated as sublime those experiences that might indicate the sovereignty of the latter over

the former, subsequent philosophers would regard as sublime the very undecidability of our conglomerate natures. At the time of writing *The Concept of Anxiety,* Kierkegaard followed this path in highlighting the intimate joining of freedom and nature in the human being. In an even more pronounced manner, Nietzsche would celebrate the contradictions and inevitable suffering of the human situation: "All well-constituted, joyful mortals . . . are far from regarding their unstable equilibrium between 'animal and angel' as necessarily an argument against existence. . . ."[27] In like manner, Munch's *The Sick Child* glorifies not the spirit's transcendence of death, but its bold encounter with it.

It is this "unstable equilibrium" of spirit and nature that Edvard Munch's *The Scream* celebrates. Just as *The Sick Child* portrays death without dismissing its sting, so, too, *The Scream* presents the anxiety of the subject impaled by forces it cannot subdue. Echoing the vision of Kant's more radical successors, Munch's sublime reveals the limits of conscious volition. The dignity of the subject rests in acknowledging this uncertain state of affairs, not in mastering it. The faithful rendering of finitude is Munch's beatific vision. In *The Scream,* he reworks the memory of a stroll along Oslo's Ljabroveien in which anxiety descends without warning:

I was walking along the road with two friends. The sun set. I felt a tinge of melancholy. Suddenly the sky became a bloody red.

I stopped, leaned against the railing, dead tired, and I looked at the flaming clouds that hung like blood and a sword over the blue-black fjord and the city.

My friends walked on. I stood there, trembling with fright. And I felt a loud, unending scream piercing nature.[28]

In the lithograph of *The Scream* (no. **7**), vertical strokes welling up from the base of the print clash with the line of the horizon. Munch's friend and fellow artist, the Polish writer Stanislaw Przybyszewski, identified the source of the scream as the "horrible battle between mind and sex." In a passage reminiscent of Kierkegaard's discussion of spirit and sexuality, Przybyszewski elaborates: "The hero of love must not exist anymore: his sexuality has crawled out of him and now it screams through all of nature. . . ."[29] While this is not Munch's own account, it should be noted that Munch changed the title of his work to *The Scream* after reading this description.

The terror of undiscriminating and ungovernable drives reappears in an exceptional prose poem composed by Munch during his stay at a clinic in Copenhagen in 1908–09, almost two decades later. The poem is a revealing record of Munch's anxieties during this period of nervous exhaustion. It tells the story of two lovers, Alpha and Omega, and their life on a deserted island (no. **45**). Tales of their appealing playfulness are interrupted by Omega's rather remarkable infidelities:

Omega's desires varied. One day Alpha saw her sitting on the beach, kissing a donkey which was lying in her lap. . . . Omega felt tired and disappointed because she could not possess all the animals of the island; she sat down in the grass and cried bitterly. . . . One day her children came to [Alpha]; a new generation had grown up on the island, and they called him "father". They were small boars, small snakes, small monkeys, and other beasts of prey, and human hybrids. He was in despair; he ran along the sea. The sky and the ocean were the colour of blood. He heard shrieks in the air, and put his hands to his ears. Earth, sky, and sea quaked, and he felt a great terror.[30]

Omega's unfaithfulness elicits Alpha's anxiety. The prospect of boundless promiscuity suggests an equally boundless jealousy, one that shakes the sovereignty of self. Like the figure in *The Scream,* abandoned by the two figures retreating in the distance, Alpha hears shrieks in the air (perhaps his own?)

and puts his hands to his ears. The sky turns red, like the blood that Munch associated with both fertility and death.

Certainly, Munch understood sexuality to be as threatening to female individuality as to male autonomy. Munch's *Madonna* (nos. **54** and **55**) renders palpable the proximity of life and death in the moment of conception. When men and women make themselves "a link in the chain that binds a thousand generations," they are at that moment "no longer themselves."[31] Whether through identification with the Madonna's "smiling corpse," or through subjection to female unfaithfulness, Munch underlines the ego-destroying potential of sexuality.

Munch's emphasis upon the encounter with sexuality and death seems at first glance opposed to Ibsen's lifelong preoccupation with the conflict of passion and conscience. Munch's "fundamentally materialistic and physiologically based view of human life"[32] is no mere variation on Ibsen's understanding of the forces which drain human vitality. While Ibsen contemplates a humanity that is deeply, if mysteriously, implicated in its own captivity, Munch focuses on the eclipse of the individual by Nature's larger purposes. In Ibsen's plays, the requirements of bourgeois decency, the claims of Christian conscience, even the demands of art are more formidable obstacles to human joy than the awareness of mortality or finitude. Nevertheless, the fact of Munch's lifelong fascination with Ibsen's work prompts one to search for underlying sympathies.

Early on, the young Munch identified with characters from Ibsen's dramas. Duke Skule of *The Pretenders* inspired the thirteen-year-old Munch's artistic efforts. Later, he designed stage sets for Max Reinhardt's productions of Ibsen's *Ghosts* and *Hedda Gabler*. More significantly, Munch makes himself the model for his sketch of Osvald, the ailing young artist of *Ghosts*. What, we may ask, was so captivating to Munch in Ibsen's presentation of the human situation? The painter was said to have remarked, "I read mostly diagonally — but not Ibsen — him I read from cover to cover."[33]

Both Ibsen and Munch weathered the censure of outraged bourgeois sensibility throughout their careers. Though Norway was by no means the only source of such criticism, both artists spent the bulk of their most productive years away from their homeland. Their self-imposed exile witnesses to a shared antipathy to an "unforgiving Nordic Lutheran deity"[34] and to the society that worshipped it. In *Ghosts*, Ibsen's Osvald, returning to Norway from Paris, complains of the bleakness of northern life:

Here everyone's brought up to believe that work is a curse and a punishment, and that life is a miserable thing that we're best off to be out of as soon as possible. . . . But they won't hear of such things down there. Nobody abroad believes in that sort of outlook anymore. Down there, simply to be alive in the world is held for a kind of miraculous bliss. Mother, have you noticed how everything I've painted is involved with this joy of life? Always and invariably, the joy of life [Livsglœden].[35]

If the naivete of Osvald's plea verges on the comical, the bitterness of his conclusion does not: "I'm afraid that everything that's most alive in me will degenerate into ugliness here."[36] Ibsen and Munch shared their wariness of moralities framed without adequate attention to the natures they are to govern. The cry of Ibsen's Julian the Apostate in *Emperor and Galilean* is a most direct response to a specifically Christian ethic: "To be fully human has been forbidden from the day the seer of Galilee gained control of the world. . . . To love or to hate, each is a sin. Has he then changed man's flesh and blood? Hasn't earthbound man remained what he always was? All that's healthy within our souls rises against this . . . ! Thou shalt! Thou shalt! Thou shalt!"[37] Munch's early rejection of his father's Lutheran faith is similar in spirit: "He could not understand my desires. I could not comprehend what he valued above them."[38] Ibsen's most characteristic protest against an ethic that does not do justice to earthbound nature

is to display its consequences—the waning resources of souls under siege by conscience and culture. Munch's, by contrast, is to revive and celebrate nature, particularly as manifested in the confrontation of life and death.

Kierkegaard, Ibsen, and Munch share a fascination with moments in which the subject faces eclipse by conscience, passion or death. The forces that are seen to encroach upon human freedom form a forbidding panorama: the paralysis of anxiety and sin, the relentless pull of unrealizable or destructive passions, and the indifferent physiology of reproduction and death. The subject that struggles to maintain its coherence in the face of these forces is surely deserving of dignity. In Munch's work, the remarkable fact is that this struggle is not only dignified. It is beautiful. For all the gravity and pathos of their subject matter, Munch's paintings are filled with exultation. Why dwell on the exceptional and anguish-filled moments in which mortal subjects are threatened with extinction? Perhaps because it is at these moments when life presents itself most vividly.

Rather than claiming an original autonomy of the will, as Kierkegaard did, or portraying the entanglement of the civilized will, as Ibsen had, Munch strove to excavate the elemental, the finite, the uncivilized subject. His *Self-Portrait with Skeleton Arm* (no. **2**) reveals the skeleton's disconcerting presence beneath ephemeral flesh, while *The Scream* itself recalls, as Cernuschi persuasively claims, a shriek that precedes and potentially usurps language. Sexual attraction encompasses the heedless desire to consume and incorporate as well as an equally unwilled self-sacrifice. While Kierkegaard set himself the ethico-religious task of reclaiming human freedom, Munch attempts to reshape conscience in such a way that the proximity of life and death, and the consequent limitations of human freedom, are definitively established. In opposition to those who would locate human grandeur in the conquest of nature by freedom, Munch elevates those moments of existence when human life is most closely confronted with an indifferent, if ravishing, nature. Nature's dance of life and death is, Munch would persuade us, as untamed and ungovernable in its essence as his *Galloping Horse*, which fairly storms off the canvas.

1 Manuscript N 154, Edvard Munch, quoted by Reinhold Heller, *Munch: His Life and Work*, Chicago: University of Chicago Press, 1984, p. 16.

2 Søren Kierkegaard, *Practice in Christianity*, edited and translated by Howard V. Hong and Edna H. Hong, Princeton, NJ: Princeton University Press, 1991, pp. 174–75.

3 Søren Kierkegaard, *Søren Kierkegaard's Journals and Papers*, vol. 3, edited and translated by Howard V. Hong and Edna H. Hong, Bloomington, IN: Indiana University Press, 1975, #3247, pp. 498–99.

4 Søren Kierkegaard, *The Sickness Unto Death*, translated by Howard V. Hong and Edna H. Hong, Princeton, NJ: Princeton University Press, 1980, p. 40.

5 Kierkegaard's father, Michael Pedersen Kierkegaard, suffered under a pervasive sense of guilt, the origins of which are not fully clear. The elder Kierkegaard had, as a child, cursed God when he found himself hungry and alone on the Jutland heath, an eleven-year-old shepherd boy. In addition, Kierkegaard's oldest sister Maren Kirsten was conceived illegitimately. Michael Pedersen came to believe that his guilt was the cause of the deaths of many of his children—five of his seven children predeceased him. He went so far as to inform Søren Kierkegaard that it was his (the father's) fate to survive *all* his children.

6 William Shakespeare, *Richard III*, as quoted in Søren Kierkegaard, *Fear and Trembling*, edited and translated by Howard V. Hong and Edna H. Hong, Princeton, NJ: Princeton University Press, 1983, p. 105.

7 Kierkegaard, *Fear and Trembling*, p. 104.

8 Søren Kierkegaard, *The Concept of Anxiety*, translated by Reidar Thomte, Princeton, NJ: Princeton University Press, 1980, p. 61.

9 Kierkegaard, *The Sickness Unto Death*, p. 95.

10 Michael Meyer, *Ibsen: A Biography*, Garden City, NY: Doubleday & Company, 1971, p. 13.

11 Meyer, *Ibsen: A Biography*, p. 10.

12 Ibsen's preliminary sketches for *The Wild Duck*, quoted in Halvdan Koht, *Life of Ibsen*, New York: Benjamin Blom, Inc., 1971, p. 29.

13 Meyer, *Ibsen: A Biography*, p. 24.

14 Ragna Stang, *Edvard Munch: The Man and His Art*, New York: Abbeville Press, 1977, pp. 159 and 260.

15 Meyer, *Ibsen: A Biography*, p. 727.

16 Henrik Ibsen, *Brand*, translated by Michael Meyer, Garden City, NY: Doubleday & Company, 1960, p. 155.

17 Meyer, *Ibsen: A Biography*, pp. 38–39, 177.

18 Henrik Ibsen, *Brand*, p. 80.

19 Henrik Ibsen, *The Wild Duck*, edited and translated by Dounia B. Christiani, New York and London: W. W. Norton & Company, 1968, p. 28.

20 Henrik Ibsen, *Emperor and Galilean*, cited in Meyer, *Ibsen: A Biography*, p. 176.

21 Henrik Ibsen, *Rosmersholm,* translated by Michael Meyer, London: Metheun Drama, 1988, pp. 62–63.

22 Ibsen, *Rosmersholm,* p. 101.

23 M. C. Bradbrook, *Ibsen the Norwegian,* London: Chatto & Windus, 1948, p. 109.

24 Kierkegaard, *The Concept of Anxiety,* pp. 71–72.

25 Bente Torjusen, *Words and Images of Edvard Munch,* Chelsea, VT: Chelsea Green Publishing Company, 1986, pp. 55–58.

26 Immanuel Kant, *Critique of Judgment,* translated by Werner Pluhar, Indianapolis: Hackett Publishing Company, 1987, pp. 119–21.

27 Friedrich Nietzsche, *On the Genealogy of Morals,* translated by Walter Kaufmann, New York: Random House Inc., 1967, p. 99.

28 Edvard Munch, diary entry of January 22, 1892, quoted in Reinhold Heller, *Edvard Munch: The Scream,* New York: The Viking Press, 1972, p. 65.

29 Reinhold Heller, *Munch: His Life and Work,* Chicago: University of Chicago Press, 1984, pp. 130–131.

30 See Arve Moen, *Edvard Munch: Woman and Eros,* Oslo: Forlaget Norsk Kunstreproduksjon, 1957, pp. 30–31.

31 See Edvard Munch, "The Frieze of Life," in Mara-Helen Wood, editor, *Edvard Munch: The Frieze of Life,* London: National Gallery Publications, 1992, p. 12.

32 Kristie Jayne, "The Cultural Roots of Edvard Munch's Images of Women," *Women's Art Journal* 10, Spring/Summer 1989, p. 30.

33 Inger Alver Gløersen, *Lykkehuset: Edvard Munch og Aasgaardstrand,* Oslo: Gyldendal Norsk Forlag, 1970, p. 5: "Jeg leser mest diagonalt—ja ikke Ibsen—ham leser jeg fra perm til perm." This careful reading is apparent in the arguments Munch marshalls to support his belief that the female characters in Ibsen's *When We Dead Awaken* were modeled on the former's *Three Stages of Woman (The Sphinx),* no. **30.**

34 Heller, *Munch: His Life and Work,* p. 20.

35 Henrik Ibsen, *Ghosts,* in *The Complete Major Prose Works,* edited and translated by Rolf Fjelde, New York: Farrar, Straus, Giroux, 1965, p. 257.

36 Ibsen, *Ghosts,* p. 257.

37 Henrik Ibsen, *Emperor and Galilean,* translated by Brian Johnson, Lyme, NH: Smith and Kraus, 1990, p. 84.

38 Heller, *The Scream,* p. 20.

KATHERINE NAHUM

Munch's *Scream* appears on my mouse pad, a ready acknowledgement of my terror and helplessness in the face of cyberspace. I punch a life-size plastic toy that is printed with the *Scream* and it bounces back . . . and back. When I wear my *Scream* T-shirt, others recognize it, smile and then, unsettled, turn away. *The Scream* is an image to which we all respond. Munch knew. We know. What he shows us is true. Munch's art galvanizes our recognition of truth.

The whole of Munch's art addresses salient themes of his time and ours: existential sadness, wrenching separations, anxiety, jealousy, illness and death, frustrated desire—all aspects of that double-headed monster, attachment and loss. Munch was convinced that he should depict such subjects as they issued from his own life. Although the anarchist writer Hans Jaeger had encouraged him in this pursuit, Munch would have come to an art of intimate expression sooner or later; he seemed destined to paint in an autobiographical manner. His art would honor "living people who breathe and feel, suffer and love," and in response, viewers "would respect the power, the sanctity of it—they would take off their hats as they do in a church."[1]

While staying in the outskirts of Paris in December of 1889 Munch received news of his father's death. This may well have been the event that set in motion the writing of autobiographical notes, Munch's Saint-Cloud Manifesto which articulated his Symbolist aims for art, and, issuing from them, his pantheistic and evolutionary view that life and death emerge sequentially from each other. Loving couples are "merely one link in an endless chain that joins one generation to the next."[2] Above all, these notes record his memories of earlier deaths in the family and a gamut of feelings.[3] Munch was so despondent with the recent, mournful news that he was unable to paint at first, but it was in Saint-Cloud and in response to his father's death that he consolidated his identity as an artist. It was there that he first conceived the Frieze of Life, "a series of decorative pictures, which, gathered together, would give a picture of life."[4] The frieze was the means by which he would make sense of his life. It would contain themes and narratives that ran through, and could be read in many images; the paintings of the frieze, and really all his works, became symbolic parts of a psychological coherence he continually strove to weave and maintain. When he began executing these images Munch turned from naturalism to a Symbolist style of painting in which meaning was ambiguously hidden within observed phenomena. For Munch that meaning was personal, psychological and drawn from the past. Permutations of trauma distilled into a metaphysical coherence formed the content of these interrelated paintings. He said "I paint not what I see but what I saw."

Munch was referring to his own and other's recurrent illnesses, and to deaths—losses—that he had witnessed and sustained. They became the subjects and informed the style of his paintings as Munch claimed, and all writers have noted. There are peculiarities of Munch's style, however, that have not been accounted for, and that redound to childhood experiences of loss within life, before loss through death. Munch's way of making art—his style—for all its primitively spare aspects, embodies a psy-

chological density that is the result of these early experiences, and that we might penetrate by turning to the perspective of developmental research.[5] The stylistic consistencies apparent in several prints, paintings and retrospective sketches from the nineties will be examined in terms of infant research and attachment theory, through which I hope aspects of Munch's art might be clarified. Then I will return to a discussion of the earlier painting, *The Sick Child* (1885–86, National Gallery, Oslo) and a print of it (no. **9**), because the image embodies remnants of Munch's self-regard, because it seems to represent a critical juncture in Munch's artistic development, and because it is his first Symbolist work.

Two woodcuts titled *Melancholy* (nos. **13** and **14**) in our exhibition are re-workings of the 1892 painting then called *Melancholy: Evening* (National Gallery, Oslo), one of the first essays in the Frieze of Life. *Night in Saint-Cloud* (1890, National Gallery, Oslo) might be considered the very first work in this Frieze because it acknowledges the loss of Munch's father. Rendered in moody blues and a deep perspective, it shows a man slumped under the weight of depression. Placed at the end of a dark space, he is a sad figure leaning on his arm and staring out a window whose mullions form a double cross that is reflected on the floor. The two images of the cross, perhaps allusions to Munch's pietistic parents, wedge the figure in deep shadow.

Melancholy: Evening adumbrates another kind of loss. Before a broad landscape at the edge of the sea a man sits desultorily, his head in his hand. In this classical pose of melancholy[6] echoing that of the mourner in *Night in Saint-Cloud,* the figure's downcast eyes look inward. Behind him the shore stretches to distant houses and trees where two small figures, a woman in white and a man in black, are about to depart in a yellow boat. The figure in the foreground is alone, separated from, yet linked to the couple by the curving line of shore moving off like a rope that binds all three. The meandering shore includes exposed rocks whose flattened and odd shapes conjure something other than geology, something like the monstrous forms swirling in a Goya print.[7] Comprising part of the background that appears as a thought bubble, the rocks evoke ill-defined, troublesome notions suggesting that the man is thinking of these distant people important to him, although they are divided from him and lost in the subdued greens, taupes and blues of the landscape. The space of the painting reaches a yawning distance, yet the couple, or thoughts of them, are just there, brought immediately to our attention, while plaguing his. Such a rendering of space effectively suggests presence and longing, physical distance and distance in time.

The painting alludes to the difficult, jealous feelings aroused by several triangular relationships: his friend, Jappe Nilssen's with Oda and Christian Krohg, Hans Jaeger's with the Krohgs, but especially Munch's own with the slightly older "Mrs. Heiberg" (Milly Thaulow) and by implication, her husband Karl Thaulow, who like Munch's father, was a military physician, and who thus raises the specter of another, and incestuous, triangle. These artists and writers of the Kristiania Bohemia had been engaged in the free love Jaeger recommended. But Munch soon found himself enslaved by feelings of jealousy, depression and self-reproach. "Everything was his fault. . . . She looked so sad. . . . Maybe she is the one who believes that he does not care for her, and that it is his own fault. What a spineless wretch you are, a yellow coward, a yellow yellow yellow yellow coward," Munch wrote in his Saint-Cloud Manifesto.[8] This passage presumably refers to the end of his affair with "Mrs. Heiberg"; but this was also a time he was thinking of many things — the death of his father, and by association, his mother's and his sister's deaths.

He memorializes a complex of feelings, including jealousy, in *Melancholy* and also in an ambiguous print of 1895 titled *Kristiania-Bohemia II* (fig. **5**) showing a heavy-set, mustachioed man fantasizing about his former wife[9] and her lovers, Munch among them.[10] "The woman belongs to none of them

and all of them belong to her," Heller trenchantly observes,[11] and the print must represent a terse, layered truth of present circumstances and those of the past when Munch and his four siblings felt the same way about their beautiful mother[12] who "looked at us, from the one to the other, and stroked our cheeks with her hands,"[13] but whose presence was withheld from them not only by death but also by her distancing preoccupations in life.

Munch turned to printmaking because "he was almost pathologically unable to part with his paintings."[14] He made five painted versions and many woodcuts of *Melancholy,* allowing him to hold onto the image, perhaps keeping alive its conflictual nature. Multiple images also freed him to play with—modify and control—the formal and emotional implications of the subject, and thereby modulate pernicious feelings like longing, guilt and helplessness.

Yet it seems that the familiar stylistic components of *Melancholy* are made more stark, rigid and immutable in our exhibited woodcut (no. **13**). The escaping lovers and the boat seem barely discernible, at a greater distance than they are in the painting. They are linked to the man more forcefully and directly, however, by the undulating shoreline that continues into the bounding line of his body; and paradoxically linked as well by the dramatic contrast of near and far. The rocks have become abstract linear elements that are mere formal parallels to the slumped, dejected figure. The figure's isolation is intensified by his position within the flat space below the horizon, while the two lovers exist beyond it. Munch's inclination to paint dichotomies, polarities and paradoxes appears both as theme and formal strategy.

The sky, always a register of feeling, is rendered here in a clear, pale green, while elsewhere it appears blood red. Sadly curving lines course through the color exposing the expressive rough grain of the wood beneath. The same murky green joins the man to the changeable sea, as if he were emotionally flattened, overwhelmed by the green as by a grave depression, as by a helpless feeling of drowning. In the painting and in other images color divides the male figure from the sea.[15] The images called *Melancholy* treat of loss, of death-in-life in a formal language that fits a labile state of depression.

Melancholy (Woman on the Shore) (no. **14**) resembles *Melancholy* in that a woman also sits in a classically melancholic pose at the edge of the sea, but a heavy shank of her hair falls forward and obliterates her face. The divergence allies Munch's print to images of the penitent Magdalene, who is traditionally shown tearing out her hair, or covered by long hair, or wearing a simple cloak and sitting before her cave. The configuration of the landscape and shoreline is sufficiently indeterminate that it might include a cave, but *Woman on the Shore,* as a Symbolist work partaking of the same emotional truth as images of the Magdalene, necessarily remains only suggestive of such sources.[16] Munch's print acknowledges that women are also subject to states of melancholy.[17]

The image is without narrative, iconic, so abstract that the woman's form seems absorbed in the patterns of color Munch uses. The sea and sky are green, the shore black, the dress red, and there are whitish shapes we read abstractly. Just as the woman leans seaward, her cascading hair masking her face, another figure barely suggested in the dark outline of rocks seems also to point in the same direction, out to sea.

Her figure is not so much isolated as fractured, and Munch uses technique to further his meaning of her connection with the sea. He has used a creative "jigsaw" method of color printing. Rather than using a separate block to register each color, Munch sawed one block into shapes, inked each one with a different color and reassembled the woodblock like a puzzle. He could then make a multicolor print in one step. In this way Munch "cut meaning into the individual shapes," created distinctly Synthetist and Symbolist images,[18] and symbolically arranged diverse elements to create his own psychological

truth. Munch's method contributes to our reading this woodcut abstractly. Because her dress is red while her head and hair are of a piece with the blackened shore, the woman becomes abstracted into a meaning beyond the mere representation of her form; it has a Symbolist meaning of hidden truth: she is identified with and absorbed by the sea. It is an image of death. The woman's whitish neck and arm, and the white lateral triangle at left all register what was the bare wood block and so create in these areas negative space, a sense of nothingness. Her hair obscuring her emotive features, the woman leans toward the open expanse of sea; the water reaches toward her. Her body is partitioned like a contested country in accord with the requirements of the artist's abstract composition; she has been returned to nature and lost to the eye.

Women are associated with the sea. The several images titled *Attraction* and *Separation* show women set before seascapes and men rooted to the ground. Men and women are drawn to each other and face each other warily in *Attraction I* (no. **21**) and *Attraction II* (no. **22**) of 1896 and 1895, two prints from a private collection. These represent the initiation of an unhappy relationship that will devolve in later prints and paintings. Munch's "handwriting," his characteristic stylistic and compositional devices, are in full array: the dichotomous pairing of woman and sea, man and earth; a shooting perspective marked out by the receding fence, the looming form of a linden tree. In these prints, the tree echoes the man's head and contains the projected shadows of the two figures. As a halo around his head the tree seems the representation of the man's mind, and within it, the introjected, hopeful fantasy of an intimate relationship, because the shaded figures seem nearly to kiss while the figures in the foreground stand stiffly apart.

In the 1896 lithograph, strands of the woman's hair curl out and surround the man's neck, drawing him to her, a surreptitious, inevitable attachment that underscores and contradicts the figures' aversive expressions and hooded eyes. Referring to his painting of *Separation* (1896, Munch Museum, Oslo), Munch said, "I symbolized the connection between the divided pair with the help of her long wavy hair. . . . The long hair is a sort of telephone wire"[19] along which a symbolic exchange, presumably the give and take of a gratifying relationship, might occur between the pair, who must represent a recent relationship of Munch's, as well as a very old one.

The figures' positions are reversed in another version of *Attraction* (no. **23**). In rigid profile, their simplified forms are set in parallel before a landscape of Aasgaardstrand, where Munch spent his summers. Pine trees form a grid behind them; Munch uses trees as metaphors of constraint in *The Voice (Summer Night)* (nos. **16**, **18B** and **19**) as well, where the girl's burgeoning desire is held in check by her constrained body language and enforced by the verticals of trees. In *Attraction* a few pine branches bridge the gap between the figures and run over the reflection of the moonlight on the water, "the moon's golden pillar"[20] given its phallic shape to suggest the nature of the attraction. Paradoxically this shape serves also to divide the figures. The woman's hair, seeming to have its own will, and working counter to the stiff rectitude of the two profiles, reaches over the moonlight toward the man. Alongside elements suggesting attraction are those that suggest repugnance and fear; as much as these figures approach, they also avoid each other.

Women's hair images the attachment between men and women. Strands of a woman's hair link the figures in *Eye in Eye* (1894, Munch Museum, Oslo); they surround the head of the man in *Man in Woman's Hair* (no. **37**); they fall over a man's shoulders in *Vampire* (nos. **40** and **41**); and a woman's hair intertwines to form a watery matrix for the *Lovers in the Waves* (no. **35**).

Here the figures float dreamily on a sea that is created by and continues from the woman's hair; the sea and hair form a blissful state of attachment. This and *In Man's Brain* (no. **36**) seem conceived

as pendants. In *Lovers in the Waves,* the man's head is subsumed and wrapped within the woman's hair; in *In Man's Brain* the woman's prone body is caught within a thought bubble formed by strands of hair. These filaments issue from both male and female heads, as if both minds confluently experience longing to connect. The beatific, if distant expression of the woman in *Lovers in The Waves* and the tense wariness of the man's full face shown in *In Man's Brain* form a striking contrast between the prints, however, and presumably between how men and women experience attachment, experience being together—according to Munch.

In a painted version of *Ashes* (1894, National Gallery, Oslo) an image of the depressing and anxious dissolution of a love affair, hair forms the last connection between the figures. Originally titled *After the Fall,* and so alluding to "the period of love in Paradise that had ended,"[21] the painting presents the figures with equal sympathy. The woman is distraught, raising her bent arms to her head in an angular gesture that resembles the child's in *The Dead Mother* (no. **11**), and the gesture of the figure in *The Scream* (no. **7**). She is locked in the rigid embrace of the trunks of pine trees behind; ghostly fragments of rocks are strewn about her. The woman has suffered a loss, but we surmise that she is still emotionally involved because strands of her hair caress the back and neck of the man who sits in Munch's familiar pose of melancholy. A form at the lower edge of the painting has been generally described as a smoldering tree trunk, its smoke running up the left edge of the painting.

The identification seems confirmed by the print *Ashes II* (no. **28**), which, as a mirror-image shows the smoke at the right edge. Yet the smoke here seems more an attribute of the dejected man, and in fact, the tenor of the print has become entirely different. The woman stands in the same pose, but her hair falls calmly down around her, containing and echoing her own form. Her expression is one of smug indifference. "She stood straight and fixed her hair with the posture of a queen. There was something in her expression that made him feel fearful—he did not know what it was—" Munch comments. In another print of *Ashes* (1896, Munch Museum, Oslo) rising smoke becomes the hair of a veritable gorgon's head centered in an upper panel and stretching the width of the image. The gorgon's face reiterates the queenly visage of the woman depicted below. Here hair and smoke merge, as water and hair merged in *Lovers in the Waves.* This printed version of *Ashes* suggests the searing, hellish aspects of attachments; *Lovers in the Waves* describes a blissful union. Hair represents for Munch the components of a problematic, sensual and spiritual attachment; the figure in *Woman on the Shore,* with her hair an unmoving shank obscuring her face, no longer has attachments.[22]

The prints called *Separation,* like the painting of *Ashes,* demonstrate that painful attachment endures after loss. The figures have pulled apart; sometimes the woman, her blank face empty of features[23] turns toward that familiarly formless unknown, the sea, while the strands of her hair pass over the man's shoulder to his heart which bleeds into the ground, nourishing the flower of art. Art flourishes from the pain of severed and lost relationships with seductive women. This is a succinct, if paradoxical register of Munch's view of relational involvement. As many writers have noted, art is the means to transcend loss; but Munch's experience of loss goes beyond death to the very nature of living relationships as well.

Edvard Munch's art grew from his experiences of attachment and loss. We know about these experiences from his retrospective writings, from drawings of his early experiences and, as we have just seen, from his formal and thematic reworkings of his images. Images and writings often mirror each other in content.[24]

In 1868, when Munch was five, his mother died from tuberculosis. She left behind her husband, a military doctor, and five children. Along with written memoirs, Munch made images of his paradoxi-

cal relationship with his mother, as well as ones of her impending death. Six of these remembered scenes titled *Outside the Gate* can be linked to Munch's *Girl on the Shore* and the *Attraction* and *Separation* images. All were executed in the1890s; Munch might have used them as preparatory drawings to work up the emotional resonance for the paintings and prints. One retrospective scene shows the mother with hooded eyes as she is shown in the *Attraction* images; more often her face is shown blank. Most use sharply receding perspectives that represent Munch's ideological perspective, his point of view, as well as the road toward death.[25] Such steep perspectives also appear forcefully in the *Attraction* prints. And it is within these retrospective images that Munch makes manifest his association of his mother with the sea:

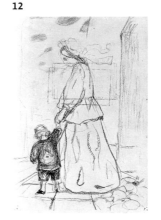

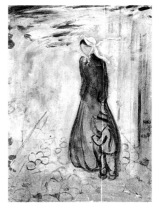

It was dark and gloomy in the stairwell. I held her hand and pulled her, I could not get out fast enough. Then I asked her why she walked so slowly. She stopped at every tread and drew her breath. But outside the gate the daylight blinded us — everything was so bright, so bright. She stopped for a while and the air was so strangely warm with a few cold gusts. The grass shot up among the cobblestones and light green grass; it was spring. She had a pale blue hat on and the band fluttered with every breath of air, hitting her in the face . . . then we went down Castle Street to the fort and looked out at the sea.[26]

The drawings show Munch and his mother emerging into the light of a street drawn in sharply receding perspective. For the most part Munch depicts himself as an assertive little boy, tugging his passive, tubercular mother by the hand. The outline of his figure is independent of the line of the mother's figure, and in some of the drawings the child raises his arms enthusiastically, as if he were trying to mobilize his mother, to enliven her. In one (fig. **12**), the four-year-old Munch seems to look down at his mother's feet, as if he were encouraging her to put one foot in front of the other. Let's see you do it, he seems to say, reversing the usual mother-child relationship. In a few other drawings within the series, however, the boy himself seems near collapse (fig. **13**). The outlines of his body are contained within his mother's as he clings to her; he seems to have given up.

The diary entry and these specific images memorialize the ritual visit to the Akershus headland just beyond the Oslo fjord where Munch and his mother went "and looked out at the sea," presumably to breathe the sea air for her diseased lungs. The fjord, the headland and sea are not represented in the drawings, but they form the pair's destination reached along a road shown in harrowingly sharp perspective.

Another retrospective drawing, *Edvard and His Mother,* shows the artist's mother sitting by a window and possibly knitting or sewing (fig. **14**). Her gaze is riveted to her hands that are brought close to her face. Edvard stands at her knee, reaching toward her; she is withdrawn and ignores him. A much later oil sketch, *Sphinx,* recreates the same scene but with an even darker mood (fig. **15**), for the faint, but unmistakable lines of the head and arms of a small child reach up toward an anxious and distracted woman.

Many writers have considered this painting, also titled *Self-Portrait for The Mountain of Mankind,* to be androgynous, presenting Munch as the woman with bare breasts and long hair. The portrait is often linked with an earlier drawing, *Self-Portrait, Sphinx* (1909, Munch Museum, Oslo), in which Munch is again represented as an androgyne, fusing the attributes and attendant associations of male and female. The ostensible reasons for so depicting himself were, no doubt, his awareness of androgyny's

appeal to turn-of-the-century decadents, and its connections to a contemporaneous, dualistic theory of psychology.[27] These ideas were prevalent and of manifest concern to Munch. However, Sarah Epstein's recognition of "Munch's sensitivity to the way both men and women feel . . . [as well as his ability to] identify with either gender"[28] is itself sensitive, descriptive of both portraits, and approaches their true and deeper significance for Munch. Gösta Svenaeus, in detailing the complex linkages among Munch's self-portraits and his conflation of several female figures within the androgynous self-portraits, also alludes to the psychological density of these works.[29] We must keep in mind, however, that in *Self-Portrait for the Mountain of Mankind* Munch represents himself doubly, as both the woman or mother, and as the ignored child.[30] Identifying himself as both mother and son in the depicted relationship is a symbolic way of engaging his mother's attention, being with her in any way he can, even if that means assuming her female form and joining her in her anxious state.[31]

Sphinx/Self-Portrait for The Mountain of Mankind is a study of a relationship that Munch in symbolic, visual terms is trying to understand and resolve. These two, the mother and the child reaching for her, appear in the foreground of *The Mountain of Mankind* (1926, Munch Museum, Oslo), which was rejected as one of the murals for the Oslo University Aula Hall. Having various titles, including *Towards the Light* and *Pillar of Mankind,* the painting "depicted a number of naked people striving towards the light and rising up towards the sun like a pillar"[32] radiating from behind a mountain top. The image was meant to convey coherence and unity. Once freed from the Aula context, it became "a sort of extension of the Frieze of Life,"[33] and so formed part of his painting campaign to create a holistic picture of life.

The two foreground figures, Munch as his mother and Munch as a child, appear, however, as a visual disruption to the people's progress. The preoccupied woman faces outward, the child reaches toward her, and both figures, thrust into the foreground near the artist's and our own space, appear excluded from the movement toward the vital, healing force of the sun. In contrast, *The Sun* (no. **81**), another mural for the Aula decorations does achieve coherence, perhaps by eliminating the human presence altogether.

One title of Munch's oil sketch is *Sphinx,* that Greek bare breasted she-monster with the winged body of a lion, that repository of arcane knowledge who poses the riddle of life to Oedipus. Munch identifies himself with this perplexing and hybrid animal, as perplexingly hybrid as an androgyne, to know himself and his mother in their relation. The sketch is also called *Self-Portrait,* a time-honored genre by which artists have striven to know themselves, and here the artist recognizes and represents himself as the yearning child. The painting poses Munch's riddle of life that the Frieze of Life attempts to solve. His great concern of the 1890s persisted as late as 1926 with these images.

Edward and His Mother and *Sphinx* are connected to Munch's *Hands* (no. **49**), in which disembodied hands reach toward a nude woman who appears withdrawn and aversive, but whose figure is presented as a classical Aphrodite, an object of beauty. Her body and gaze are self-contained; her mouth turned downward in a fashion remarkably like the mother's mouth in *Sphinx*. Her hands are placed behind her head, invisible, suggesting that she is exposed, vulnerable and that she lacks personal control. As shown, she is a woman *without* hands, an impassive object, toward which other hands, *their* hands — brilliant red, blue, green, agitated — stretch but never reach.

Madonna (nos. **54** and **55**) is also, in various ways, related to this painting and to the two sketches showing Munch as a child reaching for his mother. Now the viewer looms over a woman in sexual embrace. The reaching child has been displaced, transformed and split into an implied sexual partner as well as the little figure at left, variously interpreted as a fetus, a shriveled tubercular child, or a death's head. The little figure cannot reach out to the monumental nude because his hands are crossed piously on his chest; paradoxically he has assumed one of several gestures of the Virgin at the Annunciation,

12
Edvard Munch, *Outside the Gate,* drawing, early 1890s. Munch Museum, Oslo. MM T 2260.

13
Edvard Munch, *Outside the Gate,* drawing, early 1890s Munch Museum, Oslo. OKK M137.

14
Edvard Munch, *Edvard and his Mother,* drawing, 1886/1889. Munch Museum, Oslo. MM OKK T 2273.

15
Edvard Munch, *Sphinx,* oil on canvas, 1927. Munch Museum, Oslo. MM M801.

that of acceptance of her destiny.[34] With peevishness and resentment he looks towards the monumental Madonna, whose orgasmic pose alludes as well to a classical, dying Niobid.[35] This woman is at once sexually powerful and mortally wounded. Posed with one arm raised behind her head, one behind her back and both hands invisible, her form is echoed by a red halo and swirling colors and lines that make her figure oscillate, make her figure sacred within the boundaries of Munch's metaphysics. At the moment of sexual ecstasy her face is tilted away, her mouth and eyes cast aversively downward.

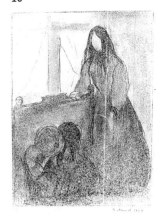

The imaged frame within the lithograph contains sperm swimming clockwise, away from the little figure at left, suggesting that he may be the source of the sperm. Yet he is separated from that sperm, and exists in the same swirling, chromatic space as the monumental woman — with her, yet without her. *Madonna* is a later elaboration of an earlier painting called *Hulda* (1886, now lost) which celebrated "Mrs. Heiberg's" or Milly Thaulow's sensuality.[36] Because Munch's painful, frustrating love relationship with "Mrs. Heiberg" ended near the time of his stay in Saint-Cloud, he associated it with the deaths of his father, sister and mother. All these concerns are recorded in the Saint-Cloud Manifesto. As a Symbolist image, *Madonna* synthesizes experiences and moments in time: ignored child, attracting, frightening, fragile mother; fearsome, powerful women; sensual and beautiful lover.

There are visual and written memoirs of a time shortly before Munch's mother's death:

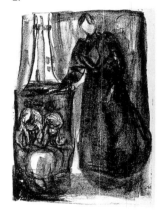

By the lower end of the large double bed were two small children's chairs, placed closely; the tall figure of a woman was standing next to them, large and dark against the window. She said she was going to leave them had to leave them — and asked if they would be sad when she was gone — and they must promise her to stay with Jesus and then they would meet her again in Heaven — They did not quite understand — but thought it was terribly sad and then they both cried, — sobbed — .

Both a drawing and a lithograph (figs. **16** and **17**) show Edvard and his older sister Sophie crouching at the foot of the bed, their heads in their hands and sobbing. Their gesture, resembling that of the screaming figure in *The Scream,* conveys their confusion and horror: they can barely contain themselves. The bed is placed below a curtained window in which the mullions form a cross, the visualization perhaps, of their mother's injunction to stay with Jesus. The motif is thereby linked to the mullions-as-crosses in *Night in Saint-Cloud,* which expressed Munch's disconsolation upon learning of his father's death. The sickly woman leans against the bedstead, supporting herself. Although Munch knew well the numerous photographs of his mother, he shows her here without any facial features, without a depicted identity. The drawing includes a personification of death that emerges from behind,[37] a stick *doppelgänger* also without facial features. Long hair obliterates the face of the *Woman on the Shore,* the woman in one of the paintings of *Separation* (1896, Munch Museum, Oslo) has no features, and a sketch that appears on the reverse of the cardboard of the original painting of *The Scream* shows a blank face, devoid of features.[38] Both feebly living and dead figures have no way of communicating with us or the world; dead or alive, they will not respond.

From early infancy, we signal who and where we are emotionally through facial expression. Emotional states are communicated through an exchange of facial and bodily cues. A baby's mimetic musculature is virtually fully developed at birth, giving him a range of expressive possibilities that he carries throughout life.[39] Very quickly he learns that facial communication has meaning; through the ongoing back and forth he learns about his own state and that of the other. He learns what he must do to elicit a response from his mother. If, however, his mother is withdrawn or depressed and unable to respond to him, he must join her in her withdrawn state if he is "to be with" her.[40] Essentially this is what Munch accomplished by portraying himself as his mother in *Sphinx/Self-Portrait for the Mountain of*

16
Edvard Munch, *Childhood Memory (By the Deathbed),* drawing, 1894. Munch Museum, Oslo. MM T2358.

17
Edvard Munch, *Childhood Memory (By the Deathbed),* lithograph, 1916. Munch Museum, Oslo. MM G510-2.

Mankind. Munch's images of his distracted mother, and here his depiction of her as altogether faceless, suggest that he experienced trauma not just in loss of her to death, but in loss of her within life.

With continuing deadened responses, and emotionless facial expressions,[41] the child becomes distraught, and feels it's "his fault,"[42] feels responsible for the mother's lack of interest. Munch's empty faces, a stylistic idiosyncrasy seen in *Childhood Memory, Separation,* and in the sketch for *The Scream,* may indicate that he could not "read" women/his mother. A more nuanced interpretation might be that he felt something he had done or failed to do in his exchanges with a woman caused her to withdraw. Relating to a face empty of features is impossible; featureless faces become stylistic remnants of remorse and frustration in a difficult emotional exchange.

Conversely, *The Kiss* (nos. **31** and **33**) and *Lovers in the Waves* represent for Munch a skewed and impossible *ideal* of interaction with women. Hair, representing attachment in *Lovers in the Waves,* joins the two figures completely, and forms soothing waves that suspend them in a beatific state; while faces, bodies and identities are totally merged in *The Kiss.* Munch has created, as a consequence, a monstrous form that is clarified or obfuscated by his record of the inspiration for the image:

I pressed her to my body. Her head rested on me. We stood like that for a long time. A wonderful soft warmth passed through me. Softly I pressed her against me. She looked up, to one side. She had such remarkable, dark, warm eyes that seemed to appear as if behind a veil. We said nothing.

She was warm and I felt her body against mine. We kissed each other for a long time. Total silence reigned in the large atelier. I pressed my cheek against hers, and stroked her hair. Her cheeks glowed. "Beloved, say something." But she did not answer. I felt a burning tear on my hand. I looked at her. Her eyes were brimming with tears.

"What is wrong with you?" I asked. I took her in my arms as if she were a small child. She embraced me convulsively. "My little girl," I said, "what is bothering you?" And I stroked her long hair. "I am afraid you might be sick," I said. "Say something." But she said nothing.

She stood on the floor, her hair in disarray. Her eyes sparkled through the tears. "I hate you," she said.[43]

His excerpt conflates merger, unresponsiveness, illness, parental concern ("My little girl"), some skewed attachment ("her hair in disarray")[44] and hatred, all remnants of what it means "to be with" a woman. It should also be regarded as a narrative sequence that moves swiftly from the warmth of merger and well-being to perplexity, alarm and enraged estrangement. We might understand the woman's "I hate you" as a projection that Munch has ascribed to her. Munch's narration contains striking parallels to particular stylistic features of his paintings, and more than that, it echoes his enterprise as an artist giving visual form to a sequence of momentous events within his life-long project, the Frieze of Life.

Munch explored his visual memories of his mother's physical death in several paintings and prints, including our etching called *The Dead Mother.* Here, a little girl, her hands raised to her flushed cheeks and perhaps screaming, turns away from her inert mother who lies supine, rigid, on her deathbed.

The elaboration of memory reaches catastrophic proportions in *The Scream* (1893, National Gallery, Oslo)[45] where the screaming figure turns from the blood-red landscape and trains its gaze on us. Munch's diary entry that is often coupled with this image provides a chilling narrative:

I was walking along the road with two friends. The sun set. I felt a tinge of melancholy. Suddenly the sky became a bloody red.

I stopped, leaned against the railing, dead tired (my friends looked at me and walked on) and I looked at the flaming clouds that hung like blood and a sword (over the fjord and city) over the blue-black fjord and city.

My friends walked on. I stood there, trembling with fright. And I felt a loud, unending scream piercing nature.[46]

The haunting repetition, "my friends looked at me and walked on . . . my friends walked on," stresses the gulf between Munch and others, as does the painting's yawning, insuperable space and the divide between the screamer and the figures in the distance. Near and far, the figures are paradoxically chained to one another by the bridge railing. "Over the fjord and city, over the blue-black fjord and city," also repeated for emphasis, refers to a meaningful place, the Akershus headland and the city just beyond the Oslo fjord where Munch and his mother had gone to look out at the sea. The two sites, that of the scream and the ritual walk with his mother are the same.[47] The origin of the scream ("I felt a loud, unending scream piercing nature") is also haunting, for "it could be the figure or Nature, or even both,"[48] and mirrors the effluent merger of the figure with the fjord and headland that rises beyond it.

Another story, portions of which have been cited earlier, rehearses Munch's fleeting encounter with his estranged lover, Mrs. Heiberg. Appearing in the Saint-Cloud Manifesto, it anticipates the emotional disintegration embodied in Munch's *Scream* and better suits its mood:

At the University clock, he turned around and crossed the street, intently looking ahead. — There she comes. — He felt something like an electric shock pass through him. — How much like her this one looked from the distance. — And then finally she came. He felt long before that she had to come. . . . He saw only her pale, slightly plump face, horribly pale in the yellow reflection from the horizon and against the blue (sky) behind her. Never before had he seen her so beautiful. How lovely was the bearing of her head, a bit sorrowful. She greeted him with a weak smile and went on. . . . He felt so empty and so alone. Why did he not stop her and tell her she was the only one — that he deserved no love, that he never appreciated her enough, that everything was his fault. She looked so sad. Perhaps she is unhappy. Maybe she is the one who believes that he does not care for her, and that it is his own fault. What a spineless wretch you are, a yellow coward, a yellow yellow yellow yellow coward. He worked himself into a frenzy. Suddenly everything seemed strangely quiet. The noise from the street seemed far away, as if coming somewhere from above. He no longer felt his legs. They no longer wanted to carry him. All the people passing by looked so strange and odd, and he felt as if they were all staring at him, all these faces pale in the evening light.[49]

Of course this diary entry has direct connections with *Anxiety* (1894, Munch Museum, Oslo), and with *Spring Evening on Karl Johan Street* (1893, Rasmus Mayer Collection, Bergen), but the usual narrative coupled with *The Scream* does not convey as powerfully the sense of loss of boundaries, the sense of emotional disintegration read in the Heiberg narrative[50] and seen in the paintings and prints of *The Scream*. In fact, the silence of the above narrative is a striking contrast to the scream of the painting; but even so this polarity is a device recognizably Munch's, and again stresses loss of boundaries. Mrs. Heiberg's "plump, horribly pale face" and her "sorrowful" way of carrying her head as well as the electric shock that passes through Munch, and his description of a state that we can only call dissociated ("everything seemed strangely quiet. . . . the noise from the street seemed far away, as if coming from somewhere from above. He no longer felt his legs. They no longer wanted to carry him. People . . . looked strange . . . staring at him . . .") — all suggest elements of *The Scream*. The painting and the Heiberg

narrative also suggest that Munch experienced dissociated states. Dissociated states appear to be the nature of Munch's responses to the loss of his love affair, and his losses of his father and sister, and the loss in life and in death of his mother—all intertwined in Munch's mind.

The Scream distills terror, helplessness and protest in an image that is universal because it merges male and female,[51] living figure and dead mummified body, figure and ground, as the four-year-old Munch might have felt that the Akershus Headland just beyond the Oslo Fjord—that place they ritually visited, and where she looked out to sea—had absorbed his mother and him at last and forever. The juxtaposition of near and far paradoxically linked by the bridge brings a correlate of yearning and panicky flight. The small Rückenfiguren in the background—Munch's two friends with their backs turned to us, who might comfortably mediate our experience of the troublesome landscape, is contrasted with the screamer, a "Halted Traveler" who alarmingly has turned to confront our gaze[52] and who no longer protects us from the impact of nature's scream, because scream, nature, space and figure are one. Raw emotional disintegration is projected into the wobbling screamer, into the swirling lines that take up his form within the blood red sky. And blood red because it represents his flesh and blood, his loss of self in the sea beyond the Akershus Headland; mother, women, himself.

Down here by the beach, I feel that I find an image of myself—of life—of my life. The strange smell of seaweed and sea reminds me of her . . . In the dark green water I see the color of her eyes. Way way out there the soft line where air meets ocean—it is as incomprehensible as life—as incomprehensible as death, as eternal as longing. And life is like that silent surface which reflects the light, clear colors of the air. And underneath, in the depths—it conceals the depths—with its slime—its crawling creatures—like death. We understand each other. It is as though no one understands me better than the ocean.[53]

Such altered states are a marker of a category of attachment called disorganized/disoriented. Researchers who are studying attachment patterns emergent at the beginning of human life have distinguished four types. One, disorganized and disoriented behavior, was observed when some toddlers were reunited with their mothers after a brief separation.[54] These studies indicate, and his art confirms, that as a child Munch had a disorganized attachment.

Mother as the haven of safety as well as the source of terror, mother who is sought for comfort but whom one tries in panic to avoid—characterize Disorganized/Disoriented Attachment. The parent is "at once the source of and the solution to [the child's] alarm"[55] and the child "cannot find a solution to the paradox of fearing the figure whom he must approach for comfort in times of stress."[56] This paradox is expressed in The Scream.

Parents of children with disorganized attachments exhibit frightened or frightening behavior that indicates they have not resolved their own loss or trauma, and they may be vulnerable to entering altered states of consciousness, such as trance-like states. These parents have said that, "I sometimes 'step outside' my usual self and experience an entirely different state of mind," or "at times I feel the presence of someone who is not physically there."[57] Both Munch's faceless personification of death— "someone who was not physically there"—emerging from behind his mother in By the Deathbed, and the figure of The Scream immediately spring to mind.

Altered states appear to be transmitted intergenerationally. Extreme parental misattunement to a needy, approaching child, contradictory signals that at once elicit and reject the child's loving intimacy, parent's role confusion, intrusive behaviors, disorientation and withdrawal are all associated with the child's disorganized and/or disoriented mode of attachment. In turn, the child becomes vulnerable to

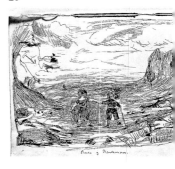

altered states or dissociative disorders.[58] The wobbling figure of *The Scream* assaults us as the embodiment of a depersonalized state in the process of forming—or disintegrating.

The infant's disorganized attachment behavior of approach to the mother as a safe haven, and avoidance of her as the source of fear (figured also in Munch's *Attraction* and *Separation* images) shift by age six to a later behavior of controlling the mother who often assumes a helpless stance (seen in the artist's retrospective *Outside the Gate* drawings). These children "seem to actively attempt to control or direct the parent's attention and behavior and assume a role which is usually considered more appropriate for a parent with reference to a child."[59]

For Munch, as evidenced by diary entries and the *Outside the Gate* images, it was necessary to be his mother's parent as well as to surrender to her moods and needs. In neither case, it seems, did she satisfy his own emotional needs as a developing child.

That hardly could be expected. Munch's mother was overwhelmed by the care of five children born in six years—all of whom "belonged to her while she belonged to none of them"[60]—and overwhelmed by her own debilitation as a consumptive. The tubercle bacillus destroys the lung's capacity to exchange oxygen for carbon dioxide; this is experienced as the inability to get enough air. The tubercular is truly consumed by the disease and wastes away, a physical reality that became a psychological reality for her son.[61]

Munch watched his mother die slowly of asphyxiation. To the five-year-old and younger Munch her behavior must have been terrifying, and he fled or collapsed in the face of it. On the other hand, Munch must have had resources of empathy that enabled him to care for her as he did. But he made great efforts never again to be so tied to a woman.[62]

Munch's work registers the import and the impact of his childhood relationship with his mother. This dynamic is later carried into his adult relationships with women, and then represented in *Attraction, Separation* and in other images. Munch never married. Believing that the dreaded entanglements of an enduring relationship were toxic and would inevitably end in loss, he enjoyed only serial relationships with women. Serial relationships allowed him to recognize something familiar, something he had brought forward from his earliest days: repeated experiences of painful attachment and loss. Through serial relationships he could recognize himself in an old, familiar pattern he knew well. This paradox is embodied in his imagery: violent spaces separating men and women, looming shadows figuring wishes or fears, willful strands of women's hair reaching toward men, stiffly separated figures, deadened women lost to the sea, seducing and repulsing women.

Munch's experience with his mother was not his only early experience with women. His life with his sister Sophie, undoubtedly much freer and happier, nevertheless reinforced many of its qualities. Of the siblings left behind when their mother died, Sophie, the oldest at age six, was the artist's favorite. A retrospective drawing of Sophie and Edvard, fictionally called *Berta and Karlemann* (fig. **18**), shows the two facing the world together as allies. They are like romantic wanderers, like *Rückenfiguren,* for their backs are turned to us as they contemplate a valley stretching out before them, and they mediate the scene for us. The ground rises on either side; there is the dead tree at left, the live one at right, as might be found in Christian images of such critical moments in time as the Resurrection.[63] Certainly the time just after their mother's death was critical for Sophie and Edvard, and perhaps Munch is showing us how the two defended themselves and met the world: Sophie holds her doll; Edvard holds his walking stick to show himself as a romantic wanderer. There is a space between them but they hold hands: their arms seem to run together as one arm.

18
Edvard Munch, *Berta and Karlemann,* drawing, c. 1888/1890. Munch Museum, Oslo. OKK T. 2761-6.

Arne Eggum has convincingly linked this drawing with the 1885–86 painting (National Gallery, Oslo) and the prints of *The Sick Child* (no. **9**), comparing the landscape of the retrospective drawing with the landscape that appears at the bottom of our drypoint. He finds the clouds and the two living trees comparable, but does not question why Munch would provide a landscape at the bottom of an image in which a sick child gazes out a window. Undoubtedly the landscape is meant to be the very one the girl is looking at, a landscape that, like the *Berta and Karlemann* setting of past comradeship with her brother, she longs for.

Eggum sees the ambiguity of the linked hands in the *Berta and Karlemann* drawing as resembling the figures' hands in *The Sick Child*. He also notes the system of hatched lines that surrounds Sophie in the drawing, in the first version of the painting which has been reworked perhaps to disguise them, and in the etchings. These lines oscillate around the girl, and we can infer that they allude to her fragility and ultimate death. The drawing appeared near Munch's diary account of the children's learning of their mother's death.

The sick girl is Sophie. Munch used as a model a girl who was fifteen, near Sophie's age when she died. For the bereaved mother he posed his aunt Karen Bjølstad who, in fact, must have cared for Sophie in her last days.

A red-haired girl is shown in profile, looking beyond her mother's bowed form toward a window as if seeking the sunlight that might cure her. The profile composition—the lost profile—is befittingly based on Renaissance medals and commemorative, posthumous portraits also shown in profile.[64] Her red head is boldly framed by the white pillow, and behind it, by the curved edge of the headboard, a segment of a halo. The mother might be thinking of her lost daughter, whose profiled form appears dematerialized, even ethereal in many of the images and in our exhibited print from a private collection. The girl's gaze out to an infinite space, her obliviousness to the world and to her mother, the compositional source,[65] the halo, and the ambiguity of the linked hands all support the idea that the two figures do not exist at the same time or in the same space and that the figure is not taken from the life, but is a commemoration of Munch's dead sister. The flattened forms and space render the image of Sophie an icon to be venerated.

The monumental size of the painting implies that this image was enormously important to the artist. But more telling is that Munch reworked the original painting more than twenty times—for over a year—to try to recapture "a certain mood."[66] "What I wanted to bring out," he wrote "—are things that cannot be measured—."[67] The mood seems to have been associated with intended atmospheric streaks that ran down the surface of a rather grey painting. In repainting and trying to return to the original mood, Munch

discovered that my own eyelashes had contributed to the impression of the picture.—I therefore painted them as hints of shadows across the picture.—In a way, the head became the picture.—Wavy lines appeared in the picture—peripheries—with the head as center.[68]

Since they cannot be seen by the viewer's gaze outward, "eyelashes" might encode Munch's own tears through which he painted his sister, his ally. He might have wanted to incorporate, by a kind of abstracting atmosphere, his remorseful and loving feelings in his homage. Munch made a conflicted record, however, undoing his work as much as creating it, for the canvas surface is impacted with paint layers, erasures and deep scorings.

This strange, if innovative technique of *The Sick Child* is repeated in the *Self-Portrait* (1886, National Gallery, Oslo),[69] linking the two paintings and indicating that the brother and dead sister were still allied

in the artist's mind. Munch's averted gaze is not so much disdainful,[70] as it is wary and guilty. He seems to be looking inward to mull over the meaning of the past, or warily looking at the painting of *The Sick Girl* itself and evaluating his relationship to it. Like *L'Art Brut,* both paintings are overwrought with gougings and tracks of Munch's obsessive activity, rendering a spaceless, scabrous environment. Weaving might be a better metaphor, for there is a sense that Munch, in both paintings, is pulling together strands to form a tapestry of meaning concerning Sophie, her death and his relation to it; but then like Penelope he also unravels his work, scrapes out, starts again.[71] *The Sick Child* served, successfully or not, as a means by which Munch could deal with Sophie's death, as well as all the deaths he had witnessed. As such it accumulates and distills meanings over time and stands, *avant la lettre,* as Munch's first Symbolist painting, his first in the Frieze of Life.

Munch himself must have considered *The Sick Child* directly significant for him over a long career, and central to the Frieze of Life, for he is shown with it in a 1938 photograph on the occasion of his seventy-fifth birthday. Seated calmly with his painting hand exposed to us, he positions his chair closest to *The Sick Child* while other paintings of the Frieze of Life spread over the walls and floor of his winter studio at Ekely. Heller notes the anachronistic character of this photograph that documents paintings Munch executed for the most part in the 1890s, and not current work.[72] Paintings within the Frieze of Life, and particularly *The Sick Child,* constitute Munch's life work.

Because it was a painting critical to his oeuvre yet one he felt he had not resolved and would continue to work on, and because it layered meanings and memories within its surface, it was appropriate to call this Symbolist painting "Study", but the title did not obviate or deflect attack. In October 1886, Munch exhibited *Study* to scornful reviews, despite Hans Jaeger's manipulations and Jaeger's expectations that since it conformed to his ideas of painting from life's experiences, it would move the public. Thereupon Jaeger told Munch not "to paint pictures of this kind" again. Surprisingly, Munch acquiesced, devaluing the painting himself[73] and allowing his work of the next few years to revert to a conservative and weaker style absent of the affective charge and technical interest of the *Self-Portrait* and *Study.* He painted nothing as experimental and Symbolist until the later components of the Frieze of Life in the 1890s.

The public reception of *Study* probably reawakened Munch's profound sense of guilt about Sophie's death, experiencing critics' caustic jibes as retaliation for her death—for which he considered himself responsible. Her death is described in diary notes written at Saint-Cloud, where he learned of his father's death, and where he conceived a new, emergent world view of death transforming into life and leading again to death. It was there that, after a hiatus of four years, he conceived the series of paintings called the Frieze of Life—although in *The Sick Child* he had already painted the first element.

In the winter and spring of 1877 when he was fourteen, Edvard himself was sick, yet again, with tuberculosis. "The sun came with its first beams of light . . . it grew larger and larger and he let the sun shine on him," Munch wrote in the Saint-Cloud diary; for miraculously by late summer and early fall he was recovering and flirting with a girl, a friend of his sister, and Sophie was interested in boys, too. Then

"Berta" [was] coughing faintly . . . and she was red in her cheeks and irascible. One fall day she jumped up and threw her arms around her father's neck —
She was spitting blood —
Then she was put to bed —
Heavy days —[74]

After Sophie died the artist inwardly railed over his father's failure as a medical doctor to save his sister. Dr. Munch had offered Sophie the consolation of religious belief in place of a cure, while telling her he wished he were the one who would die. No doubt the artist wished it too. Now in Saint-Cloud his father *was* dead.

The artist particularly railed over his own responsibility for Sophie's death, not merely as a survivor, but because he thought he had given her the tuberculosis that had killed her. Furthermore, Munch recorded in the Saint-Cloud diary that Sophie had asked "dear, sweet Karlemann to take this away from me, it hurts so, won't you do that? . . . Yes, I know you will."[75] He had been able to do nothing.

These tremendous burdens of guilt must have caused Munch to feel that "to be with" is to harm or be harmed; as much as people, particularly women, were seductive, noxious and repellent, he, too, was singularly dangerous, even deadly.

We might revisit Munch's stylistic habits with this in mind. The means by which he distanced figures, through lunging perspectives, stiff postures, and averted glances may redound to men, to Munch himself, as much as to women. It takes two to dance *The Dance of Life* (1899–1900, National Gallery, Oslo):

I danced with my first love; it was the memory of her. The smiling, golden-haired woman enters and wishes to pluck the flower of love, but it will not let itself be picked. And on the other side is she dressed in black, gazing in sorrow at the dancing couple — an outcast, just as I was cast out by her dance. And in the background, the raging mob storms about in wild embrace.[76]

The news of his father's death in Saint-Cloud refired Munch's inspiration and set in motion the work he had started in *The Sick Child*. He returned to creating a whole art, an oeuvre spread over many years and within many paintings, prints and drawings whose coherence he constantly contributed to and maintained. Munch "considered his paintings his children"[77] and if one were sold from the whole, he found it necessary to quickly remake the lost component. The Frieze of Life is Munch's successful effort to maintain his coherence — after all, *the* quintessentially human aim.[78] The paintings of the frieze became the means by which Munch told himself a story that, as traumatic as it was, made a kind of sense; he made it coherent for himself and for us. And his Frieze of Life rose, phoenix-like, from the ashes of the specific event of his father's death, and from all the deaths that he had experienced. The imagery of the Frieze of Life is the life that emerges from the deaths in Munch's history. How can we not feel gratitude? How can we not know implicitly that it is all true?

1 Reinhold Heller, *Edvard Munch: The Scream,* New York: Viking Press, 1972, p. 22.
2 Quoted by Ragna Stang, *Edvard Munch,* New York: Abbeville Press, 1977, p. 74.
3 See Stang, *Edvard Munch,* pp. 33, 72, 73; and Reinhold Heller, *Munch: His Life and Work,* Chicago: University of Chicago Press, 1984, pp. 55–58 and passim. Munch's discussions with the Danish poet Emanuel Goldstein were undoubtedly important to this process. Throughout his early years Munch seems to have gravitated to what may be termed either alter-egos or father substitutes, including the writer Hans Jaeger and the poet Goldstein, who bear some resemblance to Munch's story-telling father. Munch's relationship to his father demands scrutiny, if that is possible within the mythology that Munch constructed. See Reinhold Heller, "Response to the Reviews by Thomas L. Sloan and George Moraitis," in *Psychoanalytic Perspec-*

tives on Art II, Mary Mathews Gedo, editor, Hillsdale, NJ: The Analytic Press, 1987, p. 339.
4 Quoted by Stang, *Edvard Munch,* p.103.
5 I thank Jeremy Nahum warmly for his guidance through the labyrinths of developmental research. My missteps should not be attributed to him. His patient readings of this manuscript and his trenchant comments have been invaluable.
6 Ross Bresler is to be thanked for pointing out a classical source in Roman statuary and coins (a captured province was represented as a figure seated on the ground, his head in his hand), as well as a Renaissance source (the sleeping Joseph).
7 Munch certainly may have known Goya's prints, which since 1856 had been viewable in Paris at the Bibliothèque Impériale as it was then called. See Tomás Harris, *Goya: Engravings and Lithographs* I , Oxford: 1964, pp. 11–12. Munch found Goya's forebear, Velázquez "very interesting"

and later wondered why no one had noticed the connection between his paintings and those of the Spaniard. The connection is evident in the *Portrait of Karl Jensen-Hjell*, 1885 (private collection). See *Munch et la France*, Paris: Musée d'Orsay, 1991, p. 45.

8 Heller, *Munch: His Life and Work*, p. 40.

9 The woman is Oda Lasson Krohg, and the staring, mustachioed man at right is Jørgen Englehart, according to Patricia Berman and Jane van Nimmen. See *Munch and Women, Image and Myth*, Alexandria, VA: Art Services International, 1997, p. 27. Heller identifies him as "a wholesale grocer," in "Form and Formation of Edvard Munch's Frieze of Life," in *Edvard Munch: The Frieze of Life*, London: National Gallery, 1992, p. 29. Eyes tightly shut, Englehart the "grocer" seems to reappear in the drypoint variously called *Harpy* or *Vampire* (no. **42**). If Munch viewed Englehart as a victim of the winged harpy Oda Lasson Krohg who preys on men, we might surmise that Munch viewed her free, sexual behavior negatively—which is not to say that he did not admire Krohg's "strength, humor and confidence," as Berman and van Nimmen suggest in *Munch and Women, Image and Myth*, p.27.

10 Munch himself can be found on the left, looking downward.

11 Heller, *Edvard Munch: The Scream*, p. 38.

12 There are five men, including the husband, as there were five children. Heller counts six (*Edvard Munch: The Scream*, p. 38); and "staring adoringly up at his bohemian love," may be Hans Jaeger, but his small head has seemingly been represented as a carved stopper emerging from the foreground wine bottle. The humor alone in this ambiguous print requires more investigation.

13 Heller, *Edvard Munch: The Scream*, p. 18.

14 Elizabeth Prelinger and Michael Parke-Taylor, *The Symbolist Prints of Edvard Munch*, New Haven: Yale University, 1996, p. 9.

15 Without any comment from the artist, we cannot know why Munch chose the colors he did. Munch's color choices may be intuitive and personally expressive, may reflect the late nineteenth-century ideas of Michel Eugène Chevreul, Johann Wolfgang von Goethe, and Spiritualism, or may conflate all these sources. See Norma S. Steinberg, "Munch in Color," *Harvard University Art Museum Bulletin*, vol. III, no. 3, Spring 1995.

16 A more direct source might be Edgar Degas' late coiffure scenes showing a woman having her hair brushed. Degas' *The Coiffure* (1896), a painting now in the National Gallery, Oslo, shows a woman bending forward as her hair is painfully brushed by another woman. Munch, in Paris in 1896, could have seen this painting in Degas' studio. Prelinger and Parke-Taylor, *Symbolist Prints*, p. 167, note that the few impressions of Munch's *Woman on the Shore* were printed on inferior paper with tacky ink that produced a coarse surface, possibly not unlike the broken, smudged surface of Degas' Oslo painting. The Degas source could also have contributed to the Symbolist aspects of Munch's print.

17 Melancholic women are a staple of Romantic painting and sculpture at the beginning of the century. See Jacques-Louis David, Antonio Canova, Francis Danby, Marie Charpentier, etc.

18 Prelinger and Parke-Taylor, *Symbolist Prints*, p. 19.

19 Quoted by Carla Lathe, "Munch and Modernism in Berlin 1892–1903," in *Edvard Munch: The Frieze of Life*, Mara-Helen Wood, editor, London: National Gallery Publications, 1992, p. 43.

20 Quoted by Stang, *Edvard Munch*, p. 110.

21 Arne Eggum, "Major Paintings," in *Edvard Munch: Symbols and Images*, Washington: National Gallery of Art, 1978, p. 59.

22 At the least hair may symbolize fertility, the power of love, the issuing of longing from within the mind, bereavement; but what are the visual sources for Munch's distinctive use of hair? He may have known the Pre-Raphaelite brotherhood and Rossetti whose *Astarte Syriaca* (1875–77) bears a resemblance. See Edith Hoffman, "Some Sources for Munch's Symbolism," in *Apollo* 81, Feb. 1965, p. 90. He may have known Whistler's *White Girl* (1862) since he had already drawn on Whistler's moody colors for *Night in Saint-Cloud* and other paintings; and he certainly knew the Botticelli Venus, of all these figures the one whose long curling hair seems to move suggestively, even seductively.

23 1896, Munch Museum, Oslo.

24 See Bente Torjusen, *Words and Images of Edvard Munch*, VT: Chelsea Green Publishing Co, 1986.

25 Heller, *Edvard Munch: The Scream*, p. 59.

26 Eggum, "The Theme of Death" in Eggum, *Edvard Munch: Symbols and Images*, p. 157 cites Edvard Munch, Manuscript T 2761.

27 Patricia G. Berman, *Edvard Munch: Mirror Reflections*, West Palm Beach: The Norton Gallery of Art, 1986, p. 92.

28 Sarah G. Epstein, "The Mighty Play of Life: Munch and Religion," in *The Prints of Edvard Munch: Mirror of His Life*, Oberlin, OH: Allen Memorial Art Museum, 1983, pp. 145–146.

29 Gösta Svenaeus, *Edvard Munch: Im männlichen Gehirn II*, Lund: Skrifter Utgivna av Vetenskaps-Societeten, 1973, pp. 305–309.

30 I am grateful to Claude Cernuschi for suggesting this dynamic to me.

31 For a description of such states see E. Z. Tronick and The Change Process Study Group (Nadia Bruschweiler-Stern, Alexandra M. Harrison, Karlen Lyons-Ruth, Alexander C. Morgan, Jeremy P. Nahum, Louis Sander, Daniel N. Stern), "Dyadically Expanded States of Consciousness and The Process of Therapeutic Change," in *Infant Mental Health Journal*, vol. 19, no. 3, 1998, pp. 290–299.

32 Quoted by Stang, *Edvard Munch*, p. 245.

33 Stang, *Edvard Munch*, p. 245.

34 I am grateful to Jeffery Howe for bringing this to my attention.

35 Heller, *Edvard Munch: The Scream*, p. 53.

36 Heller, *Munch: His Life and Work*, p. 127.

37 Eggum, *Edvard Munch: Symbols and Images*, p. 163.

38 See Heller, *Edvard Munch: The Scream*, pp. 113–114, note 30.

39 I refer to the baby as "he" and the caretaker as "she" for narrative clarity and flow.

40 Louis Sander has shown that a central, ongoing paradox of existence is to learn how to "be with and yet distinct from" the other. See Sander, "Paradox and resolution: From the beginning," in *Handbook of child and adolescent psychiatry, Vol. I, Infants and preschoolers: Development and syndromes*, New York: John Wiley and Sons, 1998, pp. 153–160.

41 Such facial expressions absent of feeling have been studied in "The Still Face," a laboratory study of affective interactions between mothers and very young infants. In this study the mother was asked to assume an expression entirely void of feeling after a period of warm interaction with her toddler. Predictably the toddler became upset and then alarmed because he could not elicit any response from his mother. (Video tapes of this study are unexpectedly alarming to the viewer as well.) See Colwin Trevarthen, "Communication and Cooperation in early infancy: a description of primary intersubjectivity," in M. Bullowa, editor, *Before Speech*, London: Cambridge University Press, 1979, pp. 321–347; and E. Z. Tronick, "Emotions and Emotional Communication in Infants," *American Psychologist* 44 (2), February 1989, pp. 112–119.

42 Munch's self-castigation when "Mrs. Heiberg" barely acknowledges him on the street (". . . Everything was his fault. She looked so sad . . . Maybe she is the one who believes that he does not care for her, and that it is his own fault . . .") is a true echo of such feelings of responsibility for relational failure and disappointment.

43 Quoted by Heller, *Munch: His Life and Work*, p. 76.

44 Munch's narrative seems highly distorted. It can also be understood as Symbolist writing by a Symbolist artist.

45 A comparison of *Woman on the Shore,* so Symbolist in its mystery, abstraction and condensations, and *The Scream,* shows that the latter is a forceful embodiment of Munch's expressionism. For a complete discussion of Munch's importance to the German Expressionists see Claude Cernuschi's essay in this volume.

46 Heller, *Edvard Munch: The Scream,* p. 107. Heller translates and includes all the versions of the narrative. This one is dated January 22, 1892.

47 Eggum also links the site of *The Scream* and the destination of the figures in *Outside the Gate.* See Eggum, *Edvard Munch: Symbols and Images,* p. 162.

48 Elizabeth Prelinger, "When the Halted Traveler Hears the Scream in Nature: Preliminary Thoughts on the Transformation of Some Romantic Motifs," in *Shop Talk: Studies in Honor of Seymour Slive. Presented on His Seventy-Fifth Birthday,* Cambridge, MA: Harvard University Art Museums, 1995, p. 201.

49 Quoted by Heller, *Munch: His Life and Work,* p. 40.

50 The shift from within the mind of the narrator ("—There she comes—"), to third person, and then to second person ("What a spineless wretch you are") also suggests shifting boundaries of identity.

51 The ambiguous gender of the screaming figure, frequently seen as female, might be the result of a similar ambiguity in the source for it, the Peruvian mummy at the Trocadero in Paris which Munch may have known directly or through Paul Gauguin's images of it. See Robert Rosenblum, "Introduction: Edvard Munch: Some Changing Contexts," in Eggum, *Edvard Munch: Symbols and Images,* p. 7.

52 See Prelinger, "Halted Traveler", in *Seymour Slive,* pp. 198–203.

53 Edvard Munch, Manuscript T 2782j, quoted by Trygve Nergaard, "Despair," in Eggum, *Edvard Munch: Symbols and Images,* p. 131.

54 Secure, Insecure/Avoidant, Insecure-Ambivalent/Resistant were the three other types of attachment patterns observed when the children were reunited with their mothers. See Mary Main, "Discourse, Prediction, and Recent Studies in Attachment: Implications for Psychoanalysis," *Journal of the American Psychoanalytic Association* 61, 1993, pp. 209–243.

55 Mary Main, quoted by Karlen Lyons-Ruth and Deborah Jacobvitz, "Attachment Disorganization: Unresolved Loss, Relational Violence and Lapses in Behavioral and Attentional Strategies," in J. Cassidy and P. Shaver, editors, *Handbook of Attachment Theory and Research,* New York: Guilford Press, 1999, p. 523. Karlen Lyons-Ruth was the first to see the connection between disorganized attachment and *The Scream.* I owe her a large debt of gratitude.

56 Lyons-Ruth and Jacobvitz, "Attachment Disorganization," p. 523. Munch must have repeatedly witnessed his mother's terror when she could not get enough air to breathe; he, in turn, must have become terrified.

57 Lyons-Ruth and Jacobvitz, "Attachment Disorganization," p. 539.

58 Lyons-Ruth and Jacobvitz, "Attachment Disorganization," p. 539. These are fugues, trance states, dissociative identity disorders, experiences of depersonalization and derealization, and ideas of possession. There is no question that Munch's father's behavior contributed to the artist's psychological state. That, however, is another, large territory to cover.

59 Lyons-Ruth and Jacobvitz, "Attachment Disorganization," pp. 532–33.

60 As Heller said of the lovers surrounding Olga Lasson Krohg in *Kristiania-Bohemia II.*

61 Might not the several images of the *Red Virginia Creeper* (see also no. **74**), which shows a blood red vine spreading over a house façade, refer to diseased alveoli of tubercular lungs? In the painting called *The Red Vine* (1900; Munch Museum, Oslo) the red is an aggressive monochrome. In the foreground an anxious looking man, linked to the house by a roadway, seems to be recalling the scene in his mind's eye.

62 As an adult artist Munch must have been aware of the romantic mythologizing of the female tuberculosis patient —that she was by turns euphoric and sexually passionate, but withdrawn from life; that her translucent pallor confirmed her spiritual status while placing her in the first ranks of the fashionable. As a child, however, Munch would hardly have experienced his mother's or his sister's illnesses as part of this romantic myth. For an insightful and sensitive discussion of nineteenth- and twentieth-century attitudes toward illness see Susan Sontag, *Illness as Metaphor,* New York: Farrar, Straus and Giroux, 1978. I thank Jeffery Howe for reminding me of this essay.

63 See Piero della Francesca, *Resurrection,* late 1450s (fresco), Pinacoteca, Sansepolcro.

64 See John Pope-Hennessy, *The Portrait in the Renaissance,* Washington, DC: National Gallery of Art, 1963, pp. 35–41 and passim. I am grateful to Charles Colbert who confirmed my hunch for the source.

65 Having won a scholarship to study in Paris in May of 1885, Munch visited the Louvre where there were plenty of commemorative profile portraits to be seen, the red-haired *Princess of the Este Family* by Pisanello (c. 1440) being but one.

66 Hans Jaeger, 1886, quoted by Eggum, *Edvard Munch: Symbols and Images,* p. 144. Furthermore, Munch worked on variations of the painting over his entire life and made many prints and drawings of the motif. "To no other motif did Munch turn with such obsessive regularity," Heller states in *Munch: His Life and Work,* p. 21.

67 Edvard Munch, Manuscript T 2771, quoted by Eggum, *Edvard Munch: Symbols and Images,* p. 21.

68 Edvard Munch, 1929, quoted by Eggum, *Edvard Munch: Symbols and Images,* p. 147.

69 Heller, *Munch: His Life and Work,* p. 39.

70 As Heller feels, *Munch: His Life and Work,* p. 39.

71 See Stephen A. Mitchell, "Penelope's Loom: Psychopathology and the Analytic Process," in *Relational Concepts in Psychoanalysis,* Cambridge, MA: Harvard University Press, 1988, pp. 271–306.

72 Reinhold Heller, "Form and Formation of Edvard Munch's Frieze of Life" in *Edvard Munch: The Frieze of Life,* London: The National Gallery, 1992, p. 25.

73 Eggum, *Edvard Munch: Symbols and Images,* p. 144.

74 Edvard Munch, Manuscript T 2770, quoted by Eggum, *Edvard Munch: Symbols and Images,* pp. 170–171.

75 Quoted by Heller, *Munch: His Life and Work,* p. 19.

76 Edvard Munch, Manuscript 2759 quoted, by Heller, *Munch: His Life and Work,* p. 173.

77 Prelinger and Parke-Taylor, *Symbolist Prints,* p. 9.

78 Munch's art is not a means to create a defensive shield that Munch hid behind, as Heller, and it seems George Moraitis suggest. See Heller, "Response to the Reviews . . ." *Psychoanalytic Perspectives on Art,* p. 341.

NOCTURNES: THE MUSIC OF MELANCHOLY, AND
THE MYSTERIES OF LOVE AND DEATH

JEFFERY HOWE

Nature is not something that can be seen by the eye alone—
it lies also within the soul, in pictures seen by the inner eye.[1]

—Edvard Munch, 1907/08

Edvard Munch broke from his Norwegian contemporaries and their literal realism to create a new symbolic art that would express subjective states of mind and emotion. To depict not just the visible, but the invisible, he used color and the materials of art in bold new ways that were meant to be read symbolically. Paradoxically, his subjective approach allowed his private experiences to reveal a series of universal images that he called the Frieze of Life.[2] These works represented the gamut of human love and despair; Munch gambled that viewers would recognize the truth of these images and the parallels in their own lives.

In this essay, I will explore a number of themes in Munch's work that evolved from the depiction of night visions and the search for spiritual truth. I will try to unravel the intertwined threads of personal and universal concerns in his art, beginning, as he did, by exploring the challenge of painting a state of mind, and the aesthetic issues of representation and Symbolist art. The first section of the essay will focus on the problematic intersection of the inner world of the artist, and the outer world of society and nature as seen in the paintings and prints of *Melancholy*. Next I will examine some related mysteries of sexuality and death in Munch's art. Finally, Munch's search for transcendence and immortality will be analyzed in a number of overtly spiritual works. This investigation will consider a number of interlocking issues, including the psychological condition of melancholia and its meanings in the late nineteenth century, and the relationship of art and autobiography. I will briefly sketch the aesthetic principles of the emerging Symbolist movement, and contrast them with Realism. Various aspects of Munch's attempt to find a visual language suitable to represent interior emotion, including the analogy of music, and the role of chance in art, will also be scrutinized. The salient visual themes will include the representation of melancholia, and images of sexuality and religion.

MELANCHOLIA: HEARTBREAK AND CREATIVITY

Melancholy figures prominently in Edvard Munch's art, especially in a number of his better-known paintings and prints in the early 1890s.[3] These works not only align Munch with the fashionable pessimism of the *fin-de-siècle*, they also signify a new emphasis on mood and emotion, and were recognized at the time as reflecting a new awareness of Symbolist ideals.[4] Munch's *Melancholy*, a color woodcut of 1896 (no. **13**), shows a man sitting alone by the sea shore, watching the horizon and listening to the waves, in a pose traditionally associated with the psychological condition of melancholy. The term "melancholia" was loosely defined in the nineteenth century, and can range from contemplative sadness

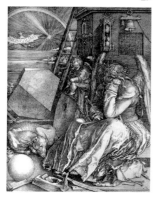

to paralyzing depression. Melancholia is also conducive to reflection and philosophical meditations. Perhaps the most famous precedent for this pose is Albrecht Dürer's print *Melancholia I* of 1514 (fig. **19**). Since Dürer's time, the melancholic temperament has been identified with artists.[5] In the late nineteenth century this pose and the associated condition of melancholia enjoyed new stature as the physiognomy and psychology of the artist became a matter of intense interest.

Munch's personal identification with the image of melancholia shows significantly in his paintings and prints of *Night in Saint-Cloud* of 1890 (National Gallery, Oslo, fig. **20**). The composition is based on sketches Munch made of Emanuel Goldstein. Reinhold Heller has traced the relationship of the melancholic mood in this image to the spiritual crisis caused by the death of Munch's father, which occurred while the artist was in France, and the unresolved conflicts that continued to haunt him.[6] Other members of Munch's family suffered from severe mental illness. Munch's sister Laura was subject to depression, and was hospitalized in the 1890s. She is the subject of one of Munch's most poignant portraits, titled *Melancholy*, of 1898 (Munch Museum, Oslo). She is depicted in this work with a trance-like gaze, turned away from the window and lost in private thoughts.

Both in popular imagination and in scientific circles, many have long believed that there is a special relationship between artists and melancholics. Besides Munch, the most famous modern example is probably Vincent van Gogh, whose portraits of Dr. Gachet (1890) also recreate the classical melancholia pose. Rudolf and Margot Wittkower charted the early history of the association of artists and melancholy in their book *Born Under Saturn; the character and conduct of artists . . .*[7] Erwin Panofsky used his analysis of Albrecht Dürer's print *Melancholia I* of 1514 as a key to the artist's character and symbolism.[8] Ancient Greek medical theory generally attributed melancholia to an imbalance of the bodily humors; a preponderance of black bile from the spleen supposedly caused the "Saturnine" character. The theory of the humors was accepted as science in the Middle Ages and Renaissance, and continued to be a powerful metaphor in the nineteenth century, as evidenced by Charles Baudelaire's poem "Spleen" in *Les Fleurs du Mal* (1857). The central figure of Auguste Rodin's *The Gates of Hell* (Rodin Museum, Paris), is a man seated in the pose of melancholia, known in separate casts as *The Thinker*. Among the extensive commentaries on the causes of melancholy, Robert Burton's *The Anatomy of Melancholy* of 1651 was the most notable.[9] Burton exhaustively catalogued the varieties of the condition, and particularly highlighted the role of unhappy love in its onset.

According to Panofsky, Dürer's *Melancholia* figure suffers from a creative block. Max Klinger's etching of *The Artist in the Garret* of the late 1870s, a portrait of Christian Krohg, a Norwegian painter who shared a studio with Klinger in Germany, may suggest the same problem (fig. **21**).[10] A copy of *Manette Salomon*, a French Realist novel by the de Goncourts published in 1867, lies at Krohg's feet. This novel, which described artists' lives and melancholia, was a favorite with painters; van Gogh included the same book in one of his melancholic portraits of Dr. Gachet.

19
Albrecht Dürer, *Melancolia I,*
engraving, 1514. Private
collection.

20
Edvard Munch, *Night in Saint-
Cloud,* oil on canvas, 1890.
National Gallery, Oslo.

21
Max Klinger, *The Artist in
the Garret* (C. Krohg), etching
and aquatint, late 1870s.
Private collection.

Many nineteenth-century writers explored melancholia and its relationship to insanity, as well as its parallels to creativity. In 1863, Cesare Lombroso argued that genius and madness were inextricably linked in his book *The Man of Genius*.[11] The question of the nature and source of the creative faculty intrigued the intellectuals and artists of Scandinavia and central Europe. The Romantic era had ushered in a new emphasis on imagination and creativity, as part of a trend elevating idealistic conceptions over craft standards as the basis for judging art. Artists and psychologists converged in the late nineteenth century in their efforts to define and locate the source of creativity. The consensus was that the ultimate source of creative imagination lay in an uncharted region of the mind—the unconscious. The primary manifestations of the unconscious were thought to be the mental phenomena of dreams, hypnotic trances, and creativity, and the physical forces of sexuality.

The discovery of the unconscious part of the mind generated broad scientific and public interest in Europe in the 1880s. At the time, both materialists and mystics shared a curiosity about the workings of the mind. The materialist viewed the unconscious component of mental activity as a zone, the workings of which had yet to be understood. The mystic sought in the unconscious the revelation of the divine, and hoped to discredit the positivist scientist with his own tool: the human mind. In the wake of the conceptual revolution led by Immanuel Kant and Arthur Schopenhauer, wherein the very nature of the world came to be seen as subjective, the issue of how the mind works assumed a new importance. Books such as Carl Gustav Carus' *Psyche* of 1846, and Eduard von Hartmann's monumental *Philosophy of the Unconscious* (1868) had enormous impact in Germany and elsewhere as they went through multiple editions and were widely translated.[12] Both Carus and von Hartmann were deeply indebted to Schopenhauer's concept of the unconscious aspects of life as expressed in *The World as Will and Idea* (1819).[13] Jean Paul and others spoke of the "inner Africa" of the mind, a new continent that, like the unconscious, awaited its explorers.[14] In the first book on Munch, published in 1894, Franz Servaes asserted that Munch had no need to travel to Tahiti to explore new worlds; he carried his "inner Tahiti" within him.[15]

The complex nature of the mind was widely recognized in the late nineteenth century; Munch's friend Richard Dehmel asked rhetorically in 1893:

Are the results of modern psycho-physiology . . . so little known that an educated person does not know how several totally different personalities can operate effectively in one and the same individual, be it simultaneously, in phases, consciously, "unconsciously"; compare the extremely minute works by Richet, Bielt, Forel, Bernheim, Moll, etc.[16]

Historical studies, such as Lancelot Whyte's *The Unconscious Before Freud* (1960) and Henri Ellenberger's *The Discovery of the Unconscious* (1970), have shown that the discovery of the unconscious had begun as early as the late seventeenth century.[17] Mid and late nineteenth-century studies made the concept fashionable and laid the foundation for the discoveries of Sigmund Freud and Carl Jung. Frank J. Sulloway's *Freud, Biologist of the Mind* has traced Freud's conceptual roots with particular precision and insight. Sulloway notes that "the history of psychology in the nineteenth century may be viewed as essentially a development away from philosophy and toward biology,"[18] Still, the philosophical admixture in the works of the pre-Freudian psychologists attracted Symbolist artists and writers, since it corresponded to their own creative blending of art and philosophy.

Munch, the son of a physician, often associated with medical men later in life; his friend Stanislaw Przybyszewski had studied neurology. Before Munch, one of the artists most associated with the new psychological developments was the German Max Klinger, whose print cycles sometimes prefigure

Surrealism with their depiction of dream-like imagery.[19] There is a striking resemblance between Munch's *Melancholy* and Klinger's *Night* of 1889 (fig. **22**), which is from a series of etchings entitled *On Death*. These works share a nocturnal setting, with a single figure in a contemplative pose. Recent research has shown that Munch was introduced to Klinger's works by Christian Krohg as early as 1880.[20] The melancholic condition and night seem to go together. Reacting against the sun-drenched period of Impressionism, and the strong clear light of socially conscious Realists such as Christian Krohg, Munch and his Symbolist colleagues explore the nuances of night and shadow.

Munch used the melancholia pose frequently; this woodcut essentially repeats the composition of his painting of 1892, titled simply *The Yellow Boat* (National Gallery, Oslo). A dejected figure sits on the shore at Aasgaardstrand, while a man and a woman walk away in the distance. The seated figure on the shore is Munch's friend Jappe Nilssen, who was involved in a romantic triangle with Christian Krohg and his wife Oda Lasson Krohg at this time.[21] Most commentators assume that the couple in the distance are Christian and Oda Krohg, and that the work represents the theme of jealousy, as well as melancholy. The flattened forms, abstract use of color and symbolic pose render the picture more iconic, and less readable as a Realist narrative. Christian Krohg praised this painting when it was shown in Oslo in 1891, noting that it was one of the earliest Scandinavian paintings related to Symbolism.[22] Instead of criticizing Munch for his turn from literal realism, Krohg praised his friend's new idealist aesthetic and emphasis on mood:

A long shoreline that moves inwards over the picture and becomes a delicious line, which is remarkably harmonic. This is music. Curving gently, it stretches downward towards the quiet water with a few small, discrete interruptions. . . .

It may even be true that this is related most closely to music and not to painting, but in any case it is brilliant music. Munch should be given credit for being a composer. . . . It is an extremely moving picture, solemn and severe—almost religious. . . . All this relates to Symbolism, the latest tendency of French art.[23]

The curving line of the shore extends in space, and may thus be analogous to the passage of time, since representing spatial distance is one of the few ways that a visual artist can imply temporal duration. Krohg equated the sinuous curvature of this line with music, such analogies or correspondences convinced him that Munch had become a Symbolist.

In 1892, Munch expressed the complexity and ambiguity of his ideas about art and the representation of life in a quotation that seems clearly related to his images of *Melancholy:*

Down here by the beach, I feel that I find an image of myself—of life—of my life. The strange smell of seaweed and sea reminds me of her. . . . In the dark green water I see the color of her eyes. Way, way out there the soft line where air meets ocean — it is as incomprehensible as life — as incomprehensible as death, as eternal as longing. And life is like that silent surface which reflects the light, clear colors of the air. And underneath, in the depths—it conceals the depths—with its slime—its crawling creatures—like death. We understand each other. It is as though no one understands me better than the ocean.[24]

His imagery calls up memories of love and loss, fear and comfort in the face of the mystery of life. It surely reflects his understanding of love and attachment at this time, without directly representing the events of his life.

The relationship between Munch's images and his biography is less transparent than is frequently assumed. Admittedly, the first commandment of the Bohemians in Kristiania (now Oslo) was "Thou shalt write thy own life."[25] Munch's art and writings repeatedly echo themes of yearning and passion, and their roots in the struggles of his own life are abundantly documented.[26] Moreover, Munch seemed to sanction a biographical reading of his art with remarks such as: "In my art I have tried to explain life and its meaning to myself. I also intended to help others to understand life better."[27] He also said, "My pictures are my diaries."[28] However, Munch took care to caution a friend about interpreting his writings too literally, and we should apply this caution to his paintings as well: "The notes that I have made are not a diary in the accepted sense of the word; they are partly extracts from my spiritual life, partly poems written as prose . . ."[29] He was well aware of the constructed nature of his personal image, and his fondness for theater should warn us not to take his images too literally.[30] His works are symbolic equivalents for his ideas and emotions, rather than merely images that seem to transparently render episodes from his life in the manner of a realist narrative.

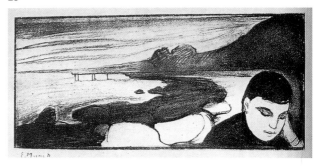

If there is one central tenet held by Symbolist artists, it is that life is fundamentally mysterious, and the artist must respect and preserve this mystery.[31] Thus they insisted on suggestion rather than explicitness, symbols or equivalents rather than description, in both painting and poetry. Choosing music as their model, Symbolists found the creation of a mood to be as important as the transmission of information, and sought to engage the mind and entire personality of the viewer by appealing to the emotions and the unconscious mind as well as the intellect. The analogy of music was chosen to highlight the subjectivity of the artist's vision; both were felt to leave considerable scope for the viewer's interpretation. Kristiania's bohemian culture prized freedom of expression in the 1880s, Munch's formative years. Symbolists were anti-materialist and anti-positivist as well; many of them found a path to meaning in mysticism.

The Symbolist movement first emerged in literature; poets such as Charles Baudelaire, Stéphane Mallarmé and others began writing mysterious and elegantly polished verse shortly after mid-century. Baudelaire outlined the foundation for the Symbolist theory of art with his poem "Correspondences," which urged that visual images, sounds, touch, tastes and perfumes all correspond to interior states of mind and higher realities. Baudelaire's theory of correspondences was rooted in the ideas of the eighteenth century Swedish mystic Emanuel Swedenborg.[32] The Symbolist goal was to find objective means with which to communicate the artist's subjective vision or meaning. The "Symbolist Manifesto" in literature was published in 1886 by Jean Moréas, drawing new adherents to this method. Visual artists were less likely to publish such theoretical charters in the nineteenth century, and the emergence of Symbolist painting is therefore somewhat harder to trace. Nonetheless, the movement quickly became multi-disciplinary and international.

Munch's close associate in the early 1890s, the critic Stanislaw Przybyszewski, regarded Munch as a Symbolist, observing that Munch's abandonment of Realism allowed him to substitute color equivalents for mythological symbols.[33] Munch's new Symbolist orientation is clear in the variation of *Melancholy* that the artist prepared for a frontispiece to a book of poetry by the Danish poet Emanuel Goldstein (fig. **23**).[34] Goldstein (1862–1921), was one of Munch's closest friends in the early 1890s; they shared an apartment in Saint-Cloud outside Paris in the winter of 1889–90. Goldstein had anonymously published a book of poetry in 1886 titled *The Interplay (Psychological Poems),* and in 1892 he republished this under his own name as *Alruner (Mandragoras,* or *Mandrakes).* According to medieval leg-

23
Edvard Munch, frontispiece to *Alruner (Mandrakes),* by Emanuel Goldstein, 1892. Munch Museum.

end, the mandrake plant was used to cure love-sickness. When picked, however, it uttered a scream terrible enough to kill, so dogs were recruited to pull it from the ground. Thus, the legend creates another association of sound with Munch's melancholic image. Furthermore, mandrakes were thought to grow from semen dripping from hanged men,[35] firmly linking the herbs to sexuality. Munch asked Goldstein to send him a drawing of a mandrake,[36] but in the end he depicted a young man tormented by love instead. The closed eyes of the figure in the *Alruner* illustration underscores the emphasis on an internally focused state of mind and memory in this work, and links it to other key works of Symbolist art such as Odilon Redon's *Closed Eyes* of 1891.[37]

Although an imbalance in the chemistry of the humors was thought to cause melancholia, for centuries music was prescribed to draw relieve depression. Aristotle and many Renaissance writers knew the curative power of listening to music. In the fifteenth century, music was used to draw the artist Hugo van der Goes out of a deep depression. Hugo van der Goes' saga (as depicted in a haunting painting by Emile Wauters; see fig. **24**) particularly affected Vincent van Gogh, who found unsettling parallels to his own condition. Vincent confided to his brother Theo in 1888:

As a matter of fact, I am again pretty nearly reduced to the madness of Hugo van der Goes in Emile Wauters's picture. And if it were not that I have almost a double nature, that of a monk and that of a painter, as it were, I should have been reduced, and that long ago, completely and utterly, to the aforesaid condition.[38]

Although it gave comfort to some artists, the nexus between genius and insanity postulated by Lombroso provided the basis for many attacks on modern artists as "decadents" and "degenerates." The critic Andreas Aubert wrote in 1890:

Among our painters, Munch is the one whose entire temperament is formed by the neuresthenic. He belongs to the generation of fine, sickly sensitive people that we encounter more and more frequently in our newest art. And not seldom they find a personal satisfaction in calling themselves "Decadents", the children of a refined, overly civilized age.[39]

Max Nordau was a physician and cultural critic who assailed nearly all modernist artists, writers and musicians in his monumental diatribe *Degeneration* of 1893. Although he never mentioned Munch, Nordau was particularly critical of the Symbolist artists and writers, the Norwegian playwright Henrik Ibsen, and the musician Richard Wagner. Nordau's terminology of "degeneration" would be used against Munch frequently throughout the years.[40] In 1937 the Nazi cultural apparatus and his works declared Munch's works and those of many other modernist artists to be degenerate and removed them from German national collections.[41]

"ALL ART CONSTANTLY ASPIRES TO THE CONDITION OF MUSIC"

24
Emile Wauters, *The Madness of Hugo van der Goes*, oil on canvas, 1872. Royal Museums of Art, Brussels.

Krohg's 1891 comparison of Munch's painting to music follows a deeply rooted trope in late nineteenth-century art criticism. The parallel between music and painting had become increasingly important in aesthetics since the Romantic era when artists as disparate as Caspar David Friedrich and Eugène

Delacroix endorsed it.[42] German Romantics thought landscape to be particularly close to music, since the spatial dimension of landscape could be seen as analogous to the temporal dimension of music.[43] Artists and poets of the Aesthetic Movement, such as James McNeill Whistler and Dante Gabriel Rossetti, inspired and exemplified Walter Pater's prescription, "All art constantly aspires towards the condition of music."[44] In an exhibition in 1892, Munch used titles such as *Color Mood in Blue, Harmony in Black and Violet* (a portrait of his sister Inger in the National Gallery, Oslo) and *Harmony in White and Blue (The Lonely Ones)*, which echo the musical titles of Whistler's *Nocturnes* and *Harmonies.*[45] Even though Munch could be casual about his titles, and would occasionally use those suggested by friends, he was clearly attracted to the provocative parallel of art and music. Much later, he compared the effect of an exhibition of his paintings to a symphony:

I placed them together and found that various paintings related to each other in terms of content. When they were hung together, suddenly a single musical note passed through them all. They became completely different to what they had been previously. A symphony resulted.[46]

The bond between content and form in Munch's art does not preclude considerable latitude for the viewer's personal interpretation. The concept of empathy (*einfühlung,* or "feeling into"), which was fundamental in late nineteenth-century aesthetics[47] explains how a work of art communicates the inner thoughts and feelings of one person to another. Empathy can not create a complete unity of viewer and artist, however, nor was it desired. Paul Gauguin noted that "you can freely dream while you listen to music just as when you look at a picture."[48] Symbolist artists preferred a suggestiveness and the possibility of multiple meanings, which is clarified by closer examination of the example of music.

Richard Wagner was a towering figure in music in Munch's time.[49] Munch admired him greatly.[50] Charles Baudelaire used the music of Wagner as an example of the way that meaning was expressed in the world and art in 1861:

For what would be really surprising would be if sound were incapable of suggesting colour, colours incapable of evoking a melody, and sound and colour incapable of translating ideas; for things have always expressed themselves through reciprocal analogy, since the day God decreed the world a complex and indivisible whole.[51]

Not surprisingly, one of the most influential Symbolist art journals in Paris in the mid-1880s was named *la Revue Wagnérienne*. In an essay for this journal, the Polish critic Téodor de Wyzéwa highlighted the Schopenhauerian idealism that was common in Symbolist aesthetics:

For it so happens that the world in which we live, and which we call real, is but a pure creation of our soul. The mind cannot get outside itself, and the things it imagines external to it are merely its own ideas. To see, to hear, is to create appearances within oneself, and this is tantamount to creating Life. . . .[52]

The artistic image, whether visual or literary, is an abstract representation of the world, which is as real as any other perception in this idealistic philosophy; the work of art is a sign, which recreates the world, and the role of the artist as creator is elevated. The world of art is a virtual reality, de Wyzéwa continued:

Therefore art must consciously re-create, by means of signs, the total life of the universe, that is to say the soul, in which the varied drama we call the universe is played. . . .

Although most artists follow a traditional descriptive Realist mode, the new Symbolist artist will use colors and lines in a mode that is:

emotional and musical, which neglects the object these colors and these lines represent, utilizing them only as emotional signs, marrying them to one another with the sole purpose of producing within us, through their free play, an impression like that of a symphony.[53]

The break with optical realism is now definite; by concentrating on the expressive potential of color and line, artists can approximate the suggestiveness of music, and the work of art becomes a symbolic "hieroglyph."[54] By the late nineteenth century, Symbolist artists such as Paul Gauguin shared the idea that painting and music were fundamentally similar:

Color being enigmatic in itself, as to the sensations it gives us, then to be logical we cannot use it any other way than enigmatically every time we use it, not to draw with but rather to give the musical sensations that flow from its own nature, form its internal, mysterious, enigmatic power. By means of skillful harmonies we create symbols. Color which, like music, is a matter of vibrations, reaches what is most general and therefore most undefinable in nature: its inner power. . . .[55]

Krohg was well informed about European developments, and was intimately acquainted with Munch's artistic career.[56] Krohg's suggestion that "Munch should have the national grant for composers" underscores Munch's striking and innovative use of color:

And the over-all color! A violet charm with a few poisonous green spots in it, which inspires devotion. Spots that one can lose oneself in and become a better person by looking at, that move one like a story of young love, that remind one of something fine and soft in one's own life, and that foreshadow almost ominously a new view of art. Serious and severe.[57]

Melancholy was one of the first pictures by Munch to use the image so explicitly as a representation for an inner state of mind, a mood, with color and line corresponding to nuances of emotion in a musical fashion.

The power of color to evoke ideas and emotions was rooted in the physiological phenomenon of synaesthesia, which is the ability of one sense to elicit sensations and even feelings generally associated with another. The study of "color-music" and the understanding of the connection between sensation and emotion were primary goals of scientists and philosophers who sought to define a "psychophysical aesthetic." This interest is one bridge between the art of the late nineteenth century and the abstract art movements of the twentieth century. Jean-Martin Charcot and his clinicians at the Salpêtrière clinic tested hypnotized patients to see if specific gestures and emotional reactions could be provoked by colors.[58] Spiritualists and theosophists wrote extensively on color symbolism and their theories of auras may have influenced Munch.[59]

Correlations between color and musical tones have fascinated musicians and philosophers for centuries. In 1730, the Jesuit Father Louis Bertrand Castel built an Ocular Harpsichord, which included sixty colored glass panes that would be illuminated as the keys were pressed.[60] In the 1860s, the noted German scientist H. L. F. von Helmholtz even drew up a concordance of matching colors and sounds, René Ghil and other Symbolist poets tried to match the vowels to musical notes, and mechanically oriented musicians tried to build instruments that could simultaneously play notes and project colors.[61]

Chromatic scale in Music and Colour.
Shewing correspondence of intervals when C = lowest spectrum red.

Such synaesthetic researches had particular relevance for artists seeking a new style in the 1880s, such as the Neo-Impressionism of Georges Seurat and Paul Signac.[62]

The parallels of color and rhythmic line with psychological expression also underlay the decorative theory of Art Nouveau, with which Munch has intriguing connections.[63] This style emerged in the early 1890s in all the visual arts: painting, sculpture, architecture, interior design, graphic arts, posters, jewelry, clothing, and furniture. The leading sources for Art Nouveau were Japanese art, the medieval revival, and the Arts and Crafts Movement, which was shaped by the design philosophies of William Morris and Walter Crane. The Aesthetic Movement, particularly Walter Pater, Oscar Wilde, and James McNeill Whistler, contributed the theoretical and practical examples of the interrelationship of music and abstraction. Art Nouveau artists and designers attempted to break down the barriers among the arts, as well as those between art and life; thus there was an important psychological dimension to Art Nouveau.[64] The movement combined national traditions and international influences. In Norway, it was preceded in the 1890s by a nationalistically inspired revival of Viking period decorative designs known as the Dragon Style. In Germany, the style was known as *Jugendstil* (Youth Style). It took its French name from the gallery L'Art Nouveau, which was opened in Paris by Siegfried Bing in 1896; its third exhibition featured the works of Edvard Munch.[65]

In the twentieth century, the combination of music and color became an important quest in music and film. Futurists and other abstract artists experimented with musical instruments and projected colored lights. A. Wallace Rimington synthesized much of this earlier research in his book *Colour-Music. The Art of Mobile Colour* in 1912 (fig. **25**). Serious works grew out of these investigations; Alexander Scriabin premiered his symphony *Prometheus: A Poem of Fire* in 1915 accompanied by an electric color organ.[66]

In its abstractness, music was a symbol of the limitless power of art. Music has long been linked to spiritual expression, both for its power to conduct the listener to a state of contemplation, and for its ability to convey abstract thought. The suggestive aspect of music also harmonized with the image of the sea in Munch's art. The sea was an image of infinity and mystery for Munch; in late 1891 he wrote another note on ocean and melancholy:

Waves rush toward the shore in endless succession. The ocean opens its mysterious, green-blue abyss as if it wanted to show me what lives down there in the depths. . . . But out there, — out there — beyond that azure blue line — behind the sparkling clouds — is the end of the world. What is there — Once I believed it was the end of the world — Now I don't know what's there. Now I know nothing![67]

The prospect of infinity can be terrifying, as many studies of the Sublime attest.[68] Although he wrote that ". . . no one understands me better than the ocean," the abyss of the sea could also instill fear. Munch was fascinated by the way in which his state of mind literally transformed his vision:

The truth of the matter is that we see with different eyes at different times. We see things one way in the morning and another in the evening, and the way we view things also depends on the mood we are in. That is why one subject can be seen in so many ways and that is what makes art so interesting.[69]

Color, which had been mistrusted by Neoclassical theorists because of its instability[70] — the appearance of a single hue can vary greatly depending on the light — was prized by Romantics for this very muta-

25
Plate from A. Wallace Rimington, *Colour-Music. The Art of Mobile Colour*, London: Hutchinson & Co., 1912.

bility. As the nature of life began to seem more and more based on change and evolution, the variability of color seemed even more appropriate as a symbol. The intensity of color hit its peak with the artists of the 1890s and the Expressionist movement of the early twentieth century, an era of unprecedented social and cultural transformation.

The subjectivity of Munch's approach is grounded in the aesthetic precepts of Realism and Impressionism, which also stressed personal perception and interpretation. However, Munch's goal is not to merely capture a visual image. As did Whistler and Gauguin, he relies on memory to simplify and condense his impressions:

I wait some time before completing a work so that I have to rely on my memory for its impressions. I find Nature somewhat overwhelming when I have it directly in front of me.[71]

His method combined memory images and his analysis of optical sensation:

I painted picture after picture of the impressions I had had in my mind in emotional moments — painted the lines and colours I had imprinted there at my inner eye — the cornea. — I just painted what I recalled without adding anything — without the details I no longer kept in mind. — Thus arose the simplicity of the paintings — the apparent emptiness.[72]

Memory thus led to simplification and a more abstract sign replaced the naturalistic image. With their broad, abstract marks and random spatters or streaks, the materials of Munch's paintings and prints deny illusionism. They call attention to the constructed aspect of the work of art,[73] emphasizing the symbolic nature of his art. Unfortunately, an uncomprehending public saw this raw quality of Munch's work as proof that he was lazy or even insane.

Munch was aware of and feared the possibility of insanity. "Sickness and insanity and death," he remarked, "were the black angels that hovered over my cradle and have since followed me throughout my life."[74] His honest confrontation with his inner fears is a primary source of the power of Munch's art, and the artist recognized the value of his struggle:

A German once said to me: "But you could rid yourself of many of your troubles." To which I replied: "They are part of me and my art. They are indistinguishable from me, and it would destroy my art. I want to keep those sufferings."[75]

Only much later, in 1908, when his drinking caused him severe difficulties, did Munch seek a cure for his problems from Dr. Daniel Jacobsen in Copenhagen, even submitting to mild electroshock therapy. In a drawing of these treatments, he notes that the physician is trying to create a balance between his male and female natures (fig. 26): "Professor Jacobsen electrifies the famous painter Edvard Munch, bringing positive masculine and negative feminine power to his crazy brain."[76]

THE FLOWER OF PAIN

Art gave Munch a means to communicate with others, and to understand himself better. Suffering nourished his art, and he insisted on sincere and deeply felt expression:

26
Edvard Munch, *Professor Jacobsen electrifies the famous painter Edvard Munch, bringing positive masculine and negative feminine power to his crazy brain*, drawing, T 1976, 1908/1909. Munch Museum, Oslo.

I do not believe in an art which has not forced its way out through man's need to open his heart.
All art, literature, as well as music must be brought about with our heart blood.
Art is our heart blood.[77]

This aesthetic doctrine is embodied in a number of works, but especially the woodcut *The Flower of Pain* of 1898 (no. **12**).[78] This motif was also used for the cover of a special issue of the journal *Quickborn* in 1899, which featured the works of Munch and August Strindberg. In this image, a nude man in the pose of Rodin's *Age of Bronze* (1876) tips his head back as blood pours from his chest, streaming out to nourish a large flower that grows in front of him. The flower is undoubtedly connected to the image of the mandrake discussed earlier. This image of beauty arising from pain is also an image of self-sacrifice, of an artist giving his life to bring a message of beauty to the world; the parallels to Christ are obvious and certainly deliberate. Munch was not alone in portraying himself as the suffering Christ; in their self-portraits, James Ensor, Paul Gauguin and other Symbolist artists identified themselves with the image of Christ as a passionate outcast, offering redemption, but misunderstood by the public.[79]

Perhaps the most famous image of modern anxiety is Munch's painting of *The Scream* of 1893, which was rendered as a lithograph in 1895 (no. **7**). This work echoes other attempts to fuse visual art with sound, as the curving lines in the sky and fjord suggest eerie tones, a continuation of the auditory equivalents of *Melancholy*. The spatial distortion in the exaggerated perspective of the railing isolates the figure in space and time, and the ghost-like character faces the viewer and cries out with an open-mouthed scream. Munch anticipated his critics, and acknowledged the disturbed quality of the vision by writing on one version "Can only have been painted by a madman."[80] The experimental nature of the painted version of this work is heightened by an innovative technique in the application of the pigment, which includes broad loose brushstrokes, with areas where the paint has dripped and run. There are even spatters of wax on the surface of the version in the National Gallery of Norway, Oslo, the results of an accident in snuffing out a candle, which Munch left, perhaps pleased with the effect of a random gesture. Munch was notoriously careless with his paintings in later years, saying that to be finished, they had to toughened up by weather, even rain or snow.[81] Although unusual, his behavior indicates not indifference to his art, but his belief that a work of art should be a part of the world, and open to natural forces, even destructive ones. August Strindberg held a similar belief; in an 1894 essay on the role of chance in the making of works of art, he celebrated the imitation of nature in creating though accident.[82] Munch's works are both personal statements and open signs; although they grew from his experience, he encouraged viewers to bring their own interpretations to the works, following the analogy of music, and he allowed the works to be open to accident in their creation and in their conservation. Paradoxically, he felt an obsessive need to keep recreating his images, particularly if they were sold, but no need to preserve them in a pristine condition, as if the process of creation went on even after he stopped working on them.

Munch wrote a number of notes about the origins of *The Scream*, which trace the connections of the work to his own experience, and suggest that the distorted figure is a self-portrait:

I was walking along a road one evening—on the one side lay the city, and below me was the fjord.
I was feeling tired and ill—I stood and looked out over the fjord. The sun went down-the clouds were stained red, as if with blood.

I felt as though the whole of nature was screaming—it seemed as though I could hear a scream.
I painted that picture, painting the clouds like real blood. The colours screamed. The result was The
Scream *in the Frieze of Life.*[83]

Fear of madness troubled Munch; his sister Laura suffered breakdowns in the early 1890s, and was admitted to the Oslo Hospital. Arne Eggum has also suggested that *The Scream* may be related to his lingering anxiety over his mother's death.[84] Writings by his friends and colleagues reinforce the personal quality of Munch's vision. Christian Skredsvig wrote in 1943:

For some time Munch had been wanting to paint the memory of a sunset. Red as blood. No, it actually was coagulated blood. But not a single other person would see it the same way as he had; they would all see nothing but clouds. He talked himself sick about that sunset and about how it had filled him with great anxiety. He was in despair because the miserable means available to painting were not sufficient. "He is trying to do the impossible, and his religion is despair," I thought to myself, but nonetheless I advised him to try to paint it.[85]

Yet this work should not be seen as a direct transcription of a panic attack; *The Scream* is as much a symbolic image as *Melancholy*. It is a carefully constructed representation of a moment of anxiety, recollected and depicted in tranquility. Rooted in Munch's memories from Oslo, *The Scream* was reworked and perfected over months in Germany. The origins of *The Scream* may not even be entirely personal; some scholars suggest that this work was inspired by Sigbørn Obstfelder's poetry.[86] *The Scream* is not an image of chaos, but of a new, searing, dissonant harmony, as raw and as elegant as the new music of Stravinsky later would be.

The work took on a life of its own after it was exhibited. Other authors emphasized their own *fin-de-siècle* preoccupations with sexuality and despair in their descriptions of *The Scream*. Stanislaw Przybyszewski wrote in 1894:

On a bridge, or something like it — it really does not matter exactly what is depicted — there stands a fantastic creature with mouth agape. The hero of love must not exist anymore: his sexuality has crawled out of him and now it screams through all of nature for a new means of manifestation in order to do no more than live through the same torture, the same battle all over again. There is something horribly macrocosmic in this picture. It is the closing scene of a horrible battle between mind and sex out of which the latter came triumphant. . . . The mind has been destroyed, and sex, the primevally eternal, screams out for new victims.[87]

As Przybyszewski describes it, the figure in *The Scream* is almost a modern mandrake, screaming as it torn from the earth by someone in search of a cure for the pains of love. Munch responded favorably to Przybyszewski's description, and changed the title from *Despair* to *The Scream* after this.[88]

Munch iterated variants of the anxiety depicted in *The Scream* throughout the 1890s, manifesting social phobias, perhaps even agoraphobia,[89] in paintings and prints simply titled "Anxiety." The lithograph of *Anxiety* of 1896 (no. **8**) calls to mind a passage in the notes Munch wrote in Saint-Cloud in 1892:

Everybody who passed by looked at him, stared at him, all those faces, pallid in the evening light. He tried to concentrate on some thought, but he could not. All he felt was an emptiness in his head . . . His whole body trembled, and sweat ran down him. He staggered, and now I am falling too. People stop, more and more people, a frightening number of people . . .[90]

Crowds disturbed Munch, and his alienation led to startling poetic visions of alienation and anxiety:

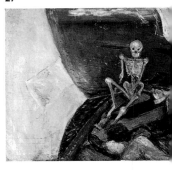

I can see behind everyone's masks. Peacefully smiling faces, pale corpses who endlessly wend their tor-tuous way down the road that leads to the grave.[91]

Strangers could easily provoke anxiety in Munch in these years; even his own family was a both a refuge and a source of tension.

THE MYSTERIES OF LOVE AND DEATH

Religious faith can cure melancholia, but an excess of religious zeal can lead to mental imbalance. Robert Burton identified religious fanaticism as a variety of love-melancholy in *The Anatomy of Melan-choly*.[92] Religion was a source of conflict between Munch and his father, particularly in his teenage years, when disagreements erupted into stormy arguments.[93]

Many of Munch's works reflect the trauma of early deaths in his family, notably *The Sick Child* of 1894 (no. **9**) and *Death in the Sickroom* of 1896 (no. **11**). *Death in the Sickroom* has frequently been linked to the Symbolist theater of Maurice Maeterlinck, whose play *L'Intruse (The Intruder)* focuses on a group of people waiting for Death to come for a family member.[94] The plays of the Belgian dramatist were among the touchstones of European Symbolism; *L'Intruse* was first performed for a benefit to raise money for Paul Gauguin's voyage to Tahiti, and Munch was at one point involved with a project to illustrate a Danish translation of Maeterlinck's *Pelléas et Mélisande*.[95]

Munch recognized *The Sick Child* as a breakthrough in his struggle to capture the inner truth of his perception in his art. For years, he sought a visual analogue for his personal emotions and sensa-tions. In the end, he framed the picture as literally seen through his own eyes:

I also discovered that by looking through my eyelashes I had a better impression of the picture.—I therefore hinted at them as shadows at the top of the painting.—In a way, the head became the pic-ture. Wavy lines appeared—peripheries—around the head.—Later, I often used these wavy lines. . . . In The Sick Child *I broke new ground—it was a breakthrough in my art.—Most of my later works owe their existence to this picture.*[96]

Impressionists had stressed the personal quality of vision, and Degas and Toulouse-Lautrec frequently called attention to the contingent nature of vision by blocking the main subject with peripheral motifs, but no one had ever included the shadows of their own eyelashes in the painting as Munch did in this work. The wavy peripheral lines are seen in several works in this exhibition, such as *Loving Woman*, or *Madonna* (nos. **54** and **55**) and *Lovers in the Waves* (no. **35**). These undulations are susceptible to other readings, since they could also indicate sound waves or psychic auras.[97]

In his 1893 painting *Death at the Helm* (fig. **27**), Munch depicts his father, who had died a few years before, aboard a sailboat being steered by a skeleton. This is a revision of the traditional theme of the ship as a symbol of the "voyage of life" which was popular in the nineteenth century.[98] Eugène Delacroix's *Barque of Dante* (Louvre, 1822) and Arnold Böcklin's *Island of Death* (1880, Kunstmuseum, Basel), are just two examples of ships rowed by the traditional oarsmen of the underworld, conveying souls through the realm of death. Sailing, which uses the natural forces of wind and water for motive power, and which is used as an image of freedom and pleasure in Impressionist art, or as an image of labor in the Realist paintings of Christian Krohg and Winslow Homer, is here given a macabre twist. Munch emphasized his personal connection to this theme when he wrote:

27
Edvard Munch, *Death at the Helm*, 1893. Munch Museum, Oslo

When I embarked on the voyage of life I felt like a boat made of old rotten wood, whose builder had launched it on an angry sea with these words: "If you go under, it will be your own fault and you will be consumed by the everlasting fires of Hell."[99]

The brilliant yellow and blue colors in this picture are startlingly beautiful, in juxtaposition with the grim skeleton; death is fully in command, even in the full sun. The paradoxical beauty of Munch's representations of themes of death and even terrible agony, such as *Death in the Sickroom,* suggest a kind of wild joy in the struggle of life against death. Munch celebrates the life force as he rejoices in the act of painting; his luscious colors and evocative surfaces call attention to the beauty of life and art, even if the subject is tragic. *Death at the Helm* was very well received in the Symbolist climate of the 1890s, but Munch never exhibited it after 1900; the symbolic skeleton may have seemed too obvious after his style settled on more natural imagery.[100]

Munch completed a *Self-Portrait with Skeleton Arm* in 1895 (no. **3**). His face and the bony arm are luminous against a deep black background:

Death is pitch black. Colors and light are one. To be a painter is to work with rays of light. To die — perhaps that's like having your eyes poked out. You can't see anymore — perhaps like being thrown into a cellar. Everyone has left you. They have slammed the door shut and gone away. You can't see a thing — you feel only the clammy odor of death itself. There's no light.[101]

Life and vision are synonymous for Munch. Light held an almost mystical force, which shows in his later images of *The Sun,* which he painted for the Aula of the University of Oslo. Munch also confronted his fear of death in the 1915 lithograph of the *Dance of Death,* a self-portrait with a skeleton (no. **5**). The dance of death is a theme deeply rooted in medieval art. A fascination with skeletons was also a hallmark of the Decadent movement in Europe in the 1880s and 1890s; morbid imagery was a device to distance the artist from the bourgeoisie, as well as a sign of the alienation of the artist. Numerous prints by James Ensor and Félicien Rops exemplify this.[102] The disturbing image of the skeleton may suggest a hope for resurrection and eternal life.

At this point, it is useful to widen the scope of this inquiry to discuss works that represent relationships with others and societal concerns. Munch's art has broad appeal, even though it begins with a narrow inward focus.

Ambivalence, fear and desire marked Munch's relations with women, and this could also be said of his approach to religion. Munch always took religion very seriously; even his images of insecurities and sexuality were invested with something of the sacred. Among his earliest notes on art is a statement written in Saint-Cloud in 1889 that joins sexuality with the sacred:

I would like to create it as I saw it, right there, but in a blue haze.

The two of them at that moment when they are no longer themselves but only a link in the chain that binds a thousand generations.

People would respect the power, the sanctity of it and they would take off their hats as they do in a church.

I would produce a number of these pictures. We should no longer paint interiors with people reading and women knitting.

We should paint real people, who breathe, feel, suffer and love.[103]

He later insisted that: "In all my work people will see that I am a doubter, but I never deny or mock religion."[104] Munch lauded the ability of art to create images both of the sacred and of the inner world of the artist, as opposed to photography, which renders only the external world: "The camera cannot compete with brush and palette—as long as it cannot be used in Heaven or Hell."[105] Around 1910, underscoring his conviction that his works had a sacred quality, Munch drew several designs of a "chapel for art," a museum patterned after an Italianate church, to house his paintings and prints.[106]

The mystery of life and death is the focus of Munch's *Death and the Maiden,* an etching of 1894 (no. **53**). This composition revises the traditional theme of the dance of death, depicting a nude young woman passionately embracing a skeleton. Traditionally, the conjunction of a young woman and a skeleton represented the theme of *vanitas,* a reminder that the flesh is mortal, and that beauty is fleeting. Examples of this abound in northern Renaissance art, such as Hans Baldung-Grien's early sixteenth-century *Young Woman and Death* in the Royal Art Museums, Brussels. In the nineteenth century, artists such as Félicien Rops and Antoine Wiertz emphasized the morbid and even necrophilic undertones of juxtaposing sensuous females with animated skeletons.[107] In contrast, Munch's picture is neither exploitative nor misogynistic. His work suggests the essential union of sexuality and death, and the sacrificial aspects of sexuality for women, who embrace death at the moment of bringing forth new life. The border of Munch's print is decorated with magnified sperm cells at the top and sides; the lower part of the border contains the depictions of three embryos. The dance of life and death is thus a circle dance; the act of lovemaking provides a glimpse into the abyss of death as well as a hope for the future.

The essential positiveness of Munch's imagery can be seen when contrasted with one of the classic images of Decadent art: Félicien Rops' undead aristocrats posed atop a relief of a skeletal Romulus and Remus suckled by a gaunt wolf. This undead, yet elegant couple, depicted in *Le Vice Suprême,* a frontispiece for the novel by Joséphin Péladan in 1884 (fig. **28**), stand for the nihilistic decadence of Western culture, especially the Latin race. The work is bitterly satirical, and is unrelieved by any tokens of new life or regeneration.

The cosmic power of sexuality is also embodied in the image that came to be known as *Madonna* of 1895 and 1902 (nos. **54** and **55**). Munch called this work alternately "Loving Woman" and "Madonna," and Strindberg called it "Conception."[108] An oil painting preceded the lithographic versions; it was first displayed in a frame that included sculpted forms of the embryo and sperm cells.[109] This frame, though lost, is reproduced in the border of the lithographs. This work depicts the chain of generations that are linked through conception; Munch described it in terms that emphasized the union of love and death:

The pause as all the world stops in its path. Moonlight glides over your face filled with all the earth's beauty and pain. Your lips are like two ruby-red serpents and filled with blood, like your crimson red fruit. They glide from one another as if in pain. The smile of a corpse. Thus now life reaches out its hand to death. The chain is forged that binds the thousands of generations that have died to the thousands of generations yet to come.[110]

It is an extremely sensuous work, which is at the same time both very intimate and symbolic. The composition combines the Naturalism in the image of the woman with a symbolic border. The woman is seen from above, as if the viewer were in the position of her lover. The border combines present and future, showing simultaneously a microscopic view of sperm and a developed embryo looking somewhat anxiously at the woman. Munch has combined the profane and the sacred in a manner that may seem shocking in order to highlight the transfiguring power of sexuality. His friend Sigbørn Obstfelder praised the seriousness of this work in 1896:

28
Félicien Rops, frontispiece to *Le Vice Suprême, Le Décadence Latine I,* by Joséphin Péladan, Paris: Librairie des Auteurs Modernes, 1884.

For me his Madonna picture is the quintessence of his art. It is a Madonna of the earth, the woman who bears her children in pain. I believe one must go to Russian literature in order to find a similarly religious view of woman, such glorification of the beauty of pain.[111]

Obstfelder's sensitive response stands in stark contrast to August Strindberg's sneering misogyny, published in *La Revue Blanche* in 1896:

Conception: *Immaculate or not, it comes to the same thing: the red or gold halo crowns the accomplishment of the act, the sole end and justification of this creature devoid of existence in her own right.*[112]

Strindberg may have correctly identified an underlying anxiety about conception, however: the fear that it leads to loss of individuality. Munch feared that marriage would distract him from his art, and frequently referred to his paintings as his real "children"; the *Loving Woman/Madonna* image may reflect his own ambivalence.[113]

The powerful force of sexuality overwhelms one's conscious control. *Fin-de-siècle* thinkers took this aspect of sexuality as proof that the ego was subject to biological forces that could obliterate one's identity at the same time as it led to the creation of new life. Obstfelder recognized the sacred nature of this existential mystery, in all of its "beauty and terror":

That which lies at the bottom of life is not clearly seen by our eyes, either in form, color or idea. Life has surrounded itself with a mysterious beauty and terror, which the human senses cannot, therefore, define, but to which a great poet can pray. The desire to concentrate on this human quality, to understand in a new way that which our daily life has relegated to a minor position, and to show it in its original enigmatic mystery — this attains its greatest heights here in Munch's art and becomes religious. Munch sees woman as she who carries the greatest marvel of the world in her womb. He returns to this concept over and over again. He seeks to depict that moment when she first becomes conscious of this in all its gruesomeness.[114]

Munch's Berlin circle in the 1890s included writers known for their misogyny and anti-religious views, but his own attitudes toward women and religion are more complex. His fear of losing his individuality in relationships is a recurring theme in the paintings of the Frieze of Life. Yet though he created images of romantic union in which men are drained of free will and power, Munch also had a remarkable ability to identify with individual women and their cultural roles. His images of *Puberty* of 1894 (fig. **118**), and numerous portraits of his sisters and other female friends show sensitive, multidimensional characters. Acutely aware of gender roles, Munch recognized the complexity of individual lives:

The woman who gives herself, and takes on a madonna's painful beauty — the mystique of an entire evolution brought together: woman in her many-sidedness is a mystery to man — woman who simultaneously is a saint, a whore and an unhappy person abandoned.[115]

Earlier studies exaggerated Munch's hostility to women, although a more balanced view has begun to emerge.[116]

Sexuality proved to be Munch's most potent metaphor for spiritual union. The erotic union of two people can be taken as a symbol for the union between the soul and god, the communication link

between artist and viewer, and also as a bridge across generations in time. *Encounter in Space,* a woodcut of 1899, further exemplifies Munch's vision of the chain of generations (no. **57**). The green figure of a woman reclines, her head on her arm. A bright red male figure lies prone near her thighs, holding his head in his hands. The figures seem to be floating against a night-black background; they are surrounded by giant sperm, which resemble stars or comets. The image unites the microcosm and the macrocosm, and simultaneously implies the present, past and future. Scholars have compared the lovers to figures by William Blake and Auguste Rodin.[117] Suggesting the cosmic nature of their union, Munch wrote:

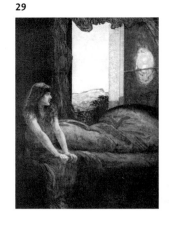

People's souls are like planets. Like a star that appears out of the gloom and meets another star — they shine brightly for a moment and then disappear completely into the darkness. It is the same when a man and woman meet — they glide towards each other, the spark of love ignites and flares up, then they vanish, both going their own separate ways. Only a few come together in a flame that is large enough for them to become one.[118]

Munch makes clear his fundamental vision of the unity of all things in this passage from the manuscript he called "The Tree of Knowledge":

Nothing is small nothing is great —
Inside us are worlds. What is small divides itself into
what is great the great into the small. —
A drop of blood a world with its solar center and planets. The ocean a drop a small part of a body —
God is in us and we are in God.
Primeval light is everywhere and goes where life is — everything is movement and light —
Crystals are born and shaped like children in the womb. Even in the hard stone burns the fire of life
Death is the beginning of life — of a new crystallization
We do not die, the world dies away from us
Death is the love-act of life pain is
the friend of joy.[119]

Munch's symbolic use of sperm cells is highly original, although other artists had earlier depicted the apparition of fetal shapes. Max Klinger incorporated embryonic shapes in *The Apparition* (fig. **29**), a part of his series of prints titled *A Love,* and Aubrey Beardsley depicted fetuses in several designs, including his *Incipit Vita Nova (Dante),* a drawing of 1893 (fig. **30**).[120] In 1900, the Czech artist Frantisek Kupka portrayed a haloed embryo rising above a pond of lily pads and lotuses in a composition steeped in Theosophical imagery titled *The Beginning of Life* (fig. **31**). The association of procreation and creativity was common in the *fin-de-siècle,* and Munch's habit of referring to his paintings as his "children" suggests a degree of self-identification in these images of love, death and immortality.[121]

In the *Madonna in the Churchyard* (c. 1896, fig. **32**), Munch depicts the abandonment that he believed would befall every woman. The watercolor shows a sorrowful Madonna in a graveyard, fully clothed, her long skirt embellished with pictures of falling leaves, echoing the autumnal branches above her. The leaves, symbolizing the transience of life, have been shed by the trees, just as she has been discarded.[122] A skeletal cupid armed with a bow and arrows creeps up on her from the left; the link

29
Max Klinger, *The Apparition,* from the series *A Love,* etching and aquatint, 1887. Private collection.

30
Aubrey Beardsley, *Incipit Vita Nova (Dante),* drawing, c. 1893. From *The Early Work of Aubrey Beardsley,* London and New York: John Lane, 1901.

31
Frantisek Kupka: *The Beginning of Life,* aquatint, 1900. Private collection.

32
Edvard Munch, *Madonna in the Churchyard,* watercolor and drawing, c. 1896. Munch Museum, Oslo.

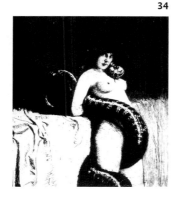

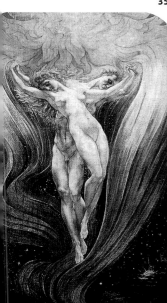

between them is reinforced by the fact that both have haloes. It is a peculiar vision of the bond between love and death, and seems closest to the morbid visions of Félicien Rops' etchings, who included skeletal cupids in his etchings. Arne Eggum has noted that the tombstone with a wreath is the same shape as the stone placed over the grave of Munch's brother Andreas in 1895.[123] The private grief that Munch felt for his dead mother, father, sister and brother certainly inform this work.

The many permutations of desire can be seen in the kaleidoscopic lens of Munch's art in the 1890s. Munch makes emblematic the blind force of male lust in *Hands* (1896, oil on cardboard, no. **49**), which shows a nearly nude woman surrounded by disembodied hands grasping for her. The compositional device of the cropped grasping hands was anticipated in the Belgian Symbolist Fernand Khnopff's frontispiece for Péladan's novel *Femmes honnêtes* of 1888 (fig. **33**), but the bold surface texture, with its abstract accents and spatters and bleach marks, is uniquely Munch's. Munch explores traditional Biblical imagery of Eve as a sexual temptress in his lithographs of *Sin* in 1901, and *Jealousy II* in 1896 (nos. **44** and **29**). *Sin* shows a red-headed temptress with piercing green eyes; *Jealousy II* juxtaposes the haunted face of Stanislaw Przybyszewski with a sensual image of his wife, Dagny and another man beneath an apple tree, a clear reference to the theme of temptation. *Woman with Snake,* a lithograph from his *Alpha and Omega* series of 1908–09, transposes the Eve-like figure called Omega to a mythic Nordic island (no. **45**). There, she mates indiscriminately with all the animals on the island, rekindling the passion of jealousy in her companion, Alpha. The embrace of woman and serpent is clearly based on the works of German Symbolist artists Max Klinger and Franz von Stuck. In the 1890s, von Stuck executed eighteen oil paintings of Eve and the Serpent titled either *Sin* or *Sensuality,* as well as several prints (fig. **34**). Munch's negative depiction of women in both of these images is part of a reaction to his disastrous relationship with Tulla Larsen in these years.

Munch gives mystical form to the cosmic union of man and woman in *The Flower of Love* (no. **32**) and *Lovers in the Waves* (no. **35**), both from 1896. *The Flower of Love* is a counterpart to *The Flower of Pain,* and shows a full-length embracing couple, whose floating forms are encased in a flame-like flower. In their mystical union, the two lovers offer an interesting parallel to the idealized Neoplatonic realm invoked in Jean Delville's image of spiritual union in *The Love of Souls* of 1900 (fig. **35**, Musée d'Ixelles, Brussels). Although Delville's Rosicrucian-inspired art may seem foreign to Munch, much of Munch's art reveals a decidedly spiritual aspect. Arne Eggum has shown that Munch was close to Spiritualists in Berlin in the 1890s.[124] Marcel Réja, a physician who worked with Jean Martin Charcot, wrote a poem about this work which stressed that the man and the woman are unconscious of the forces of biological destiny and fate that draw them together.[125]

Lovers in the Waves shows the heads of a man and woman juxtaposed, as if they are floating in the water; in the narrow band of sky visible above the horizon, stars are clearly marked. The model is the same woman whom Munch hired in Berlin for the *Madonna.* At the time there was some speculation that Dagny Juel Przybyzewska was his model, but Munch attempted to dispel that confusion, although he admitted that there was some resemblance.[126] The rippling waves of water and hair suggest equivalents of sound and psychic energy; the figures fuse with their environment. Some of Munch's friends called this print *Death in the Waves,* underscoring the recurring theme of *Liebestod,* or love and death.[127]

33
Fernand Khnopff, *Avec Joséphin Péladan: Pallentes Radere Mores,* frontispiece to *Femmes honnêtes,* Paris: Dalou, 1888. Private collection.

34
Franz von Stuck, *Sensuality,* etching, c. 1891. Private collection.

35
Jean Delville, *The Love of Souls,* 1900. Musée d'Ixelles, Brussels.

VISIONS OF TRANSCENDENCE—NATURE MYSTICISM

Spiritual and cosmic themes emerge in a number of works that are rooted in Munch's own life, but are made symbolic of universal principles. One of Munch's most obscure paintings, *Metabolism* (Munch Museum, Oslo) of 1899 addresses the unity of nature and the mysterious forces of life and death. He described this painting as the key to the entire Frieze of Life series (fig. **36A**):

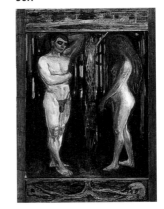

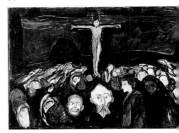

The Frieze was planned as a poem on life, on love and death. The theme of the largest picture, of the two people, the man and woman in the forest, is perhaps somewhat unrelated to the ideas expressed in the other paintings, but it is as necessary to the Frieze as a whole as the buckle is to the belt. It is the picture of life drawing sustenance from the dead, and of the city growing up behind the crowns of the trees. It is the picture of life's power to endure.[128]

In this picture a nude couple, recalling Adam and Eve, are positioned on either side of a tree in a forest. The tree roots continue down into the frame, where they are carved intertwining with a human skull and an animal skull. Death grows from life, as the tree takes nourishment from the decaying bodies; matter is transformed, but conserved and remains eternal. Munch once wrote: "Flowers will grow up from my rotting corpse and I will live on in those blooms."[129] Similar imagery is found in Munch's poster for his 1902 exhibition at the Hollaendergaarden in Oslo (no. **57**).

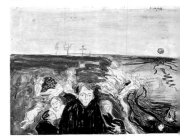

 The two figures in *Metabolism* are based on Munch and Tulla Larsen, a woman with whom he had a passionate but stormy relationship during the late 1890s and early 1900s. A photograph of the painting taken at the time of its exhibition in Leipzig in 1903 shows that it originally included a human embryo growing from the flowering leaves of the tree (fig. **36B**). The picture was repainted, probably around 1918, according to Reinhold Heller.[130] A complex synthesis of the Biblical story of Adam and Eve with Greek myths of the birth of children born from plants may be indicated here, with the underpinnings of Munch's vision of life growing from death.[131] Trees are frequently associated with fertility and are often seen as counterparts of the human soul in mythology.[132] As repainted by Munch, the tree is less obviously a fertility symbol, but now reaches between heaven and the depths of the earth, to fulfill another symbolic function of the tree, which mediates between the earth and sky. Considering the intensity of August Strindberg's interest in alchemy in the 1890s,[133] one wonders if the presence of this "homunculus" perhaps had alchemical symbolism as well.

 Several paintings and drawings of traditional Biblical subjects reflect Munch's struggle with faith. He painted a picture of the crucifixion, titled *Golgotha,* in 1900 (fig. **37**), when he was undergoing treatment for nervous exhaustion in a sanatorium.[134] His identification with the scene of suffering and redemption shows in both the crucified Christ and the pale figure in profile, who may represent the Evangelist Saint John, in the foreground; both are self-portraits. The face in the crowd directly below Christ may be that of his father, Dr. Christian Munch.[135] The name Munch is an obvious pun on "monk" in Norwegian, and the artist painted himself as a monk in the watercolor *The Empty Cross* around 1900 (fig. **38**). By portraying himself as a monk, Munch declares that creating art is a sacred vocation. Both Romantic and Symbolist artists often identified themselves with members of religious orders.[136] This scene is not Golgotha—the historical site of the crucifixion—there is only one symbolic cross, not three. Rather, it is the modern world, and the setting sun perhaps suggests an approaching Last Judg-

36
A Edvard Munch, *Metabolism,* oil on canvas, 1899. Munch Museum, Oslo.
B Photograph of *Metabolism* taken at 1903 exhibition, Leipzig.

37
Edvard Munch, *Golgotha,* oil on canvas, 1900. Munch Museum, Oslo.

38
Edvard Munch, *The Empty Cross,* drawing and watercolor, c. 1900. Munch Museum, Oslo.

ment. Temptations of the flesh are shown in the embracing couples at left, and other figures are drowning in the sea at right.

On the heights in the background the cross stands empty and weeping women pray to the empty cross — lovers-whores-drunkards-and criminals fill the terrain below — and to the right in the picture — a steep slope goes down to the sea — the human beings fall down the steep slope — and terror-stricken [sic] — they hug the edge of the precipice — In the center of the chaos stands Munch, staring ahead, bewildered and with the frightened eyes of a child at all this — and says why why — It was I here — Passion and the vices are raging all over the city — the terror of death lurked behind — a blood-red sun shines down on everything — and the cross is empty . . .[137]

The cross is an empty symbol; Munch wanders in a world of confusion and lack of faith.

Although he could not accept his father's fundamentalist religious faith, Munch formed his own ideas about immortality. Besides the personal immortality that would come to him through his pictures, he believed in a general immortality through union with nature; he described a vision of such natural immortality in his diary in 1892:

I felt it to be a rapture to pass into, be united with — become this earth which always, always fermented, always shone upon by the sun — and lived, lived — and there were to grow plants up and out of my rotting body — and trees and flowers and the sun were to warm them and I was to be in them and nothing was to come to an end — that is eternity.[138]

The pain of his mother's death and the later losses of family members weighed heavily on him. Munch's diary records his continuing struggle to find answers to the riddle of existence and faith:

The breath of life is, if you wish, the same as the soul or the spirit. It would be foolish to deny the existence of the soul, and one cannot deny the existence of a life-force.

We must all believe in immortality, and also, for that matter, that it is possible to claim that the breath of life, the spirit of life, lives on after the body is dead . . . What becomes of the spirit of life, the power that holds a body together, the power that fosters the growth of physical matter? Nothing — there is no evidence in nature to suggest that anything does. A body that dies does not vanish — its substance is transformed, converted. But what happens to the spirit that inhabits it?

Nobody can say where it goes to — to try and assert its nonexistence after the body has died is as ridiculous as insisting on trying to demonstrate how or where that spirit will continue to exist.[139]

Munch was intrigued by the new currents of mysticism in the 1890s, which wedded the idealistic philosophy of Schopenhauer to occult beliefs in hidden realities. The rapid pace of scientific discoveries in the late nineteenth century seemed to confirm the belief in invisible realities, with the novel visions of x-rays presenting the skeletons of living beings, and astronomy expanding the vision of the cosmos. (X-rays were discovered in 1895, the same year he painted his *Self-Portrait with Skeleton Arm* (no. **2**), but were not introduced to the public until 1896, so a direct influence cannot be established.) To many scientists of the day, it seemed that every mystery of nature would soon be explained, but for an artist such as Munch, this overly-confident positivism provoked an opposite reaction towards mysticism:

Mysticism will always be with us. The more we discover, the more unexplained things there will be.

The new movement, whose advances and fires can be detected everywhere, will express all those things that have been repressed for a generation, everything that mankind will always have in great abundance: mysticism. It will find expression for what now is so refined as to be recognized only in vague inclinations, in experiments of thought. There is an entire mass of things that cannot be explained rationally. There are newborn thoughts that have not yet found form.[140]

Munch's pantheistic vision of the cycles of life and afterlife took on a cosmic scale, and he expressed this vision in poetic, rather than scientific terms. He envisioned a unity between the microcosm and the macrocosm, a unity based on the vital force of desire:

I was standing on a high mountain and I saw the whole world below me—the world after thousands of years—I saw the small and the large planets which, obeying the laws of nature followed their fixed orbits—I saw the small planet Earth—which circled the sun. I saw how the transubstantiation began—how the air corroded the earth—how the desire first arose in the hard mass of the earth to be united with the air—and the transitory forms between the stones and the air were created: the living: men, animals—plants—There was a desire for procreation—for combustion, and the animals, men—the plants mated—Obeying the laws, the male loved the female—I saw men multiply—and were gathered in masses—they spread over the earth and where the mass became lumpy and encountered other masses, they fought in order that the stronger would win—so also did the animals, men, and so also the plants.[141]

Munch sees even air and rocks driven by desire for union, recapitulating mythic legends of the earth goddess mating with the sky god. He sees a universal diffusion of the desire to mate, which leads to a Darwinian struggle for existence.

Considering his pantheistic view of nature, and his artistic tendency to use the image as an analog for emotional expression, it is not surprising that Munch's landscapes have such spiritual power. His painting *Starry Night* (1923–24, no. **82**), which returns to a theme he first depicted in 1893, may have been inspired by Vincent van Gogh, and has also been connected to themes of death in the plays of Ibsen.[142] This gloriously Romantic vision of infinity, painted from the terrace of his studio at Ekely, is a worthy match to the night visions of van Gogh. The stars pulse with radiant energy above the snowy landscape, and his shadow traces its furtive outline in the snow, a subtle reminder of mortality with its fleeting presence.

The Sun of c. 1912 was painted as a study for the great public murals that he created for the Aula in the University of Oslo (no. **81**). The centerpiece of the mural decorations, the sun is an image of healing and eternity, which Munch believed was present throughout his works:

A straight line leads from Spring *to the Aula Paintings. The Aula Paintings are humanity as it strives towards the light, the sun, revelation, light in times of darkness.*

Spring *was the mortally ill girl's longing for light and warmth, for life. The sun in the Aula was the sun shining in the window of* Spring. *It was Osvald's sun [in Ibsen's* Ghosts].

In the identical chair in which I painted the sick girl, I and all those I loved, beginning with my mother, once sat winter after winter, sat and longed for the sun—until death took them away.[143]

The Sun is an incandescent vision of the light that Munch sought throughout his career, even though he is more widely associated with his images of nocturnal melancholy and the anxieties inherent in the abysses of love and loss of faith.

Munch's art is rooted in the philosophical and religious concerns of his time, and he identified most with those artists and writers who searched for original answers to the troubling questions of life and death. In 1892, his friend Hans Dedekam noted:

One day when I talked to Munch about the art that had impressed him most deeply, he named Edgar Allan Poe's Tales of Fantasy [Tales of Mystery and Imagination] *and Dostoyevsky's* Prince Myshkin [The Idiot] *and* The Brothers Karamazov. *These two deeply poetic writers are also his kindred spirits. No one in art has yet penetrated as far as they have into the mystical realms of the soul, towards the metaphysical, the subconscious. They both view the external reality of the world as merely a sign, a symbol of the spiritual and the metaphysical.*[144]

In the Symbolist era, belief in external realities was undermined by the philosophic idealism of Schopenhauer, modern psychology, and the scientific revolution. Mysticism offered a validation of traditional mythic wisdom that seemed more spiritually fulfilling. Mysticism also validated the work of artists, who were otherwise marginalized in the new age of science and technology; as shapers of images, which were signs of intuited reality and inner states of mind, they could interpret the world rather than just describe it. Munch's evolution from Realism to Symbolism also prepared the foundation of Expressionism, which carried the concept of the work of art as an analog of inner experience even further.

Edvard Munch's art never became completely abstract, however; it was always grounded in his own lived experiences and his direct perceptions of nature. His most overtly symbolic works were created in the 1890s and the early twentieth century when he was most in the grip of his inner conflicts, and the role of Symbolist art was most powerful. After 1909, his work became increasingly naturalistic as he became more concerned with public commissions, and came to a greater peace with his emotions. The role of communication was always fundamental to Munch; he rejected comparison with excessively literary Symbolism and abstruse Germanic "thought-painting" *(Gedankenmalerei)*, which he found trivial.[145] Munch compared his pictures to his diaries, but as we have seen, these "texts" are densely layered symbolic representations, not literal transcriptions. His private sorrows were signified in his images of *Melancholy, The Scream* and *Anxiety*, but these works embody a wild joy in creation and discovery. As did Goya, Munch depicted even his darkest subjects in a manner that celebrates the act of painting and the desire for life even in the face of death. His skepticism made it impossible for him to be satisfied with the pious fundamentalism of his father's religion, but he fastened on a concept of life after death through his artistic legacy, and a final union with nature. After years of struggle, he wrote in 1937:

Prayer and religious thought — the idea of God, of eternity — take us out of ourselves; unite us with the universe, with the origins of light, with the origins of life, with the world. It soothes, thus does faith make us strong. It allows us to distance ourselves from the body.[146]

This excerpt of a late letter weaves together the themes of faith that had always been a part of his family and his individual quest for transcendence.

The connecting thread through this essay has been Munch's quest to represent the invisible rather than the visible: the emotion of melancholy, the passions of love and death, and his individual view of spirituality and nature. I have followed Munch as he shifted his focus concentrically outward from his inner world to social and universal concerns — in other words, from psyche to symbol to expression. His "pictures seen by the inner eye" combined the personal and the abstract in a way that still speaks today. He has attained the immortality he sought.

I am grateful to my colleague, Katherine Nahum, for her thoughtful assistance in the preparation of this essay.

1 Edvard Munch, 1907/8; quoted by Ragna Stang, *Edvard Munch,* New York: Abbeville Press, 1977, p. 11.

2 *Edvard Munch: The Frieze of Life,* Mara-Helen Wood, editor, London: National Gallery, 1992.

3 Trygve Nergaard, "Despair," in Arne Eggum, *Edvard Munch: Symbols and Images,* Washington, DC: National Gallery of Art, 1978, pp. 113–141.

4 Reinhold Heller, "Edvard Munch's *Night,* the Aesthetics of Decadence and the Content of Biography," *Arts Magazine,* 53, 2, October 1978, pp. 80–105. See also Reinhold Heller, *Munch: His Life and Work,* Chicago: University of Chicago Press, 1984, p. 87

5 Erwin Panofsky and Fritz Saxl, *Dürer's Melancholia I,* Leipzig-Berlin, 1923.

6 Heller, "Edvard Munch's *Night,* the Aesthetics of Decadence . . . ," pp. 80–105.

7 Rudolf and Margot Wittkower, *Born Under Saturn; the character and conduct of artists: a documented history from antiquity to the French Revolution,* New York: Random House, 1963.

8 Erwin Panofsky, *The Life and Art of Albrecht Dürer,* Princeton, NJ: Princeton University Press, 1971.

9 Robert Burton, *The Anatomy of Melancholy* [1651], New York: Tudor Publishing Co., 1941.

10 J. Kirk T. Varnedoe, with Elizabeth Streicher, *The Graphic Works of Max Klinger,* New York: Dover, 1977.

11 Cesare Lombroso, *The Man of Genius,* London: W. Scott; New York: C. Scribner's Sons, 1891.

12 Lancelot L. Whyte, *The Unconscious Before Freud,* New York: 1960, p. 169. C. G. Carus, *Psyche* [1846], translated by R. Welch, New York: 1970. Eduard von Hartmann, *Philosophy of the Unconscious* [1868], translated by N. C. Coupland, London: 1950.

13 Carus' *Psyche* is particularly interesting to the art historian, because in addition to being a physician, Carus was also a painter who had been a pupil of the German Romantic artist Caspar David Friedrich. He was thus also an associate of Johan Christian Dahl, who is often called the "father of Norwegian landscape painting."

14 J. P. F. Richter, known as Jean Paul, quoted in Lancelot Whyte, *The Unconscious Before Freud,* p. 132.

15 Franz Servaes, *Das Werk des Edvard Munch,* 1894, p. 37ff.: "Im gegensatz zu allen diesen Leuten (von Stuck, Hofmann, Liebermann, Gauguin) steht, obwohl im innersten Kern mit ihnen verwandt, Eduard Munch, der Norweger. Er braucht nicht Bauern und nicht Kentauren und nicht Pardiesesknaben die Primitivität der Menschennatur zu erblicken un zu durchleben. Er tragt sein eigenes Tahiti in sich, und so schreitet er mit nachtwandlerischer Sicherheit durch unser verworrenes Culturleben, ganzlich unbeirrt, im Besizt seiner durchaus culturlosen Parsifal-Natur. Der reine Thor in der Malerei—das ist Eduard Munch."

16 Richard Dehmel, letter of August 26, 1893, in *Ausgewählte Briefe I,* Berlin: 1923; quoted in Carla Lathe, "Edvard Munch and the Concept of 'Psychic Naturalism'," *Gazette des Beaux Arts* 93, March 1979, p. 143.

17 L. Whyte, *The Unconscious Before Freud,* pp. 168–169. Henri Ellenberger, *The Discovery of the Unconscious,* New York: 1970.

18 Frank J. Sulloway, *Freud, Biologist of the Mind: Beyond the Psychoanalytic Legend* [1979], New York: 1983, p. 251.

19 Hans-Georg Pfeifer, *Max Klingers (1857–1920) Graphikzyklen. Subjektivität und Kompensation im künstlerischen Symbolismus als Parallelentwicklung zu den Anfangen der Psychoanalyse,* Giessener Beiträge zur Kunstgeschichte, Band V, 1980.

20 Marit Lange, "Max Klinger og Norge," *Kunst og Kultur* (Norway), vol. 80. pt. 1, 1997, pp. 2–40.

21 Heller, *Munch: His Life and Work,* pp. 78–82. See also Patricia Berman and Jane van Nimmen, *Munch and Women, Image and Myth,* Alexandria, VA: Art Services International, 1997, p. 7.

22 Quoted by Trygve Nergaard, "Despair," in Eggum, *Edvard Munch: Symbols and Images,* p. 130.

23 Christian Krohg, Nov. 1891, quoted in Heller, *Munch: His Life and Work,* p. 82.

24 Edvard Munch, Manuscript T 2782j; quoted in Eggum, *Edvard Munch: Symbols and Images,* p. 131.

25 "Bohembud" (commandments for the Bohemians), *Impressionisten,* No. 8, February 1889; quoted by Stang, *Edvard Munch,* p. 52.

26 Biographical studies first dominated Munch scholarship: Rolf Stenersen and Ragna Stang produced well informed and valuable commentaries. Later scholars such as Reinhold Heller, Arne Eggum, and Patricia Berman focused on interpretation, and Elizabeth Prelinger and others have made important contributions to the technical study of Munch's printmaking techniques.

27 Edvard Munch, Manuscript N 45; quoted by Stang, *Edvard Munch,* p. 107.

28 Edvard Munch to Ludvig Ravensberg; quoted by Stang, *Edvard Munch,* p. 11.

29 Edvard Munch, letter to Ragnar Hoppe, 1929; quoted by Stang, *Edvard Munch,* p. 11.

30 A point effectively made by Carla Lathe, "Edvard Munch's Dramatic Images, 1892–1909," *Journal of the Warburg and Courtauld Institutes,* vol. 46, 1983, pp. 191–206.

31 In a sense Paul Gauguin's relief carving *Soyez Mysterieuses* (1890) sums up this goal of the Symbolist movement. See H. R. Rookmaaker, *Gauguin and Nineteenth-Century Art Theory,* Amsterdam: 1972, pp. 220–224, and Vojtech Jirat-Wasiutynski, *Gauguin in the Context of Symbolism,* New York: 1976.

32 Heller, *Munch: His Life and Work,* p. 66. The Scandinavian connection with Swedenborg may have made the theory of correspondences even more appealing to Munch.

33 Stanislaw Przybyszewski, "Psychischer Naturalismus," *Die Neue Rundschau,* February 1894, pp. 150–156; reprinted in Stanislaw Przybyszewski, editor, *Das Werk des Edvard Munch,* Berlin: S. Fischer, 1894: "Munch, to put it briefly, does not want to project a psychical, naked process through mythology, i.e., through sensual metaphors, but directly in his color equivalents, and from this consideration Munch is the naturalist of the phenomena of the soul par excellence, just in the same way that Lieberman is about the most ruthless naturalist of the external world." Quoted by Lathe, "Edvard Munch and the Concept of 'Psychic Naturalism'," *Gazette des Beaux Arts,* p. 136.

34 Bodil Ottesen, "The Flower of Pain: How a Friendship Engendered Edvard Munch's Predominant Artistic Metaphors," *Gazette des Beaux-Arts* 6, 124, October 1994, pp. 149–158.

35 Maria Leach, editor, *Funk & Wagnalls Standard Dictionary of Folklore, Mythology, and Legend,* New York: Harper & Row, 1984, pp. 671–672.

36 Trygve Nergaard, "Despair," in Eggum *Edvard Munch: Symbols and Images,* p. 132.

37 Brooks Adams, "The Poetics of Odilon Redon's Closed Eyes," *Arts Magazine,* Jan. 1980, pp. 130–134.

38 Vincent van Gogh, Letter 566, 1888, *The Complete Letters*

of Vincent van Gogh, Boston, Toronto, London: Bulfinch Press, 1991, vol. 3, p. 90. Emile Wauters (1846–1933) combined the Romantic interest in psychology and the role of insanity in artistic creativity in his haunting vision of *The Madness of Hugo van der Goes* (1872, Royal Museums of Fine Arts, Brussels). Hugo van der Goes (d. 1482) was a very gifted painter who retired from the world in 1475 and entered a monastery in search of a cure for his mental illness. He was stricken while returning from a trip to Rome, according to an account written by Gaspar de Ofhuys, of the Roode Clooster, a monastery near Brussels which sheltered van der Goes. The author of this report had been a young novitiate at the time of van der Goes' illness. He speculated that the illness may have been sent by Divine Providence, or may have stemmed from natural causes, such as "the malignity of corrupt humors that predominate in the human body." Ofhuys noted that van der Goes was "deeply troubled by the thought of how he could ever finish the works of art he wanted to paint," and also perhaps drank too much wine. Wauters' brother A. J. Wauters, was a noted art historian who had written a biography of Hugo van der Goes in 1864; he undoubtedly brought the chronicles of the artist's madness to the attention of his brother. Emile Wauters portrayed van der Goes in the monastery, in the grip of his melancholic depression, while young boys sing to ease his spirits. This picture, with its subject of artistic madness, has fascinated many later observers intrigued by the relationship between artistic creation and insanity.

39 Andreas Aubert, 1890, quoted in Heller, *Munch: His Life and Work*, p. 69.

40 Notably by a doctor of psychology, Johan Scharffenberg, in 1895, in the aftermath of a lecture on Munch's art. See Heller, *Munch: His Life and Work*, p. 68.

41 Stephanie Barron, editor, *Degenerate Art: The Fate of the Avant-Garde in Nazi Germany*, Los Angeles: Los Angeles County Museum of Art, 1991.

42 Hugh Honour, "Frozen Music," *Romanticism*, New York: Harper & Row, 1979, pp. 119–155. George Mras, *Eugène Delacroix's Theory of Art*, Princeton, NJ: Princeton University Press, 1966, pp. 37–35. Günther Metkin, "Music for the Eye, Richard Wagner and Symbolist Painting," in Jean Clair, editor, *Lost Paradise. Symbolist Europe*, Montreal: The Montreal Museum of Fine Arts, 1995, pp. 116–123.

43 Elizabeth Prelinger, "When the Halted Traveler Hears the Scream in Nature: Preliminary Thoughts on the Transformation of Some Romantic Motifs," in *Shop Talk: Studies in Honor of Seymour Slive Presented on his Seventy-Fifth Birthday*, Cambridge, MA: Harvard University Art Museums, 1995, p. 385.

44 Walter Pater, *The Renaissance. Studies in Art and Poetry* [1873], London, New York: MacMillan, 1893, p. 106. See also Ron Johnson, "Whistler's Musical Modes: Symbolist Symphonies," *Arts Magazine*, April 1981, pp. 164–176.

45 Roy Asbjörn Boe, "Edvard Munch: His Life and Work from 1880 to 1920," unpublished Ph.D. dissertation, New York University, 1971, p. 160.

46 Draft of a letter of c. 1932, quoted in Heller, *Munch: His Life and Work*, p. 103.

47 Wilhelm Worringer, *Abstraction and Empathy, A Contribution to the Psychology of Style* [1908], New York: International Universities Press, Inc., 1967.

48 Paul Gauguin, quoted in H. R. Rookmaaker, *Gauguin and Nineteenth-Century Art Theory*, Amsterdam: Swetz & Zeitlinger, 1972, p. 321.

49 One evidence of the strength of Wagner's influence is the length of Max Nordau's attack on him in "The Richard Wagner Cult," *Degeneration* [1892], translated by G. L. Mosse, New York, 1968, pp. 171–213.

50 Regarding German art, Munch wrote: "For example, Böcklin, whom I would almost rank above all other modern painters, Max Klinger, Thoma. Among musicians, Wagner; among philosophers, Nietzsche. France has an art that is greater than Germany's, but no artists greater than these I named." Quoted in Heller, *Munch: His Life and Work*, p. 109.

51 Charles Baudelaire, "Richard Wagner et Tannhäuser," *Curiosités esthétiques. L'art romantique*, 1861; quoted in Günther Metkin, "Music for the Eye, Richard Wagner and Symbolist Painting," in *Lost Paradise. Symbolist Europe*, p. 118.

52 Téodor de Wyzéwa, "Notes on Wagnerian Painting (1886)," translated from the *Revue Wagnérienne*, II, May 8, 1886, pp. 107–108, in Henri Dorra, *Symbolist Art Theories*, Berkeley and Los Angeles: University of California Press, 1994, pp. 147–149.

53 de Wyzéwa, "Notes on Wagnerian Painting (1886)."

54 Elizabeth Prelinger, "Halted Traveler," *Seymour Slive*, p. 385.

55 *Paul Gauguin. The Writings of a Savage*, edited by Daniel Guérin, New York: Viking Press, 1928, pp. 146–147.

56 Kirk Varnedoe, "Christian Krohg and Edvard Munch," *Arts Magazine*, April 1979, pp. 88–95.

57 Quoted in Eggum, *Edvard Munch: Symbols and Images*, p. 130.

58 Deborah L. Silverman, *Art Nouveau in Fin-de-Siècle France. Politics, Psychology, and Style*, Berkeley, Los Angeles and London: University of California Press, 1989, pp. 84–85.

59 Norma Steinberg, "Munch in Color," *Harvard University Art Museums Bulletin*, vol. 3, no. 3, Spring 1995, pp. 8–54.

60 This device ". . . consisted of a 6-foot square frame above a normal harpsichord; the frame contained 60 small windows each with a different colored-glass pane and a small curtain attached by pulleys to one specific key, so that each time that key would be struck, that curtain would lift briefly to show a flash of corresponding color. Enlightenment society was dazzled and fascinated by this invention, and flocked to his Paris studio for demonstrations. The German composer Telemann traveled to France to see it, composed some pieces to be played on the Ocular Harpsichord, and wrote a German-language book about it." *Animation World Magazine*, Issue 2.1, April 1997, p. 1.

61 Hermann Ludwig Ferdinand von Helmholtz (1821–94), *Treatise on Physiological Optics* (1867), p. 237, quoted in Arthur Jerome Eddy, *Recollections and Impressions of Whistler*, Philadelphia and London: Lippincott, 1908, pp. 195–196. Eddy tried to lay a scientific foundation for Whistler's harmonies of color, see especially pp. 186–200. Helmholtz's chart:

F#	End of the red
G	Red
G#	Red
A	Red
A#	Orange-red
B	Orange
C	Yellow
C#	Green
D	Greenish-blue
D#	Cyanogen-blue
E	Violet

Early examples of color organs are shown in A. Wallace Rimington, *Colour-Music. The Art of Mobile Colour*, London: Hutchinson & Co., 1912.

62 The relationship of color to mathematics, as well as music,

was a concern of Georges Seurat and the Neo-Impressionists. Robert Herbert, editor, *Georges Seurat 1859–1891*, New York: Metropolitan Museum of Art, 1991, pp. 391–393, discusses Charles Henry's contribution to Neo-Impressionist theory.

63 See Stefan Tschudi Madsen, *Sources of Art Nouveau*, Oslo and New York: 1956. Also Robert Schmutzler, *Art Nouveau*, New York: 1978.

64 See Deborah Silverman, *Art Nouveau in Fin-de-Siècle France*, chapter 5, "Psychologie Nouvelle," pp. 75–106. Silverman concludes on p. 106: "The discovery that the interior of the human organism was a sensitive nervous mechanism, prone to suggestion, visual thinking, and imagistic projection in dreams — these elements of a new psychological knowledge would alter the meaning of interior decoration in the fin-de-siècle."

65 Gabriel P. Weisberg, "S. Bing, Edvard Munch and l'Art Nouveau," *Arts Magazine*, 1986, vol. 61, no. 1, pp. 58–64.

66 Scriabin's *Prometheus* was partly inspired by the Belgian Symbolist artist Jean Delville; it was written while Scriabin was staying with Delville during the period when the artist was creating a mural of Prometheus for the Université Libre in Brussels. See Olivier Delville, *Jean Delville, Peintre 1867–1953*, Brussels: Laconti, 1984, p. 26. A "Clavilux" was featured at the 1933 World's Fair in Chicago, and Walt Disney's *Fantasia* (1940) was the most popular example of synaesthetic art. Synaesthesia is a major goal of much contemporary computer and video art.

67 Edvard Munch, Manuscript T 2760, December 12, 1891, p. 36; quoted in Eggum, *Edvard Munch: Symbols and Images*, p. 131.

68 Edmund Burke, *A Philosophical Enquiry Into The Origin Of Our Ideas Of The Sublime And Beautiful*, University of Notre Dame Press, 1968. Thomas Weiskel, *The Romantic Sublime: Studies in the Structure and Psychology of Transcendence*, Baltimore and London: The Johns Hopkins University Press, 1976, links the terror of the sublime to Freudian castration anxiety; see Michael Fried, *Realism, Writing, Disfiguration: On Thomas Eakins and Stephen Crane*, Chicago and London: University of Chicago Press, 1987, p. 66.

69 Edvard Munch, 1891, Manuscript T 2761; quoted by Stang, *Edvard Munch*, p. 16.

70 Robert Rosenblum, *Transformations in Late Eighteenth-Century Art*, Princeton, NJ: Princeton University Press, 1969, p. 179.

71 Munch to Ragnar Hoppe; quoted by Stang, *Edvard Munch*, p. 174. Working from memory was an important tool for many artists to simplify their images; Edgar Degas praised the memory training of Francois Lecoq de Boisbaudran, and later declared: "It is very good to copy what one sees; it is much better to draw what you can't any more but in your memory. It is a transformation in which imagination and memory work together. You only reproduce what struck you, that is to say the necessary. That way, your memories and your fantasy are freed from the tyranny of nature." Richard Kendall, *Degas Landscapes*, New Haven and London: Yale University Press, 1993, p. 212. Even Vincent van Gogh began working from memory during the fall of 1888: "I am going to set myself to work from memory often, and the canvases from memory are always less awkward, and have a more artistic look than studies from nature . . ." Letter 561, November 1888, in *The Complete Letters of Vincent van Gogh*, Boston, Toronto, London: Bulfinch Press, 1991, vol. 3, p. 103.

72 Munch, *Livfrisens tilblivelse* (On the creation of the Frieze of Life), Oslo: 1929; quoted in Arne Eggum, *Munch and*

Photography, New Haven and London: Yale University Press, 1989, p. 52.

73 Reinhold Heller, "Concerning Symbolism and the Structure of Surface," *Art Journal*, vol. 45, no. 2, Summer 1985, pp. 146–153.

74 Edvard Munch; quoted by Stang, *Edvard Munch*, p. 31.

75 Edvard Munch, Manuscript T 2748; quoted by Stang, *Edvard Munch*, p. 107.

76 Patricia Berman, *Edvard Munch: Mirror Reflections*, West Palm Beach, FL: The Norton Gallery, 1986, p. 92.

77 Edvard Munch, Manuscript N 29; quoted in Eggum, *Edvard Munch: Symbols and Images*, p. 154.

78 Ottesen, "The Flower of Pain . . .", pp. 149–158.

79 See James Ensor's *Ecce Homo*, private collection, 1891, and his *Self-Portrait as Crucified Christ*, drawing, private collection, 1886, and Paul Gauguin's *Christ in the Garden of Olives*, Norton Gallery, West Palm Beach, 1889 and *Self-Portrait near Golgotha*, Museo de Sao Paolo, Brazil, 1896.

80 Arne Eggum, "Major Paintings," in Eggum, *Edvard Munch: Symbols and Images*, p. 39.

81 Munch called such treatment of his pictures his "horse cure"; aspects of this were explained to me by Jan-Thurman Moe, former conservator at the Munch Museum in an interview at Munch's studio in Ekely, May 2000. See Jan Thurmann-Moe, "Edvard Munch's Kill or Cure Treatment: Experiments with Technique and Materials." *Edvard Munchs "hestekur": Eksperimenter med teknikk og materialer,* exhibition catalog, Oslo: Munch Museum, 1995. (Norwegian and English text.)

82 August Strindberg, "The New Arts, or the Role of Chance in Artistic Creation," in *Inferno, Alone and Other Writings*, Evert Sprinchorn, editor, New York: 1968, pp. 98–104.

83 Edvard Munch, *Livfrisens tilblivelse* (Origin of the Frieze of Life), p. 12; quoted by Stang, *Edvard Munch*, 1977, p. 90.

84 Arne Eggum, *Munch and Photography*, New Haven and London: Yale University Press, 1989, p. 49. Arne Eggum makes the connection to Munch's mother in his essay "The Theme of Death," in Eggum, *Edvard Munch: Symbols and Images*, p. 162.

85 Quoted in Heller, *Munch: His Life and Work*, pp. 82–83.

86 Carla Lathe, "Edvard Munch and the Concept of 'Psychic Naturalism'," *Gazette des Beaux Arts*, p. 141. Also, Rolf E. Stenersen, *Edvard Munch, Close-Up of a Genius* [1944], Oslo: Sem & Stenersen, AS, 1994, p. 101.

87 Stanislaw Przybyszewski, quoted in Heller, *Munch: His Life and Work*, p. 129. Przybyszewski had been a medical student in 1890 at the University of Berlin where he studied neurology and the microscopic anatomy of the cerebral cortex.

88 Heller, *Munch: His Life and Work*, pp. 130–131.

89 A. McElroy Bowen, "Munch and agoraphobia: his art and his illness," *RACAR: Revue d'Art Canadienne*, 1988, vol. 15, no. 1, pp. 23–50.

90 Munch, quoted by Stang, *Edvard Munch*, p. 107.

91 Edvard Munch, The Tree of Knowledge, Manuscript T 2547; quoted by Stang, *Edvard Munch*, p. 107.

92 Robert Burton, *The Anatomy of Melancholy*, Section 4, subsection 1, p. 866ff.

93 Sarah G. Epstein, "The Mighty Play of Life: Munch and Religion," in *The Prints of Edvard Munch: Mirror of his Life*, Oberlin, OH: The Allen Memorial Art Museum, 1983, pp. 131–147. Stenersen, *Edvard Munch, Close-Up of a Genius*, p. 11, recounts an episode of Munch storming out of the house after an argument with his father over the duration of purgatory.

94 Arne Eggum, "The Theme of Death," in Eggum, *Edvard Munch: Symbols and Images*, p. 179, and p. 183, note 126.

See also Lathe, "Edvard Munch's Dramatic Images," pp. 191–206.

95 Eggum, *Munch and Photography*, p. 100. See also Patricia Berman and Jane van Nimmen, *Munch and Women, Image and Myth*, Alexandria, VA: Art Services International, 1997, p. 182. The Danish translation was by Anna Mohr Leistikow, wife of Munch's friend and fellow artist Walter Leistikow. A copy of her translation of Maeterlinck's play *De Blinde* (*Les Aveugles*, 1890), Copenhagen: 1891, is still in Munch's library. See also Geneviève Aitken, "Edvard Munch et la scène francaise," in *Munch et la France*, Paris: Editions de la Réunion des Musées Nationaux, 1991, pp. 222–239.

96 Extract from the catalog Munch produced to accompany his 1918 exhibition at Blomquist's gallery in Kristiania. Quoted in Wood, *Edvard Munch: The Frieze of Life*, pp. 11–14. Munch told Jens Thiis: "As far as the sick child is concerned I might tell you that this was a time which I refer to as the 'pillow period.' There were many painters who painted sick children against a pillow—but it was after all not the subject that made my sick child. No, in the sick child and 'Spring' no other influence was possible than that which of itself wells forth from my home. These pictures were my childhood and my home. He who really knew the conditions in my home—would understand that there could be no other outside influence than that which might have had importance as midwifery.— One might as well say that the midwife had influenced the child.—This was during the pillow era. The sick bed era, the bed era and the comforter era, let it go at that. But I insist that there hardly was one of those painters who in such a way had lived through his subject to the last cry of pain as I did in my sick child. For it wasn't just I who sat there, it was all my loved ones." Manuscript N 45; quoted in Eggum, *Edvard Munch: Symbols and Images*, p. 146. The model for this work was the fifteen year old Betzy Nielsen, who was the same age as his sister Sophie had been when she died; see *Edvard Munch*, exhibition catalog, Peter W. Guenther, editor, Houston: University of Houston, 1976, p. 62

97 Eggum, *Munch and Photography*, pp. 60–64.

98 Lorenz Eitner, "The Open Window and the Storm-Tossed Boat, an Essay in the Iconography of Romanticism," *Art Bulletin*, vol. 36, 1955, pp. 281–290.

99 Stang, *Edvard Munch*, p. 15.

100 Eggum, "The Theme of Death," in Eggum, *Edvard Munch: Symbols and Images*, p. 168; also Boe, "Edvard Munch," p. 191.

101 Stenersen, *Edvard Munch, Close-Up of a Genius*, pp. 65–66

102 James Ensor, *Self-Portrait in 1960*, etching, 1888, and Félicien Rops, *Dancing Death*, 1870s, are just two examples. Decadent literature is also replete with images of death. See Jean Pierrot, *The Decadent Imagination*, Chicago and London: University of Chicago Press, 1981, and Mario Praz, *The Romantic Agony*, London and New York: Oxford University Press, 1970, for examples.

103 Wood, *Edvard Munch: The Frieze of Life*, pp. 11–14.

104 Edvard Munch, Manuscript OKK 2734; quoted by Stang, *Edvard Munch*, p. 120.

105 Edvard Munch, *Livfrisens tilblivelse* (On the creation of the Frieze of Life), quoted in Eggum, *Munch and Photography*, 1989, p. 124.

106 Arne Eggum, *Edvard Munch: Paintings, Sketches and Studies*, Norway: J. M. Stenersens Forlag AS, 1984, p. 260

107 Félicien Rops, *Dancing Death*, 1870s. Antoine Wiertz, *La Belle Rosine*, 1847, Wiertz Museum, Brussels.

108 Elizabeth Prelinger and Michael Parke-Taylor, *The Symbolist Prints of Edvard Munch*, New Haven and London: Yale University Press, 1996, p. 102. It was exhibited under the title of "Loving Woman" in 1897. See also Berman and van Nimmen, *Munch and Women, Image and Myth*, p. 118.

109 Eggum, *Edvard Munch: Paintings, Sketches and Studies*, p. 169.

110 Edvard Munch, Manuscript T 2547; quoted in Eggum, *Edvard Munch: Symbols and Images*, p. 105.

111 Quoted in Eggum, *Edvard Munch: Symbols and Images*, 1978, p. 165.

112 Quoted in Guenther, *Edvard Munch*, p. 117.

113 Edvard Munch, quoted by Stang, *Edvard Munch*, p. 174: "I have always put my art before everything else. Often I felt that women would stand in the way of my art. I decided at an early age never to marry. Because of the tendency towards insanity inherited from my mother and father I have always felt that it would be a crime for me to embark on marriage."

114 Sigbørn Obstfelder, 1896, in *Samtiden*; quoted in Eggum, *Edvard Munch: Symbols and Images*, p. 105.

115 Edvard Munch, Manuscript N 30; quoted in Heller, *Munch: His Life and Work*, p. 136.

116 Munch is cast as a misogynist in many earlier works; see Martha Kingsbury, The Femme Fatale and her Sisters," in Thomas B. Hess and Linda Nochlin, editors, *Woman as Sex Object*, New York: Allen Lane, 1973, pp. 293–314; and Bram Dijkstra, *Idols of Perversity: Fantasies of Feminine Evil in Fin-de-Siècle Culture*, New York: Oxford University Press, 1986. The recent catalog on *Munch and Women, Image and Myth*, by Patricia Berman and Jane van Nimmen provides a more balanced account of his relationships with and attitudes toward women.

117 Berman and van Nimmen, *Munch and Women, Image and Myth*, p. 147. See also J. A. Schmoll gen. Eisenwerth, "Munch und Rodin," in Henning Bock und Günter Busch, eds., *Edvard Munch. Probleme—Forschungern—Thesen*, Munich: Prestel, 1973, pp. 99–132.

118 Edvard Munch, Manuscript OKK T 2782c; quoted by Stang, *Edvard Munch*, p. 148.

119 Munch, The Tree of Knowledge, Manuscript A 31; quoted in Eggum, *Edvard Munch: Symbols and Images*, p. 252.

120 Malcolm Easton, *Aubrey and the Dying Lady, A Beardsley Riddle*, Boston: David R. Godine, 1972, pp. 178–81.

121 van Gogh worried that excess in physical love would drain his paintings of their potency; in a letter to his younger colleague Emile Bernard in August, 1888, he advised him (in crude terms) to transfer his sexual energy to his paintings. Letter B 14 [9], November 1888, in *The Complete Letters of Vincent van Gogh*, vol. 3, p. 509.

122 I thank Katherine Nahum for this observation.

123 Eggum, "The Theme of Death," in Eggum, *Edvard Munch: Symbols and Images*, pp. 163–164.

124 Eggum, *Munch and Photography*, pp. 61–64.

125 For more on Marcel Réja, who was actually a physician named Paul Meunier, see John M. MacGregor, *The Discovery of the Art of the Insane*, Princeton, NJ: Princeton University Press, 1989, p. 172ff. This poem was never published, and it was quoted for the first time in Eggum, *Edvard Munch: Symbols and Images*, p. 222.

126 Edvard Munch; quoted by Stang, *Edvard Munch*, p. 86: "In connection with the picture Lovers in the Waves (the lithograph), which D has bought, I should like to make it clear that the subject or the inspiration for that picture is a model that I had in Berlin in the 1890s. I also used her for the big lithograph, Madonna. I let Przybyszewski have one of the sketches to illustrate a collection of poetry. It bore a certain resemblance to Dagny . . . When we dis-

cussed whether it was in fact Dagny or the girl I had used as a model, we were completely mistaken. On the other hand, there is a definite likeness . . ."

127 Letter from Dr. Linde to Gustav Schiefler; cited in Eggum, *Edvard Munch: Symbols and Images*, p. 166.

128 Quoted in Eggum, *Edvard Munch: Symbols and Images,* p. 204.

129 Edvard Munch, Manuscript T 2547; quoted by Stang, *Edvard Munch*, p. 26.

130 Heller, *Munch: His Life and Work*, p. 143.

131 One example of a vegetable birth is the story of Attis, who was the lover of Cybele; his mother was made pregnant by a either a ripe almond or a pomegranate from a tree which grew from the severed genitals of Agdistus; *The Oxford Classical Dictionary*, N. G. L. Hammond and H. H. Scullard, editors, Oxford: The Clarendon Press, 1970, pp. 146–147.

132 J. G. Frazer, *The Golden Bough*, New York: MacMillan, 1951, pp. 790–92.

133 Strindberg's alchemical obsession is recounted in his *Occult Diary* and *Inferno*. See Michael Meyer, *Strindberg*, Oxford: Oxford University Press, 1985, pp. 328–346. Munch visited Strindberg in his apartment in Paris, where he conducted his occult experiments. After Strindberg's mental collapse in Paris and return to Ystad, Sweden, Munch wrote to his aunt Karen Bjølstad: "He is under treatment for mental illness—he had so many strange notions—made gold, and found that the earth was flat and the stars were holes in the vault of heaven. He had persecution mania and once thought I wanted to poison him with gas." Meyer, *Strindberg*, p. 346.

134 Sarah G. Epstein, "The Mighty Play of Life: Munch and Religion," p. 133.

135 Epstein, "The Mighty Play of Life: Munch and Religion," p. 133, identifies the figure as Munch's father. Wood, *Edvard Munch: The Frieze of Life*, p. 104, less convincingly proposes that it is Stanislaw Przybyszewski.

136 The German Romantic Nazarenes modeled themselves on monks, and even occupied a monastery near Rome for a while. The Pre-Raphaelite Brotherhood borrowed the religious title of "brotherhood" at least, and in the Symbolist era, the identification of the artist as priest was most explicitly given by the Rosicrucian Joséphin Péladan, who proclaimed: "Artist, you are priest; Art is a great mystery and as soon as your effort is rewarded with a masterpiece a divine ray descends as if on an altar. O presence of glorious divinity, shining forth from the splendour of supreme names: Vinci, Raphael, Michaelangelo, Beethoven and Wagner. Artist, you are king: Art is a veritable empire, when your hand traces a perfect line the cherubims themselves descend and take delight, as if looking into a mirror." Joséphin Péladan, Introduction to catalog of first Salon de la Rose-Croix, quoted and translated by F.-C. Legrand, *Symbolism in Belgium,* translated by Alastair Kennedy, Brussels: Laconti, 1972, p. 42.

137 Quoted in Berman, *Edvard Munch: Mirror Reflections*, p. 90.

138 Quoted in Eggum, *Edvard Munch: Symbols and Images*, p. 239.

139 Edvard Munch, Violet Book, Manuscript T 2760, January 8, 1892; quoted by Stang, *Edvard Munch,* p. 120.

140 Edvard Munch, Manuscript T 2760; 1892; quoted in Heller, *Munch: His Life and Work*, p. 62.

141 Edvard Munch, Manuscript T 2782—bi; quoted in Eggum, *Edvard Munch: Symbols and Images*, 1978, p. 239.

142 Louise Lippincott, *Edvard Munch. Starry Night*, Malibu, CA: Getty Museum Studies on Art, 1988, p. 88ff.

143 Quoted in Heller, *Munch: His Life and Work*, p. 209.

144 Hans Dedekam, 1892; quoted by Stang, *Edvard Munch,* p. 111.

145 Munch wrote to Ragnar Hoppe, "It has interested me greatly that you wish to hold a lecture on the subject of the exhibition, and that you want to draw attention to the spiritual aspects of my art. Nowadays, to my irritation, it is often described as literary, and, with even less justification, it has also been called German 'Gedankenmalerei' ('Thought painting')—remarks that are not intended to be complimentary. I have an extremely high opinion of good German art, but not the sort that is quite rightly reviled as 'Gedankenmalerei'." Quoted by Stang, *Edvard Munch*, p. 108.

146 Quoted by Øivind Storm Bjerke, *Edvard Munch and Harald Sohlberg, Landscapes of the Mind*, New York: National Academy of Design, 1995, pp. 22–23.

FROM SPIRITUAL NATURALISM TO PSYCHICAL NATURALISM: CATHOLIC DECADENCE, LUTHERAN MUNCH, *MADONE MYSTÉRIQUE*

STEPHEN SCHLOESSER, S.J.

How can he stand to comprehend the hard, pitiful
Unrelenting cycles of coitus, ovipositors, sperm and zygotes,
The repeated unions and dissolutions over and over,
The constant tenacious burying and covering and hiding
And nesting, the furious nurturing of eggs, the bright
Breaking-forth and the inevitable cold blowing-away?

— Pattiann Rogers,
*The Possible Suffering
of a God During Creation*

Creation was subjected to futility, not of its own will but by the will of one who subjected it in hope that the creation itself will be set free from its bondage to decay and will obtain the freedom of the glory of the children of God. We know that all of creation has been groaning in birth-pangs until now; and not only creation, but we ourselves as we wait for the redemption of our bodies. For in this hope we are saved. Hope that is seen is not hope. For who hopes for what one sees?

— *Saint Paul's Letter
to the Romans 8:20-24*

39

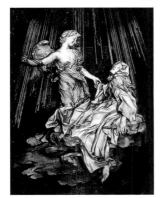

40

In 1893, Edvard Munch exhibited six paintings entitled *Studies for a Series: Love.*[1] This series, intended to represent the close interconnections between love and death,[2] included not only the erotic *Kiss* (no. **31**), but also the unnerving kiss of a vampire (first titled *Love and Pain,* later, *Vampire;* nos. **40** and **41**) and the eerily evocative *The Scream* (no. **7**).[3] Munch's most explicit invocation of the supernatural, however, was *Madonna* (fig. **39**)—easily read as an allusion to the ancient trope of the Madonna and Child. With her closed eyes suggesting the moment of erotic transcendence, Munch's *Madonna,* suspended in a thickly-textured swirl of ecstasy, shares little in common with a traditional mother and child. For an early religious analogue, we would do better by comparing it with Gian Lorenzo Bernini's masterwork of the Catholic Reformation, *The Ecstasy of Saint Teresa* (fig. **40**). Both Bernini and Munch fuse the religious and the erotic into a single moment of self-transcendence.

Two years later, Munch re-worked the piece as a lithograph (nos. **54** and **55**). In this bolder 1895 version, the Madonna remains solitary in her suspended moment of self-transcendence—but now the biological materials of human love have invaded the margins. Spermatozoa, swimming around the emphatic swirling lines of the woman, frame the figure on three sides. Moreover, the result of the union of Madonna and sperm is now explicitly represented: an embryo, crouched in the corner in a fetal position, stares hieratically at the viewer, skeletal facial features suggesting death even as life has only just begun. In his juxtaposition of this Madonna and sperm, the sacred and the profane, Munch has also united love and death—the limits of human finitude as well as the natural possibilities for a kind of self-transcendence.

39
Edvard Munch, *Madonna,*
oil on canvas, 1893.

40
Gian Lorenzo Bernini,
The Ecstasy of Saint Teresa,
1645–52. In the Cornaro Chapel,
Santa Maria della Vittoria,
Rome.

Why did Munch risk possible imprisonment, not only for the candid representation of biological sexuality, but for charges of sacrilege as well? Assuming that sacrilege was not intended, why would Munch, raised in a strict and puritanical Lutheran household, turn to a form so closely related to Catholic and Latin culture? In the following attempt to answer these questions, I will situate my effort within the wider historical project proposed by the medievalist Caroline Walker Bynum: "we all—scholars and ordinary readers alike—must ask about how society constructs, uses, and eclipses the wondrous."[4]

Nineteenth-century Europe witnessed a concerted effort to eclipse the wondrous. This effort, beginning with the Realist reaction to Romanticism in the 1830s and sustained in the areas of science, politics, and the arts, has been particularly well studied in France. Republican and Socialist movements against political and class privilege gave such Realism a progressive moral valence. Scientific advances and technological applications made the eradication of mystery—in the form of organized religion, metaphysical speculation, or simply the unknown—seem within reach. Realism and Naturalism in literature and painting, having vowed to represent only the visible surface with the mimetic precision of a scientist or journalist, re-mapped the artist's terrain. In short, a culture war was waged on many fronts over contested claims to what constituted the really real.

Edvard Munch came to the shores of France during the high tide of this contest. The sudden death of his father coincided with Munch's exposure to the Symbolist struggle against Naturalism; the coincidence sent the young artist in search of new answers. Although he no longer believed in his childhood Lutheranism, he still did not embrace Catholic mysticism—as did Paul Verlaine, Arthur Rimbaud and Joris-Karl Huysmans in France, Oscar Wilde and Walter Pater in Britain. Unable to adopt Huysmans' mystical double vision of a Spiritual Naturalism, Munch nevertheless proposed his own dialectic: Psychical Naturalism. In response to the Naturalists' suffocating eclipse of mystery, he constructed and used his own vision of the wondrous. Spermatozoa—those terrifying carriers of human heredity, passing on the miseries of madness, tuberculosis, syphilis, and other familial degenerations with a merciless determinism—were juxtaposed with the Madonna and embryo, the New Eve, the re-generation of the race. Within the *fin-de-siècle* French context of anxiety over heredity, hygiene and generations, Munch suggested the irrational, the unpredictable, the possibility of metaphysical rupture.

I. NATURALISM: THE ECLIPSE OF WONDER

Yes, yes, manure! I insist on the word. Hold your nose if it offends you. Everything comes from manure in what feeds and clothes us, and we ourselves are nothing more than manure, according to chemistry and the Bible.

—Max Buchon,
Recueil de dissertations
sur le réalisme, 1856

Today the world is without mystery.

—Marcelin Berthelot, 1885

During the nineteenth century, technological marvels eclipsed the experience of wonder in the face of the unknown. For the bourgeoisie at least, advances in medicine, hygiene and city-planning had progressively reduced infant mortality and lengthened the average life-span.[5] The newly-invented sewer systems in the great cities (beginning with London) stood as exciting icons of modernity's magical promise to combat cholera and plague, bringing health and unprecedented longevity to city-dwellers (fig. **41**).[6] Newly-imagined capacities for conjuring away the specter of death are suggested in the proliferation

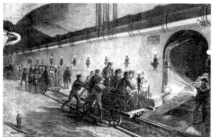

of diary-keeping and private collecting of every kind, intimate practices that grew tremendously in popularity throughout the late eighteenth- and early nineteenth centuries.[7] The bold promise of longer lives led in turn to "mythologies of heredity,"[8] middle-class anxieties about the passing on of inherited wealth to healthy new generations.

An older view of the Victorians has imagined them to be reticent about sex; but as Michel Foucault has suggested, the Victorians talked about little else (fig. **42**).[9] In 1859, Charles Darwin's *Origin of Species* irrevocably altered the way Europeans thought about sexuality, illness, and heredity. They worried about the inheritance of mental illness; the depletion of vital sources via masturbation; passing on weak susceptibilities to cholera and tuberculosis; the newly-invented category of homosexuality ("inversion"); and of course, prostitutes, the carriers of venereal diseases (fig. **43**).[10] Thus, the late Victorians employed new technologies—hygiene, contraception, eugenics (including racial segregation) and surveillance of all kinds—as means of making sure that sexual reproduction did not degenerate the bourgeois family's genes and dissipate its fragile fortunes.

The Realist artistic movement grew out of these cultural anxieties as well as out of contemporaneous political and social upheavals. After the political revolutions in France of 1830 and 1848, literary Realism assumed moral significance as it aligned itself with a progressive Republican social agenda. This fascination with representing the external world truthfully in all its brutal violence received added impetus in 1859 with the publication of Darwin's *On the Origin of Species by Means of Natural Selection, or The Preservation of Favoured Races in the Struggle for Life.* Along with Karl Marx's *Communist Manifesto* published a decade earlier, Darwin's work shaped a cultural vision. A traditional religious vision had once seen the world as a place of providence and supernatural intervention. The Enlightenment removed providence and naturalized the supernatural, imagining the world as a place of eternal, cosmic clockwork order.[11] The visions of Marx and Darwin challenged this optimistic vision, imagining life as an arena of contest in which individuals, races, and classes competed for scarce resources.

In this darkly competitive world, Romanticism was conceived of as a deformation that mis-represented harsh truths, while Realism was imagined to be a faithful mirror of life, a mimetic copy with complete verisimilitude.[12] Realism, of course, was no less a semantic system of codes than Romanticism. But as an ideology that claimed to represent reality in a transparent way, Realism carried highly specific cultural meanings.[13] The post-1859 Naturalist movement, of which Édouard Manet and Émile Zola stood as masters, sought to translate this social and scientific vision through literary and artistic means. Gone were the Academy's official heroes of ancient mythology, the saints of the scriptures, bucolic pastorals and still-lifes. Naturalists of all stripes (Realists, Impressionists, and Post-Impressionists) celebrated the new subjects of mundane life: washer-women, miners, prostitutes, betrayed revolutionaries, and the ubiquitous working-class plague of absinthe and alcoholism.

41
Bourgeous patrons take a pleasure cruise through the new Paris sewer system. *Sewer Cruise below the Rue Laffitte,* engraving, 1870.

42
From *Town Talk,* July 18, 1885.[14]

43
Orthopedic device to prevent masturbation. Paris, Bibliothèque de l'Ancienne Faculté de Médecine.[15]

In Émile Zola's novels, the Darwinian vision achieved its perfect literary expression. Tracing the fortunes of a single family through the twenty-volume *Chronicles of the Rougon-Macquart Family*, Zola focused his evolutionary concerns on generations and the role of heredity in determining human lives.[16] The plights of impoverished coal miners *(Germinal),* the dilemmas of prostitution *(Nana),* the social diseases of alcoholism *(L'Assomoir)* and even kleptomania *(The Ladies' Paradise)*[17]—all received Zola's journalistic attention to the minutest detail.

However, Realism had more than a progressive moral appeal. It also acquired a titillating allure for a new market of mass consumption, spilling over into a popular voyeurism of spectacular realities.[18] By using wood engravings of photographs, tabloids could reproduce life-like scenes with lurid details. They thrived on bringing realistic images of bruised bodies to the public (fig. **44**). Not content with pictures, crowds thronged to view the corpses themselves, exhibited in windows at the morgue dressed like department store displays.[19] For verisimilitude, however, nothing matched the new wax figures at the Musée Grévin. The newspaper *L'Illustration* noted that the new museum's statues were "the triumph of Naturalism."[20] In these wax dioramas, Zola's progressive social vision satisfied the hunger of a new market of consumers for lurid detail (fig. **45**). The museum's founder, writing to Zola, promised that "The Musée Grévin will be Naturalist or will not be."[21]

The social agenda of a Realist like Zola found its political carrier in Liberalism. Although such republican ideas swept across Europe (including Norway) during the second half of the century, they assumed a new meaning in France of the 1870s, the age of the Sorbonne in the newly-formed Third Republic. Here a new laicism was born in the intersection of three elements: an ideology of modern liberty stretching back to the Enlightenment *philosophes;* modern science, which strictly delineated the limits of experience and reason, and gave birth to a technical universe without any reference to religion; and a republican political state.[22] This state suppressed religious educational institutions with the public school system, inculcating the values of an all-inclusive and enduring laicist culture.[23] Laicist ideology was totalizing in its territorial claims. As the chemist Marcelin Berthelot wrote in 1885,

Today the world is without mystery. Rational conception claims to clarify and comprehend everything. It works hard at giving everything a positive and logical explication, and it spreads its fatal determinism all the way to the moral world.[24]

Five years later, Ernest Renan, the mid-century author of the disenchanted *Life of Jesus,*[25] celebrated the future absolute triumph of Science over Religion:

Everything that the State has extended in the past to religious exercise will rightfully return to science, the only definitive religion . . . Science, in fact, will only be valuable insofar as it replaces religion.[26]

In sum, Scientism, artistic Naturalism, and socially progressive Liberalism found an ideal center in the Third Republic's colonizing efforts. At home and abroad, French republican institutions worked to rationalize and centralize local cultures: primitive, peasant, and religious.[27] What began as a bleak vision

44
"Le mystère de la rue du Vert-Bois," from *Le Journal Illustré,* August 15, 1886.[28]

45
Tableau from *Germinal.* Musée Grévin archives.[29]

of the competitive natural world was transformed paradoxically into a *fin-de-siècle* logic of progress. The historian Jacques Barzun described it thus:

All events had physical origins; physical origins were discoverable by science; and the method of science alone could, by revealing the nature of things, make the mechanical sequences of the universe wholly benevolent to man. Fatalism and progress were as closely linked as the Heavenly Twins and like them invincible.[30]

The determinist logic of progress assumed suffocating proportions as scientific wonders eclipsed the wondrous and fertilizer replaced fertility rites.[31]

Norway embraced this Liberal vogue. In the 1880s, artists returned from abroad to sleepy Oslo (at that time Kristiania), replacing a parochial nationalistic Romanticism with the more cosmopolitan Realism imported from France and Germany. Manet and Camille Corot stood as the Norwegians' artistic models, Flaubert and Zola as literary ones.[32] Christian Krohg was Norway's foremost Naturalist painter. We see in Krohg's 1880–81 study, *The Sick Girl,* why Munch was attracted to study with this Naturalist. Munch's father was a doctor. In 1868, when Munch was five, his mother died of tuberculosis; his sister Sophie died of the same disease nine years later. His brother Andreas died at the young age of thirty in 1895. His sister Laura suffered from mental illness. Munch himself was hospitalized for nervous breakdowns and alcohol abuse, first in 1900 and again in 1905. As a consequence, Munch had a life-long fear of illness in general and of the suspected degenerate blood in his particular family. "Illness, insanity and death," he wrote, "were the black angels that kept watch over my cradle and accompanied me all my life."[33]

In Krohg's work, Munch would have found the ideal artistic vehicle for representing such "black angels." Krohg reproduced the details of the young girl's illness—an illness not unlike Munch's sister's three years earlier—in the manner of a doctor or a journalist with a Naturalist's precise photographic record (fig. **4**). Newly-imported Naturalism—like photography, journalism, and science itself—seemed to epitomize all that was modern.

However, Socialist-inclined Liberals in Norway would soon see—as their French counterparts had fifteen years earlier—just how illiberal Liberalism could be.[34] Hans Jaeger, at the center of the Kristiania Bohemia (and whose influence lured Munch away from his father's Lutheranism), published his novel, *From the Kristiania Bohemia,* in 1885. Tame by today's standards, the novel was banned, confiscated, and destroyed for both its anti-Christian rhetoric and its explicit sexual accounts. (Jaeger talked about sex as a tool for revolution; seducing a banker's young daughters was one proposal.) Jaeger himself was jailed. In 1886, Christian Krohg, Munch's Naturalist artistic mentor, published his own novel, *Albertine.* Its discussion of proletarian social ills and explicit references to prostitution earned Krohg a fate similar to Jaeger's. As Carl Naerup would write about the disillusionment of Norway's younger generation:

Thus was revealed in the most ugly manner how lacking in character and how cowardly the reigning "Liberalism" was . . . One day it became apparent that the dream was over . . . What we now found facing us was the identical drab existence of before, appearing twice as repulsive after our visions had ceased.

This socio-political disillusionment led Naerup to a new post-Naturalist estimation of art's function, one that would turn its eyes away from surface realities to deeper psychic ones:

We had been taught bitterly of what little value all temporary movements and tendencies were in the world of the spirit. We began to understand that art, like all the ideals of mankind, is a revelation from the innermost, unspeakable, sacred depths of the personality, from the personal realm of an individual's most private life . . ."[35]

Perhaps it was this kind of disillusionment with the fates of his friends that drove Munch to re-think his own style. Or perhaps it was simply that, due to increasing economic and political stability under Liberal governments in Scandinavia, "the problems revealed by Naturalist paintings and novels were seemingly in the process of being solved by the state, thus reducing their artistic attractiveness and viability."[36]

Whatever the reason, Munch began to deviate from Naturalism. In 1885–86 he painted his own version of *The Sick Child,* which he revised as an etching in 1895 (no. **9**). A comparison with Krohg's own *Sick Girl* painted five years earlier (see above, 1880–81) demonstrates Munch's expressive departure from his mentor's mimetic style. Not interested in photographic verisimilitude, Munch instead attempted to express the psychic state experienced in the sick room. Looking back on it, Munch later thought of *The Sick Child* as a turning point and considered it to be the first painting of his massive Frieze of Life.

In April 1889, Munch was featured in the first one-man show ever held in Norway, at the Kristiania Student Organization. Critics were generally negative, but Munch's mentor Krohg wrote a review prescient in its vision of a third-way synthesis. The "first generation" of Norway's painters, wrote Krohg, had been German-trained Romantic artists, parochial in their efforts to create a Scandinavian *Kultur.* The "second generation" had been trained in Paris as *plein-air* Naturalists. A "third generation" was struggling to be born—and only one young painter had survived the birth process. Munch, exclaimed Krohg, "is an Impressionist, our only one so far!"[37]

Certainly Krohg's deployment of a mythic generational evolution was a fictive construct, albeit an increasingly popular one as the modern nineteenth century progressed. Generally used to obliterate other distinctions such as class, race, and gender, the idea of a generation represented an inverted authority pyramid: once wise men ruled by nature; youth now displaced them with an equally natural force.[38] By using the term "third generation" just three years after the condemnation of his Naturalist novel, Krohg's intent was clear: the generation of Liberal legitimacy was passing into old age.

More importantly though, the language of two generations demanding dialectical synthesis into a superior third way gave Munch and his circle a hint of double vision. They were somehow to synthesize in a single act of the imagination two earlier schools. On the one hand, they must clearly turn to the emotional interior, that truest place of reality for the Romantics. On the other, they could not abandon the lessons forged in the Naturalist period; they had to retain Naturalism's radical technical innovations as well as its fundamental moral concern to paint mundane experiences. By framing the problem as the need for a third way *uniting* two past generations, Krohg's call prefigured the double vision Munch would encounter in Decadent France—Spiritual Naturalism.

In the October following his disastrous spring show in 1889, Munch left for France. One month after his arrival in Saint-Cloud (on the outskirts of Paris), he received news of his father's sudden death—and only *after* his father's burial. The death was momentous, for Munch's spiritual journey (like his fellow Scandinavian Søren Kierkegaard's) was dominated by the deep despair of his father.[39] Munch wrote that his father was given over to "periods of religious anxiety which could expand to the very limits of madness."[40] Perhaps Munch felt his own deep anxieties for having rejected his father's intense Lutheranism and having embraced Hans Jaeger's free-thinking atheism.[41] Or perhaps, unable to share

his family's hopeful Lutheran faith in the afterlife, Munch had to search elsewhere for a new kind of immortality.[42]

Whatever the reasons, the winter of 1889–1890 that Munch spent at Saint-Cloud with the writer Emanuel Goldstein proved to be a definitive turning point. Munch's diary entries from those months served as small manifestoes for his turn away from Realism and towards the interior realm:

No longer shall interiors be painted with people reading and women knitting. . . .
There shall be living people who breathe and feel and suffer and love.

Painting needed to come to terms with the inner life of sentiment: love and suffering. Munch's vision was not explicitly concerned with organized religion or Lutheran orthodoxy, but he clearly considered his vision sacred: "People will understand what is sacred in them and will take off their hats as if in church."[43] In this expansion of the boundaries of the sacred, Munch would find fellow-travelers in the Decadent movement. Co-opting the language of the Naturalists and inverting it for their own purposes, these pioneers also sought to re-invent the sacred so as to restore the possibility of wonder.

II. SYMBOLISM AND DECADENCE: A REACTIONARY REVOLUTION

The reaction of inner humanity against the superficial objectivity of Naturalism . . . is a departure from the impudent despotism of things dead and the return of the living man.

—Hermann Bahr (1890)[44]

All I have to do is think of Naturalism and Realism and all that other manufactured art and I get nauseous.

—Emanuel Goldstein
to Edvard Munch (1891)[45]

Twenty-five years before Munch arrived in France, Charles Baudelaire had proposed his theory of *The Painter of Modern Life* and, in doing so, redefined the term "modern." Before Baudelaire, Flaubert seemed to have settled modernity's boundaries in a definitive way with his 1856 novel, *Madame Bovary*. Aiming for a dispassionate Realist description of the bourgeois, Flaubert tried to represent (without interpretation or evaluation) their dullness, their stupidity (e.g., an unnecessary amputation), and their collective suicide. Three years later, Darwin's account of a world in which "favoured races" competed for preservation in the struggle for life gave such grotesqueness a cosmic cast. In 1863, relentless Realism seemed the very definition of the modern. Thus, Baudelaire's revolutionary linkage of modern beauty with the supernatural went against the grain.[46]

Baudelaire's alternative double vision of modernity insisted that beauty necessarily involves two elements: that which is always changing, or the modern; and that which remains unchanging, or the eternal.

Beauty is always and inevitably of a double composition, although the impression that it produces is single—for the fact that it is difficult to discern the variable elements of beauty within the unity of the impression invalidates in no way the necessity of variety in its composition. Beauty is made up of an eternal, invariable element, whose quantity it is excessively difficult to determine, and of a relative, circumstantial element, which will be, if you like, whether severally or all at once, the age, its fashions, its morals, its emotions. Without this second element, which might be described as the amusing, enticing, appetizing icing on the divine cake, the first element would be beyond our powers of digestion or appreciation, neither adapted nor suitable to human nature.[47]

From one perspective, Baudelaire had to account for the keystone of modernity: ever-changing fashion had taken on a qualitatively new importance in the commodification of artistic production after the Revolution of 1848[48] as well as in the face of technological revolutions.[49] But for Baudelaire, ever-fickle fashion and the perceived sense of rapid change represented only one side of modernism's dilemma.

From another perspective, Baudelaire felt that the modern artist must represent the unchanging and eternal. In attempting both to overcome Academic painting's fetish of the antique and to legitimize painting scenes drawn from everyday urban life, Baudelaire formulated his theory of correspondences. The world for Baudelaire was a "forest of symbols" in which sounds, scents and colors acted as echoes and corresponded to another world of infinite things:

The pillars of Nature's temple are alive
and sometimes yield perplexing messages;
forests of symbols between us and the shrine
remark our passage with accustomed eyes.

Like long-held echoes, blending somewhere else
into one deep and shadowy unison
as limitless as darkness and as day,
the sounds, the scents, the colors correspond.

. . . possess the power of such infinite things
as incense, amber, benjamin and musk
to praise the senses' raptures and the mind's.[50]

In seeing the correspondence between this forest of symbols in which we live and the eternal world which they symbolize, an *intuition of the atemporal* or spiritual could suddenly illuminate that rapid passage of surface forms that dizzies us in hectic modern life.[51]

Thus, Baudelaire fashioned a double vision. Like all Realists, Baudelaire's artist would reject the Academy's archaic interest in gods and ruins and instead look to mundane modern life for subject matter. However, unlike the Realists, the artist would find there not more evidence of the cosmos's aimlessness, but rather ephemeral flickers of eternal truths. "The pleasure we derive from the representation of the present," wrote Baudelaire, "is due, not only to the beauty it can be clothed in, but also to its essential quality of being the present."[52]

Baudelaire's 1863 revolutionary re-mapping of the modernist terrain demonstrated deep internal fissures in the discourse of modernity—a conflict between eternal values and passing phenomena. On the one hand, the Enlightenment "project of modernity" was fundamentally a secular movement that sought to demystify and desacralize knowledge.[53] Rational modes of thought, valuing empirical observation of passing phenomena, promised liberation from the murky irrationalities of myth, religion, and superstition.[54] On the other hand, the Enlightenment would not have been satisfied with nineteenth-century positivism's exaltation of the ephemeral appearance. The eighteenth-century *philosophes* had aimed at revealing universal, eternal, and immutable qualities. Baudelaire's Symbolist double vision exposed modernity's conflicted origins and paradoxical embrace of both particular and universal, contingent and eternal.[55] Although the movement that became Symbolism would have complicated origins,[56] it had a single simple aim: to oppose Scientism's and Naturalism's claims to provide adequate representations of reality. Against all the claims for light and clarity as the path to modernity, Baudelaire reclaimed a place for dark and mysterious depths at the very heart of the modern.

2° Période de clownisme.			3° Période des attitudes passionnelles		4° Période de délire.	
F	G	H	I	J	K	L

Delahaye et E. Lecrosnier, Editeurs

PÉRIODE DES ATTITUDES PASSIONNELLES DE LA GRANDE ATTAQUE HYSTÉRIQUE.
Attitude de crucifiement.

PÉRIODE DES ATTITUDES PASSIONNELLES DE LA GRANDE ATTAQUE HYSTÉR
Attitude de supplication.

SCRUTIN DE BALLOTTAGE DU 4 FÉVRIER 1883

BIBLIOTHÈQUE BARBOUX

BOURNEVILLE
Candidat Républicain Radical Socialiste

46
Charcot's iconographic table. Paul Richer, *Etudes cliniques sur la grande hystérie,* second edition, Paris: Delahaye & Lecrosnier, 1885.

47
Charcot's Crucified position. J.-M. Charcot and Paul Richer, *Les demoniaques dans l'art,* fifth edition, Paris: Delahaye & Lecrosnier, 1887.

48
Charcot's Supplication position. Charcot and Richer, *Les demoniaques dans l'art.*

49
Engraving from Richer, *Etudes cliniques sur la grande hystérie.*[62]

50
Anti-clerical cartoon used in 1883 political campaign of Dr. D.-M. Bourneville (see also figs. **51** and **52**).[63]

In his *New Notes on Edgar Allen Poe* (1867), Baudelaire once again innovated by transforming the word *décadence* into a positive virtue.[57] The following year, Théophile Gautier repaid the compliment in his introductory essay to the 1868 edition of Baudelaire's poems, *Flowers of Evil.* Gautier celebrated Baudelaire's *style de décadence,* for here modern art had:

arrived at that point of extreme maturity to which aging civilizations give rise as their suns begin to set: a style that is ingenious, complicated, learned . . . listening, in order to translate them, to the most subtle confidences of neuroses, the confessions of aging passions entering depravity, and the bizarre hallucinations of obsession changing into madness.[58]

The human motor, sent into overdrive by the frenetic crush of modernity, succumbed to *neurasthenia,* a favorite mental illness of the *fin-de-siècle.*[59] Like the Decadent movement in general, Gautier delighted in inversions. He took the very elements that fast-paced modern culture feared most—neurosis, sickness, and madness—and exalted them as signs of a civilization reaching an "ingenious" and "complicated extreme maturity."

The most important inversion of the Decadents came, however, with the attention to the body of the *hysteric*—usually female but not always—as the contested site between two visions of reality. Here the main figure was the French psychologist Jean Martin Charcot. Charcot, a professor of neurological pathology at the Salpêtrière clinic (where Freud sat at the master's feet), specialized in psychical research. In this epoch, both female hysteria and male homosexuality (associated with neurasthenia) were being invented—not in traditional religious or metaphysical terms (i.e., as demonic possession or "sinful activity"), but rather as materialistic "inversions" subject to scientific explanation and manipulation.[60] Hysteria came to be imagined as a malady of the nervous system, the symptoms of which could be fully explained by accurate descriptions of surface phenomena. The totalizing character of Charcot's detailed iconography of the hysteric—remarkably similar to a chemist's periodic table—demonstrated his own attempt to fully map and categorize the states of the inner psyche (figs. **46**, **47** and **48**). Moreover, this malady of the nervous system required treatment by a newly-invented psychiatric profession which would scientifically displace the old religious practitioners (i.e., priest-confessors and exorcists; see figs. **49** and **50**). Thus, the hysteria diagnosis took on Liberal political significance: it was used by anti-clerical groups under the Third Republic to discredit religious beliefs and institutions.[61]

The wars may have been political, social, and cultural in nature, but the battle-lines were drawn on

the privileged site of the female body. Charcot set the physiognomy of the hysteric side-by-side with traditional religious iconography in order to demonstrate (in the words of the brothers de Goncourt) that "religion is a part of the female sex."[64] The self-evident implication was that religion, notoriously feminine, was not only irrational and anti-modernist but also a species of neurosis (*nevrosité*; see figs. **51** and **52**).

The ferociously anti-clerical novel *L'Hystérique* (1885) by Camille Lemonnier (considered a kind of "Flemish Zola") provides an instructive example of these associations.[65] Here, the phenomena inscribed in the unmanageable body of Sister Humility (*Soeur Humilité*) present a question of two possible and conflicted readings: is she a "mystic" (as the fiendish clerics insist), undergoing an interior event not accessible to scientific observation? Or, rather, are these phenomena rather thoroughly explainable manifestations of the hysterical attack, a purely physiological eruption of the female body easily classified within the new psychological clerics' categories? Such representations drove home the ideological message that allegedly mystical manifestations were in fact a psycho-materialistic disorder. In this Naturalist and anti-clerical ideology of the hysteric, total description led inevitably to total explanation.

The Decadents co-opted what bourgeois culture most feared. They celebrated the neurasthenic and the hysteric as positive icons. Scientific and artistic positivists, imagining nature as ruled by an observable, descriptive, and predictive reality, had refused to recognize the irrational and the absurd in human experience. In opposition, Decadence exploited, to the point of the grotesque, representations of the irrational and the absurd as the truly real. By liberating the imagination from social and psychological determinism, Decadence can perhaps best be interpreted simply as *the restoration of mystery by the perversion of the logic of Naturalism.*[66]

The Parisian Joris-Karl Huysmans played a commanding role in this strategy to liberate the spirit by perverting nature and its law. Huysmans had first fashioned himself as a disciple of Zola. His 1877 study of Zola's novel on alcoholism among the working poor *(L'Assomoir)*[67] has been variously described as "one of the most important manifestoes of the Naturalist movement," "an exposé and apology for Naturalism," and "one of the best statements of the Naturalists' aims."[68] In 1879, *Les Soeurs Vatard*, his own novel in the style of Zola, was published. No less an authority than Flaubert himself praised its lack of "falseness of perspective" *(la fausseté de la perspective)* — that is, Huysmans had not allowed his own perspective to deform his faithful representation of reality.[69]

However, in 1881 Huysmans began to drift, choosing a middle-class, would-be writer as his protagonist in *En Ménage*. His aim, he said, was a detailed description of the "minuscule district of a soul" *(minuscule district âme).*[70] In choosing the soul as his subject, he had begun to reject not only Zola's proclamation that Naturalists devote themselves to studies of working-class subjects *(le peuple),* but also the external world itself.

While writing his 1884 landmark novel, *À Rebours,* Huysmans "grew tired once and for all of writing in a polemical Social Realist vein about overworked seamstresses, exploited washerwomen and unemployed burly salt-of-the-earth laborers."[71] Although the title has been translated into English variously as *Against the Grain* or *Against Nature,* the term *à rebours* translates most simply as "on the contrary" or "the wrong way." Thus, the novel's contrarian turn against Naturalism towards Decadence's delight in decline implied an impish question: Was decline and the perversion of nature's laws the "wrong way"? Or was it a rediscovery of the right path?

As Zola himself acknowledged, *À Rebours* delivered "a terrible blow to Naturalism."[72] Its neurasthenic hero of modernity, Des Esseintes, had the stereotypical highly refined sensitivities of the urban

51

Charcot's model Augustine demonstrates the Crucifixion pose for the scientist's camera. Désire-Magliore Bourneville, *Iconographie photographique de la Salpêtrière* (2 volumes), Paris: Aux bureaux du Progrès médical, V. A. Delahaye & Compagnie, 1877–78.

52

Augustine demonstrates the Supplication pose. Bourneville, *Iconographie photographique de la Salpêtrière.*

FULL DISCOVERY
OF THE
TRANGE PRACTICES
OF
r. ELLIOTSON
On the bodies of his
FEMALE PATIENTS!
HIS HOUSE, IN CONDUIT STREET, HANOVER SQ.
WITH ALL THE SECRET
PERIMENTS HE MAKES UPON THEM,
AND THE
rious Postures they are put into
hile sitting or standing, when
awake or asleep!

female Patient being blindfolded, to undergo an operation.

THE WHOLE AS SEEN
Y AN EYE-WITNESS,

53
Pamphlet,
London: E. Handcock, 1842.

dandy,[73] including erotic fetishes that hinted at hysteria.[74] In a later preface to *À Rebours*, Huysmans (who later became a Benedictine monk) would define his conversion to Decadence as an essentially Roman Catholic revolt against the materialism of his age.[75] In this association of Catholicism with Decadence he became the rallying point[76] for that "reactionary revolution" called the *renouveau catholique* (Catholic Revival).[77]

What was it about Decadence that lured Huysmans to the mystical, and by implication, Catholicism itself? In *À Rebours*, Huysmans' protagonist Des Esseintes expresses his admiration for Baudelaire, who left the surface and "descended to the bottom of the inexhaustible mine," who "penetrated those districts of the soul where the monstrous vegetations of the sick mind flourish." Baudelaire wrote pages that were "magnificent" precisely because they were "exasperated by their powerlessness to express the whole truth." The more Des Esseintes reread Baudelaire, the more he admired this writer who,

in days when verse had ceased to serve any purpose save to depict the external aspect of men and things, had succeeded in expressing the inexpressible, *thanks to a sinewy and firm-bodied diction which, more than any other, possessed the wondrous power of defining . . . the most fleeting, the most evanescent of the morbid conditions of broken spirits and disheartened souls.*[78]

In 1884, Des Esseintes looked back to Baudelaire for this ability to "express the inexpressible."

To accomplish this paradox for himself, Huysman called upon the image of "double lines."[79] Responding a year later to a novel of Edmond de Goncourt, for example, he expressed his admiration:

There is, in this novel (La Faustin), *a unique art of evocation, that is to say, an art of double lines. Under the line which is written and printed, there is another which is silent. The flame of this line's art is like phrases sketched in an invisible and sympathetic ink, which appears to touch fire . . .*[80]

Huysmans transposed this image of double lines—one physically written on the page and one sympathetically felt by the reader—from his correspondence to his fiction. In *À Rebours*, Des Esseintes contemplates *La Faustin*, one of the volumes he most delighted in:

Indeed, that suggestiveness, that invitation to dreamy reverie which he loved, abounded in this work, where underneath the written line peeped another visible to the soul only, *indicated rather than expressed, which revealed depths of passion piercing through a reticence that allowed spiritual infinities to be defined such as no idiom of human language could have encompassed.*[81]

In both his letters and his fiction, the metaphor of the "double lines" helped Huysmans spatialize Baudelaire's abstract theory of correspondences: one must view the world as a "forest of symbols" pointing beyond themselves to a deeper reality. For six years of development, Huysmans refined this image of the double lines. In the end, it evolved from a description of the writer's craft into a metaphysical claim on the ultimate nature of reality itself. Between 1884 and 1891, Huysmans gradually and self-consciously cultivated his notion of a Spiritual Naturalism.

Huysmans' turn to Spiritualism did not occur in a vacuum. In the same period, the new religio-philosophical movement known as Spiritualism continued to sweep through America, England, and the Continent.[82] From the late eighteenth-century Franz Anton Mesmer in Austria and the Marquis de Puységur in France to the fictional yet ubiquitous Svengali in *fin-de-siècle* Britain and America,[83] hypnosis promised to "unlock many chambers of mystery."[84] Not surprisingly, the bodies that submitted most "naturally" to the mesmeric powers of another were those of women (fig. **53**).

In addition to hypnosis, religious visions took on a contested medical meaning. In the Anglo-American context, an ongoing debate continued to rage about whether fits, trances, and visions—usually exploding from within the female body—were natural (and therefore not religious) or supernatural (and therefore religious).[85] Back on the Continent, visions of the Virgin Mary captured the popular imagination and encouraged the cultural war between Catholicism and the state. Neither Bismarck's Germany nor the French Third Republic could suppress the religious movements emerging from the visions at Lourdes (1858) or Marpingen (1876).[86] Even Zola's *Lourdes,* a literary attempt to de-mystify the Grotto with a narrative of sick multitudes bereft of miracles, could not undermine these enthusiasms (figs. **54**, **55** and **56**).[87]

54

Finally, psychical studies emerged as an academic discipline that "secularized the soul."[88] Charcot's studies of hypnosis and hysteria became a symbolic flashpoint in the European debate over science and religion: did such phenomena have esoteric or purely physiological sources (figs. **57** and **58**)?[89] Later, a student would displace the master's fame. In 1885, the same year Munch came to Paris for the first time, a young Sigmund Freud arrived on scholarship to continue his neurological studies at the feet of Charcot, the "Napoleon of neuroses."[90]

In sum, the French Decadent movement took shape within this enormous reaction to dominant ideologies. Even as conspicuous consumption[91] became the mode in the Gilded Age, modernity's progressive disenchantment induced discomfort to the point of nausea, leading many to seek out alternative forms of re-enchanted wonder.[92] This international context of Spiritualism, hypnosis, visions, and psychical research carried meanings that associated gender, race, and religion.

57

58

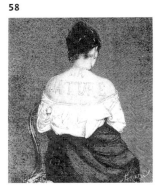

In Britain, for example, the ability to fall under the influence of mesmerists was associated not only with the female body, but also with social or cultural primitiveness. The colonized Bengalis were considered to be especially vulnerable—their habits were "sedentary," movements "languid," and their physiology "feeble even to effeminacy."[93] In France, primitives at home succumbed to mass hypnosis as well. Lucien Lévy-Bruhl lamented that as late as 1903, even in a fully-developed civilization such as France, educated people accepted "so gross a contradiction" as believing in miraculous interventions of the Virgin or other saints while at the same time holding to the absolute determinism of the laws of nature.[94] As seen above, belief in unseen forces was the very cornerstone of Lévy-Bruhl's theory of primitive mentality in "inferior societies,"[95] and the Catholic association of observable phenomena with occult causes was considered a vestige of primitive consciousness.

And not only Catholics: Jews were linked with mesmerism and even more often with neurasthenia and hysteria. Charcot insisted that Jews were disproportionately prevalent among those with degenerative diseases: hysterics, epileptics, neurasthenics, and diabetics. The *Revue de l'hypnotisme* claimed that the over-representation of Jews in the wards of Paris hospitals was not surprising given their "propensity to neurosis."[96] The objective measure of rational modernity marginalized women, peasants, colonized peoples, Catholics, and Jews.

Within this larger context of marginalization, the French Decadent movement acquired institutional shape. Two journals devoted to the movement were founded in 1886: *Le Décadent littéraire et*

artistique and *Le Décadence artistique et littéraire*. The editor of *Le Décadent* celebrated the point at which social evolution had arrived and undermined the "superimposed strata of classicism, Romanticism and Naturalism." Symptoms included "neurosis, hysteria, hypnotism, morphinomania, scientific charlatanism, Schopenhauerism to an excess."[101] These authors invented Decadence as the quintessentially modern movement, displacing outdated Enlightenment notions as well as Marxist and Darwinian materialism. As the editor Anatole Baju wrote a year later, the Decadents had "the honor of crushing Naturalism" without being "in contradiction with modern progress" (as the Romantics were).[102] Mesmerism, hysteria, and morphine were hip.

Within this large conflict in the world of psychical studies, the serious stakes for Huysmans' double vision become clear: he wanted to hold onto *both* Spiritualism and Naturalism simultaneously. An 1890 letter of Huysmans to the occultist Abbé Boullan demonstrates how carefully he constructed his militant alternative to a world devoid of mystery:

I want to confuse everyone — to create a work of art of supernatural realism, of Spiritualist Naturalism [d'un réalisme surnaturel, d'un naturalisme spiritualiste]. I want to show Zola, Charcot, spirits and otherwise that none of the mysteries which surround us [des mystères qui nous entourent] are explained."[103]

Writing later that same year to Jules Destrée, Huysmans further developed this apparent oxymoron, supernatural Naturalism. Huysmans had experienced a profound intellectual conversion while studying the paintings of the Flemish Primitivist school, and looking back to the sixteenth century he found a solution to his late nineteenth-century conundrum. In these Nordic primitives such as Grünewald, he distinguished materialistic Naturalism from its supernatural strain:

I await with impatience your transpositions of Primitives . . . They contained the whole of art, supernaturalism, which is the only true and great art. The only true formula, sought after by Rogier van der Weyden, Metsys, Grünewald, absolute realism combined with flights of the soul, which is what materialistic Naturalism has failed to understand — and has expired on account of it, despite all its useful service.[104]

"Absolute realism combined with flights of the soul": in this formula of a spiritual, psychic, or supernatural Realism, Huysmans struggled to articulate the complexity of his project. We completely misunderstand him if we imagine him simply as turning against nature — for he saw himself paradoxically as integrating reality's double aspects, that is, both rationality and irrationality, nature and super-nature.

In a recent study of *Decadence and Catholicism*, one scholar has formulated Huysmans' mystical discovery in Grünewald's grotesque representation of the Crucified Christ's wounds (fig. **59**):

Huysmans believed that art — even the body as art, or nature as art — is the primary mode of mystical reverie. What Huysmans discovered in Grünewald's brutal Crucifixion is a spiritualization of the hysterical symptom. The symptom, in other words, as a work of religious art. For the hysteric also experiences through the symptom an irruption of the Real on the body, a fragmentation of the familiar fantasy of the body to make way for another, more occult fantasy. . . . For Huysmans, the irruption of the Real is often a religious spectacle of torture and murder.[105]

Huysmans took the very symptom that Charcot employed as the irreducibly naturalistic and endowed it with a mystical significance. To a Naturalist, the body irrupting with sores pointed only to itself and a world of violence. To a Spiritual Naturalist, however, the same bodily symptoms pointed beyond them-

selves. Like the Catholic sacrament of the Body and Blood, the sores manifested the outward irruption of the unseen Real.

In 1891, Huysmans published the definitive statement of his solution in *Là-bas (Down There)*, a novel packed with "popular sorcery, mesmerism, spiritism, hypnotism (and) the oriental thaumaturgies of one sort or another" so popular in Paris.[106] In the opening chapter of *Là-Bas*, a fictionalized conversation between the protagonist Durtal and his friend Des Hermies probed the problem of Naturalism:

You shrug your shoulders, but tell me, how much has Naturalism done to clear up life's really trouble-some mysteries which surround us?[107] *Nothing. When it comes down to explaining a passion, when you have an ulcer of the soul—or indeed the most benign little pimple—to be probed, Naturalism can do nothing. "Appetite and instinct" seem to be its sole motivation and rut and brainstorm its chronic states. The field of Naturalism is the region below the navel. Oh, it's a hernia clinic of emotions* (senti-ments); *it puts a bandage on the soul and sends you on your way!*[108]

Flaubert had written about the education of one's emotions *(sentiments)* in *Sentimental Education*, but this reduction of the soul to sentiment no longer sufficed. About the "mysteries which surround us" Realism had nothing to say. Thus, Huysmans believed that the Spiritualist movement had "accomplished an enormous task." As another character enthused several chapters later:

Spiritism has accomplished one important thing. It has violated the threshold of the unknown, broken the doors of the sanctuary. It has brought about in the extranatural a revolution similar to that which was effected in the terrestrial order in France in 1789. . . . There remains this unanswerable question: is a woman possessed because she is hysterical, or is she hysterical because she is possessed? Only the Church can answer. Science cannot.[109]

These assaults on reason disturbed Durtal. After the door closed and left the protagonist all alone, he began to reflect. "For some months" now Durtal had been "trying to reassemble the fragments of a shat-tered literary theory which had once seemed inexpugnable." His friend's assault had persuaded him, yet Durtal "could see no possibilities for the novelist outside of Naturalism." Were they expected to "go back to the pyrotechnics of Romanticism," that complete deformation of reality? He then succinctly formulated his synthesis of a double vision:

We must . . . retain the documentary veracity, the precision of detail, the compact and sinewy language of Realism, but we must also dig down into the soul and cease trying to explain mystery in terms of our sick senses. If possible the novel ought to be compounded of two elements, that of the soul and that of the body, *and these ought to be inextricably bound together as in life . . . In a word, we must follow the road laid out once and for all by Zola, but at the same time we must trace a parallel route in the air by which we may go above and beyond. . . . A spiritual Naturalism!*[110]

A parallel route, double-lines: Spiritualist Naturalism. One had to conserve the Naturalist generation's *total description* without any deformation of reality. Yet, simultaneously, one had to resist the Natu-ralists' conclusion of *total explanation* from *total description*.[111] In a world without mystery, Huysmans stood against its eclipse and called for its return: one must *"no longer desire to explain away mystery."*

Of course, the Symbolists had also constructed their world of mystery, but Huysmans considered his solution to be significantly different from their project. Symbolists were content to represent exotic

symbols—from Jewish and Christian scripture, ancient Greece and Rome, the Orient, and Egyptian mythology (fig. **60**). However, Huysmans rejected this turn to scriptures and antiquity for subject matter, insisting rather that he was the true Naturalist. When asked by an admirer what made him primarily a Naturalist and not a Symbolist, he replied, "I believe, just as you do, *both in exact documentation and in life,* and I have absolutely no intention of abandoning this belief." Both matter and method set him apart: he believed in life as subject matter—that is, drawn from the streets and not from antiquity or the Orient; and he believed in exact documentation as method, recording details with excruciating precision. (His minute descriptions of appalling events in *Là-bas,* for example, render the novel grotesque.)[112] He would not "deform reality."

Yet, he distinguished himself from other Naturalists by investigating an inner reality—a psychic reality of the soul. "I am also going to a place beyond *(vers un au-delà)* Zola and even Goncourt," he added. "I am going toward the lesser-known states of the soul *(états-d'âmes)* which are both interesting and troubling."[113] He was still producing, in the words of one historian, "a literature of observation, but observation of the invisible."[114]

From this point on Huysmans wanted to observe and represent the states of the soul in all their sickly, neurasthenic, hysteric, and perverse profundity. This double desire made the hysterical body a privileged site for the Spiritual Naturalist.

III. *LA MADONE MYSTÉRIQUE:* A PSYCHICAL NATURALISM

Space is peopled by microbes. Is it more surprising that space should also be crammed with spirits and larvae? Water and vinegar are alive with animalcules. The microscope shows them to us. Now why should not the air, inaccessible to the sight and to the instruments of man, swarm, like the other elements, with beings more or less corporeal, with embryos more or less mature?

— Joris-Karl Huysmans,

Là-Bas (1891)

Called to a destiny more momentous
than any in all of Time,
she did not quail
. . .
to bear in her womb
Infinite weight and lightness; to carry
in hidden, finite inwardness,
nine months of Eternity . . .

— Denise Levertov,

"Annunciation"

If a man were a beast or an angel, he would not be able to be in dread. Since he is a synthesis he can be in dread.

— Søren Kierkegaard,

The Concept of Dread (1844)

After the death of his father and during his stay at Saint Cloud in the winter of 1889–90, Edvard Munch underwent his French conversion. From now he would paint "living people who breathe and feel and suffer and love." His subjects would be so sacred that people would "take their hats off" before them.[115] Munch's conversion was echoed back home. In the summer of that same year, Arne Garborg wrote of the Idealistic Reaction sweeping Norway:

A steady distaste grows for Naturalism's preference for rendering people that consist only of nerve ends and the physical phenomena of the senses, people who are only living evidence for the laws of hered-

60
Gustave Moreau, *Mystic Flower,*
1890. Moreau Museum, Paris.

ity, or are the soulless products of one or another milieu. Instead, there is a longing for depictions of people with souls. . . . The phalanx of young authors has already formulated a new slogan: l'esprit seule importe. . . .[116]

"L'esprit seule importe" ("only the spirit matters"). Suffocated by a materialist gerontocracy, a new generation of young artists looked to the soul.[117] Even sleepy Norway had been mesmerized:

No longer is our mentality dominated by positivist philosophy. We live in the age of hypnotism and spiritism. We are tired of superficial facts and their regulated categorization. We long for what lies behind them, for the abnormal, for the mystical. The soul alone is of significance . . . Our soul is a dark continent where the pitiful lamp of science does not reach. Our soul is a primeval forest of mysteries.

Mystery filled the air: Garborg wrote these lines about the inability of the lamp of science to illuminate the soul the same year that Huysmans wrote *Là-bas*.

Moreover, the Norwegian's "primeval forest of mysteries" seems directly lifted from Stéphane Mallarmé's complaint that only the most vulgar Naturalism would try to capture in writing "the actual and palpable wood of trees" rather than the inner experience that a forest inspires.[118] Mallarmé insisted that words cannot imitate transparently. Because language is "allegorical," the relationship between representation and referent is too arbitrary. Thus he concluded:

The ideal is to suggest the object. It is the perfect use of this mystery which constitutes the symbol. *An object must be gradually evoked in order to show a state of soul; or else, choose an object and from it elicit a state of soul by means of a series of decodings.*[119]

Mallarmé intended to represent not the external reality but rather the psychic reality — that is, "the state of soul." In the scientist's "world without mystery," artists had to create mystery to suggest a deeper reality. Mallarmé envisioned reality as double-edged, both visible and invisible, and saw the artist's task as representing un-representable mystery.[120] It was "the perfect use of this mystery" that constituted the symbol: Garborg's "primeval forest of mysteries."

Garborg concluded his account of this Idealistic Reaction by noting that the practioners of this antimaterialist movement in France, Denmark, Sweden, and Germany were "fond of calling themselves Decadents." Here Garborg was following the lead of essays published earlier that year in a new periodical called *Samtiden*. This publication was founded by and associated with the Bohemians (including Munch himself) surrounding Hans Jaeger, who was no longer in jail and no longer a Naturalist. In a late spring issue, Andreas Aubert published three long articles under the rubric "Tendencies in French Cultural Life."[121] Aubert took Baudelaire's decadent celebration of that which "appears morbid and artificial to more simple natures" and applied it to the person and painting of several artists including Munch. Later that year, Aubert devoted an article uniquely to Munch:

Among our artists, Munch is the one whose temperament is formed by the neurasthenic. *He belongs to the generation of fine, sicklily sensitive nerves that we encounter more and more frequently in the newest art. And not seldomly they find a personal satisfaction in calling themselves "Decadents," the children of a refined, overly civilized age.*[122]

In these pieces, suggests Reinhold Heller, Aubert achieved a unique aim. He constructed Munch so that he "transcended the provincial limitations of Kristiania" and represented "the first modern Norwegian artist contributing to the development of an artistic movement not nationally focused in Norway: Decadence."[123]

Munch's heroic mission was specified, moreover, in Hermann Bahr's call for a double vision that synthesized both psychology and Naturalism. Bahr praised Aubert's idea of an Idealistic Reaction but criticized his term "neo-idealism." He agreed that a reaction was needed, but not a retreat into idealism. Rather, a new dialectical synthesis had to preserve Naturalism even as it embraced the psychological turn to the soul. Thus, a truly novel Decadent would call for a

psychology in opposition to the one-sidedness of existing Naturalism, [but also demand] a psychology that comes to terms with the long-standing habits of Naturalism. He [would demand] a psychology that has passed through Naturalism and has gone beyond it [and was] no longer at peace with the old pre-Naturalist psychology.[124]

In other words, as in France, there could be no question of returning to Romanticism as such. The world had grown too old for such youthful naivete. A truly modern vision of the soul would have to bring with it all that had been learned through the long century.

Krohg, Munch's early artistic mentor—like Jaeger, now no longer threatened with jail and no longer Naturalist—continued to make the case that Munch was the double-visioned hero. In the autumn of 1891, Krohg tried to articulate this paradox:

Thus we are confronted with the strange fact that Munch, who here at home is regarded as the most incorrigible of all Realists and the most impudent and presumptuous painter of hideousness, is really the first and only artist to have embraced that Idealism, who dares to subordinate Nature, his model, to his mood . . . It is related to Symbolism, the latest movement in French art.[125]

A year later Munch moved to Berlin with Krohg's words in mind: the need to maintain both the "hideousness" of a Realist as well as the inward vision of an Idealist. As Huysmans would have said, Munch needed to record spiritual realities with a Naturalist's "veracity of the document."

In Bahr's Berlin, Munch fell in with a bohemian Nordic crowd that met at the Black Piglet tavern. August Strindberg, the German poet Richard Dehmer, and Julius Meier-Graefe all circled around the Polish writer Stanislaw Przybyszewski and his Norwegian *femme fatale* wife, Dagny Juell. Strindberg was fascinated by hypnosis and medicine and avidly studied the work of Charcot; Przybyszewski studied medicine in Berlin, specializing in neurology. Thus in Berlin Munch found himself once again, as in his childhood, in a medical milieu. Yet he was in a far different position, for he had become dissatisfied with the "materialistic, shallow optimism and self-satisfaction"[126] that science and medicine promised. "One became accustomed to the idea of not believing in a god," Munch wrote, "but that was a belief, after all." He continued:

All this was in connection with that great wave that went over the earth: Realism. Things did not exist unless they could be pointed to, be explained by chemistry or physics. Painting and literature consisted only of what one saw with one's eyes or heard with one's ears; it was the shell of nature. One had become self-satisfied with the great discoveries that had been made.[127]

Thus, Munch set out to express a new kind of reality—a mystical reality:

Mystical qualities will always exist; after all, the more one discovers the more inexplicable things there will be. The new movement whose progress and whose flashes of light are being felt everywhere, it will give expression to all that which now has been suppressed for an entire generation, all that of which humanity will always have a great quantity: mysticism.[128]

Munch's new mysticism would emerge from the milieu of the Black Piglet. Przybszewski, known to his friends as Staczu, suffered from hallucinations and wrote "bold, ecstatic works" in German. His wife, nicknamed "Ducha" (which means "soul"), "drank absinthe by the litre without ever getting tipsy." Strindberg would talk about chemical analysis while Munch remained silent. In the noisy background, Staczu ferociously pounded on the piano and kept ongoing his conversations about pathological eroticism. Both Strindberg and Przybyszewski were obsessed by the occult, dabbled in black magic, and reveled in the idea of being a "Satanist."[129] (One of Przybyszewski's books—written in Norway and published in Paris—was entitled *Satan's Children* (*Satans Kinder*).)[130] Recalling those days in Berlin with Munch, Meier-Grafe considered its unspoken background "the Paris of Huysmans" whose grotesque *Là-bas* accounts of Satanism, sadism, and child-murder had caused a sensation just the year before.[131]

Munch exhibited at the Verein der Berliner Künstler in 1892. Violent debates closed the exhibition and the scandal gave Munch German notoriety. Shortly thereafter, Munch exhibited his six-painting series entitled "Love" in Berlin. As a means of publicizing but also (presumably) setting the terms of interpretation for this unnerving vision, Przybyszewski published an essay appearing in Bahr's Berlin entitled simply "Psychic Naturalism": *"Psychischer Naturalismus."*[132]

Although the phrase substitutes the Greek *psyche* for the Latin *spiritus,* both, of course, signify spirit or soul. (In fact, throughout Przybyszewski's essay the word soul or spirit *(die Seele)* occurs more often as a synonym for psyche.) Most importantly, however, Przybyszewski clearly intended to articulate a project parallel to Huysmans's. His Psychical Naturalism was to be another double vision, a variation on Spiritual Naturalism.[133]

"Psychical Naturalism" begins by associating individuality—the "eternal in humanity" *(das Ewige im Menschen)*—with the very "foundation of the psychical life" *(der Urgrund des psychischen Lebens).*[134] According to Przybyszewski, Edvard Munch was among the first artists to have represented *(darzustellen)* this eternal element of the soul's most intimate and subtle states *(Seelenvorgänge).* He described Munch's paintings as utterly faithful "dissections of the soul" *(Präparate der Seele),* the soul as it lay in its "animalistic" and "irrational" state *(tierischen, vernunftlosen Seele),* independent of any distortions that might come from the interference of the intellect.

Until now, Przybyszewski asserted, no one had understood the central element in Munch. All painters were concerned with the "external world" *(der äusseren Welt).* Even the Symbolists represented interior emotions and moods by means of some distorting medium (metaphorical or mythological) that had been taken from the outer world of appearances.[135] They always tried to express the phenomena of the soul *(seelische Phänomene)* in scenes taken not from the interior but from the outside world *(äussere Vorgänge).*[136]

Munch turned his back on this tradition. He painted as only one could "whose eyes have turned toward the interior *(nach Innen gekehrt)* and away from the world of appearances *(der Welt der Erscheinungen)."* "His landscapes," said Przybyszewski, were "found in the soul."[137] In short, Munch wanted to render the psychical world without mediation *(unmittelbar)*—transparently *(einen psychischen, nackten Vorgang)* as opposed to the Symbolists who used mediating symbols (both mythological and metaphorical).[138] The transparency Munch wanted seemed to be both psychical and Naturalist at the

same time. The subject matter was the soul, but he wanted it represented using just the bare facts.[139] For this reason, Przybyszewski considered Munch *"par excellence"* the "Naturalist of the soul's phenomena" *(der Naturalist seelischer Phänomene par excellence)* just as Max Liebermann, "the disciple of the ugly," was "the most ruthless Naturalist of the outer world" *(rücksichtsloseste Naturalist des Äusseren).*[140]

The aesthetic laws with which critics judged Munch had no validity since they had been developed based only on external things *(aus dem Äussern entwickelt wurden).* Munch could not be judged thus, for he was the painter of "psychical compositions of emotional impulses" *(des psychischen Gestaltungsdranges von Gefühlsimpulsen)* that extended even to "psychical rapture" *(psychischen Übergeschwanges).* (Here one could almost hear Przybyszewski pounding on the piano.) Such phenomena *(Erscheinungen)* transcended the physical world and stood on the same level as the phenomena of the "pure life of the individual" along with such hypnotic and hysterical irruptions such as "visions, clairvoyance, dreams, and so on" *(Vision, Hellsehen, Traum u.s.w.).*

For Munch's true parentage, Przybyszewski encouraged the reader to escape Berlin and look around in Brussels and Paris where were found those "obviously 'totally crazies'" who had the "totally insane idea" of translating these "finest and most subtle associations of the soul" *(seelischen Associationen)* into words. Among these artists, "The soul, their inner world, is the only reality, a cosmos." *(Ihre Seele, ihr Inneres ist die einzige Realität, ein Kosmos.)* The line translated into German Arne Garborg's description of the Idealist reaction in France. For this new generation, he had written, *"l'esprit seule importe."* The soul alone mattered.[141]

As if to stress this French genealogy, Przybyszewski concluded by inserting the words of the Symbolist in the original French:

Nommer un object, sagt Stéphane Mallarmé, c'est supprimer les trois quarts de la jouissance du poème qui est faite du bonheur, de deviner peu à peu; le suggérer, *voilà la rêve.* [*To name an object, says Stéphane Mallarmé, is to suppress three-quarters of the delight of a poem . . . to suggest* it: voilà, *that precisely is the dream.*][142]

Those who had turned against the de-mystifying naming of objects were the true innovators *(die Neugestalter);* they alone established the younger generation's standards of worth. They were the true aristocrats of the spirit *(die wirklichen Aristokraten des Geistes).* Edvard Munch—here the cosmopolite Przybyszewski slipped into English—was an aristocrat of the spirit "every inch" of the way.

Although the details are opaque, Przybyszewski's intent is clear. He considers Psychical Naturalism a middle-road between both Naturalism and Symbolism. Admittedly, one wonders how he imagined Munch's painting of inner states directly, transparently, and nakedly, without a Symbolist's mediating tool of mythology or metaphor. Yet, like Huysmans' Spiritual Naturalism, Munch's Psychical Naturalism attempted a synthesis. It turned inward for the truly real—the world of "vision, clairvoyance and dream"—yet it desired to record such inner facts immediately, nakedly, and faithfully with a Naturalist's precision. Przybyszewski imagined the possibility of a double vision.

Munch left Berlin the next year to exhibit in his native Norway, for it seemed as though the ground might be better prepared now for this vision. The art of the youngest generation, the *Samtiden* had recently declared, was a generation of mysticism. The Realist generation had boasted of a "stupid, self-confident clarity which is clarity only because it is superficial." Attempting to explain humanity and the world in only rational terms, they had merely simplified human problems by "amputating away all uncomfortable contradictions." In reaction, the new generation "cast themselves down into the world of mysteries." They cultivated "that aspect of their personality tied to their mystical unconscious, as if it were a sacred object."[143] Perhaps such a milieu would now welcome Munch's new mystical vision.

Kristiania, however, was still not ready for Munch. The reviews were mostly negative. Yet, in a dissenting opinion, the editor of the Parisian *La Revue Blanche,* Thadée Natanson, applauded the exhibition and reproduced Munch's lithograph of the *The Scream* (no. **7**). Like German artists, the Frenchman complained, Munch indulged in too many "metaphysical speculations." Natanson recommended that Munch come back to Paris—presumably to absorb some Mediterranean earthiness.[144]

Munch took his advice and moved to Paris in 1896, receiving favorable reviews at the Salon des Indépendants that year and the next. He began to simplify his style by producing color lithographs and his first woodcuts at Auguste Clot's print shop. The new prints helped him establish new connections with the Symbolists. In 1896 he made two portraits of Stéphane Mallarmé: a lithograph and a watercolor (whose existence is attested to in a short note of thanks from Mallarmé to Munch).[145] He also produced illustrations for a new edition of Baudelaire's *Les Fleurs du Mal,* including one for "Posthumous Regret" and one for "The Happy Corpse" (figs. **61** and **62**). Even as the lithograph demanded a simplification of Munch's style, it gave him greater freedom for bolder gestures and stark dramatic contrasts.

In 1895 Munch took his Madonna motif from the 1893 painting and re-figured it as one of his first lithographs, revising it at least twice again in color between 1895 and 1902. The added elements—the embryo and the swimming spermatozoa—seem to be Naturalist elements with a Decadent twist. Yet even before these biological re-figurations pointed to the perils of heredity, the 1893 Madonna already had a Decadent genealogy.

Munch had been influenced by Odilon Redon,[146] a friend and collaborator of Huysmans.[147] (Redon's Symbolist works still stand as the best visual translation of Huysmans' occult and Satanist writings.) An 1893–4 sketch for the *Madonna* (fig. **63**) shows similarities between the halos in Munch and in Redon's lithograph *Serpent Halo* (1890, fig. **64**). *Serpent Halo,* itself a variation on Franz von Stuck's Surrealist *Sensuality* (1889, fig. **33**), perfectly captured Huysmans' spirit. Composed the same year as *Là-bas,* it showed a pregnant woman in a crucifixion pose, erotically entangled by a coiled serpent whose tail formed an occult halo behind her head.[148]

The halo, painted blood-red by Munch, had played a central though mysterious role in the first *Madonna.* As Przybyszewski wrote in "Psychical Naturalism," this Madonna had "the halo *(Glorienschein)* of the coming martyrdom-by-means-of-birth" *(Geburtsmartyriums).*[149] The puzzling neologism connotes several layers of meaning. In the calendars of Christian antiquity, the martyrs' deaths were celebrated as birthdays into eternal life. Moreover, their rebirth through self-sacrificed blood gave birth to later generations. As the Latin Church father Tertullian wrote, the blood *(sanguis)* of the martyrs was the seed *(semen)* of the church.[150] In the *Madonna's* esoteric allusion to the ancients, not only does a bloody physical birth prefigure the inevitable end for the newborn (a Naturalist theme), but a bloody end also signals a spiritual birth of the eternal (a supernatural theme).

On another level, perhaps it is the woman herself who must be martyred and give her body as seed to bequeath life to a new generation. The Norwegian poet Sigbjørn Obstfelder, also in Berlin in 1894–1895, considered Munch's painting of "the world's Madonna, woman who gives birth in pain" as a mystery become religious:

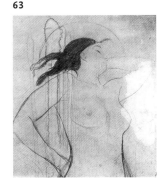

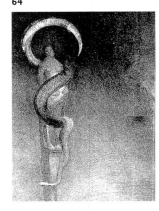

61
Edvard Munch, *Posthumous Regret,* illustration for *Les Fleurs du Mal* of Baudelaire, drawing, 1896. Munch Museum, Oslo.

62
Edvard Munch, *The Happy Corpse,* illustration for Baudelaire's *Les Fleurs du Mal,* drawing, 1896. Munch Museum, Oslo.

63
Edvard Munch, Sketch for the *Madonna,* 1893–94. Munch Museum.

64
Odilon Redon, *Serpent-Halo,* lithograph, 1890. Private collection.

That which lies at the bottom of life is not clearly seen by our eyes, either in form, color or idea. Life has surrounded itself with a mysterious beauty and terror, which the human senses cannot, therefore, define, but to which a great poet can pray. The desire to concentrate on this human quality, to understand in a new way that which our daily life has relegated to a minor position, and to show it in its original enigmatic mystery—this attains its greatest heights here in Munch's art and becomes religious.

Munch sees woman as she who carries the greatest marvel of the world in her womb. He returns to this concept over and over again. He seeks to depict that moment when she first becomes conscious of this in all its gruesomeness.[151]

The halo of the birth-martyrdom, the woman who gives birth in pain: whatever Munch meant to convey by this enigmatic mystery, the halo entangles the spiritual and the natural in Decadent ways. Munch represents life, which has "surrounded itself with a mysterious beauty and terror," in a way that becomes religious.

In addition to the occult halo, the bodily pose and swirling hair of the 1893 Madonna seemed to echo that of Death personified as a woman in Redon's *La Mort* (fig. **65**). Redon's piece, from a series produced in homage to Flaubert for a new edition of his post-Realist *Temptation of Saint Anthony*, was entitled "Death: My Irony Surpasses All!" For Przybyszewski as well, the woman's life-giving capacities were inextricably intertwined with her destructive ones. At the beginning of "Psychical Naturalism" comes this description of "das Weib"[152]—the term for woman Przybyszewski later uses to describe the "Madonna"—in the painting by the Decadent Félicien Rops:

In a catacomb stands a woman in a corset and petticoat. She has lifted up her skirt and with a savage, brutal, and cynical grandiosity she points to her genitals. At her feet rests a coffin. . . . This is the terrible tragedy of the man who is destroyed by the woman (das Weib). This is the woman, the Babylonian whore, this is Mylitta, the apocalyptic slut, this is George Sand and Nana rolled into one: an enormous symbol of the eternal, savage battle of the sexes.[153]

As the allusions to prostitution and promiscuity suggest, the symbolic linkage of the woman to death has its roots in *fin-de-siècle* anxieties over syphilis. The myth of hereditary syphilis transformed sexual desire into what Jean Borie has called an "infernal machine."[154] The woman's genitals served as a sure door to the syphilitic coffin.

But there is more to the image than this Naturalist litany of anxieties. Like the obscure allusion to Christian "martyrdoms by means of birth", the image of the "catacomb" connotes sacred overtones of late antiquity as well. These dark subterranean passages ("down there") ambiguously served both as places of safe refuge for the Christians hunted down by the imperial state and as their burial grounds after their deaths. The catacombs were hallowed places. Mass was said on altars over the bones of martyrs—relics delineating zones of sanctity where temporality and the eternal fused.[155]

In this ambiguously sacred place of purity and danger,[156] the woman's womb is paralleled with the coffin: life's beginning intermingles with its end. *Eros* draws a man to *thanatos* as a flame draws a moth: irrational instinct lures the male to give his seed for the species, an act that both enables the survival of species-life but also foreshadows his individual death. In imitating Redon's *Death* personified as woman, then, the bodily pose of Munch's *Madonna* seems to have more than stylistic roots. Munch once again inextricably entangles the spiritual and the natural in Decadent ways.

Finally, Munch had framed his *Death and the Maiden* (painted along with the first *Madonna* in 1893) with embryos, a suggestion of life beyond the seeming finality of Death's skeleton (no. **53**). Here

65
Odilon Redon, *Death: My Irony Surpasses All! For Gustave Flaubert III*, lithograph, 1889. Private collection.

too Redon provided a precedent that explicitly alluded to Darwin's evolutionary thesis *On the Origins of Species*. In an 1883 series entitled *The Origins*, six illustrations move from the primal origins of life through an evolutionary progression up to the human species. Redon had used sperm-like seed forms to signal the primal origins of the race (fig. **66**).

Przybyszewski echoed Redon's imagery in "Psychical Naturalism." Both medical student and psychical researcher, Przybyszewski wrote that the seed of human generation is a double-reality: irreducibly material, still it contains the individuality that (as seen above) signified for him the eternal element in the human being. This hope in the possibilities of human procreation emerges from both the continuity and innovation of generations:

For me, individuality is the immortal, the inalienable. It is the basis onto which new characteristics are grafted through hereditary transmission. Individuality is the medium of hereditary transmission. *The individuality is passed on forever. It lives continuously from the first beginnings, from the first dim signs of life in the embryo to the highest developed forms. It is like a growing wave, a germ cell which reproduces itself in ever new metempsychoses until eternity. The individuality is the collecting point of all the characteristics which are typical for all parts of the whole chain of development. It is a pangenesis in the sense which* Darwin himself pointed out: each seed contains the complete human being with all his characteristic traits.[157]

The seed gives both life and death: even as procreation must inevitably result in the death of the individual, so also it perpetuates the eternity of the race. Thus Munch's *Madonna*, hemmed in by the inevitable biological forces of life and death, still suggests a subversion of nature in its ability to outwit heredity.

In the end, how can situating Munch's work within the Decadent context help deepen our appreciation of this subversive Madonna? What cultural meanings does she convey? How does she embody a double vision?

A Naturalist framework might read her one-dimensionally, perhaps as one of Charcot's *passionnelles,* an over-libidinous female body exhibiting hysterical symptoms. It might additionally suppose that, having framed the erotic moment with spermatozoa and an embryo, Munch reproduced not only his own biological obsessions with heredity and the perils of sexual reproduction but those of his bourgeois culture as well. Munch spent his entire life enveloped in medicine, madness, sickness and death. The skeletal embryo—precariously balanced between life and death and framing the biological act of human love—might well convey the terror he felt towards the seeds of destruction contained within sexual pleasure.

Within the Decadent context, however, a far more complex picture emerges: a Psychical Naturalist hope that the irruption of bodily symptoms sacramentally suggests the unseen. In Przybyszewski's phrase, they would point to the soul, the individuality, "the eternal element in the human." Quite clearly, Munch and Przybyszewski intended this Madonna's moment of ecstasy to transcend itself in nearly cosmic dimensions—a moment in which the destructive natural struggles with the undying metaphysical. Przybyszewski interpreted the Madonna this way:

The third picture represents a Madonna. It is a half-dressed woman in a completely self-surrendered state—a state, that is, in which all of the senses become essentially stimulants of intense delight. A half-dressed woman on crumpled sheets with the halo of the coming martyrdom by birth. At this very moment, the secret mysticism [geheime Mystik] *of the eternal act of procreation radiates on the*

Odilon Redon, *Les Origines*, 1883. Private collection.

woman's face with a sea of beauty. In this burst of passion, civilized humanity [der culturelle Mensch]—*with its metaphysical striving for eternity* [Ewigkeitsdrange]—*confronts the animal with its passionate destructive frenzy.*[158]

Needless to say, Munch has endowed the woman's womb and the procreative act with a significance that is cosmic in both space and time. In her womb, the human—as a natural animal on the low end of the evolutionary scale, passionately propelled to self-destruction—collides with its cultural self on evolution's high end. This is Kierkegaard's source of dread. The human being, a doubly composed "god who shits," demands in the face of self-destruction what only the metaphysical or supernatural can provide: meaning, endurance, and even eternity.[159] The woman's body as the site of contest between Naturalists and Decadents has rarely reached such a feverish pitch of significance.

What name might we use for this Decadent female body, the ambivalent contested site of mystic nature? Theorist Luce Irigaray has coined a neologism which, uniting Charcot's *hystérique* and Huysmans *mystique,* names the double vision of this icon:

La mystérique: *this is how one might refer to what, within a still theo-logical onto-logical perspective is called mystic language or discourse. Consciousness still imposes such names to signify that other scene, off-stage, that it finds* cryptic.[160]

In a world where religious discourse still holds sway, a theological or ontological vocabulary to name and represent unseen realities is taken for granted. In a post-religious world, however, new language must be invented to signify that which, no longer considered theological, remains nonetheless mysterious and impenetrable. The ambivalent figure of the *mystérique* gives the disenchanted *hystérique* a subversive, psychic, mystic meaning.

To what cryptic hope in things unseen does Munch point? Munch, carrying from his Lutheran childhood a sense of "sin, anxiety, predestination,"[161] seems to have been on a quest for some sort of immortality ever since his father's death. Unlike so many other Symbolists and Decadents, Munch never embraced the sensuous mysticism of the Catholic Mass as a solution, even while in Paris.[162] Heller speculates that perhaps the elder Munch's "puritanical Lutheranism remained too powerful still."[163] But perhaps Munch was simply unpersuaded by theism of any kind—a man no longer capable of a "theo-logical onto-logical perspective."

Nevertheless, death remained *cryptic.* It propelled Munch to create a vision of what might be the unperishing *(ewig)* element in human existence. Rejecting Naturalism, he formulated an intense vision of the sacred character of human life—if not exactly mystical, then perhaps mysterical. Huysmans' double lines, natural yet yearning for transcendence, have been inscribed on the Madonna's body. One plane foregrounds the natural: a half-dressed woman, crumpled sheets, sexual ecstasy, hysterical pose, viscous spermatozoa, skeletal embryo.

Yet another supernatural plane suggests an unseen beyond: the ancient trope of the "Madonna and Child"; a blood-red halo anticipating martyrdom; the seed in which "individuality is passed on forever" *(ewig pflanzt sie sich fort)* and lives continuously "from the first dim signs of life in the embryo to the highest developed forms"; an eternal struggle between humanity's destructive animal tendencies and metaphysical desires for eternity.[164]

Juxtaposing just three of Munch's works during 1895–1897—*Madonna* (1895–6), *Madonna in the Churchyard* (1896, fig. **31**), and *Inheritance* (1898, fig. **82**)—we see both Munch's Naturalist despair and his transcendent hope. Though the syphilitic child painfully portrays the specter of hereditary degen-

eration, Munch found transcendent hope in iconic embryos and spermatozoa—the human ability to generate new generations. A man and woman entwined in lovemaking, he wrote just after his father's death, are "at that moment . . . no longer themselves but only a link in the chain that binds a thousand generations."[165] Later he sharpened this hopeful vision:

Thus now life reaches out its hand to death. The chain is forged that binds the thousands of generations that have died to the thousands of generations yet to come.[166]

The complete intertwining of the irreducibly Naturalist images (represented with documentary veracity) and the ambivalent irruptions of transcendent meanings in the female body (hysterical, mystical, or mysterical) boldly demonstrates Munch's own double lines of Psychical Naturalism. The woman is no longer simply herself. Her body is the site of a cosmic contest between life and destruction, earthly finitude and metaphysical eternity. She is the Madonna, the New Eve, the "link in the chain that binds a thousand generations." She is the mysterical Madonna: *la Madone mystérique.*

CONCLUSION: MYSTERICAL WONDER

The only adequate response to reality is wonder.

—Flannery O'Connor

Let us return to the challenge posed at the beginning of this essay: "we all—scholars and ordinary readers alike—must ask about how society constructs, uses, and eclipses the wondrous."[167] When we look at our great-great-grandparents' episodes of Spiritualism, mesmerism, and psychical research, we frequently enough treat them with familial indulgence or dismissive condescension. Either way, we think of them as our doddering ancestors on the brink of modernity, struggling with something new—not quite able to be modern, yet no longer able to believe in tradition. We do not, however, respect them for what they saw as absolutely vital issues at stake: the need to represent for themselves what ultimately mattered—in a word, reality, whatever that might mean.

The subversive use of religious iconography can lead to stereotyped responses. On one hand, religious believers see sacrilege; on the other, defenders erect an autonomous aesthetic of art for art's sake. Neither position takes such artistic representations seriously. If we see in Baudelaire's "flowers of evil" or Huysmans' Black Masses either sacrilege or solipsism, we miss not only the point but also the serious fortunes in play.

If there was a blasphemy for the Symbolists, the Decadents, the Rosicrucians, and the Catholic Revivalists (to name only a few), it would not have been diabolism, the occult or the new mysticisms.[168] The blasphemy would have been rather a totalizing ideology that reduced the real to empirical facts, domesticated transcendence,[169] and thus foreclosed all hope in things unseen.

For at least three decades now, historians have been attempting to rescue religion from the margins to which it was banished—that is, as an epiphenomenon of economic, social, or political desires.[170] Cultural historians have turned to anthropology to recover religion as a powerful force capable of motivating the most deeply held passions, to recover religion as an ultimate claim on reality for which human beings have been willing to fight, suffer, kill and be killed, martyr and be martyred.[171] Religious people in the past saw salvation at stake.[172]

But perhaps religion is not the most helpful word for understanding nineteenth-century European history. It connotes too much the official institutions that embodied religious impulses. While certainly

battles were bitterly fought in those church-state trenches, other conflicts were engaged on fields more familiar to intellectual and cultural historians. Cultures clashed in classrooms and pulpits, but also, and most vividly, in novels and poetry, on canvases and operatic stages, in art museums, wax museums, daily tabloids, and psychiatric wards.

In approaching the complex cultural world of Munch in Paris, I suggest substituting the category of "wonder" for that of "religion." We can retrieve our doddering forebears on the brink of modernity from the "enormous condescension of posterity"[173] only if we see what was at stake for them: nothing less than claims on the ultimate constitution of reality. Significance, meaning, and purpose beyond the tuberculosis ward and the syphilitic grave: these ultimate human concerns had been largely eclipsed in the dominant public discourse. A suffocating logic of progress with vast institutional resources (including schools and hospitals guided by positivism) ruled questions of significance as being out-of-bounds. We should not regard the many attempts to restore a sense of wonder to a world without mystery — often using the tools of fantasy, magic, and the occult — as either sacrilege or as child's play. Neither response honors our forebears.

In the year of Munch's turn away from Naturalism, Arne Garborg seasoned his Norwegian text with the French flavor: *"l'esprit seule importe."*[174] The spirit, the mind, the soul, the *psyche:* in a world that eclipsed mystery, however one translated *l'esprit,* this alone mattered. It alone liberated individual freedom, grounded human creativity, hinted at glimmers of eternity.

What our ancestors wanted was a mystery that faced the facts: not a heavenly assumption without a body, but rather a Naturalist's keen attention to the states of the soul. A Spiritual Naturalism or perhaps a Psychical Naturalism — both signified a synthetic approach to reality as a double-composition of wonder. Like the *mystérique* herself, the marvelous real both attracted and repulsed, appeared in nature yet possessed supernatural energy, allured even in its aspects of dread. Before modernity's disenchantment, this object both *tremendens et fascinans* would have been called religious. In a world such as ours, perhaps (as Bynum suggests) we would do better to call it "wondrous."[175] Relieved of institutional and confessional overtones, the "wonder-response" nonetheless recovers what was at stake: a response of wonder in the face of realities beyond those sanctioned by disenchanting authorities.

In this broader sense, the category of wonder belongs to the language of the mystic. As the Jesuit Michel de Certeau wrote suggestively:

In a word, one might say that the mystical is a reaction against the appropriation of truth by the clerics . . . It favored the illuminations of the illiterate, the experience of women, the wisdom of fools, the silence of the child; it opted for the vernacular languages against the Latin of the schools. It maintained that the ignorant have competence in matters of faith. . . . The mystical is the authority of the crowd, a figure of the anonymous, that makes an indiscreet return in the field of the academic authorities.[176]

There are many kinds of clerics in the world — academic authorities, for example — who appropriate truth and eclipse the mysterious. When we see nineteenth-century spiritual symptoms irrupting on so many *fin-de-siècle* bodies — hysteria, hypnosis, diabolism and visions — we see a reaction against the appropriation of truth by a new caste of clerics — the clerics of modernizing disenchantment.

For many centuries, the Madonna's gently smiling face has offered solace and hope. Munch's ecstatic *Madonna* most certainly extended this traditional use. Yet in the face of the unseen, even this Madonna's face points to hope and rescues despair. In every Decadent *mystérique,* irrupting bodily symptoms possess a spiritual significance, pointing beyond themselves — just as religious sacraments do — to a hope in things unseen.[177]

Munch's untraditional *Madonna* and Grünewald's *Crucifixion* both body forth a *mystique*—at the very least, a double-composed *mystique naturaliste*. Their many levels of meaning resist any complete explanation. Despite this unfathomable complexity, Huysmans thought he had finally found a description adequate to the *mystérique*. His moving tribute to Grünewald's mysterical Christ serves as an appropriate epitaph to Munch's mysterical Madonna:

I find that [Grünewald's] work can only be defined by coupling together contradictory terms . . . The man is, in fact, a mass of paradoxes and contrasts . . . He is at once naturalistic and mystical . . . He personifies . . . the religious piety of the sick and the poor. That awful Christ who hung dying over the altar of the Isenheim hospital would seem to have been made in the image of the acid-burnt patients who prayed to him; they must surely have found consolation in the thought that this God they invoked had suffered the same torments as themselves, and had become flesh in a form as repulsive as their own; and they must have felt less forsaken, less contemptible . . . His pestiferous Christ would have offended the taste of the courts; he could only be understood by the sick, the unhappy and the monks, by the suffering members of Christ's body.[178]

In the late nineteenth century, new hospitals sprang up with new illnesses, both factual and fictitious, irrupting primarily on the bodies of women. New suffering members needed new forms of consolation.

In a modern world imprisoned by apparent dead ends, Munch too escaped and went *à rebours*. Declaring an end to the "impudent despotism of things dead," he boldly painted the "return of the living." His degenerate *Madonna* regenerates future generations.

1 Reinhold Heller, *Munch: His Life and Work,* Chicago: University of Chicago Press, 1984, p. 114.

2 Letter of Munch to Danish painter John Rohde, dated March 1893. "At the moment I am occupied with studies for a series of paintings . . . It will have love and death as its subject matter." In John Boulton Smith, *Munch,* revised and enlarged edition, London: Phaidon Press, 1992, pp. 11–12.

3 The six paintings were *The Voice (Summer Night); Kiss* (later: *The Kiss*); *Love and Pain* (later: *Vampire*); *The Face of a Madonna* (later: *Madonna*); *Jealousy* (later: *Melancholy*); and *Despair* (later: *The Scream*).

4 The phrase is adapted from Caroline Walker Bynum's review for the publisher, printed on the hardcover copy of William A. Christian, *Visionaries: The Spanish Republic and the Reign of Christ,* Berkeley: University of California Press, 1996. Bynum writes, "this study of Catholic religiosity in the 1930s sheds light on fundamental aspects of human spirituality and psychology and on the sophisticated questions we all—scholars and ordinary readers alike—must ask about how society constructs, uses, and eclipses the wondrous." For Bynum's own recent investigations into the category, see: *Fragmentation and Redemption: Essays on Gender and the Human Body in Medieval Religion,* New York: Zone Books, 1991; *The Resurrection of the Body in Western Christianity, 200–1336,* New York: Columbia University Press, 1995; and "Wonder," *American Historical Review* 102, February 1997, pp. 1–26.

5 For the radical shift in hygiene and mentalities effected by the invention of sewer systems see Alain Corbin, *The Foul and the Fragrant: Odor and the French Social Imagination,* translated by Miriam L. Kochan, Roy Porter and Christopher Prendergast, Cambridge, MA: Harvard University Press, 1986, originally published as *Le Miasme et la*

jonquille: l'odorat et l'imaginaire social XVIIIe–XIXe siècles, Paris: Aubier Montaigne, 1982.

6 Spurred by the example of the British public health movement, "water mania" and the building of massive urban sewer systems swept across Europe as a successor to the "railway mania" of the 1840s. In Paris, the irruptions of epidemics were associated with the irruptions of revolutions. The horrific cholera epidemic of 1832, two years after the July Revolution, killed some twenty thousand in Paris and its suburbs and touched off riots. Again in 1849 a cholera epidemic presented a "biological complement" to the Revolution of 1848. After overthrowing the Second Republic in a coup d'état in 1851 and replacing it with the Second Empire, Emperor Napoleon III transformed Paris both above and below ground. "Not only did this improve public hygiene in the city, it also disrupted the metonymical relationship of the sewers to the social threat from below." For this relationship between bodily disease and disease in the body politic, see Donald Reid, *Paris Sewers and Sewermen: Realities and Representations,* Cambridge, MA: Harvard University Press, 1991, pp. 9–36.

7 Alain Corbin, "Backstage," *A History of Private Life IV: From the Fires of Revolution to the Great War,* edited by Michelle Perrot, translated by Arthur Goldhammer, Cambridge, MA: The Belknap Press of Harvard University Press, 1990, pp. 451–668; originally published as *Histoire de la vie Privée,* vol. 4, *De la Révolution à la Grande Guerre,* Paris: Éditions du Seuil, 1987.

8 "In the second half of the century, what Jean Borie has called 'mythologies of heredity' were developed by physicians and novelists (such as the Zola of *Fécondité* and *Docteur Pascal*), by fear of the great 'social scourges'—tuberculosis, alcoholism, and syphilis—and by terror of

flaws transmitted by tainted blood. Because of these hereditary weaknesses the family came to be seen as a weak link to be protected from danger through constant vigilance. Chastity was recommended, even to young men, whose escapades had once been tolerated as a mark of virility, while young women were required to remain virgins." Michelle Perrot, "The Family Triumphant," *A History of Private Life. Vol. IV: From the Fires of Revolution to the Great War*, edited by Michelle Perrot, translated by Arthur Goldhammer, Cambridge, MA: The Belknap Press of Harvard University Press, 1990, p. 124. See Jean Borie, *Mythologies de l'hérédité au XIXe siècle*, Paris: Galilée, 1981.

9 Michel Foucault, *The History of Sexuality: An Introduction*, translated by Robert Hurley, New York: Pantheon Books, 1978; originally published as *Histoire de la sexualité*, Paris: Gallimard, 1976.

10 For prostitution see Judith R. Walkowitz, *City of Dreadful Delight: Narratives of Sexual Danger in Late-Victorian London*, Chicago: University of Chicago Press, 1992; and Alain Corbin, *Women for Hire: Prostitution and Sexuality in France after 1850*, translated by Alan Sheridan, Cambridge, MA: Harvard University Press, 1990, originally published as *Les filles de noce: misère sexuelle et prostitution (19e siècle)*, Paris: Flammarion, 1982. For mental illness, see Michel Foucault, *Madness and Civilization: A History of Insanity in the Age of Reason*, translated by Richard Howard, London: Tavistock Publications, 1971, originally published as *Folie et déraison; histoire de la folie à l'âge classique*, Paris: Plon, 1961. For connections between madness, masturbation, homosexuality and schizophrenia see Sander L. Gilman, *Disease and Representation: Images of Illness from Madness to AIDS*, Ithaca: Cornell University Press, 1988; for these themes in the context of race see Gilman, *Difference and Pathology: Stereotypes of Sexuality, Race, and Madness*, Ithaca: Cornell University Press, 1985; and *Freud, Race, and Gender*, Princeton, NJ: Princeton University Press, 1993. As Martha Hanna recounts, French writers had associated the newly invented "homosexuality" with Germany at least as early as 1896. See Hanna, "Natalism, Homosexuality, and the Controversy over *Corydon*," in *Homosexuality in Modern France*, edited by Jeffrey Merrick and Bryant T. Ragan, Jr., New York: Oxford University Press, 1996, p. 203 and note 7, p. 222; and also John Fout, "Sexual Politics in Wilhelmine Germany: The Male Gender Crisis, Moral Purity, and Homophobia," in *Forbidden History: The State, Society, and the Regulation of Sexuality in Modern Europe*, edited by Fout, Chicago: University of Chicago Press, 1992.

11 This naturalization of the supernatural had already occurred with the Romantics. See M. H. Abrams, *Natural Supernaturalism: Tradition and Revolution in Romantic Literature*, New York: Norton, 1971.

12 R. Girard, *Deceit, Desire and the Novel: Self and Other in Literary Structure*, translated by Y. Frecerro, Baltimore: Johns Hopkins University Press, 1976; originally published as *Mensonge romantique et vérité romanesque*, Paris: Grasset, 1961.

13 Although the label "Realist" is a useful point of entry, it "is not one that can be maintained once we start to think about what 'reality' in a work of literature can possibly be." See Alison Finch, "Reality and its Representation in the Nineteenth-Century Novel," *The Cambridge Companion to the French Novel from 1800 to the Present*, edited by Timothy Unwin, New York: Cambridge University Press, 1997, pp. 36–52; p. 37. See also A. Fairlie, *Flaubert: Madame Bovary*, London: Edward Arnold, 1962; M. Butor, "Balzac et la réalité," *Répertoire*, Paris: Minuit, 1960–82,

vol. I, pp. 79–93. C. Prendergast highlights the fact that language can never copy reality but as a code can only symbolize it. See Prendergast, *The Order of Mimesis*, New York: Cambridge University Press, 1986.

14 The life of the prostitute is traced from its beginnings [The Procuress] to its victimization [The Victim; One Year After] to its end [The End! Died in the Streets]. "The Vile Traffic," British Newspaper Library.

15 Alain Corbin describes this device: "When surveillance by parents and teachers failed, only a special orthopedic device could quell the adolescent's irrepressible need for solitary release and save him from premature senility or even death from loss of precious bodily fluid." *A History of Private Life. Vol. IV: From the Fires of Revolution to the Great War*. Edited by Michelle Perrot and translated by Arthur Goldhammer. Cambridge, MA: The Belknap Press of Harvard University Press, 1990, p. 495.

16 For the definitive edition see Émile Zola, *Les Rougon-Macquart*, vols. 1–5, Paris: Gallimard, 1960–67.

17 On associations of late-century consumption with hysteria and women's compulsions to shop see Patricia O'Brien, "The Kleptomania Diagnosis: Bourgeois Women and Theft in Late 19th-c. France," *Journal of Social History* 17, Fall 1983, pp. 65–77; and Leslie Camhi, "Stealing Femininity: Department Store Kleptomania as Sexual Disorder," *Differences* 5, 1993, pp. 26–50.

18 Vanessa R. Schwartz, *Spectacular Realities: Early Mass Culture in Fin-de-Siècle Paris*, Berkeley: University of California Press, 1998.

19 Schwartz, *Spectacular Realities*, pp. 76–79.

20 *L'Illustration*, December 10, 1881, in Schwartz, *Realities*, p. 121.

21 Letter from Grévin to Zola, July 6, 1881; in Schwartz, *Realities*, p. 122.

22 Émile Poulat, *Liberté, laïcité. La guerre des deux France et le principe de la modernité*, Paris: Éditions du Cerf, 1987.

23 The importance of the Republican educational system, along with innovations in transportation and the military as a means of consolidating the new Republic, is well-documented in Eugen Weber's classic *Peasants into Frenchmen. The Modernization of Rural France, 1870–1914*, Stanford: Stanford University Press, 1976. See also the chapter on Jules Ferry, Minister of Education and author of the Third Republic's educational system and colonialist policies in Jean-Marie Mayeur and Madelein Rebérioux, *The Third Republic From its Origins to the Great War, 1871–1914*, translated by J. R. Foster, Cambridge: Cambridge University Press, 1984, pp. 72–100. On the replacement of religious sisters as teachers with a newly invented "professional" class of female *instituteurs*, see Jo Burr Margadant, *Madame le Professeur. Women Educators in the Third Republic*, Princeton, NJ: Princeton University Press, 1990.

24 Marcelin Berthelot (1827–1907), an organic chemist as well as a man of politics, synthesized acetylene in 1860, thus demonstrating that it was possible to artificially create the molecules which comprised living beings — that is, without the intervention of some metaphysical *force vitale*. "Le monde est aujourd'hui sans mystère. La conception rationnelle prétend tout éclairer et tout comprendre: elle s'efforce de donner de toute chose une explication positive et logique, et elle étend son déterminisme fatal jusqu'au monde moral." Quoted in Gérard Cholvy and Yves-Marie Hilaire, *Histoire religieuse de la France contemporaine, 1880–1930*, vol. 3, Paris: Bibliothèque historique Privat, 1986, p. 143. Biographical information on Berthelot from *Le Petit Robert des noms propres*, edited by Alain Rey, revised edition, Paris: Dictionnaires Le Robert, 1997, p. 245.

25 Ernest Renan, *Vie de Jesus*, Paris: Michel Lévy Frères, 1863. In this historicist portrait, Jesus was painted as the supreme moral exemplar while at the same time stripped of all supernatural significance. This process of naturalizing the supernatural was theorized as "disenchantment," a necessary element in the process of "modernization," by the sociologist Max Weber. For Weber, "disenchantment" (*Entzauberung*, literally: the end of magic) means a world in which phenomena are no longer explained by gods and spirits but rather by laws scientifically investigated. For a succinct overview of Weber's narrative of modernity as the effect of *Kulturprotestantismus*, see Max Weber, "Religious Rejections of the World and Their Directions," in *From Max Weber: Essays in Sociology*, translated and edited by H. H. Gerth and C. Wright Mills, New York: Oxford University Press, 1946, pp. 323–59. For historicization of Weber's thesis as an artifact of late nineteenth-century confessional conflicts, see *Weber's 'Protestant Ethic': Origins, Evidence, Contexts*, edited by Hartmut Lehmann and Guenther Roth, New York: Cambridge University Press, 1993.

26 Ernest Renan, *L'avenir de la science—pensées de 1848* [1849], Paris: Calmann-Lévy, 1890; quoted in André Valenta, *Le Scientisme ou L'Incroyable séduction d'une doctrine erronée*, Evry: self-published, 1995, p. 10. Renan's book was published immediately after the Revolution of 1848, but it only achieved widespread notoriety (and translations into several languages) in 1890 during the Third Republic.

27 On the Third Republic's universalizing project and the suppression of local and particular differences, see Eugen Weber, *Peasants into Frenchman*; on the universalizing project of modernity in general and its suppression of the local, particular, and contingent, see Stephen Toulmin, *Cosmopolis*, cited above. For the close associations between anti-religious ideology and the French colonial project, see the work of Lucien Lévy-Bruhl: published approximately ten years apart, Lévy-Bruhl's three large works on primitive thought were: *Les fonctions mentales dans les sociétés inférieures*, Paris: F. Alcan, 1910; *La mentalité primitive*, Paris: Librairie Félix Alcan, 1922, and *Le surnaturel et la nature dans la mentalité primitive*, Paris: F. Alcan, 1931. For his early study on morality see *La morale et la science des moeurs*, Paris: F. Alcan, 1903. As the British translator of the 1923 edition put it, *Primitive Mentality* would enable "a colonizing country such as ours" to understand much better much that had been puzzling hitherto, especially "the very real sense in which the primitive 'participates' in the mystic nature of all that surrounds him, the way in which *he lives in the seen and the unseen worlds simultaneously*. . ." See Lilian A. Clare, "Translator's Note," in Lucien Lévy-Bruhl, *Primitive Mentality*, London: George Allen and Unwin Ltd., 1923, p. 5; originally published as *La mentalité primitive*, Paris: Alcan, 1922. On the paradoxes of the Republic's imperialist agenda see Alice L. Conklin, *Mission to Civilize: The Republican Idea of Empire in France & West Africa, 1895–1930*, Stanford: Stanford University Press, 1999.

28 The corpse of a four-year-old girl found in a stairwell at 47, rue du Vert-Bois is displayed. See Schwartz, *Spectacular Realities*, p. 77. When the corpse was put on display at the local morgue in August 1886, newspapers reported that about fifty thousand visitors came to see the body. Despite extra policing, the size of the crowd forced the traffic in front to a halt while vendors turned the quai de l'Archêveché into "a genuine fairgrounds, hawking coconut, gingerbread, and toys." Not coincidentally, this was the era of the invention of the department store: see Michael

Miller, *The Bon Marché: Bourgeois Culture and the Department Store, 1869–1920*, Princeton, NJ: Princeton University Press, 1981. Émile Zola published *Au Bonheur des dames*, his "realist novel" of the department store and its effect on women, in 1885. It was translated immediately into English; see *The Ladies' Paradise: A Realistic Novel*, London: Vizetelly, 1887.

29 In January 1886 the Musée Grevin opened a scene from Zola's *Germinal*. This tableau represented a typically bleak scene at the end of the novel: Etienne has just killed Chaval and the mine has just flooded. Etienne and Catherine, trapped and about to die, make love not far from the corpse. The wax representation hoped to be worthy of its ultra-realist subject matter. "Here is a real mine shaft," reported a tabloid, "black and deep with pieces of real coal and its timbers that were taken from the depths of the shafts at Anzin. Everything is of the most exact nature. . . . As we already said, all is real . . . the timbers, the lamps, the tools, right down to the clothing that is worn by *real* miners." *L'Illustration*, January 2, 1886, in Schwartz, *Realities*, p. 123.

30 Jacques Barzun, *Darwin, Marx, Wagner: Critique of a Heritage*, Boston: Little, Brown and Company, 1941, pp. 351–2.

31 As Eugen Weber recounts, a farmer in the *fin-de-siècle* returned from the railway station with a cartful of fertilizer and met the priest. "What are you carting there?" asked the curate. "Chemicals," replied the farmer. "But that is very bad," admonished the priest; "they burn the soil!" "Monsieur le curé," said the farmer, "I've tried everything. I've had masses said and got no profit from them. I've bought chemicals and they worked. I'll stick to the better merchandise." Weber concludes, "It was the requiem of nineteenth-century religion." Weber, *Peasants into Frenchmen*, p. 356. Weber quotes historian Keith Thomas who "suggests that fertilizers replaced fertility rites. But he says this about Tudor England. We find it happening in the days of Jean Jaurès." Keith Thomas, *Religion and the Decline of Magic: Studies in Popular Beliefs in Sixteenth and Seventeenth-Century England*, London: Weidenfeld & Nicolson, 1971, p. 792; in Weber, *Peasants into Frenchmen*, p. 356.

32 Smith, *Munch*, pp. 6–8.

33 Quoted in Smith, *Munch*, p. 5.

34 During the Paris Commune of 1871, various socialist groups of citizens staged an insurrection against the provisional government set up after the French defeat in the Franco-Prussian War. During "the bloody week" of May 21, government troops massacred about 20,000 Communards and permanently exiled the working-class masses out to the "Red Belt" surrounding Paris. Afterward, 38,000 more were arrested and 7,000 deported. This irrevocably altered the relationship between Liberalism and the Left in France. For a wonderfully readable account see Rupert Christiansen, *Paris Babylon: The Story of the Paris Commune*, New York: Viking, 1995.

35 Carl Naerup, *Skildringer og Stemminger fra den yngre Litteratur* [Kristiania: 1897], p. 78; in Reinhold Heller, "Edvard Munch's *Night*, the Aesthetics of Decadence, and the Content of Biography," *Arts Magazine* vol. 53, no. 2, October 1978, p. 83. Hereafter, "Decadence."

36 Heller, "Decadence," p. 83.

37 Christian Krohg, "Tredje Generation," *Verdens Gang*, April 27, 1889; reprinted in Krohg, *Kampen for Tilvaerelsen*, second edition, Oslo: Gyldenal Norsk Verlag, 1952, pp. 172–174; in Heller, "Decadence," p. 81.

38 A new generation comes and replaces an outmoded one in a natural evolutionary moment rooted in the biological

processes. "The twilight of legitimacy, the dawn of the notion of generation. The past is no longer the law: this is the very essence of the phenomenon." See Pierre Nora, "Generation," in *Realms of Memory: Rethinking the French Past. V. 1. Conflicts and Divisions*, under the direction of Pierre Nora; English language edition edited and with a foreword by Lawrence D. Kritzman; translated by Arthur Goldhammer, New York: Columbia University Press, 1996, pp. 499–531; here, p. 502. The discourse of "generations" has its roots in the French Revolution: the Declaration of the Rights of Man of 1793—Condorcet's text—proclaims that "a generation has no right to subject any future generation to its laws" (Article 30). As Saint-Just summed up the revolutionary measures, "You have therefore decided that one generation cannot place another in chains."

39 Jean Cassou, "Munch en France," *Oslo Kommunes Kunstsamlingers. Aarbok,* Oslo: Oslo Kommunes Kunstsamlingers, 1963, p. 124.

40 In Cassou, "Munch en France," p. 124.

41 Suggested by Smith, *Munch*, p. 8.

42 Suggested by Heller, "Decadence," p. 101.

43 Smith, *Munch*, p. 8.

44 Hermann Bahr, "Maurice Maeterlinck," *Ueberwindung*, p. 196; in Heller, "Decadence," p. 86. Translation altered.

45 Letter of Emmanuel Goldstein to Edvard Munch, dated "Copenhagen, 30 Dec. 1891," in Heller, "Decadence," p. 95.

46 As Baudelaire wrote in *Fusées*: "Two fundamental literary qualities: supernaturalism and irony." ("Deux qualités littéraires fondamentales: surnaturalisme et ironie.") See Max Milner, "Baudelaire et le surnaturalisme," in *Le Surnaturalisme français: actes du colloque organisé à l'Université Vanderbilt les 31 mars et 1er avril 1978*, edited by Jean Leblon and Claude Pichois, Neuchâtel: Éditions de la Baconnière, 1979, pp. 31–49.

47 Charles Baudelaire, "The Painter of Modern Life," 1863, in *The Painter of Modern Life and Other Essays*, translated by Jonathan Mayne, London: Phaidon Press Ltd., 1964, p. 3. Emphasis added. Baudelaire (1821–1867) inherited the Romantic tradition even as he watched the destruction of medieval Paris by Baron von Haussman. Consequently, he forged a modernist esthetic vision which sought to represent a lasting element underlying a rapidly-changing world. For the classic interpretation of Baudelaire and his relationship to the new Paris of Napoléon III see Walter Benjamin's essays "The Paris of the Second Empire in Baudelaire" (1938), "Some Motifs in Baudelaire" (1939), and "Paris—the Capital of the Nineteenth Century" (1935), collected in *Charles Baudelaire: A Lyric Poet in the Era of High Capitalism*, translated by Harry Zohn, New York: Verso, 1976. "Some Motifs in Baudelaire" is also available along with "An Introduction to the Translation of Baudelaire's *Tableaux parisiens*" in Benjamin's *Illuminations. Essays and Reflections*, edited by Hannah Arendt, translated by Harry Zohn, New York: Schocken, 1968. See also David P. Jordan's *Transforming Paris: the Life and Labors of Baron Haussmann*, New York: Free Press, 1995.

48 After 1848, traditional forms of artistic patronage—aristocratic, ecclesiastical and monarchical—gave way to a market form of artistic competition. Artists were forced to become the inventors of fashion, producing, in David Harvey's phrase, "a work of art, a once and for all creation . . . a cultural object that would be original, unique, and hence eminently marketable at a monopoly price." See David Harvey, *Condition of Postmodernity*, Cambridge, MA: Blackwell, 1990, p. 22. Baudelaire's 1863 essay "The Painter of Modern Life" appeared the same year as Manet's controversial painting, *Olympia*. For a discussion of com-

modification in the newly modernist context of post-Haussmannization, see T. J. Clark, *The Painting of Modern Life: Paris in the Art of Manet and his Followers,* Princeton, NJ: Princeton University Press, 1984, esp. pp. 79–146.

49 In the eighteenth century, Saint-Simon had imagined art as the new religion and the artists as the new priesthood: "It is we, artists, who will serve you as avant-garde. What a most beautiful destiny for the arts, that of exercising over society a positive power, a true priestly function, and of marching forcefully in the van of all the intellectual faculties in the epoch of their greatest development!" However, the new technical capacity to reproduce, distribute and sell books and images to mass audiences changed the social and political role of the artist. If a photograph could faithfully reproduce mimetic resemblances of reality and, better yet, quickly manufacture multiple copies for a wide audience, what role was left for the artist? In addition, the commodification and commercialization of a market for cultural products during the nineteenth century forced cultural producers into a market form of competition. This shift from artist-as-priest to artist-as-magician led Walter Benjamin to call modernist art "auratic" in the sense that "the artist had to assume an aura of creativity, of dedication to art for art's sake, in order to produce a cultural object that would be original, unique, and hence eminently marketable at a monopoly price. The result was often a highly individualistic, aristocratic, disdainful (particularly of popular culture), and even arrogant perspective on the part of cultural producers. . ." David Harvey summarizing the theory of Benjamin. See Harvey, *Condition of Postmodernity*, pp. 19–20, 22; and Walter Benjamin, "The Work of Art in the Age of Mechanical Reproduction," in *Illuminations*, edited by Hannah Arendt, New York: Harcourt, Brace & World, 1955, pp. 217–252. Saint-Simon quoted in Daniel Bell, *The Cultural Contradictions of Capitalism*, New York: Basic Books, 1976, p. 35; and Renato Poggioli, *The Theory of the Avant-Garde*, translated by Gerald Fitzgerald, Cambridge, MA: Belknap Press of Harvard University Press, 1968, p. 9.

50 Charles Baudelaire, "Correspondences," *Les Fleurs du Mal*, trans. Richard Howard, Boston: David R. Godine, 1982.

51 The phrase is from Peter Nicholls, *Modernisms. A Literary Guide,* Berkeley: University of California Press, 1995, p. 5.

52 *Baudelaire: Selected Writings on Art and Artists*, translated by P. E. Charvet, Harmondsworth: Penguin Books, 1972, p. 391; in Nicholls, *Modernisms*, p. 5.

53 For the Enlightenment philosophes and the Liberal historians (e.g., Lecky and J. B. Bury) who followed them, "the progress of truth consisted in the light of science invading dark chambers inhabited by mysticism, until at last no darkness should be left. . . . The problem of 'enlightenment' began to turn into the new problem of 'secularization.'" Owen Chadwick, *The Secularization of the European Mind in the Nineteenth Century*, New York: Cambridge University Press, 1975, pp. 15, 7.

54 What Habermas calls the project of modernity came into focus during the eighteenth century as an attempt "to develop objective science, universal morality and law, and autonomous art according to their inner logic." Following Ernst Cassirer's account, Harvey summarizes Enlightenment thought as embracing "the idea of progress," and actively seeking "that break with history and tradition which modernity espouses. It was, above all, a secular movement that sought the demystification and desacralization of knowledge and social organization in order to liberate human beings from their chains." Rational modes of thought and forms of social organization "promised libera-

tion from the irrationalities of myth, religion, superstition, release from the arbitrary use of power as well as from the dark side of our own human natures. Only through such a project could the *universal, eternal, and the immutable qualities of all humanity* be revealed." See Jürgen Habermas, "Modernity: an Incomplete Project," in Hal Foster, editor, *The Anti-aesthetic: Essays on Postmodern Culture*, Port Townsend, WA: Bay Press, 1983, p. 9; Ernst Cassirer, *The Philosophy of the Enlightenment*, translated by Fritz C. A. Koelln and James P. Pettegrove, Princeton, NJ: Princeton University Press, 1951; Harvey, *Condition of Postmodernity*, pp. 12–13. Emphasis added.

55 On the conflicted origins of modernity and its ambivalent attitudes towards both the particular and the universal, see Stephen Toulmin, *Cosmopolis: the Hidden Agenda of Modernity*, New York: Free Press, 1990.

56 The Symbolist movement had a complex genealogy which included: Gustave Moreau's paintings (such as *Oedipus and the Sphinx*, 1864) and Odilon Redon's lithographs (such as *Dans le Rêve*, 1879); the literature of J.-K. Huysmans whose descriptions of Moreau's work in *À Rebours* (1884) solidified Moreau's place as the movement's master); the music and operas of Richard Wagner, especially as interpreted in the *Revue Wagnérienne* (begun in 1885); and the name as coined in a manifesto by a minor poet, Jean Moréas, in *Le Figaro*, September 18, 1886. For a succinct introduction, see Edward Lucie-Smith, *Symbolist Art*, London: Thames and Hudson, 1972.

57 The study of the Decadent movement has exploded within the last twenty years. See, for example, in order of publication: Jean Pierrot, *The Decadent Imagination 1880–1900*, translated by Derek Coltman, Chicago: University of Chicago Press, 1981; Murray G. H. Pittock, *Spectrum of Decadence. The Literature of the 1890s*, New York: Routledge, 1993; R. K. R. Thornton, *The Decadent Dilemma*, London: Edward Arnold, 1983; Barbara Spackman, *Decadent Genealogies: The Rhetoric of Sickness from Baudelaire to D'Annunzio*, Ithaca: Cornell University Press, 1989; Jean de Palacio, *Figures et formes de la décadence*, Paris: Nouvelles Editions Séguier, 1994; David Weir, *Decadence and the Making of Modernism*, Amherst: University of Massachusetts Press, 1995; *The Decadent Reader: Fiction, Fantasy, and Perversion from Fin-De-Siècle France*, edited by Asti Hustvedt, Cambridge, MA: MIT Press, 1998; and *Decadents, Symbolists, & Aesthetes in America. Fin-de-Siècle American Poetry: An Anthology*, edited by Edward Foster, Jersey City, NJ: Talisman House, 2000.

58 Théophile Gautier, "Charles Baudelaire," in Baudelaire, *Les Fleurs du mal*, Paris: Lévy, 1868, p. 17; in Heller, "Decadence," p. 82.

59 For an excellent overview of "neurasthenia" see Anson Rabinbach, *The Human Motor: Energy, Fatigue, and the Rise of Modernity*, New York: Basic Books, 1990.

60 Charcot's exact term for "homosexuality" was "inversion of the genital sense" *(inversion du sens génital)*. However, since the French *sens* also means "way" or "direction" (as when a street sign indicates, "*sens unique*," meaning "one-way street"), it also connotes going "the wrong way" (*à rebours*). See Vernon A. Rosario II, "Pointy Penises, Fashion Crimes, and Hysterical Mollies. The Pederasts' Inversions," in *Homosexuality in Modern France*, edited by Jeffrey Merrick and Bryant T. Ragan, Jr., New York: Oxford University Press, 1996, pp. 146–176; and Rosario, *The Erotic Imagination. French Histories of Perversity*, New York: Oxford University Press, 1997. For a general overview of the modern move from morality to medicine in sexuality, see Thomas Laqueur, *Making Sex: Body and Gender from the Greeks to Freud*, Cambridge, MA: Harvard University Press, 1990.

61 Jan Goldstein, *Console and Classify: The French Psychiatric Profession in the Nineteenth Century*, New York: Cambridge University Press, 1987; "The Hysteria Diagnosis and the Politics of Anticlericalism in Later Nineteenth-Century France," *Journal of Modern History* 54, 1982, pp. 209–39; and "The Uses of Male Hysteria: Medical and Literary Discourse in Nineteenth-Century France," *Representations* 34, Spring 1991, pp. 134–165. See also Foucault, *History of Sexuality*, cited above.

62 See Goldstein, *Console and Classify*, p. 237: "An engraving from an 1881 text by a member of the Salpêtrière school unabashedly emphasizes the grotesqueness of a woman in the throes of this pathology."

63 See Goldstein, *Console and Classify*, p. 236: "This newspaper cartoon from the early Third Republic comments on the candidacy of Dr. D.-M. Bourneville for the Chamber of Deputies from the fifth arrondissement of Paris. For the cartoonist, Bourneville's whole identity as a politician is bound up with anti-clericalism. The candidate champions the laicization of the Paris public hospitals (note the fleeing nursing sisters in the lower left-hand corner). He edits the Bibliothèque Diabolique (in whose doorway he stands), the series of books reinterpreting famous episodes of demonic possession as instances of hysterical pathology. Bourneville's bid for election in 1883 proved successful."

64 Edmond et Jules de Goncourt, April 11, 1857, *Journal, Mémoires de la vie littéraire*, Paris: Laffont, coll. "Bouquins,"1989, p. 1:248.

65 *L'Hystérique* was very likely inspired by Louise Lateau (1850–1883), a Belgian woman who was a famous instance of a stigmatic. Her case was examined by the medical establishment, which was unable to find an explanation for her wounds. The novel has been recently republished with an excellent preface by Éléonore Roy-Reverzy situating the *fin-de-siècle* concern over hysteria and women's bodies within its historical context, has been recently republished as Camille Lemonnier, *L'Hystérique* [1885], Paris: Nouvelles Éditions Séguier, 1996. The phrase "une sorte de Zola flaman" is from Roy-Reverzy's "Présentation," p. 7.

66 Following René Girard's use of the term "erotic" (in *Violence and the Sacred*) to refer to "all forms of violence and rupture as it is related to the experience of otherness" (i.e., the irrational), Donald Leach writes: "The naturalist, representative of late nineteenth-century culture generally, *seeks to deny natural disorder by humanizing, ideologizing, representing it*. This obsession with ideological order explains the obsession of Huysmans' culture with natural disorder in all its forms: sexuality, sickness, insanity, crime, poverty, to name only a few examples . . . An authentic aspiration towards totality requires of man that *he embrace the otherness which is his corporeal self*, the objectivity of his body. This act is the essence of eroticism." I owe this approach to Donald Lee Leach, *Ideological Order and Erotic Disorder in the Conversion of J.-K. Huysmans from Naturalism to Catholicism*, Ann Arbor, MI: University Microfilms, 1989, p. 126. Emphases added. For Decadence as a series of counterfeit values intended to devalue Naturalist categories of meaning and representation, see Leonard Koos, *Decadence: A Literature of Travesty*, Ann Arbor, MI: University Microfilms, 1990.

67 Huysmans' "Émile Zola et *L'Assommoir*" was published in *L'Actualité*, a Belgian newspaper headed by his friend Camille Lemonnier, the author of *L'Hystérique* (see note 65).

68 George Ross Ridge, *J.-K. Huysmans*, New York: Twayne, 1968, p. 17; Henry M. Gallot, *Explication de J.-K. Huysmans*, Paris: Agence parisienne de Distribution, 1955, p. 68; Henry Brandreth, *Huysmans*, New York: Hillary, 1963, p. 23; all cited in Ruth B. Antosh, "Huysmans' Doctrine of Spiritual Naturalism," *Reality and Illusion in the Novels of J.-K. Huysmans*, Amsterdam: Rodopi, 1986, p. 14.

69 Gustave Flaubert, *Oeuvres complètes*, VIII, p. 224; in Antosh, "Spiritual Naturalism," p. 24.

70 Antosh, "Spiritual Naturalism," 25.

71 Ted Gott, "Odilon Redon," in *Paris in the Late Nineteenth Century*, edited by Jane Kinsman, Canberra: National Gallery of Australia; New York: Distributed by Thames and Hudson, 1996, p. 148.

72 Émile Zola quoted by J.-K. Huysmans, 1894 Preface to *À Rebours*, 1884, reprint, "Paris: Garnier-Flammarion, 1978, p. 55; in Theodore P. Fraser, *The Modern Catholic Novel in Europe*, New York: MacMillan; Twayne Publishers, 1994, p. 16.

73 For the dandy as a modernist icon, see Marshall Berman, *All That is Solid Melts into Air: The Experience of Modernity*, London: Verso, 1983, pp. 53–4. Berman draws directly on Baudelaire's essay on "The Painter of Modern Life"; the section on the Heroism of Modern Life cites the Dandy as a modern hero. For a critique of the gender implicit in the construction of modernity, see Rita Felski, *The Gender of Modernity*, Cambridge, MA: Harvard University Press, 1995. As Felski says with respect to Marshall Berman's reading of the tradition: "All the exemplary heroes of his text—Faust, Marx, Baudelaire—are of course symbols not just of modernity, but also of masculinity, historical markers of the emergence of new forms of bourgeois and working-class male subjectivity. Both in Berman's account of Faust and in his later evocation of Baudelaire's flâneur, the stroller who goes botanizing on the asphalt of the streets of Paris, the modern individual is assumed to be an autonomous male free of familial and communal ties . . ." Felski, *Gender of Modernity*, p. 2.

74 Although Des Esseintes is male, the association of femininity with physical disorder remained constant in Huysmans' move from naturalism to Catholicism. Just as the naturalist takes femininity as the object of his science, so in the decadent novels women tend to be the locus of the inexplicable. After Huysmans' conversion, the woman's body becomes the privileged site of both divine action and satanic temptation. See Leach, *Ideological Order and Erotic Disorder*.

75 Ellis Hanson, *Decadence and Catholicism*, Cambridge, MA: Harvard University Press, 1997, pp. 5, 11. Hanson examines in detail the cases of Verlaine and Huysmans in France and Pater and Wilde in England.

76 See for example these illuminating titles: Abbé Jules Pacheu, *De Dante à Verlaine; études d'idéalistes et mystiques: Dante, Spenser, Bunyan, Shelley, Verlaine, Huysmans*, Paris: Plon, Nourrit, 1897; and *Du Positivisme au mysticisme. Étude sur l'inquiétude religieuse contemporaine*, Paris: Librairie Bloud et cie, 1906; Henri Bachelin, *J.-K. Huysmans, du naturalisme littéraire au naturalisme mystique*, second edition, Paris: Perrin, 1926.

77 For an overview of the Catholic Revival in general, see Richard Griffiths, *The Reactionary Revolution. The Catholic Revival in French Literature 1870–1914*, New York: Frederick Ungar Publishing Co., 1965. The title of the French translation is instructive in its allusion to Huysmans: *Révolution à rebours. Le renouveau catholique dans la littérature en France de 1870 à 1914*, Paris: Desclée de Brouwer, 1971. For two recent studies see Elke Lind-horst, *Die Dialektik von Geistesgeschichte une Literatur in der modernen Literatur Frankreichs: Dichtung in der Tradition des "renouveau catholique" von 1890–1990*, Würzburg: Königshausen & Neumann, 1995; and Frédéric Gugelot, *La conversion des intellectuels au catholicisme en France 1885–1935*, Paris: CNRS Éditions, 1998. Gugelot has assembled a helpful bibliography.

For primary sources in the study of the *renouveau catholique* see for example: Abbé Julien Laurec, *Le Renouveau catholique dans les lettres*, Paris: P. Feron-Vrau, 1917; Thomas Mainage, O.P., *Les Témoins du renouveau catholique*, sixth edition, Paris: G. Beauchesne, 1919; *La Psychologie de la conversion: leçons données à l'Institut Catholique de Paris (1914)* Paris: G. Beauchesne, 1915; and *Le Témoignage des apostats; leçons données à l'Institut Catholique (1915–1916)*, Paris: G. Beauchesne, 1916; Louis Rouzic, *Le Renouveau catholique. Les Jeunes avant la guerre*, second edition, Paris: P. Tequi, 1919; Jean-Antoine Calvet, *Pour refaire la France*, Paris: n.p., 1919; *Le Renouveau catholique dans la littérature contemporaine*, Paris: F. Lanore, 1927; and *D'une critique catholique*, Paris: Éditions Spes, 1927; Claude Romain, *Le Catholicisme de quelques contemporains*, Paris: Librairie Aniéré, Victorion Frères & Cie, 1933. Hermann Weinert, *Dichtung aus dem Glauben. Ein beitrag zur problematik des literarische renouveau catholique in Frankreich*, Hamburg: Hamburg Seminar für Romanische Sprachen und Kultur, 1934. Elizabeth Fraser, *Le Renouveau religieux d'après le roman français de 1886 à 1914*, Paris, Société d'édition "Les Belles Lettres," 1934; Joseph Ageorges, *Le Manuel de littérature catholique en France de 1870 à nos jours*, Paris: Éditions Spes, 1939; Louis Chaigne, *Anthologie de la renaissance catholique*, 3 vols., Paris: Éditions «Alsatia», 1938–1940; and the ongoing six-volume study, Louis Alphonse Maugendre, *La Renaissance catholique au debut du XXe siècle*, 6 vols., Paris: Beauchesne, 1963–.

78 J.-K. Huysmans, *Against the Grain (À Rebours)*, translator unknown, New York: Dover Publications [1931] 1969, pp. 133–135; in Huysmans, *Oeuvres complètes de J.-K. Huysmans*, Paris: Éditions G. Crès et Cie, 1929, VII, pp. 216–218.

79 See Pierre Lambert's note 5 in *Lettres inédites à Edmond de Goncourt*, edited by Pierre Lambert, Paris: Librairie Nizet, 1956, p. 73; and Antosh, "Spiritual Naturalism," pp. 27–28.

80 J.-K. Huysmans to Edmond de Goncourt, dated "Paris, 19 January 1882," in *Lettres à Edmond de Goncourt*, p. 70.

81 Huysmans, *Against the Grain*, p. 170; in Huysmans, *Oeuvres complètes*, VII, p. 275.

82 See Ruth Brandon, *The Spiritualists: The Passion for the Occult in the Nineteenth and Twentieth Centuries*, New York: Alfred A. Knopf, 1983.

83 See Daniel Pick, *Svengali's Web: The Alien Enchanter in Modern Culture*, New Haven: Yale University Press, 2000; Alison Winter, *Mesmerized: Powers of Mind in Victorian Britain*, Chicago: University of Chicago Press, 1998; Robert Darnton, *Mesmerism and the End of the Enlightenment in France* [1968], Cambridge, MA: Harvard University Press, 1995.

84 Allen Putnam, *Mesmerism, Spiritualism, Witchcraft and Miracle: A Brief Treatise Showing that Mesmerism is a Key which will Unlock Many Chambers of Mystery*, Boston: Colby & Rich, 1890. For a contemporary overview see William B. Carpenter, *Mesmerism, Spiritualism, &c.: Historically & Scientifically Considered*, New York: D. Appleton and Co., 1895. For a recent cultural history see Derek Forrest, *The Evolution of Hypnotism*, Scotland: Black Ace Books, 1999.

85　See the excellent study by Ann Taves, *Fits, Trances, & Visions: Experiencing Religion and Explaining Experience from Wesley to James*, Princeton, NJ: Princeton University Press, 1999. For links between prostitution and the séance, see the chapter "Science and the Séance: Transgressions of Gender and Genre," in Judith R. Walkowitz, *City of Dreadful Delight: Narratives of Sexual Danger in Late-Victorian London*, Chicago: University of Chicago Press, 1992, pp. 171–189. William James published his masterwork in 1902: *The Varieties of Religious Experience*, New York; London: Longmans, Green, 1902.

86　For recent cultural histories of apparitions, see: David Blackbourn, *Apparitions of the Virgin Mary in Nineteenth-century Germany*, New York: Knopf, 1994; Ruth Harris, *Lourdes: Body and Spirit in the Secular Age*, New York: Viking Press, 1999; and William A. Christian, *Visionaries: The Spanish Republic and the Reign of Christ*, Berkeley: University of California Press, 1996.

87　Émile Zola, *Lourdes*, Paris, G. Charpentier et E. Fasquelle, 1894. For a reply to criticism of his "Lourdes" in a letter dated July 31, 1894, see Zola, *À propos de Lourdes*, Lyon: Société des Amis des Livres, 1894; for a statement by Waldeck-Rousseau on behalf of Zola in a libel suit, see Pierre-Marie-René Waldeck-Rousseau, *M. Bourgeois contre M. Zola à propos de Lourdes: plaidoirie de Me Waldeck-Rousseau pour M. Émile Zola*, Paris: G. Charpentier et E. Fasquelle, 1895. Waldeck-Rousseau, a senator, became premier of France in a government of "republican defense" in response to the Dreyfus Affair in 1899.

88　John J. Cerullo, *The Secularization of the Soul: Psychical Research in Modern Britain*, Philadelphia: Institute for the Study of Human Issues, 1982; Alan Gould, *The Founders of Psychical Research*, New York: Schocken, 1968; and Janet Oppenheim, *The Other World: Spiritualism and Psychical Research in England, 1850–1914*, Cambridge: Cambridge University Press, 1985; Thomas Leahey and Grace Leahey, *Psychology's Occult Doubles*, Chicago: Nelson-Hall, 1983; John C. Burnham, *How Superstition Won and Science Lost: Popularizing Science and Health in the United States*, New Brunswick, NJ: Rutgers University Press, 1987.

89　See Robert G. Hillman, "A Scientific Study of Mystery: The Role of the Medical and Popular Press in the Nancy-Salpêtrière Controversy on Hypnotism," *Bulletin of the History of Medicine* 39, 1965, pp. 163–182.

90　For helpful overviews of the Charcot-Freud relationship, see Adam Crabtree, *From Mesmer to Freud: Magnetic Sleep and the Roots of Psychological Healing*, New Haven: Yale University Press, 1993; and Maria M. Tatar, *Spellbound: Studies on Mesmerism and Literature*, Princeton, NJ: Princeton University Press, 1978. The phrase is Tatar's.

91　Thorstein Veblen coined the theory "conspicuous consumption" in his *Theory of the Leisure Class*, New York: Macmillan, 1899.

92　One upper-class New York cosmopolite, a graduate of both Yale and Columbia, wrote in apocalyptic terms: "It may be said in conclusion, and without any attempt at the discursive, that the moral atmosphere of the present century is charged with three distinct disturbances—the waning of religious belief, the insatiable demand for intense sensations, and the increasing number of those who live uncompanied, and walk abroad in solitude. . . . The immense nausea that is spreading through all lands and literature is at work on the simple faith, the contented lives, and joyous good-fellowship of earlier days, and in its results it brings with it the signs and portents of a forthcoming though undetermined upheaval." Edgar Saltus, *The Philosophy of Disenchantment*, New York: Houghton, Mifflin, and Co., 1885; in Foster, *Decadents, Symbolists & Aesthetes in America*.

93　See Alison Winter on "Colonizing Sensations in Victorian India," in *Mesmerized: Powers of Mind in Victorian Britain*, p. 199.

94　See *Ethics and Morality*, English 2–3; also above, section 2, "Analytic Abstraction vs. Synthetic Concreteness."

95　*Les fonctions mentales dans les sociétés inférieures*, Paris: F. Alcan, 1910.

96　Daniel Pick, *Svengali's Web*, pp. 144–146.

97　In this engraving, the figure of death in the lower right corner releases its grip on the woman who lets go of her crutches in a "supplication" pose to the Virgin Mary. See Ruth Harris, *Lourdes: Body and Spirit in the Secular Age*, New York: Viking, 1999, p. 286.

98　See Harris, *Lourdes*, p. 338: "Two devils, one carrying Zola's *Lourdes*, look at the crowds before the Grotto and wonder why their attempts to undermine the shrine have met with so little success."

99　See Harris, *Lourdes*, p. 263.

100　Alison Winter writes, "In this example of mesmeric 'autographisme' from the journal *La Nature* (1890), a hysterical French patient of Dr. Mesnet made her body write the words 'La Nature' on her back. Readers were to understand that the phenomenon was caused by 'natural law' and not from 'supernatural' sources." *Mesmerized. Powers of Mind in Victorian Britain*. Chicago: University of Chicago Press, 1998, p. 352.

101　The Editors (i.e., Anatole Baju), "Aux Lecteurs," *Le Décadent litteraire et artistique* [April 10, 1886]; in Noel Richard, *Le Mouvement décadent: dandys, esthétes et quintessents*, Paris: Librairie Nizet, 1968, p. 27; in Heller, "Decadence," p. 82.

102　Anatole Baju, *L'École décadente*, Paris: 1887, p. 5; in Richard, *Mouvement décadent*, p. 26; in Heller, "Decadence," p. 82.

103　J.-K. Huysmans to Abbé Boullan, February 7, 1890, in Robert Baldick, *La Vie de J.-K. Huysmans*, Paris: Denoël, 1958, p. 195; quoted in Marc Eigeldinger, "Du supranaturalisme au surréalisme," *Le Surnaturalisme français: actes du colloque organisé à l'Université Vanderbilt les 31 mars et 1er avril 1978*, edited by Jean Leblon and Claude Pichois, Neuchâtel: Éditions de la Baconnière, 1979, p. 115. Translation mine.

104　Earlier in the same letter Huysmans wrote: "I have finished my book on Satanism, which is enormous (five hundred tightly packed pages!) . . . I expect nothing from it . . . I am resigned knowing that the reading public and the press like only badly put together books, whose documentation is worthless, false or falsified, as all Zola's are; he doesn't check them, and doesn't give a damn." J.-K. Huysmans to Jules Destrée, December 12, 1890, in *The Road from Decadence: From Brothel to Cloister. Selected Letters of J.-K. Huysmans*, edited and translated by Barbara Beaumont, London: The Athlone Press, 1989, p. 105.

105　See the chapter entitled "Huysmans' Mystérique" (a pun on Charcot's *hystérique*) in Hanson, *Decadence and Catholicism*, especially pp. 122–123.

106　As one reviewer summed up *Là-bas*: "Popular sorcery, mesmerism, spiritism, hypnotism, the oriental thaumaturgies of one sort or another that are so popular these days— all of this has certainly been touched upon, and to some effect, in the modern novel. But no-one has yet endeavored in this form, based on personal observation and using authentic documents, a study of the Satanism of today. That is what J.-K. Huysmans has done, audaciously and successfully, in his book *Là-bas* . . ." B.-H. Gausseron,

"Conférence bibliologique sur la littérature d'actualité," *Le livre moderne*, May 10, 1891, pp. 280–281, in Ted Gott, "Odilon Redon," p. 148.

107 ". . . des mystères qui nous entourent": the phrase repeats exactly that in Husymans' letter to Abbé Boullan a year earlier, February 7, 1890, cited above. Emphasis added.

108 *Down There*, pp. 1–2. Translation altered.

109 The passage continues: "No, come to think it over, the effrontery of the positivists is appalling. They decree that Satanism does not exist. They lay everything at the account of major hysteria, and they don't even know what this frightful malady is and what are its causes. No doubt Charcot determines very well the phases of the attack, notes the nonsensical and passional attitudes, the contortionistic movements; he discovers hysterogenetic zones and can, by skilfully manipulating the ovaries, arrest or accelerate the crises, but as for foreseeing them and learning the sources and the motives and curing them, that's another thing. Science goes all to pieces on the question of this inexplicable, stupefying malady, which, consequently, is subject to the most diversified interpretations, not one of which can be declared exact. For the soul enters into this, the soul in conflict with the body, the soul overthrown in the demoralization of the nerves. You see, old man, all this is as dark as a bottle of ink. Mystery is everywhere and reason cannot see its way." *Down There*, pp. 143, 154.

110 *Down There*, pp. 4–5. Emphasis added.

111 This reading is heavily indebted to the chapter "J.-K. Huysmans" in René Dumesnil, *Le Réalisme*, Paris: J. de Gigord, 1936, pp. 433–46. *Le Réalisme* was the ninth volume of *Histoire de la littérature française*, edited by Mgr. Jean-Antoine Calvet, a significant figure in the Catholic Revival. See his volumes *Le Renouveau catholique dans la littérature contemporaine* (1927) and *D'une critique catholique* (1927), cited above.

112 By employing the grotesque to evoke metaphysical and even spiritual significance, Huysmans created a trajectory which would be followed by a long line of Catholic novelists: François Mauriac and Georges Bernanos in France, Graham Greene in Britain, Flannery O'Connor in the United States. For a helpful investigation into the grotesque and religion see *The Grotesque in Art and Literature: Theological Reflections*, edited by James Luther Adams and Wilson Yates, Grand Rapids, MI: Wm. B. Eerdmans Publishing Co., 1997.

113 The word "au-delà" can mean simply "beyond" as well as in a religious sense: "the great beyond." The text of this letter to an unknown admirer is printed in *L'Amateur d'Autographes: Revue rétrospective et contemporaine*, June 1907, p. 166; in Antosh, "Spiritual Naturalism," p. 29. Translation mine.

114 Pie Duployé, *Huysmans*, Paris: Bruges: Desclée de Brouwer, 1968, p. 65; in Antosh, "Spiritual Naturalism," p. 30.

115 Smith, *Munch*, p. 8. One should note that Munch had been prepared for this turn by his exposure to German art in the preceding decade, e.g., that of the Swiss Arnold Böcklin and Max Klinger.

116 Arne Garborg, "Den idealistiske reaktion," *Dagbladet*, June-July 1890, translated and reprinted as "Neuidealismus," *Freie Bühne* I, 1890. The article was praised by Hermann Bahr in "Die Krisis des Naturalismus," *Die Überwindung des Naturalismus als zweite Reihe von "Zur Kritik der Moderne,"* Dresden: E. Pierson, 1891, p. 66; in Heller, "Decadence," p. 94.

117 "Youthfulness" suggests the prerogative of a new generation to assume power after history has passed by the generation of the fathers. As Pierre Nora notes, the ideology of "youthfulness" as rightfully assuming its historical role

and supplanting the *ancien régime* must be seen in terms of "an inversion of what one might call the age-prestige pyramid." More than a word, the ideology of "youthfulness" implies an opposite word - *gerontocracy*. See Pierre Nora, "Generation," p. 510 and footnote 46: "Robert's dictionary attributes the word to Béranger in 1825, but Fazy, *De la gérontocratie ou abus de la sagesse des vieillards dans le gouvernement de la France* (Paris, 1928), writes of 'this new word, which I have put together out of the language of the Greeks." See also Pierre Bourdieu, "La 'jeunesse' n' est qu'un mot," in *Questions de sociologie*, Paris: Éditions de Minuit, 1980, pp. 143–154.

118 Mallarmé's phrase alludes to Baudelaire's poem, "Correspondences," quoted in part above: "The pillars of Nature's temple are alive/and sometimes yield perplexing messages;/ forests of symbols between us and the shrine/remark our passage with accustomed eyes." See Charles Baudelaire, *Les Fleurs du Mal*, translated by Richard Howard, p. 5; and *Mallarmé: Selected Prose Poems, Essays, and Letters*, translated by Bradford Cook, Baltimore: Johns Hopkins University Press, 1956, p. 40; Nicholls, *Modernisms*, p. 36.

119 *Mallarmé*, p. 21; Nicholls, *Modernisms*, p. 36. Emphasis added.

120 The need to represent the un-representable was not a uniquely French concern. For British efforts similar to the French Symbolists' see W. David Shaw, *Victorians and Mystery. Crises of Representation*, Ithaca: Cornell University Press, 1990. For an interpretation of the early German Romantics as "modernists" similarly subverting this view of literature as mimetic representation see Ernst Behler, *German Romantic Literary Theory*, New York: Cambridge University Press, 1993; and Winfried Menninghaus, *In Praise of Nonsense: Kant and Bluebeard*, translated by Henry Pickford, Stanford: Stanford University Press, 1999; originally published as *Lob des Unsinns: über Kant, Tieck und Blaubart*, Frankfurt am Main: Suhrkamp, 1995. For an immensely readable overview of the period in Britain which highlights the problem of representing mystery see A. N. Wilson, *God's Funeral*, New York: W. W. Norton and Co., 1999.

121 Andreas Aubert, "Strömminger i fransk aandsliv," *Samtiden* I, 1890, p. 153ff. Among other works, Aubert reviewed Paul Bourget's essay on "Charles Baudelaire" in his *Essais de psychologie contemporaine* (1881) which included a section on the "Théorie de la Décadence." For the Norwegian appropriations of French Decadence, see: Heller, "Decadence"; and Jacques Letheve, "Le Thème de la Décadence dans les lettres français à la fin du XIXe siècle," *Revue de l'histoire littéraire de la France* 63, 1967, p. 51.

122 Andreas Aubert, "Höstudstillingen Aarsarbeidet IV. Edvard Munch," *Dagbladet*, no. 355, November 5, 1890, pp. 2–3; in Heller, "Decadence," p. 81. Emphasis of *neurasthenic* is from the original.

123 Heller, "Decadence," p. 82.

124 Bahr," "Krisis des Naturalismus," p. 67; in Heller, "Decadence," p. 94.

125 Christian Krohg. The quotation here is a collation of two translations: see J. P. Hodin, *Edvard Munch*, New York: Praeger, 1972, p. 50; and Smith, *Munch*, p. 10. The "Evening" motif reappeared later as "Jealousy," renamed "Melancholy."

126 Reinhold Heller, "Love as a Series of Paintings and a Matter of Life and Death. Edvard Munch in Berlin, 1892–1895. Epilogue, 1902," in Arne Eggum, *Edvard Munch: Symbols and Images*, Washington, DC: National Gallery, 1978, p. 98.

127 Edvard Munch, Manuscript T 2760 (The Violet Book), entry dated "Nice, 8 January 1892"; in Heller, "Love as a Series," p. 98.

128 Edvard Munch, Manuscript T 2760, in Heller, "Love as a Series," p. 98.

129 Ragna Stang, *Edvard Munch,* New York: Abbeville Press, 1977, p. 96.

130 Stanislaw Przybyszewski, *Satans Kinder: Roman,* Paris: Albert Langen, 1897.

131 Julius Meier-Grafe, in Hodin, *Edvard Munch,* pp. 64, 66.

132 Stanislaw Przybyszewski, "Psychischer Naturalismus," *Die neue deutsche Rundschau* (Feb. 1894), pp. 150–6; reprinted in *Das Werk des Edvard Munch: vier Beiträge von Stanislaw Przybyszewski,* edited by Przybyszewski (Berlin, 1894). For the translations which follow, I have consulted the unpublished manuscript *The Work of Edvard Munch: Four Essays by Stanislaw Przybyszewski, Dr. Franz Servaes, Willy Pastor, Julius Meier-Graefe,* edited by Stanislaw Przybyszewski, translated by Dr. Hanna Marks, Unpublished: National Gallery, n.d. This manuscript, however, always translates the word "psychischer" as "emotional" and thus completely obscures any allusive connections to Huysmans. For the concept "psychic naturalism" I am indebted to Carla Lathe, "Edvard Munch and the Concept of 'Psychic Naturalism'," *Gazette des Beaux Arts* 93, March 1979, pp. 135–146.

133 As if to make the parallel clear, the editors of *Die neue deutsche Rundschau* placed *"Psychischer Naturalismus"* next to an article entitled: "Letter from Paris. A Visit with Joris-Karl Huysmans." Having arrived in Paris the essay's author finds modern Paris a bit dull: nothing much in the way of theater, art or literature. But this great void is filled when the author makes his "trip to J.-K. Huysmans, the great critic in our petty age, the new high priest of both Satan and God, that pessimistic refugee who was plucked out of the modern world and thrown into the unfathomable chaos of the Middle Ages. I had finally found my stride. . . . When you want to visit Huysmans, you have to pick him up at the Ministry of the Interior: at Plan Beauvais, just at the Elysée. There, the author of *Là-Bas (Down There)* works as *sous-chef de bureau* directly across from where Mr. Carnot sits. . . . he works at the office of the state everyday from from 10 to 4." "Pariser Brief. Bei Joris-Karl Huysmans," *Die neue deutsche Rundschau,* February 1894, p. 157ff.

"Pariser Brief" employs a clever series of plays on imagery: for example, the infamous "high priest of the occult" works in the "ministry of the interior"—the German *Innern* is the same word used by Przybyszewski to denote the "inner life" of the psyche. Huysmans (the author of "Down There") works as the *sous-chef*—literally, the "subboss" (assistant manager) of the office. Finally, this satanist works in the very heart of the materialist beast—at the Elysée presidential palace of the Third Republic, seated directly across from Marie-François-Sadi Carnot (an engineer turned statesman who served as the Republic's fourth president (1887–94)). What the author could not have known in this February essay was that Carnot would be assassinated four months later in Lyon by an Italian anarchist on June 24, 1894.

134 In 1892 the twenty-four-year-old Przybyszewski had published a pamphlet entitled *Zur Psychologie des Individuums* in which he analyzed Chopin and Nietzsche. Stang, *Edvard Munch,* p. 96.

135 "Die Wirkung war immer mittelbar durch das Mittel der äusseren Erscheinungwelt."

136 Here Przybyszewski juxtaposed the German with the French: "*états d'âmes* durch *états de choses* auszudrücken."

137 "Seine Landscaften sind in der Seele geschaut."

138 Admittedly, Przybyszewski's details are opaque: he thought Munch could paint colors "directly" without the necessity for mediating symbols. The German reads: "Munch will, um es kurz zu sagen, einen psychischen, nackten Vorgang nicht mythologisch, d.h. durch sinnliche Metaphern, sondern unmittelbar in seinem farbigen Aequivalente wiedergeben . . ."

139 The German "nackten," literally denoting "naked," can figuratively connote the unadorned, bare or hard facts of a scene, e.g., "die nackten Tatsachen."

140 Max Liebermann (1847–1935), a realist in Berlin, was known for his studies of the life and labor of the poor. Critics dubbed him the "disciple of the ugly," a phrase that the Catholic Revivalist Léon Bloy would later pick up and apply to his friend Georges Rouault: "the apostle of the ugly."

141 Arne Garborg, "Den idealistiske reaktion," *Dagbladet,* June–July 1890.

142 In a paragraph describing the final painting which Przybyszewski calls an "emotional landscape" *(Gefühlslandschaft),* he also quotes a lengthy passage from Baudelaire's "Confiteor of the artist" without translation from the original French. These foreign language quotations from Baudelaire and Mallarmé suggest a desire to be legitimated by their genealogical pedigree.

143 Gerhard Gran, "Den yngste generation," *Samtiden* 5, 1894, p. 42; in Heller, "Decadence," p. 83. Gran was the editor of *Samtiden.*

144 Smith, *Munch,* pp. 14–15.

145 Note reproduced in Cassou, "Munch en France," p. 122.

146 The argument for these connections between Munch and Redon comes from Gösta Svenæus, *Edvard Munch. Das Universum der Melancholie,* Lund: Gleerup, 1968. See especially pp. 129–144.

147 Huysmans celebrated his good friend Odilon Redon in *À Rebours* as one of the protagonist's two ideal painters (the other being Gustave Moreau). For Redon's relationship with Huysmans and especially with respect to the Catholic Revival, see Maryanne Stevens, "Redon and the Transformation of the Symbolist Aesthetic"; and Fred Leeman, "Redon's Spiritualism and the Rise of Mysticism"; in *Redon: Prince of Dreams, 1840–1916,* edited by Douglas W. Druick (et al.), New York: Abrams, 1994, pp. 196–236.

148 The description is from Ted Gott, "Odilon Redon," p. 148. Gott concludes: "*Serpent-auréole* is a consummate image of satanic impregnation, the goal of certain black rituals studied by Huysmans."

149 The German reads: "ein Weib im Hemde auf zerknitterten Laken mit dem Glorienschein des kommenden Geburtsmartyriums . . ." Przybyszewski, "Psychischer Naturalismus," *Die neue deutsche Rundschau,* p. 152. Curiously, the unpublished translation by Hanna Marks has omitted the phrase completely.

150 In the *Apologeticus adversus gentes pro christianis* (chapter 50), Tertullian argues that Christianity is not just a philosophy but a divine revelation, and thus cannot be destroyed by its persecutors. Hence, "nothing whatever is accomplished by your cruelties, each more exquisite than the last. It is the bait which wins men for our school. We multiply whenever we are mown down by you; *the blood of Christians is seed.*" (Nec quicquam tamen proficit exquisitior quaeque crudelitas vestra: illecbra est magis sectae. Plures efficimur, quoties metimur a vobis: *semen est sanguis Christianorum.*) *Patrologia Latina,* edited by J.-P. Migne, 50.13. Emphasis added.

151 Sigbjørn Obstfelder, "Edvard Munch, et forsøk," *Samtiden* 7, 1896, p. 21; in Heller, "Love as a Series," p. 105.

152 "Das Weib" is the word which, combined with modifiers,

carries a pejorative gendered meaning: "das alte Weib" can be translated as "crone," "geezer," or "hag"; "das zänkische Weib" as "shrew," "vixen," or "virago" (extremely pejorative).

153 The German reads: "Das ist die furchtbare Tragödie des Mannes, der durch das Weib zerstört wird, und das ist das Weib, die babylonische Dirne, das ist Mylitta und die apokalyptische Hure, das ist Georges Sand, und Nana zugleich: ein Riesensymbol ist es von dem ewigen, wüsten Kampfe der Geschlechter." Przybyszewski, "Psychischer Naturalismus," p. 151. The passage is a commentary on Félicien Rops *Vengeance d'une femme (Vengeance of a Woman)*.

All three proper names refer in some way to promiscuous female sexuality: George Sand was a British Romantic socialist writer who wrote under a male pseudonym. She was known not only for her feminist novels but also for her romantic liaisons with (among others) Prosper Mérimée, Alfred de Musset, and Frédéric Chopin. Nana was the prostitute-protagonist of Zola's novel by the same name. "Mylitta" is the Greek transcription for the Assyrian goddess Mullissu—a fertility and birth goddess, identified by Herodotus with the Greek Aphrodite, and by other writers with Ishtar. Her cult demanded that every woman serve in her temple as a sacred prostitute, until released by a fee from a stranger. The money for the service was given in the name of the goddess. See the *Oxford Classical Dictionary* and *The New Century Classical Handbook*. As noted above, Przybyszewski's own wife was considered just such a *femme fatale*: she was shot by a Russian lover, who then shot himself.

154 "The naturalization of sin, indeed of mere negligence, placed new responsibilities on the shoulders of every individual. The myth of hereditary syphilis transformed desire into what Jean Borie has called an 'infernal machine.' The pox became a pervasive symbol in novels and iconography. Huysmans' heroes and Félicien Rops's hideous portraits reflected collective anxieties reinforced by the tragic fates of well-known syphilitics. The risks of debauchery now became more serious; the impossibility of biological redemption supplanted or reinforced existing fears of sin and hellfire. The belief in morbid heredity made it imperative for man to rise above animality." Michelle Perrot, "Cries and Whispers," in *History of Private Life: Vol. IV*, p. 619. See also Jean Borie, *Le Tyran timide: le naturalisme de la femme au XIXe siècle*, Paris: Klincksieck, 1973.

155 For an excellent investigation into the anthropology of relics, see Peter Brown, *The Cult of the Saints: Its Rise and Function in Latin Christianity*, Chicago: University of Chicago Press, 1981.

156 For anthropological investigations into the relationship between blood and sexuality, see Mary Douglas, *Purity and Danger: An Analysis of Concepts of Pollution and Taboo* [1966], New York: Praeger, 1970.

157 The translation, with slight alterations, is from "Psychical Naturalism," translated by Hanna Marks, p. 2. Emphasis added.

158 The German reads: "Das dritte Bild stellt eine Madonna vor. Es ist ein Weib im Hemde, mit der charakteristischen Bewegung der absoluten Hingebung, in der alle Organempfindungen zu Erethismen intensester Wollust werden; ein Weib im Hemde auf zerknitterten Laken mit dem Glorienschein des kommenden Geburtsmartyriums, eine Madonna, in dem Momente erfasst, in dem die geheime Mystik des ewigen Zeugungarausches ein Meer von Schönheit auf dem Gesicht des Weibest erstrahlen lässt, in dem die ganze Tiefe ins Empfinden tritt, da der culturelle

Mensch mit seinem metaphysischen Ewigkeitsdrange und das Tier mit seiner wollüstigen Zerstörungswutsich begegnen." Przybyszewski, "Psychischer Naturalismus," p. 152.

159 The phrase is Ernest Becker's. See his Pulitzer Prize winning study, *The Denial of Death*, New York: The Free Press, 1973. For an overview of Kierkegaard on "dread" as a production of humanity's double-composition of animality and psychic self-consciousness, see Becker's chapter five, "The Psychoanalyst Kierkegaard," pp. 67–92. See also Vanessa Rumble in this catalog.

160 Luce Irigaray, *This Sex Which is Not One*, translated by Catherine Porter, Ithaca: Cornell University Press, 1985; originally published as *Ce sexe qui n'en est pas un*, Paris: Éditions de Minuit, 1977; quoted in Hanson, *Decadence and Catholicism*, p. 108.

161 Cassou, "Munch en France," p. 124.

162 Ellis Hanson discusses the conversions of Huysmans, Oscar Wilde, Walter Pater, Verlaine and Rimbaud. "Paul Verlaine, lionized by (the converted) Huysmans as the only great Catholic poet of his time, also underwent a conversion while serving a prison sentence for shooting his lover, Arthur Rimbaud, who was himself a deathbed convert." Hanson, *Decadence and Catholicism*, p. 12.

163 Heller, "Decadence," p. 93.

164 Przybyszewski, "Psychical Naturalism," translated by Hanna Marks, p. 2.

165 *Edvard Munch: The Frieze of Life*, edited by Mara-Helen Wood, London: National Gallery, 1992, pp. 11–14.

166 Quoted in Eggum, *Edvard Munch: Symbols and Images*, p. 105.

167 Bynum, review for the publisher, Christian, *Visionaries*.

168 Indeed, for Huysmans, the truly "improper" art was "*l'art sulpicien*"—that is, the religious *kitsch* produced and sold in the quarter surrounding the church of Saint-Sulpice—which he considered to be the "revenge of the devil." In Huysmans' book *The Crowds of Lourdes (Les Foules de Lourdes)*, the devil was portrayed as speaking to the Virgin Mary and admitting that she had conquered him through the death and resurrection of her Son, Jesus. However, the devil then announced that he would yet avenge himself by appropriating "religious art": "I will set about in such a way that I will cause you to be insulted without relief by *the continuing blasphemy of ugliness (de la laideur)*." Huysmans' bitterly ironic reversal lay, of course, in his association of "the continuing blasphemy of ugliness" with mass-produced Madonnas, Crucifixions, and Nativity scenes which domesticated transcendence—and *not* with his gory accounts of sadomasochism and satanic Black Masses. See Jean-Pie Lapierre and Philippe Levillain, "Laïcisation, union sacrée et apaisement (1895–1926)," *Histoire de la France religieuse*, edited by René Rémond, vol. 4, Paris: Éditions du Seuil, 1992, p. 114. Emphasis added.

169 For a helpful historical-theological study, see William C. Placher, *The Domestication of Transcendence: How Modern Thinking about God Went Wrong*, Louisville, KY: Westminster John Knox Press, 1996.

170 See for example historian Jonathan Sperber's notion of religion as a "loyalty toward a way of life, a set of beliefs and institutions, created in response to given social and political circumstances by a group in which certain socioeconomic interests were most influential—a 'sociomoral milieu'—which can be politically mobilized." As opposed to a narrow ecclesiastical reading, Sperber argues against treating religion as an autonomous entity existing alongside socioeconomic conditions and independent of them. On the other hand, he wants to avoid a reductionism in

which religious issues in modern politics are "pretexts for the defense of certain socioeconomic interests," thus reducing religious cultural expressions "to an epiphenomenon of economic interests." He prefers "to understand religious practices, organizations, and beliefs as being shaped in response to socioeconomic change. They provide ways of interpreting society and suggest, justify, or explain a certain course of action." Jonathan Sperber, *Popular Catholicism in Nineteenth-Century Germany*, Princeton, NJ: Princeton University Press, 1984, pp. 286–7.

171 See the helpful historiographical overview along with responses: Mack P. Holt, "Putting Religion Back into the Wars of Religion," *French Historical Studies*, Fall 1993, pp. 542–51; Henry Heller, "Putting History Back into the Religious Wars: A Reply to Mack P. Holt," *French Historical Studies*, Spring 1996, pp. 853–61; Mack P. Holt, "Religion, Historical Method, and Historical Forces: A Rejoinder," *French Historical Studies*, Spring 1996, pp. 863–73; Susan Rosa and Dale Van Kley, "Religion and the Historical Discipline: A Reply to Mack Holt and Henry Heller," *French Historical Studies*, Fall 1998, pp. 611–629.

172 Brad S. Gregory, *Salvation at Stake: Christian Martyrdom in Early Modern Europe*, Cambridge, MA: Harvard University Press, 1999. Gregory's new study argues that reductionism of religious issues to socio-political-economic epiphenomena is not sufficient to an understanding of sixteenth-century martyrdom.

173 The phrase is from E. P. Thompson, *The Making of the English Working Class*, New York: Vintage Books, 1963.

174 Arne Garborg, "Den idealistiske reaktion," *Dagbladet*, June-July 1890.

175 The seminal study of the "holy" as something that both lures and terrifies was published just as the horrors of the Great War were ending. See Rudolph Otto, *The Idea of the Holy: An Inquiry into the Non-rational Factor in the Idea of the Divine and its Relation to the Rational*, translated by John Wilfred, New York: H. Milford, Oxford University Press, 1923; originally published as *Das Heilige: über das Irrationale in der Idee des Göttlichen und sein Verhältnis zum Rationalen*, Breslau: Trewendt und Granier, 1917. The medievals also considered the "wondrous" as an inextricable combination of the fascinating and the dreadful. See Bynum, "Wonder."

176 Michel de Certeau, interview in *Le Nouvel Observateur*, September 25, 1982, pp. 118–21; quoted in Roger Chartier, *On the Edge of the Cliff: History, Language, and Practices*, translated by Lydia G. Cochrane, Baltimore: Johns Hopkins University Press, 1997, p. 46.

177 Note the obvious sacramental language of "substance" and "accident" in Emmanuel Goldstein's remarks on the symbolist poet Maurice Maeterlinck: "Thus the poet creates an inner reality that is truer and deeper than the accidentals of external reality." In C. E. Jensen, preface to Maurice Maeterlinck, *Prinsesse Maleine*, Copenhagen: 1892; in Heller, "Decadence," p. 95.

178 J.-K. Huysmans, "The Grünewalds in the Colmar Museum," trans. Robert Baldick, in *Grünewald, with an essay by J.-K. Huysmans*, Oxford: Phaidon, 1976; originally published in Huysmans, *Trois primitifs les Grünewald du Musée de Colmar, le Maître de Flémalle et la Florentine du Musée de Francfort-sur-le-Mein*, second edition, Paris: L. Vanier, 1905.

"A STRANGE BOULDER IN THE WHIRLPOOL OF THEATER":
EDVARD MUNCH, MAX REINHARDT, AND *GHOSTS*

SCOTT T. CUMMINGS

On November 8, 1906, Henrik Ibsen's *Ghosts* opened at a small theater in Berlin. Although this was far from the first showing of Ibsen's modern tragedy in the German capital, it was an event of tremendous historical importance for two reasons. First, the production marked the opening of the Kammerspiele, a new, more intimate theater created by Max Reinhardt as part of his effort to change the very nature of theatrical experience. Second, the scenic designs were created from a series of paintings commissioned by Reinhardt from Edvard Munch.

By 1906, Munch had been associating for the past twenty-five years with some of modern Europe's leading poets, playwrights, and polemicists. In the 1890s, he began a short-lived but intense friendship with August Strindberg in Berlin, designed playbills for two experimental Ibsen productions in Paris, and gave Ibsen, thirty-five years his senior, a private tour of an Oslo exhibit of his work. Munch later claimed that his painting *Woman in Three Stages (Sphinx)*, a lithograph of which appears in this exhibition (no. **30**), had exerted an influence on Ibsen's *When We Dead Awaken*. Munch went on to render Ibsen's portrait many times, showing him most often in the restaurant of Oslo's Grand Hotel, the playwright's favorite haunt following his return to Norway in 1891 after twenty-seven years of self-imposed exile (no. **58**).

Of Munch's many theater-related works, his design studies for Reinhardt's *Ghosts* represent his most direct involvement in the theater practice of his day. Reinhardt at that point had emerged as the *wunderkind* of the Berlin stage, an ambitious director and impresario with plans to build a theater empire that would revitalize German theater in the new century. Reinhardt was turning to Munch, as he had to so many others, for a particular strategic contribution to his general effort to replace Naturalism in the theater with a new stage Symbolism. Munch in turn provided him with images so steeped in his personal connections to the play that they prefigured the coming shift from Symbolism to Expressionism in European, and especially German, drama. The historic collaboration of these two giants represents a crucial passage in Munch's troubled life as well as an important transition in modern theater history, one which can only be fully understood by a closer look at Ibsen's play and Reinhardt's career.[1]

"ONE OF THE FILTHIEST THINGS EVER WRITTEN IN SCANDINAVIA"

Ghosts is a tightly constructed modernist tragedy in three acts that takes the form of an unusual child custody battle. It takes place in provincial Norway in the isolated home of Mrs. Helene Alving on the day before the dedication of a new orphanage she has built as a memorial to her deceased husband, Captain Alving. Their son Osvald, a thriving young painter living in bohemian Paris, has returned home for the first time in two years for the ceremony. Jacob Engstrand, a local carpenter putting finishing touches on the orphanage, is on hand, as is his young daughter Regina, who serves as Mrs. Alving's maid. Pastor Manders, Mrs. Alving's spiritual and business adviser as well as long-time friend, will pre-

side at the dedication. In a manner similar to Greek tragedy, the forward action digs deeper and deeper into the past and thereby demonstrates how "the sins of the fathers are visited upon the children."[2]

In this instance, the sins in question belong—initially at least—to Captain Alving, a man who had a healthy appetite for hedonism. Nearly thirty years ago, Mrs. Alving fled her free-spirited husband after only a year of marriage to be with Pastor Manders, who sent her back to Captain Alving with a stern reprimand about a woman's marital duty. Since then, she has maintained a curtain of secrecy around her life with Captain Alving, who grew so increasingly dissolute that Mrs. Alving had to take over management of the estate, which she did for the sake of their young son, Osvald. The Captain's promiscuity led him to contract syphilis, and also led to the pregnancy of the household maid, whom the opportunistic Engstrand agreed to marry for a price. The child of that union was Regina, who was summoned by Mrs. Alving to work for her not long after Captain Alving finally succumbed, ten years before the play's action begins, to the ravages of prolonged and isolated debauchery.

Since Osvald's birth, Mrs. Alving's life has been dedicated to protecting her precious son from the influence, and even the knowledge, of his father's immorality. She sent him away from the estate as a boy, and her letters since then have been filled with glowing reports on Captain Alving's character. In her effort to make sure Osvald inherits nothing whatsoever from his father, she has calculated the cost of the new orphanage to equal the Captain's net worth before she married him; the public monument to his supposed virtue will be for her a final private exorcism of his hidden vice. But as the Norwegian title *Gengangere,* meaning "those who return to walk again," suggests, the Captain is a formidable antagonist, even in death. In body and spirit, he "returns to walk again" in Osvald, who displays a similar inclination towards wine, women, and unconventional living. Away from the gloomy, repressive, duty-bound climate of home, the life of an artist in Paris led him to appreciate such controversial values as free love and to express what he calls the "joy of life" *(livsglede)* in his painting, much to the chagrin of the orthodox Pastor Manders.

As it turns out, Osvald has returned home not because he wants to honor his father, but because his health is rapidly deteriorating due to a case of syphilis which, unbeknownst to him until the third act, he inherited from his father. Fearful that his next attack will reduce him to a human vegetable, he has saved up a fatal dose of morphine and is counting on either Regina or his mother to help him take his own life when the dreaded hour comes. The play's mounting revelations prompt Mrs. Alving to recognize that an imperfect and thwarted search for the "joy of life" motivated her husband's behavior, and that her dutiful efforts to quash it have contributed to the demise of the son she fought so hard to protect. Thus, in the play's terms, the sins of the mother are also visited upon the child. When Osvald's symptoms strike again and he is reduced to a babbling paralytic, she is caught in a mother's tragic dilemma between taking a child's life or prolonging his misery. With the meanings of love and duty now unhinged from conventional orthodoxy, she is both liberated and condemned to make a free and conscious choice. As the play ends, she stands over her son, pills in hand, transfixed by agonizing indecision (fig. **67**).

Ibsen was living in exile in Rome when *Ghosts* was first published in Copenhagen on December 13, 1881, in time to benefit from Christmas sales. A few weeks earlier, he had written to his publisher: "*Ghosts* will probably cause alarm in some circles; but there is nothing to be done about it. If it didn't do that, there would have been no need to write it."[3] Ibsen's suspicions were soon confirmed. The scandal that greeted the play throughout Scandinavia forced bookstores to return much of the first edition to the publisher and prompted theater managers and official censors to reject the play as unsuitable for performance. The play's more universal and subtextual themes were eclipsed by outrage over its frank discussion of virtually taboo subjects: syphilis as a disease that reaches proper bourgeois homes, the

specter of sanctioned incest between Osvald and Regina, questioning the filial obligation of child to parent, free love and raising children out of wedlock, the ethical legitimacy of euthanasia, and the legalization of prostitution.[5] The dramaturg of the Kristiania Theatre rejected the play on the basis that it was "lacking in dramatic effect and tries to hide this by the use of pathological and titillating material."[6] Ludvig Josephson, one-time director of the Kristiania Theatre and champion of Ibsen's earlier plays, called it "one of the filthiest things ever written in Scandinavia."[7]

An editorial in a Kristiania newspaper proclaimed: "The book has no place on the Christmas table of any Christian home."[8] The play quickly became what Swedish actor-manager August Lindberg called literary "contraband,"[9] a perfect instance of the free-thinking literature that Pastor Manders is shocked to find on Mrs. Alving's reading table. The controversy in Scandinavia contributed to the play's unlikely world premiere in Chicago, where it was first presented in its original language more than a year earlier, on May 20, 1882, by an enterprising group of amateurs led by the Danish actress Helga von Bluhme. In the fall of 1883, Lindberg organized the European and Scandinavian premiere of *Ghosts*, a private touring production which played provincial venues as well as theaters in Copenhagen, Stockholm, and Kristiania.

For most of the 1880s, productions of *Ghosts* were mounted privately for a subscription audience, often by hastily organized theater clubs — thus avoiding the censor's refusal to grant a license for public performances. Several of these private performances were presented by landmark theaters of the independent theater movement, making *Ghosts* a play of unsurpassed importance in the history of modern theater. In 1887, André Antoine, an army veteran and clerk at the Paris Gas Company, became "the animator of forces which I did not even suspect"[10] when he founded the Théâtre Libre as a theatrical home for Naturalism and a testing ground for a "slice of life" realism in stage production (fig. **68**). Antoine's actors turned away from the audience and spoke to each other in conversational rather than declamatory tones, transforming the spectator into a voyeur who has the illusion of peeking through the imaginary "fourth wall" of the proscenium stage at a private world within. In the spirit of Naturalism pioneered in the novel, playwrights marshaled the life-like depiction of everyday behavior to demonstrate how adverse social conditions, manifest in an unfriendly environment, contributed to the misery of the downtrodden and the disadvantaged. Aesthetically and politically, the stage became a challenge to the status quo of the bourgeois mainstream.

As soon as the Théâtre Libre was established, Antoine began plans to stage *Ghosts* and to play the role of Osvald himself. After a series of delays, the play had its Paris premiere on May 30, 1890, the first performance of an Ibsen play in France. Less than a year later, not long after George Bernard Shaw published his provocative pamphlet *The Quintessence of Ibsenism*, J. T. Grein triggered a firestorm of controversy in London when he opened his new Independent Theatre with a single performance of *Ghosts* on March 13, 1891. By the time of this English-language premiere, there had already been several productions of *Ghosts*, albeit private ones, in Germany: at the Stadt-Theater in Augsburg (1886), the Court Theater at Meiningen sponsored by the famous "theater Duke" (1886), and the Residenz Theater in Berlin (1887). Ibsen was on hand for all three of these productions; in Berlin, he was accompanied by one of his principal champions in Germany, the critic Otto Brahm. When Brahm and others went on to establish the Freie Bühne, an independent theater in Berlin on the model of Antoine's Théâtre Libre, they opened on September 29, 1889 with *Ghosts*.

In the literary journal published by the theater, Brahm proclaimed the Freie Bühne's mission:

We are launching a Free Stage for Modern Life. Art shall be the object of our strivings — the new art, which fixes its attention on reality and contemporary existence . . . The banner slogan of the new art,

68
Contemporary cartoon of Antoine from Jean Chothia's *André Antoine*.

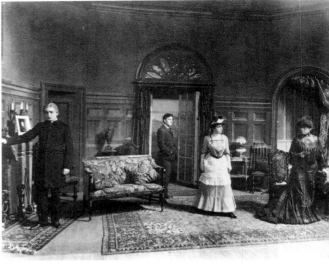

written up in golden letters by the leading spirits, is the single word Truth; and Truth it is, Truth on every path of life, which we too strive for and demand. Not the objective truth which eludes those who stand in battle; but the individual Truth which is freely created out of the most personal conviction and which is freely expressed — the Truth of the independent spirit who has nothing to euphemize and nothing to conceal. And who has therefore but a single foe, his arch enemy and mortal antagonist: lies, of every shape and manner.[11]

This zealous commitment to the sovereignty of the individual, the ideal of Art, and the necessity of telling "the Truth" was a hallmark of what Shaw and his continental contemporaries called "Ibsenism." Inspired by Ibsen, these three—Antoine in Paris, Brahm in Berlin, and Grein in London—triggered what Brian Johnston has called the "three seismic shocks that forever altered the modern cultural landscape."[12] In championing a free and independent theater art, they split from the cultural and commercial mainstream and began a tradition of alternative, often oppositional, experimental theaters, most of them operating on shoestring budgets in makeshift venues, which continues to this day. *Ghosts,* in addition to its intrinsic interests, thus acquired a tremendous historical importance (figs. **69A, B**).

69B

"A KIND OF THEATRICAL CHAMBER MUSIC"

70

The play's historical weight could not have been lost on a young Max Reinhardt, who, in 1890, was an aspiring seventeen-year-old actor from Vienna about to embark on a career in the theater. By the time he was twenty-one, Reinhardt had already played dozens of roles at theaters in Vienna, Bratislava, and Salzburg. In 1894, he was invited to join the company of the Deutsches Theater in Berlin by Otto Brahm, who was in the process of taking over the ten-year-old theater from its owner, the playwright and impresario Adolph L'Arronge. Partly because of his diminutive stature, Reinhardt came to specialize in older character roles (fig. **70**), including Jacob Engstrand in *Ghosts,* which Brahm mounted again in his first season at the Deutsches Theater.[13] Over the next eight years, Reinhardt had an opportunity to witness first hand Brahm's efforts to bring the Naturalist repertoire and naturalistic methods of the Freie Bühne into

the more expressly professional theater of the day. In that period he grew from a novice young actor out of the provinces to the ambitious leader of a new generation ready to challenge the policies of Brahm and his peers.

　Still in his twenties, Reinhardt grew weary of his life as a young actor playing old men in gritty, Naturalist dramas, sticking on false beards and eyebrows and sitting around on stage eating real sauerkraut, night after night after night. In a famous 1901 meeting with Arthur Kahane, who was to become Reinhardt's chief dramaturg, he articulated his theatrical vision:

69
A, B Two 1903 productions of *Ghosts,* each with detailed, naturalistic scenery.[14]

70
Max Reinhardt as Jacob Engstrand in *Ghosts.*

What I have in mind is a theater which gives people pleasure again. One which serves as a means to lead them out of the grayness of their everyday lives into the clear and pure air of beauty. I feel that people have had enough of always encountering their own misery in the theater, that what they long for are brighter colors and an intensification of life. Which doesn't mean that I want to renounce the great achievements of naturalistic acting, its truth and authenticity, which had never been attained before. I could not do so even if I wished to . . . But I would like to take the development further, applying it not just to the description of states and surroundings, but to other things, beyond the odor of poor people and the problems of social criticism, applying the same high degree of truth and authenticity to purely human matters, in a deep and subtilized art of the soul; I would like to show life from another side, not that of pessimistic negation, but one which is equally true and authentic in its serenity, filled with color and light.[15]

In the late 1890s, with Brahm's blessing, Reinhardt had already helped to organize touring productions featuring younger members of the company and guest veterans that traveled to Prague, Vienna, and Budapest in the summer, when the Deutsches Theater was closed. Then, in January 1901, much in the spirit of the day, Reinhardt and his friends created a cabaret theater called *Schall und Rauch* (Sound and Smoke), which presented evenings of satirical songs, poems, and sketches, often followed by a trenchant parody of Friedrich Schiller, Gerhardt Hauptmann, or Maurice Maeterlinck. Begun as a fundraiser for one of their compatriots, the writer Christian Morgenstern, who suffered from tuberculosis and needed money for a cure in Switzerland, *Schall und Rauch* quickly became a Berlin sensation. It led that fall to the formation of the Kleines Theater as more of a legitimate playhouse. All of this activity prompted Reinhardt to break his contract and leave the Deutsches Theater at the end of 1902, thus incurring Brahm's wrath and a stiff fine. Less than three years later, in 1905, Reinhardt managed a triumphant return to the Deutsches Theater as its newly appointed director, replacing a bitter Otto Brahm, whose lease on the theater was not renewed by L'Arronge.[16] In just over a decade, the young apprentice had overthrown the master (at the peak of his career no less) and emerged at age thirty-two as the face of the future of German theater (fig. **71**).

In his effort to create a theatrical "art of the soul," Reinhardt became the prototype of a *régisseur*, a director who masterminds all aspects of a production and molds them into a unified artistic whole, which Richard Wagner famously dubbed a *Gesamtkunstwerk* (total art work). From early on, Reinhardt demonstrated a particular practical awareness of how theater architecture and stage design defined the relationship of actor to audience and shaped the subliminal nature of the theatrical event. As Hugo von Hofmannsthal, the Austrian playwright who worked with Reinhardt for many years, described it:

He considers place in the highest degree important. For months and sometimes for years he has dreamed of how a room will shut an audience in, whether with solemnity of height as in a church, or with solemnity of breadth as in the ancient theatre, or mysteriously, as in some grotto, or agreeably and socially, as in a pleasant, peopled salon.[17]

In the interest of creating for the spectator the most immediate and direct experience possible, Reinhardt made a special effort to choose plays well suited to the performance space at hand and to find theaters well suited to the plays that he liked. As early as the 1901 meeting with Kahane, he dreamt of

operating multiple theaters of different sizes: a standard playhouse of the day, seating 1,000 or so, such as the Deutsches Theater; a smaller, plainer, more intimate space for a coterie of a few hundred; and what he later called his "theater of the 5000," a large amphitheater for a mass audience with a thrust stage suitable for theater on a grand scale.

At root, Reinhardt's directorial strategy was Symbolist and essentialist. For him, each play had an animating spirit or essential pulse, and he summoned the technical means at his disposal to create a sensuous, inwardly focused world onstage that put the audience in touch with the soul of the play through a kind of theatrical mesmerization. "For him the process of a theatrical performance goes on not on the stage but in the imagination of the audience," wrote Hofmannsthal.[18] "His endeavor," wrote Frank E. Washburn-Freund, "as ought to be that of every real producer, is to bring out the mood and atmosphere of the play in such a way as to force the audience into it and keep it there during the action as completely as possible."[19]

Reinhardt became famous for his capacity to marshal light, sound, color, and movement in a manner that generated a powerful mood—*Stimmung*—onstage. Years earlier, August Strindberg, among others, had advocated for a theater that worked on the spectator like a hypnotist, but Reinhardt's 1905 production of *A Midsummer Night's Dream* at the Neues Theater was the first to cast such a spell. For Reinhardt, the essence of Shakespeare's romantic comedy lay in its setting: the fertile, fantastic forest outside Athens. With the innovative use of a turntable stage, he and his designer Gustav Knina created a charming, enchanting wood which struck the Berlin theater as a revelation. "The stage has gone and no one seems any longer to be a mere actor," wrote Herman Bahr with typical enthusiasm. "Everything is transformed, the stage into the earth, acting into dream, everything appears only as forest, the breath of the forest, the exhalation of the forest, now in human form, now like a transient ghost, woven from air, blown away into air."[20]

The success of *A Midsummer Night's Dream* secured for Reinhardt the appointment as head of the Deutsches Theater. His contract there required him to relinquish the two theaters in his nascent theatrical empire, which included the tiny Kleines Theater where he had produced several of Strindberg's chamber plays, Oscar Wilde's *Salomé*, Frank Wedekind's *Earth Spirit*, and a very successful production of Maksim Gorky's *The Lower Depths*. "Do you remember that delightful Viennese evening which we experienced at the Bösendorfer Rooms, when the Rosé Quartet played chamber music by Haydn, Mozart and Beethoven?" Reinhardt said to Kahane as early as 1901. "I should like to achieve something similar to that. What I have in mind is a kind of *theatrical chamber music*."[21] Such theatrical chamber music required what he dubbed a Kammerspiele, a chamber theater, a performance space that by virtue of its intimate confines and humble décor served as a natural resonator for the ethereal introspection and psychological subtlety of certain contemporary plays. In his description, Hofmannsthal picked up on the musical analogy:

What he dreamed of was a house resembling as closely as possible the body of a violin and, like the violin, attuned to receive and respond to the slightest vibration. That was the famous Kammerspiele, in which he later produced all plays which depended for effect on intimacy, and spiritual delicacy, on wit or smartness of dialogue: Bernard Shaw and Wilde, Maeterlinck too, and Knut Hamsun, much of Goethe, and particularly the supernatural plays of Strindberg's last phase.[22]

Six months after Reinhardt took over directorship of the Deutsches Theater in 1905, he bought it and the adjacent buildings from L'Arronge. With the architect William Müller, he made plans to convert the Emberg Dancehall next door into the theater still known to this day as the Kammerspiele (figs.

72

73

74

75

72 and **73**). In doing so, Reinhardt pioneered the now common practice of coupling a smaller studio theater with a theater's larger mainstage facility—perhaps his most lasting and widespread contribution to theater history. This original chamber theater was built to accommodate an audience of about three hundred in twenty-two rows of leather seats. The theater was noted for "the harmony of its proportions and its simple, but very distinctive decoration."[23] Without loges or gallery, the auditorium was all on one raked level, as "simple and elegant as a Pullman car"[24] and not much larger than the stage itself. The connection between the two was promoted by the elimination of footlights and the prompter's box and the inclusion of two steps which led down from the edge of the stage to the floor of the house.[25] The proscenium arch was relatively plain and only twenty-two feet tall by twenty-six feet wide, as opposed to the much larger opening at the Deutsches Theater next door (figs. **74** and **75**).

One of the critics on hand when the Kammerspiele first opened described the experience in terms that must have pleased Reinhardt:

Immediately upon entering the auditorium, the visitor is struck with a feeling of being at home. Nothing artificial, nothing ostentatiously obtrusive; a noble mind discovered these forms, created this room filled with warmth and coziness. Arranged these wonderfully comfortable seats, banished the dreadful theater programs full of advertisements, and replaced them with simple but handsome sheets of stiff paper; posted at the doors ushers dressed in tasteful, unobtrusive garb. And one is no longer in a theater, but in a private house.[26]

Everything about the Kammerspiele was designed to generate a feeling of austere comfort and resonant intimacy and to concentrate the audience's attention on the atmospheric stage-world that was to unfold before them. The first world Reinhardt sought to conjure on the Kammerspiele stage was the Nordic gloom of Ibsen's *Ghosts*. Ever the showman, Reinhardt sought to make his mark at his new chamber theater with the same notorious play that in Berlin, Paris, and London had already triggered the earthquake of modernism.

72
Interior view of the Kammerspiele in Berlin, c. 1906.

73
Exterior view of the Kammerspiele, c. 1906.

74
Kammerspiele elevation.

75
Kammerspiele groundplan.

"A COMBINATION OF ME AND BIEDERMEIER!"

In Germany, the censorship on *Ghosts* had been lifted in 1894 for simultaneous productions of the play at the Deutsches Theater and its cross-town rival, the Lessing Theater. By 1906, the twenty-five-year-old play had lost its initial shock value and become a standard of the modern repertoire, making Rein-

hardt's decision to inaugurate the Kammerspiele with *Ghosts* not so much inflammatory as revisionist and commemorative. After a prolonged illness and a series of debilitating strokes, Ibsen, champion of the individual and hero to a whole generation of European artists and intellectuals, died on May 23, 1906 in Kristiania. Reinhardt chose to honor Ibsen by opening the Kammerspiele with *Ghosts,* and in doing so, he also laid claim to him as more of a Symbolist than a Naturalist. Of course, Ibsen was neither Symbolist nor Naturalist in any orthodox sense, but Reinhardt's theatricalist approach was a calculated corrective to Ibsen's early reputation as a libertarian *provocateur* and proto-feminist out to rupture the moral fabric of bourgeois Christian society in Northern Europe. Reinhardt wanted to switch the axis of *Ghosts,* the third installment in Ibsen's twelve-play prose cycle, from the social to the spiritual and to align it with the later, more introspective plays in the cycle, such as *John Gabriel Borkman* and *When We Dead Awaken*. Towards this end he sought the aid of Ibsen's fellow countryman and one of the most famous painters in Germany at that time: Edvard Munch.

Reinhardt's approach might well have been inspired by the Ibsen productions mounted in Paris at the Théâtre de l'Oeuvre by Aurélien Lugné-Poë. As the leading proponent of Symbolist theater in France, Lugné-Poë sought to realize Maeterlinck's vision of a static drama which revealed *le tragique quotidien* through a hauntingly resonant stillness that evoked the ineffable presence of cosmic forces in ordinary life. Starting in 1892, Lugné-Poë mounted ten Ibsen dramas in five years, including *Peer Gynt* (1896) and *John Gabriel Borkman* (1897). Both of these productions featured posters and playbills with graphic images provided by Munch (figs. **76** and **77**), who had met Lugné-Poë in Stockholm in 1894 when the Théâtre de l'Oeuvre was on tour with Ibsen's *Rosmersholm*. Frederik and Lise-Lone Marker find in Munch's image for *Peer Gynt:*

a graphic intimation of the suggestive, somnambulistic mood which this director invariably sought to invoke, irrespective of which Ibsen play he was presenting . . . we see the ravaged, sorrowful countenance of an old woman lost in thought, significantly juxtaposed with the figure of a young girl with long, flowing hair who stands gazing—as figures in symbolist dramas were wont to gaze—into the far distance, across a dream-like landscape of deep valleys and distant mountains.[27]

This is much the same ambient sense of mood that Reinhardt sought to realize in his theater, and he had already articulated a strategy for achieving it:

I cannot tell you how much I long for music and color. It is my intention to employ the best painters, I know how they are waiting for it and how interested they are in the cause of the theater, and just as a suitable director is sought to direct each play, and each role is played by the most suitable actor, so I should like to find the most suitable, and where possible the only suitable, painter for every individual work.[28]

The "well-cast" painter would create images that would conjure the spirit of the play in a visual and infectious form that would inspire first the director, then the actors, and finally the audience, all the more so in the intimate confines of the Kammerspiele. By 1906, Reinhardt had already worked with a number of painters, but none of them were as famous as Munch.

Reinhardt might have become aware of Munch as early as November 1892, when the early retrospective of Munch's work presented by the *Verein Berliner Künstler*, Berlin's most prestigious artists' society and the semi-official arbiter of German imperial taste, was shut down in a week, triggering a nationwide controversy and eventually leading to the formation of the Berlin Secession in 1898. As noted by the painter Lovis Corinth, the "Munch Affair" made the Norwegian painter for awhile "the most famous man in the whole German Empire."[29]

Among the publications that rose to his defense was the journal of the Freie Bühne, which despite the theater's commitment to Naturalism wrote of Munch's work with an appreciation of its incipient Symbolism: "All this has been precisely observed, has been experienced, has been felt deeply and intensely! If someone can speak like that, or paint, or sing — I am uncertain how to describe it — in him a poet's soul is alive."[30] From this point forward, Munch spent periods of time in Berlin on a regular basis, much of it with the international bohemian community that gathered at an Armenian wine cellar known as *Zum Schwarzen Ferkel* (The Black Piglet). This is where Munch met and befriended Strindberg, whose plays were being promoted by Otto Brahm at the Freie Bühne. Within weeks, an admiring Munch had completed a portrait of Strindberg, which was featured prominently in Munch's next Berlin exhibit (no. **67**). For many, it has become the definitive Strindberg likeness. As a critic wrote when it was first shown, "it is as though he had been caught unaware in his study and skillfully captured in a characteristic moment. Head and torso emerge vividly from the warm background, disclosing an impetuous temperament and a certain touch of superiority and bitter agitation."[31]

Munch continued to exhibit in Berlin through the 1890s and into the new century, becoming the inspiration and prophet for a generation of German painters. He was at the peak of his fame in Germany when Reinhardt approached him about contributing to his preparation for the production of *Ghosts* that would open the Kammerspiele. In a letter to Munch from one of Reinhardt's right-hand men, Felix Hollaender, written only weeks after the playwright's death, the invitation became official:

Dear Sir, I take the liberty of resuming the conversation we had in Weimar. We would like to open our new little theater, which we've told you something about, with Ghosts. *We would really be very pleased if you would agree to sketch a design for the décor. You won't be in the least further troubled — what we would like is to obtain from you, for transforming to the stage, just a sketch from which we might draw ideas for the decor. We believe no other painter could capture the character of Ibsen's family tragedy as well as you — and we can think of no more solemn or more beautiful funeral rite than this production. Thus we beg you most sincerely to grant our request. This sketch must show a view of the landscape through the window — in everything else, we leave the execution entirely to you.*[32]

That Reinhardt would dispatch one of his chief lieutenants to Weimar to meet with Munch personally suggests the importance and urgency of the mission. For Reinhardt, there was no other possible choice of designer. To add to the inducement, he offered a second-floor foyer of the new theater for Munch to paint in any way he desired. This led to the so-called "Reinhardt Frieze," a series of seaside scenes which revisited some of the motifs of Munch's Frieze of Life and its themes of love, jealousy, melancholy, and pain (fig. **78**). In a letter to Jens Thiis, Munch wrote, "I have recently taken on a daunting task — I am painting a frieze for the Kammerspiele. I find providing decoration for a definite place both difficult

78
Edvard Munch, Sketches for the Reinhardt frieze, 1906. Munch Museum, Oslo.

and unfamiliar—and almost impossible in this case, when the theatre is so small and already decorated in fine Biedermeier style. Can you imagine—a combination of me and Biedermeier!"[33] Delays prevented the twelve tempera paintings of the Reinhardt frieze from being hung until December 1907. As it turned out, the designated room proved unworkable as a foyer for the Kammerspiele and was closed off, except for special occasions; Munch's paintings languished there in relative obscurity for six years, before being dispersed.[34]

When Munch agreed to work on *Ghosts*, Arthur Kahane followed up with a letter of thanks dated July 11, 1906. He relayed Reinhardt's request that Munch send "a sketch within the next few days, if it is in any way possible (preferably before July 15th, if at all possible). Anything whatever that will give him an idea for the *mise-en-scène*."[35] The letters from Hollaender and Kahane both emphasize the necessity of including a large picture window with a view of the landscape beyond; a subsequent set of detailed "notes" from Reinhardt to Munch concerning the scenery for *Ghosts* makes clear why. Without describing it in any topographical detail, Reinhardt makes clear that for him the landscape outside constitutes an objective correlative for what goes on inside. Reinhardt tells Munch that, for him, "the landscape visible through the windows toward the back is, so to speak, the soul of the room, and changes so that it substantially affects the mood inside."[36]

Reinhardt's instructions to Munch are worth quoting in full because of the inferential light they shed on this unusual and historically important collaboration and the reminder they provide about the unavoidable practical concerns of the theater artist. Here is what Reinhardt wrote:

Notes for the interior of Ghosts:

The high-ceilinged, soberly-colored central room of a rather old-fashioned Norwegian house located outside of the city. A kind of vestibule which is both a living room and the main room of the house, and in which Frau Alving is usually to be found. Accordingly, it must have about it something quite simple, solemn, almost ascetic, while also revealing something of the raw hedonism and brutality of the deceased chamberlain—so it need not be altogether tasteful.

At the same time, this room must have secrets, dark nooks and crannies with strange, old-fashioned furniture that—in the dark, for instance—has a sinister effect. The room could have wainscoting, perhaps half-way up the wall, and above it not light-colored, but faded, wallpaper. (A sketch of this would be greatly appreciated.) The greenhouse (towards the back) is brighter and the staircase—as much of it as can be seen through the doors at the left—is similarly bright and specifically recalls to mind the chamberlain Alving. For the color of the chair-covers and curtains (something plush) perhaps a dark, somewhat tired violet would be suitable. The parquet floor, of an old-fashioned pattern, is only partially covered with carpets (under the table in the center and at the left by the window, perhaps). By the window at the left, in front of the doors to the staircase, stands a big armchair, or perhaps a small sofa, and in front of it a sewing table. This is Mrs. Alving's special place and also the place where Osvald goes mad at the end.

By the armchair, a small footstool. Leading to the staircase, which is illuminated from the side, French doors, one of which always remains closed. In the middle of the room, a round, dark, heavy family table with chairs around it. To the right, two doors, one of which—the one nearest the front—opens into the dining-room, while the one further back leads into the hallway. Between the two doors, a fireplace, upon which stand two old candelabra, and between them an old-fashioned grandfather clock. In front of the fireplace are two fauteuils. Against the left side wall, which closes the staircase off from the room, a high cabinet and rigidly upright, high-backed chairs. A couple of steps lead back into the slightly elevated greenhouse, the far wall of which consists entirely of glass windows reaching from

floor to ceiling and affording a view of the countryside. The landscape visible through the windows toward the back is, so to speak, the soul of the room, and changes so that it substantially affects the mood inside. The ceiling might be thought of as a raftered ceiling of dark wood. Veils of fog might hang between the landscape and the room, thickening and evaporating accordingly with the fluctuating mood.

Act I: Bleak, gray, wet weather. Outside brighter than inside. Main source of light from the window on the left. Windowpanes: wet, clouded with dew. Damp, pale, rainy atmosphere. Variation through lighting. Morning.

Act II: Slowly approaching dusk. Dark shadows grow longer. At first brighter, later darker and darker until it is black outside. Inside, towards the end floor lamps that brightly illuminate one part of the room, especially the table, leaving the corners of the room in an eerie darkness. At the end, the slight, red glow of a fire outside the window. Afternoon — evening.

Act III: Night. Lamps. Later, very slowly: a pale shimmering light that grows much stronger toward the end, and together with the lamp that still burns, creates a strange, sinister twilight. At the very end, cold, desolate sunlight from the back so that the play ends with a magnificent finale, like a symphony. Night — early morning.

To begin, it is of highest priority *— and would be of great help to us — that we receive a sketch for the interior without atmospheric lighting, and sketches* for the most important pieces of furniture, for the wall-paper patterns, the wainscoting, and the windows, *these, in particular, as soon as* possible; *like-wise, colors for the curtains, tablecloths, and upholstery, and for the wood and wallpaper.*

The individual sketches indicating mood and changes in the lighting can wait until later, perhaps until mid-September, when we will already be rehearsing and will be able to have positive influence on the artistic work. The landscape, also later. However, because of the very pressing orders, the afore-mentioned detail sketches are needed absolutely as soon as possible — also because it takes a great deal of time to fill the orders, as Ghosts *is the* opening performance *of the new theater.*

Until now, Ibsen interiors have been indescribably neglected and abused. However, in my opinion, they convey to a significant extent much that lies between and behind the lines in Ibsen and not only frame but also symbolize the action.

Only with your help, I firmly believe, will we be able to make people and scenery interact so har-moniously — while also retaining their effectiveness as separate entities — that we will illuminate yet unplumbed depths of this splendid work, and will produce, on the whole, something quite remarkable.

Up to now, the German theater has pushed a more or less successful clinical study of madness into the dazzling limelight and allowed all else to operate in shadow.

In my opinion, quite the opposite *would be the right thing.*

Respectfully, with best wishes,

Max Reinhardt

Reinhardt's instructions are noteworthy in a number of respects. First, they suggest how the mind of a modern *régisseur* works. Despite Hollaender's assurance that the details of the sketches would be left to Munch as long as they contained a window with a landscape view, Reinhardt spells out the ground plan for *Ghosts* in painstaking detail, indicating the type and placement of furniture, the location of walls, doors, and archways, and the character of the home as one that should reflect not only the proper if progressively minded Mrs. Alving but also the ten-years-after lingering presence of the debauched Captain Alving. These concerns are all within a director's purview and, it should be noted, most of them derive directly from Ibsen. Nevertheless, the precision of Reinhardt's description reveals the level of

influence he presumed to exercise on Munch's work. Most of what is left to Munch is a matter of decorative detail; even then, Reinhardt cannot refrain from suggesting that the curtains and chair covers might be a dark, faded violet.

Second, Reinhardt's logistical concerns as producer compete with his artistic ones as director. His top priority is to get a number of detailed sketches—of the curtains and other fabrics, the treatment of the walls, and the style of furniture—so that his scene shop can get to work placing orders for upholstery, wallpaper, wood, and other materials necessary for the construction of the set. Because lighting design is not to be executed until later in production, sketches suggesting it can wait; ironically, so can the all-important landscape that will serve as the very pulse of the interior world. As is often the case in the deadline-driven process of producing a play, the countdown to opening night jostles with aesthetic concerns, all the more when it is the first-ever opening night in a brand new theater. Hollaender and Kahane start out entreating Munch to provide a sketch that will provide an "impetus"—"You won't be in the least further troubled"—and the next thing Munch knows Reinhardt is haranguing him for wallpaper patterns, fabric swatches, and wood trim. The show must go on.

Third, Reinhardt's letter makes it clear that he conceived the theatrical chamber music of *Ghosts* in terms of *chiaroscuro*. His specific notes for the three acts outline a lighting plot that moves rhythmically from light to dark and dark to light, marking not just the temporal movement of each act but a spatial rhythm as well. Reinhardt clearly intends a dynamic tension between inside and outside (in terms of stage geography, downstage and upstage), modulated by the changing time of day and the settling and lifting of the fog, as well a more strictly interior tension between different parts of the room (more right and left perhaps), achieved through the use of corners, furniture, and lamps to create areas of light and ghost-like shadows. He explicitly asks Munch for a sketch "*without* atmospheric lighting" in order to prepare a basic set which, almost like a screen, will receive and reflect a variety of lighting effects.

In this regard, Reinhardt must have been inspired not only by the earlier work of Lugné-Poë but by more recent experiments by the visionary designer-directors Adolphe Appia and Gordon Craig. Although underappreciated in his own day, Appia revolutionized the approach to scenography by his concentration on the rhythm of the stage space. The American scene designer Lee Simonson has outlined Appia's agenda as follows: "The plastic elements involved in scene design, as Appia analyzed them, are four: perpendicular painted scenery, the horizontal floor, the moving actor, and the lighted space in which they are confined. The aesthetic problem, as he pointed out, is a single one: How are these four elements to be combined so as to produce an indubitable unity?"[37] For Appia, the key was in the fourth element, lighting, because its ability to reflect changes in mood and tone, even subtle ones, most closely approximated the effect of music and its unrivaled capacity to express the Eternal. "Light and light alone," Appia wrote, "quite apart from its subsidiary importance in illuminating a dark stage, has the greatest plastic power, for it is subject to a minimum of conventions and so is able to reveal vividly in its most expressive form the eternally fluctuating appearance of a phenomenal world."[38] Simonson articulates the difference for Appia between mere illumination and plastic light: "Diffused light produces blank visibility, in which we recognize objects without emotion. But the light that is blocked by an object and casts shadows has a sculpturesque quality that by the vehemence of its definition, by the balance of light and shade, can carve an object before our eyes. It is capable of arousing us emotionally because it can so emphasize and accent forms as to give them new force and meaning."[39] Thus did Appia introduce the centuries-old painting technique of *chiaroscuro* into the visual realm of the stage.

Gordon Craig, the illegitimate son of actress Ellen Terry and architect and designer Edward Godwin, was a disciple of Walter Pater who imagined theater as "a place in which the entire beauty of life

can be unfolded, and not only the external beauty of the world, but the inner beauty and meaning of life."[40] His aestheticist conviction prompted him to pursue a vision similar to Appia's in terms of its emphasis on light as a compositional element, the elimination of realistic detail in favor of austerity and grandeur in design, and a sculptural and rhythmic conception of stage space. But where Appia concentrated on the play of light and shadow, Craig experimented with color and texture, sometimes in the form of huge hanging curtains or tall pillars. In addition, Craig sought to add plasticity to the stage picture by designing scenery that moved, experimenting with large screens with textured surfaces, neutral in color to receive light, and intended to glide across the stage from one position to another.

In 1904, Craig was introduced to the Berlin theater scene by Count Harry Kessler, a Weimar diplomat and cosmopolitan patron of the arts who, coincidentally, had been a champion of Munch's in Germany for the past decade. Kessler had seen Craig's work in London and wanted to fuse his visual lyricism with the verbal lyricism of Austrian playwright Hugo von Hofmannsthal. Craig came to Berlin to work with Otto Brahm on the world premiere of Hofmannsthal's adaptation of Otway's *Venice Preserv'd* at the Lessing Theater; the arrangement turned into a fiasco, paving the way for Craig to work with Brahm's new rival and competitor, Reinhardt.[41] Off and on for the next two years, at precisely the time when Reinhardt was taking over the Deutsches Theater and making plans to build the Kammerspiele and stage *Ghosts,* he and Craig engaged in a series of negotiations about plays Craig might direct and design for Reinhardt, starting with Shaw's *Caesar and Cleopatra* and including Hofmannsthal's *Oedipus and the Sphinx, The Oresteia* of Aeschylus, and Shakespeare's *King Lear.* The collaboration was stillborn. Disagreements over choice of play, contractual details, and artistic control led to contentious relations, with Craig eventually claiming that Reinhardt appropriated his work. Craig was notorious throughout Europe for accusing others of imitating his ideas, but in this case, according to L. M. Newman, the charge is not without some merit.[42]

"THE ARMCHAIR SAYS IT ALL!"

As the italicized entreaties in the letters of Hollaender, Kahane, and Reinhardt suggest, Munch was slow at first to produce images for *Ghosts.* As prolific as he was, Munch was notorious for periods of inactivity during which he mulled over his subjects. Max Linde, an eye doctor who became an important patron of Munch's, explained it this way: "Munch can go for weeks without actually putting brush to canvas, merely saying *'Ich male mit meine Gehirne'* in his broken German ['I'm painting with my senses']. He carries on like that for a long time, just absorbing, until suddenly he will give shape to what he has seen, pouring his whole body and soul into his work. Then it is only a matter of days, even hours, before his pictures are ready. He puts everything he has into them. That is why his pictures have such a feeling of greatness, of genius."[43]

Frustration with Munch's pace of work is evident in an oft-quoted anecdote from Ernst Stern, Reinhardt's Costume and Scenery Director for fifteen years and the man ultimately responsible for turning whatever Munch produced into a stage set. In his memoir, Stern recalled the summer of 1906:

Today in his study Reinhardt showed me an oil painting by the famous Norwegian painter Edvard Munch. It represented a room whose characteristic feature was a big black armchair. The room was intended as staging for Ibsen's drama Ghosts, *with which the recently completed Kammerspiele was scheduled to open. Munch's picture, painted in his usual manner, gave me only very few hints in regard to details, and I said so to Reinhardt. "That may be," he responded, "but the armchair says it all! Its black-*

ness restlessly reflects the entire mood of the drama! And then the walls of the living room in Munch's picture," he went on, *"they have the color of sick gums. We must make sure to find a wallpaper of that color. It will transpose the actors into the proper mood. In order to live fully, acting needs a room shaped by form, light, and most of all color."*[44]

Eventually, Munch completed a series of paintings which depicted different moments from the play, each one of which includes the conspicuous presence in the foreground—or downstage center, as theater people would say—of the same high-backed black armchair, turned away (upstage) at an angle as if to provide a view of the landscape outside or to protect whoever sat there from view (no. **59**). Munch scholars have been quick to associate the black armchair in Munch's *Ghosts* sketches with the wicker chair of *Death in the Sickroom* (oil painting of 1893, lithograph of 1896, no. **10**), the painting in which Munch recalls the 1877 death from tuberculosis of his fifteen-year-old sister, Sophie.[45] This traumatic loss, along with the equally traumatic death of his mother nine years earlier when Munch was a five-year-old boy, accounts in large part for Munch's fascination with death and his repeated depiction of deathbed scenes (no. **60**). No wonder then that Munch seems to have regarded *Ghosts* as a three-act deathbed play centered on Osvald, who he adopted as his *doppelgänger.*

There is more than ample basis for Edvard's identification with Osvald. Both were young idealistic painters who left the oppressive cultural climate of their native Norway to study painting in Paris, where they enjoyed the camaraderie and pleasures of a thriving bohemian counter-culture. As Osvald says after his return home, "I'm afraid that everything that's most alive in me will degenerate into ugliness here."[46] Both were abandoned by their mothers at a young age, Edvard by way of death and Osvald by virtue of being sent away by his mother for his own protection. Both were victims of hereditary illness. Osvald blames what he calls his "carelessness" for the syphilis which is killing him, until his mother takes away "the agony of remorse and self-reproach" in the third act by telling him the truth of his father's past and the hereditary cause of his disease. Edvard was a notoriously weak child from birth, often missing school because of rheumatic fever or some other illness; he attributed his frailty to hereditary factors on both his mother's and father's side: "Sickness and insanity and death were the black angels that hovered over my cradle and have since followed me throughout my life."[47]

At Christmas time in 1881, when the publication of *Ghosts* first sparked controversy throughout Scandinavia, Munch was a new student of painting at Kristiania's Royal School of Art and Design and just turning eighteen. Two years later, in October 1883, the August Lindberg production had a run of thirteen performances at Kristiania's Möllergaten Theatre, which, according to Arne Eggum, "there is every reason to believe that Munch attended."[48] By that time, Munch had already been introduced by Christian Krohg and others to the Kristiania Bohemians gathering around the writer and free-love advocate, Hans Jaeger, who had written in defense of *Ghosts* when it was first published.[49] Among the impishly sacrilegious "Nine Commandments" formulated by the Kristiania Bohemians, three might have been inspired in part by Ibsen's scandalous play: "Thou shalt sever thy family roots. . . . Thou canst not treat thy parents harshly enough. . . . Thou shalt take thy life."[50] Whether or not Munch saw the Lindberg production, he could not have escaped notice of the play and the prototype it offered him of an artist *in extremis.* Over the next twenty-five years, as *Ghosts* became a fixture of the modern repertoire, Osvald became Munch's theatrical alter ego.

Perhaps the most immediate and intense point of identity between Edvard and Osvald at the time of Munch's work on *Ghosts* was that both men were going crazy. In act two, Osvald explains to his mother that when he returned to Paris after his last visit home, he "began having such tremendous pains in my head—mostly toward the back, it seemed. It felt like a tight iron band squeezing me from my neck up— . . . At first I thought they were nothing more than the old, familiar headaches I've been

bothered by ever since I was little." When he went to work on a new large painting, "it was as if all my talents had flown, and all my strength was paralyzed; I couldn't focus any of my thoughts; everything swam — around and around." Clutching his head, he says, "Mother, it's my mind that's broken down — out of control — I'll never be able to work again!"[51]

In the summer of 1906, Edvard was in much the same condition. His troubled relationship with Tulla Larsen had come to a traumatic and bloody conclusion in September 1902 with a gunshot wound to one of Munch's fingers. Since then, he had become increasingly restless and agitated, sedating himself with excessive amounts of alcohol, moving about from place to place even more than usual, picking fights with strangers, experiencing hallucinations and temporary paralysis, and behaving erratically. He took refuge in the home of concerned patrons, who commissioned portraits from him partly in an effort to settle his nerves. "I am glad that I am going to Weimar," he wrote to a friend on January 13, 1904, "as I have on three occasions threatened people with a pistol purely on impulse. Apart from that, the fact that Germany has fallen under the spell of my art affords me cold comfort, but at least it has stimulated interest in it. I am now going to paint Count Kessler in Weimar, and so all that is missing is a commission from the Duke."[52]

By 1906, Munch's physical and psychological health had so deteriorated that he yielded to pressure to forsake alcohol for awhile and take a rest cure at a spa in Thuringia near Weimar. As he later recalled:

While at Kösen I repeatedly felt small attacks of lameness, especially at night. My legs and arms would be numb frequently. During the days, I felt a sort of pressure in my right leg. I limped a little. Then there were the strange attacks and notions I had.

One day I am sitting in the spa's restaurant and am eating breakfast with a Dutchman, a habitual guest. "I can hypnotize you," I suddenly say. "No, I don't want to," he responds. "You will see."

Then I mix together in a bowl some mustard, pepper, tobacco ash, and vinegar. "Eat this," I say and gaze fearfully at him. "If you don't, I'll shoot you on the spot."

The Dutchman got up and left. On the same day, he departed from the hotel.[53]

While in Weimar that summer, Munch painted one of his most famous self-portraits, *Self-Portrait with Wine Bottle*, which shows the artist sitting impassively at a near-empty table in the restaurant of the Hotel Russischer Hof, hands in lap and a blank inward stare on his face (no. **6**). The painting has been celebrated as a consummate portrait of melancholic despair and a barometer of Munch's deeply troubled psyche at this particular time. Such was Munch's state of mind when Reinhardt and his associates invited him to make "just a sketch from which we might draw ideas" for their production of *Ghosts*. The master director was celebrated for finding the best possible painter to create images that would evoke the soul of a particular play, but in this instance, he could hardly have known just how apt his choice was. He was, in effect, inviting the character of Osvald to design the sets for his own play.

Munch responded with a number of sketches, in charcoal, pen, tempera, and oil, some of which were completed too late to be of direct benefit to Reinhardt's production. Much of the work was done right on the premises. As Arthur Kahane later recalled:

Munch was in the Deutsches Theater every day, lived among us, worked days, drank nights, and painted alternately on the pictures for Ghosts *and on his cycle [the Reinhardt Freize]. Sometimes he also sat for a long time, long and quite still and absorbed, and nothing moved in his face: what was going on behind these brazen features? And then at some small provocation, he awoke and was quite bright and laughed — the simple, cheerful laugh of a child — with his eyes, the corners of his mouth, his whole face. He was always friendly in manner, but at the same time reserved, with a northern sort of stiffness, with-*

drawn and impenetrable. He remained the stranger, remained a mystery to us . . . He was sometimes ridiculously obstinate, did not look up, did not listen at all, remained unmoved, unflustered by either praise or blame; but behind this obstinacy he had a titanic, iron will of his own, of which he was only semiconscious. And a desire for freedom that seemed to burst the bounds of society, as if he could only have been born in, and could only thrive in, the most profound state of solitude. This Munch was certainly a strange boulder in the whirlpool of theater.[54]

In terms of groundplan and furnishings, Munch's sketches follow Reinhardt's (and Ibsen's) directions closely: the requested picture window at the rear, area rugs which expose the floor, the French doors, and round family table are all there (fig. **79**). The greenhouse is suggested only by a tall potted plant, and the grandfather clock stipulated by Reinhardt for the fireplace has been shifted to the opposite wall (upstage right in stage terms), where it anchors the composition and suggests an inanimate figure tall enough to compete with the characters drawn into the sketches. That same stage-right wall contains Munch's major

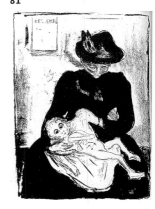

decorative addition to the room: a pair of family portraits, which, according to Paal Hougen, are based on portraits painted by Peder Aadness of Munch's great-grandparents.[55] If only by virtue of their frames, these portraits and the imposing clock are present in even the roughest of the *Ghosts* sketches, an inscription of hereditary influence into the scene (fig. **80**).

At a time when his mental health was diminishing, Munch's work on *Ghosts* revived his conviction that he was a victim of heredity. One of the paintings he initially planned to include in the Reinhardt Frieze was a re-working of *Inheritance*, which he first painted in the late 1890s (fig. **81**). Originally titled *The Syphilitic Child*, it shows a grieving woman seated on a bench against a green wall with a ghost-white infant in her lap. Munch wrote:

The woman bends over the child which is infected by the sins of the fathers. It lies in the lap of the mother. The mother bends over it and weeps so that her face becomes scarlet red. The red, tear-swollen, distorted face contrasts strongly with the linen-white face of the child and the green background.

The child stares with big, deep eyes at a world into which it has come involuntarily. Sick, anxious, and questioning does it look out into the room, wondering about the land of agony into which it has entered, asking, already, Why—why?

It was the usual feeling of Ghosts *—I wanted to stress the responsibility of the parents. But it was my life, too—my Why. I, who came into the world sick, in sick surroundings, to whom youth was a sickroom and life a shiny, sunlit window—with glorious colors and glorious joys—and out there I wanted so much to take part in the dance, the Dance of Life.*[56]

By the "Dance of Life" Edvard must have meant what Osvald refers to as the "joy of life," which both of them image as a radiant, life-giving sun.

79
Edvard Munch, Design sketch for *Ghosts:* Osvald, Pastor Manders, and Mrs. Alving in act one, 1906. Munch Museum, Oslo.

80
Edvard Munch, Rough sketches for *Ghosts*, 1906. Munch Museum, Oslo.

81
Edvard Munch, *Inheritance*, 1898. Munch Museum, Oslo.

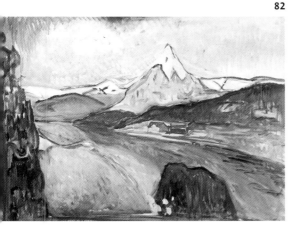

"THE SUN—THE SUN"

One of the renderings of the *Ghosts* interior depicts the very end of the play, after Osvald, anticipating the imminent, final attack that will reduce him to catatonia, has insisted that his mother give him a fatal dose of morphine. When she shrinks from the task, he echoes the syphilitic child when he explodes in anger: "I never asked you for life. And what is this life you gave me? I don't want it! You can take it back!"[57] He chases her when she flees the room to call a doctor and then locks them both inside. This physical exertion is sufficient to trigger the brain fever that he dreads. He sits in the armchair, which minutes earlier Mrs. Alving had pulled over to the sofa in order to talk to him. Dawn is breaking, and Ibsen's stage direction indicates that "the glaciers and peaks in the background shine in the brilliant light of morning." Munch painted this view bathed in gentle pink and blue light, with a snow-capped peak in the distance, a village enclave in the valley below, and in the foreground an ambiguous natural mass which in shape, color, and contour resembles the high back of Osvald's big black armchair (fig. **82**).

As Osvald settles in, his posture echoes that of Munch in *Self-Portrait with a Wine Bottle;* according to Ibsen, he "appears to crumple inwardly in the chair; all his muscles loosen; the expression leaves his face; and his eyes stare blankly." All he can do is mutter over and over again, "The sun. The sun," which stands as both a desperate appeal for the killing drug and a final incantation of the "joy-in-life" that Osvald's art has stood for. As James McFarlane, translator and editor of the *Oxford Ibsen,* has put it:

The entire weight of the drama bears down on this one select, refined moment of terror, where words fail and speech has become an idiot's babble and a mother's wounded cry of pain, where gesture has been paralyzed by seizure and the torment of excruciating indecision. After the stolid monumentality of Pillars of Society, *after the daring bouleversement of* A Doll's House, *Ibsen built up* Ghosts *to a fateful, final situation, then knocked away the props to leave it desperately balanced on a knife-edge of infinite resolution and of unspeakable distress.*[58]

The Munch sketch shows Osvald slumped over in the chair and Mrs. Alving standing by the table, transfixed by indecision, arms down, clasping the pills in front of her (fig. **83**). The composition—in which a standing female figure, shoulders square to the picture plane, defiantly faces down the viewer (or spectator) while a prostrate or stooped male figure languishes wounded at her side—harkens back to such works as *Ashes II* (1894, no. **28**) and looks forward to Munch's rendering of his final encounter with Tulla Larsen, *Death of Marat* (1907, fig. **84**), except that here the female figure is maternal rather than sexual. As opposed to Munch's other *Ghosts* images, which show the chair facing upstage, its high black back an ominous void into which Osvald will eventually disappear, this sketch follows Ibsen's stage directions and places Osvald "with his back toward the distant view." The sun he is calling for is one he sees in his mind, not with his eyes. Munch made this vision of Osvald's concrete in *The Sun,* one of the huge murals that he painted for the building at the University of Oslo known as the Aula. The painting, and several studies for it, depict a blazing sun with solid, colorful beams that radiate out to the four edges of the canvas, penetrating the landscape with divine intensity and the same symphonic magnificence that Reinhardt described as the finale of *Ghosts* (no. **81**). Munch traced this painting's origins as far back as 1889, to one of his earliest depictions of a deathbed subject, *Spring* (fig. **85**)

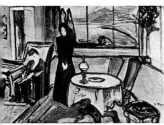

82
Edvard Munch, Fjord landscape for *Ghosts,* 1906. Munch Museum, Oslo.

83
Edvard Munch, Rendering of the final moments of *Ghosts,* 1906. Private collection.

84
Edvard Munch, *Death of Marat,* 1907. Munch Museum, Oslo.

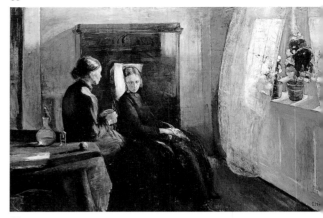

A straight line leads from Spring *to the Aula Paintings. The Aula Paintings are humanity as it strives towards the light, the sun, revelation, light in times of darkness.*

Spring was the mortally ill girl's longing for light and warmth, for life. The sun in the Aula was the sun shining in the window of Spring. *It was Osvald's sun.*

In the identical chair in which I painted the sick girl, I and all those I loved, beginning with my mother, once sat winter after winter, sat and longed for the sun — until death took them away.[59]

The most remarkable of Munch's *Ghosts* paintings, the one that suggests the key to understanding this foray into scene design, is one that omits scenery altogether (nos. **61** and **62**). It zeroes in on mother and son alone in an expressionistic *pietà* that extends the composition of *Spring, The Sick Child* (no. **9**), and *Inheritance.* Mrs. Alving, according to Ibsen, "drops to her knees beside him and shakes him," crying out "Osvald! Osvald! Look at me! Don't you know me?" Munch shows the kneeling mother with head bowed, leaning on and holding her son's left arm, as he sits slack and motionless, facing away from her, eyes slightly downcast. The figures are rendered in swift, broad strokes. Mrs. Alving's face is an unnatural red similar to that of the mother in *Inheritance,* and Osvald's contorted face seems to be dissolving into a blur, as if uttering the words "The sun. The sun." made its yellow glow leak out of his sagging mouth like some corrosive acid or bile. Munch's image is a stunning representation of this moment — "where ultimately the only gesture is a gesture of negation"[60] — except that the "idiot's babble" drowns out the "mother's wounded cry of pain" and Osvald's dissolution into paralysis upstages Mrs. Alving's "excruciating indecision." Munch's close identification with Osvald results in the repetition of the existentialist query of "Why? Why?" which he noted in *Inheritance.* His calling for "The sun. The sun." is a proto-Expressionist wail every bit as painful as *The Scream* (no. **7**).

In this light, Munch's representations of the Alving home — the central and dominant black armchair waiting for Osvald, the living room walls "the color of sick gums," the looming, inescapable family portraits and sentry-like grandfather clock, even the shadows drawn into one of the sketches, trailing behind the characters like limp pod-like sacs (no. **60**) — should be seen as projections of Osvald's subjective perception of the immediate world around him. Reinhardt had described the interior to Munch in terms that reflected a lingering tug-of-war between the "simple, solemn, almost ascetic" Mrs. Alving and "the raw hedonism and brutality of the deceased chamberlain." Moreover, just as the key to Reinhardt's *A Midsummer Night's Dream* was the intoxicating atmosphere of the forest, "the soul of the room" in *Ghosts* lay in the required "landscape visible through the windows." Reinhardt intended that changes outside the house would affect the mood inside, drawing people and scenery into an emotional symbiosis. Nowhere does Reinhardt designate Osvald as the psychic engine at the center of the play, and his enigmatic comments in the final paragraphs of his extensive notes to Munch suggest that he is less interested in spotlighting a "clinical study of madness" than in presenting a more ethereal atmosphere of light and dark forces caught up in an impressionistic dance of death. In short, Reinhardt asked Munch for a Symbolist treatment which emphasized the emotional effect of the scenery on the char-

85
Edvard Munch, *Spring,* oil on canvas, 1889. National Gallery, Oslo

86
Edvard Munch, Design sketch for *Ghosts:* Osvald on the sofa. Bergen Kunstmuseum.

acters (and the actors and the audience), and what he got was an Expressionist treatment which emphasized the perceptual effect of one central character's emotions on the scenery (fig. **86**).[61]

Max Reinhardt's memorial production of *Ghosts* received its gala opening at the Kammerspiele on November 8, 1906, with Agnes Sorma as Mrs. Alving, Alexander Moissi as Osvald, Friedrich Kayssler as Pastor Manders, Lucie Hoeflich as Regina, and Reinhardt himself reprising the role of Jacob Engstrand. Critics, who were not admitted until the second night, declared the production a rousing success, partly because of the novelty of the occasion and the much vaunted intimacy of the new theater. "From every row one feels able to touch the stage," wrote Siegfried Jacobsohn.[62] "A destiny is fulfilled, an intractable fate of dreadful power," said Richard Wilde, "and in the Kammerspiele, this painful event does

not pass over us — we *experience* it; we are a part of the small circle of people whose fates are intertwined."[63] For at least one critic, the intimacy was too much, depriving the play of a needed aesthetic distance. "Whether or not *Ghosts* is quite suitable for the first experimental effort with the Kammerspiele seems to me to be questionable," wrote Alfred Klaar. "I don't want to say that this masterpiece of technique and of nuanced characters is crude, because the transitions are much too subtle, but the play advances gradually in keeping with its inner consistencies to brutalities, in the presence of which the moderation afforded by spatial distance is more welcome than harmful."[64]

Although no photographs of the production are known to exist, prevailing scenographic practices and contemporary reports suggest that the set built for the Kammerspiele stage, while being more realistic than Munch's abstract sketches, was nevertheless free of the fussy details of Naturalism typical of earlier productions.[65] Klaar found the décor "all the more praiseworthy as its contribution was both unpretentious and effective." Wilde credited the set for heightening the theatrical illusion, citing the constant drumming of the rain on the windowpane through the first two acts and the sound of a distant foghorn coming across from the fjord. Reinhardt's Symbolist orientation to the play would seem to be borne out by these atmospheric sound effects as well as the subtlety and nuance of the acting and his liberal use of silences which might allow the haunted soul of the play to resonate.

While the critics praised Alexander Moissi's characterization of Osvald as subtle, simple, and likeable, there was nothing about it to indicate that Osvald's subjective experience determined the tone or mood of the whole. Still, Munch's sketches for *Ghosts* and the influence they had on Reinhardt and his actors constitute just as meaningful a forerunner of Expressionism in the theater as the play that received its world premiere at the Kammerspiele only twelve days after the opening of *Ghosts:* Frank Wedekind's *Spring Awakening* (fig. **87**).

Munch was in Berlin for the premiere of *Ghosts* and the Kammerspiele, attending an opening-night party where he sat with Gordon Craig and Arthur Kahane, but nervous relapses and bouts of heavy drinking prompted him to return to Bad Kösen later in November. He came back to Berlin in early 1907 to work on the Reinhardt Frieze and scenic designs for another production at the Kammerspiele, Ibsen's *Hedda Gabler* as staged by Hermann Bahr, which opened on March 11, 1907. Unlike *Ghosts*, this was not a success. Several of Munch's sketches for the play include representations of Hedda Gabler (fig. **88**) modeled on the figure of Tulla Larsen, a lingering psychic presence which he sought to exorcise in a series of paintings depicting the unfortunate incident at his summer retreat in Aasgaardstrand. Although Munch continued to produce work as prolifically as ever, his health and sanity degenerated throughout that year and the next. Feelings of persecution drove him from city to city. On one occa-

87
The final, graveyard scene from Frank Widekind's *Spring Awakening* at the Kammerspiele.

88
Edvard Munch, Design sketch for Kammerspiele production of *Hedda Gabler*, 1907. Munch Museum, Oslo.



sion, he rented two rooms in the same hotel "so that he could escape from one into the other."[66] The voices in his head grew louder and more insistent until he finally had a nervous breakdown and entered the Copenhagen psychiatric clinic of Dr. Daniel Jacobsen on October 3, 1908.

After a seven-month stay, during which he continued to paint in a makeshift studio on the premises, Munch left the clinic renewed, if still weak, and at age forty-two returned to Norway. In a letter to Reinhardt a year after his breakdown, Munch expressed hopes that they would work together again: "I have often thought of our plans—sketches for *Peer Gynt, Rosmersholm,* and other plays by Ibsen. Wonderful motifs. Perhaps it will be possible that I carry them out some day."[67] Nothing came of those plans. Munch traveled less and less, and he came to prefer the solitude and sanctuary of his live-in studios near Oslo. As with Osvald, he sought the healing power of the sun, which was reflected in his central painting for the Aula of the University of Oslo and illuminates his late landscape paintings.

The Kammerspiele *Ghosts* came at a traumatic period in Munch's personal life and a pivotal moment in Reinhardt's professional career. While Osvald, Munch's theatrical twin and anchor in the storm, returned to his native Norway to die, Edvard, "a strange boulder in the whirlpool of theater," had come home to live.

1 I would like to extend my gratitude to the following people for material aid they provided to the research and writing of this essay: Peter Ferran, Crystal Tiala, Dan Brunet, Sissel Biørnstad of the Munch Museum in Oslo, Alexander Weigel and Eberhard Keienburg of the Deutsches Theater in Berlin, and especially Elizabeth A. McLain. Further thanks are due to the Inter-Library Loan Office of Boston College's O'Neill Library and to the Office of Research Administration for a Research Expense Grant which supported my work on this project.

2 Henrik Ibsen, *Four Major Plays: Volume II,* translated by Rolf Fjelde, New York: New American Library, 1970, p. 88.

3 James Walter McFarlane, translator and editor, *The Oxford Ibsen: Volume 5*, London: Oxford University Press, p. 474. In addition to McFarlane (pp. 465–91), information regarding the history of *Ghosts* is drawn from Asbjørn Aarseth, *Peer Gynt and Ghosts: Text and Performance*, London: Macmillan Education Ltd., 1989, pp. 95–112; Robert Ferguson, *Henrik Ibsen: A New Biography*, London: Richard Cohen Books, 1996, pp. 248–69; Brian Johnston, "Historical Background" in *Henrik Ibsen's* Ghosts: *A Dramaturgical Sourcebook*, edited by Donald Marinelli, Pittsburgh: Carnegie Mellon University Press, 1997, pp. 9–34; Frederik J. Marker and Lise-Lone Marker, *Ibsen's Lively Art: A Performance Study of the Major Plays*, Cambridge: Cambridge University Press, 1989, pp. 90–125; and Michael Meyer, *Ibsen: A Biography*, New York: Doubleday & Co., Inc., 1971, pp. 473–92.

4 August Lindberg as Osvald and Hedvig Charlotte Winter-Hjelm as Mrs. Alving.

5 In the play, Jacob Engstrand recruits his daughter Regina to join him in his own cynical tribute to Captain Alving, a brothel posing as a hostel for sailors. Prostitution was legalized in Norway in 1868, but by the time of *Ghosts* public sentiment had swung towards its abolition.

6 Ferguson, *Henrik Ibsen,* p. 265.

7 Meyer, *Ibsen: A Biography*, p. 484.

8 Meyer, *Ibsen: A Biography*, p. 484.

9 Meyer, *Ibsen: A Biography*, p. 483.

10 Jean Chothia, *André Antoine*, Cambridge: Cambridge University Press, 1991, p. 3.

11 Otto Brahm, "To Begin," translated by Lee Baxandall,

in Eric Bentley, editor, *The Theory of the Modern Stage*, Middlesex, England: Penguin Books, 1968, p. 373.

12 Johnston, in Marinelli, *Henrik Ibsen's* Ghosts, p. 16.

13 Reinhardt's other Ibsen roles included Foldal in *John Gabriel Borkman*, Mortensgard in *Rosmersholm*, and Old Ekdal in *The Wild Duck*. In eight years at the Deutsches Theater, he played 94 different roles, including Baumert in Hauptmann's *The Weavers*, Akim in Tolstoy's *The Power of Darkness*, and Luka in Gorky's *The Lower Depths*. His diary for April 1895, at which point he was twenty-one, includes the following entry: ". . . I seldom have the opportunity in my sphere of activity to play myself. Half of my work consists in the purely technical job of making myself look older, which I constantly have to bear in mind . . . Of course, the audience is completely unaware of all this. It assumes that I am the required age and does not take the technical preparations into account, since it knows nothing of them. The same applies to the critics. If they knew my real age, they would judge me differently." Gottfried Reinhardt, *The Genius: A Memoir of Max Reinhardt*, New York: Alfred A. Knopf, 1979, p. 26.

14 Top: New York production presented by the company of George Fawcett. Bottom: Danish Royal Theater production in Copenhagen staged by Johannes Nielsen.

15 Max Reinhardt, *The Magician's Dreams*, edited by Edda Fuhrich and Gisela Prossnitz, translated by Sophie Kidd and Peter Waugh, Salzburg: Residenz Verlag, 1993, p. 31.

16 Paul Lindau, a writer turned theater director, was Brahm's immediate successor at the Deutsches Theater, but due to poor financial management he remained in his position for barely a year.

17 Hugo von Hofmannsthal, "Reinhardt as an International Force," in *Max Reinhardt and His Theatre* [1924], edited by Oliver Sayler, New York: Benjamin Blom, 1968, p. 24.

18 Hofmannsthal, in Sayler, *Max Reinhardt and His Theatre*, p. 24.

19 Frank E. Washburn-Freund, "The Evolution of Reinhardt," in Sayler, *Max Reinhardt and His Theatre*, p. 51.

20 Simon Williams, "The Director in the German Theater: Harmony, Spectacle and Ensemble," *New German Critique* 29, Spring/Summer 1983, p. 125.

21 Max Reinhardt, *The Magician's Dreams*, p. 32.

22 Hofmannsthal, in Sayler, *Max Reinhardt and His Theatre*, p. 24.

23 Max Reinhardt, *The Magician's Dreams*, p. 48.

24 Hofmannsthal, in Sayler, *Max Reinhardt and His Theatre*, p. 24.

25 In a 1901 letter to Berthold Held with instructions for the design of the *Schall und Rauch* Theater, Reinhardt wrote: "In my opinion, there must *at all costs* be a flight of steps leading from the stage into the audience. We will really need this and it increases the intimacy, perhaps a few steps on either side, which we should also include in the plan." Max Reinhardt, *The Magician's Dreams*, p. 48.

26 Richard Wilde, *Boersen-Courier* no. 528, November 10, 1906, in Hugo Fetting, editor, *Freien Bühne zum politischen Theater. Drama und Theater im Spiegel der Kritik*, Leipzig: Verlag Philipp Reclam, 1987, p. 318. Translation by Elizabeth A. McLain.

27 Marker and Marker, *Ibsen's Lively Art*, p. 20.

28 Max Reinhardt, *The Magician's Dreams*, p. 33.

29 Reinhold Heller, *Munch: His Life and Work*, Chicago: The University of Chicago Press, 1984, p. 101.

30 Heller, *Munch: His Life and Work*, p. 102.

31 Reidar Dittmann, *Eros and Psyche: Strindberg and Munch in the 1890s*, Ann Arbor, MI: UMI Research Press, 1982, p. 81. Munch's complicated relationship with Strindberg is germane to the general topic of Munch and theater but is beyond the immediate scope of this essay. Dittman's study provides a thorough introduction to the subject. Harry G. Carlson also takes up the subject in *Out of Inferno: Strindberg's Reawakening as an Artist*, Seattle: University of Washington Press, 1996, pp. 269–284.

32 Peter Krieger, *Edvard Munch: Der Lebensfries für Max Reinhardts Kammerspiele*, Berlin: Gebr. Mann Verlag, p. 14. Translation by Elizabeth A. McLain.

33 Ragna Stang, *Edvard Munch*, New York: Abbeville Press, 1977, p. 194. For a complete discussion of the Reinhardt Frieze, see Krieger, *Edvard Munch: Der Liebenfries*, pp. 32–63.

34 Stang, *Edvard Munch*, p. 192. Most of the paintings in the Reinhardt frieze now reside in the Nationalgalerie, Berlin. Others are in the Hamburg Kunsthalle, the Museum Folkwang in Essen, and in private collections.

35 Krieger, *Edvard Munch: Der Lebensfries*, p. 14. Translation by Elizabeth A. McLain.

36 Max Reinhardt, "Anmerkungen für das Gespenster Interieur," in Knut Boeser and Renata Vatková, editors, *Max Reinhardt in Berlin*, Berlin: Verlag Frölich & Kaufmann, 1984, pp. 272–73. Also quoted in full in Krieger, *Edvard Munch: Der Lebensfries*, pp. 16–17. Translation by Elizabeth A. McLain.

37 Lee Simonson, *The Stage is Set* [1932], New York: Theatre Arts Books, 1963, p. 355.

38 Simonson, *The Stage is Set*, p. 358.

39 Simonson, *The Stage is Set*, p. 358.

40 Gordon Craig, *The Art of the Theatre*, quoted in Bentley, p. 144.

41 For one account of the Craig-Brahm collaboration, see Horst Claus, *The Theatre Director: Otto Brahm*, Ann Arbor, MI: UMI Research Press, 1981, pp. 122–23.

42 L. M. Newman, "Reinhardt and Craig?", in Margaret Jacobs and John Warren, editors, *Max Reinhardt: The Oxford Symposium*, Oxford: Oxford Polytechnic, 1986, p. 14.

43 Stang, *Edvard Munch*, p. 187.

44 Paal Hougen, "Munch and Ibsen," in Reidar Dittman, translator and editor, *Edvard Munch and Henrik Ibsen*, Northfield, MN: Saint Olaf College, 1978, p. 16.

45 See Hougen, "Munch and Ibsen," p. 16, or Krieger, *Edvard Munch: Der Lebensfries*, p. 15.

46 Henrik Ibsen, *Four Major Plays: Volume II*, p. 95.

47 Stang, *Edvard Munch*, p. 33.

48 Arne Eggum, "Henrik Ibsen as a dramatist in the perspective of Edvard Munch," an on-line catalog essay that accompanies "From Stage to Canvas: Ibsen's plays reflected in Munch's work," an Internet exhibition of the Munch Museum (http://www.museumsnett.no/munchmuseet/nettutstillinger/munch_og_ibsen/english/english_index.htm). The on-line exhibit provides a thorough overview of Munch's many treatments of Ibsen plays, scenes, and characters, including the studies of *Ghosts* which are the primary concern here.

49 Meyer, *Ibsen: A Biography*, p. 485.

50 Stang, *Edvard Munch*, p. 52.

51 Ibsen, *Four Major Plays: Volume II*, p. 87.

52 Stang, *Edvard Munch*, p. 187.

53 Heller, *Munch: His Life and Work*, p. 190.

54 Arthur Kahane, "Edvard Munch and Gustav Knina," in Boeser and Vatková, *Max Reinhardt in Berlin*, p. 271.

55 Hougen, "Munch and Ibsen," p. 15.

56 Hougen, "Munch and Ibsen," p. 17.

57 Ibsen, *Four Major Plays: Volume II*, p. 112. All subsequent quotes from *Ghosts* come from the last few pages of the play (pp. 112–14).

58 McFarlane, *The Oxford Ibsen*, p. 13.

59 Heller, *Munch: His Life and Work*, p. 209.

60 McFarlane, *The Oxford Ibsen*, p. 13.

61 Kirsten Shepherd-Barr argues that Reinhardt's engagement of Munch was "not only a startling break with his previous practices but a prescient attempt to align the theatre with modernist tendencies in general, specifically Expressionism." While prescience is hard to disprove and Reinhardt often drew on the modernist avant-garde for ideas and inspiration, this seems to overstate the case, particularly regarding any specifically Expressionist intentions on Reinhardt's part. Shepherd-Barr, "Ibsen, Munch and the Relationship between Modernist Theatre and Art," *Nordic Theatre Studies*, vol. 12, 1999, p. 52.

62 Siegfried Jacobsohn, *Die Schaubühne*, no. 46, November 15, 1906, in Fetting, *Freien Bühne zum politischen Theater*, p. 320. Translation by Elizabeth A. McLain.

63 Wilde, in Fetting, *Freien Bühne zum politischen Theater*, p. 319.

64 Alfred Klaar, *Vossiche Zeitung*, no. 528, November 10, 1906, in Fetting, *Freien Bühne zum politischen Theater*, p. 327. Translation by Elizabeth A. McLain.

65 For the Edvard Munch exhibition at the McMullen Museum, Crystal Tiala and I created a scale model of what Munch's design studies for *Ghosts* might have looked like had they been more or less literally translated to the Kammerspiele stage. Unfortunately, this experiment was not completed in time to be illustrated here in the catalog.

66 Heller, *Munch: His Life and Work*, p. 198.

67 Hougen, "Munch and Ibsen," p. 22.

NOTES ON THE RECONSTRUCTION OF A SCENIC DESIGNER'S MODEL FOR IBSEN'S *GHOSTS*

CRYSTAL TIALA

The invitation from the McMullen Museum to explore the works of Edvard Munch in relation to the works of Henrik Ibsen was, for Scott Cummings and me, an exciting opportunity to explore the connection between modernist painting and theater. We quickly focused on Munch's 1906 studies for the production of Ibsen's *Ghosts* at Max Reinhardt's Kammerspiele.[1] Although the broad outlines of this historic collaboration are well known, there are still many unresolved issues.

The deeper we probed, the more we were intrigued by basic questions about the purpose, art and practice of scene design. Contrary to many reports, Munch did not create detailed design drawings for the set of *Ghosts*, but produced instead a series of mood-sketches from which Reinhardt and his staff of designers might derive inspiration. But, how did they translate Munch's two-dimensional renderings into three-dimensional scenery? No documentary evidence, no photographs, plans, or detailed verbal descriptions have survived, so the look of the actual production is unknown. This absence of primary source material led us to pursue an alternative form of theater research: we used our interpretation of Munch's *Ghosts* sketches to build a scenic designer's model.[2]

A scenic designer's model assists the director, lighting designer, costume designer, actors, and other members of the production team in visualizing the play. The director must imagine the changing stage picture from moment to moment and image to image as it progresses through the script. A costume designer needs to coordinate color palettes, textures, and styles with the scene designer to create a unified and visually balanced production and to define each character through clothing and accessories. The lighting designer must enhance the mood and atmosphere, make the actors visible where appropriate and complement the color in the scenery with the color gels in the lights. As a material tool in the production process, a good model operates as a bridge between the production as imagined (the ideal) and the final product (the real).

The effectiveness of a design will be immediately recognizable once the model is finished. Robert Edmond Jones, one of the most influential scene designers of the twentieth century, wrote in his book *The Dramatic Imagination:*

A good scene design should be, not a picture, but an image. Scene-designing is not what most people imagine it is: a branch of interior decorating. There is no more reason for a room on a stage to be a reproduction of an actual room than for an actor who plays the part of Napoleon to be Napoleon or for an actor who plays Death in the old morality play to be dead. Everything that is actual must undergo a strange metamorphosis, a kind of sea-change, before it can become truth in the theatre.[3]

A set that is appropriate to the production will transform an empty stage into a new world and compel the audience to accept that world completely, automatically, almost subconsciously. As in a painting, the story is told within the image. Just as a person's facial expression tells us more than the words, an effective set can communicate more than the spoken dialogue.

Although Munch is known for his ability to convey the emotional content of a moment to the viewer, building a set from his sketches is a challenge. The sketches suggest a floor plan that combines walls, doors, archways and windows into a conventional realistic scenic design known as a "box set." Here the audience watches the performance through an invisible but implied fourth wall. The floor is flat, and the furniture is arranged as it would be in a real house. Although Munch included realistic elements in his sketches, he drew the furniture and the architecture with an exaggerated perspective and distorted shapes that emphasize the intense emotions of the play. To what extent was Munch's expressive style actually captured in production? Would the furniture placed onstage have the misshapen qualities found in the sketch, or did Reinhardt's designers use stock furniture pieces from the theater's props storage? From Reinhardt's letters, we know that he asked Munch for more sketches detailing the treatment of the furniture, wainscoting, and windows, and that he instructed his staff to look for a wallpaper to match the greenish-yellow hue of Munch's painting. These requests suggest that Reinhardt translated the mood-sketches into a traditional, realistic set rather than imitating Munch's distortions.

In scenic shops of today, Munch's images could be executed exactly as drawn. Complete plates, similar to a set of architect's drawings, would define the detail of every constructed item. To duplicate Munch's sense of distortion, a variety of shapes could be carved from hard-foam insulation, or molded from fiberglass or heat-sensitive plastics. These techniques, relatively efficient and affordable today, were not available in 1906. But what if they had been? The historical evidence suggests that Munch did not participate in the hands-on construction and decoration of the *Ghosts* set, even though he was on the premises of the Kammerspiele during part of the production process. But what if he had?

Scott and I sought answers to these questions by building a model that represents the set of *Ghosts* as it would have looked if Munch's mood-sketches if had been implemented literally. Evidence from critics and collaborators can tell us something about Munch's unusual partnership with Reinhardt and its results, but we could learn even more by experiencing Munch's scenic design visually. While this experiment is speculative, we believe that it helps us to peer back at Ibsen's play as Munch envisioned it in 1906. It allows us to imagine the human form of Reinhardt's actors interacting with the fluid strokes of Munch's canvas. We can see whether or not Munch's images retain their impact when translated into three dimensions. Munch's expressive style creates intense and emotional images that seem to match Ibsen's drama. Actualizing the artist's designs helps us learn whether they still move us in the same manner as his painting, leading us to a better understanding of how to use images for our own theatrical purposes.

1 See also the essay by Scott T. Cummings: "'A Strange Boulder in the Whirlpool of Theater': Edvard Munch, Max Reinhardt, and *Ghosts*" in this catalog.
2 This model will be included in the exhibition, but was not ready in time to be reproduced in the catalog.
3 Robert Edmond Jones, *The Dramatic Imagination* [1941], New York: Theatre Arts Books, 1969, p. 25.

SEX AND PSYCHE, NATURE AND NURTURE,
THE PERSONAL AND THE POLITICAL:
EDVARD MUNCH AND GERMAN EXPRESSIONISM

CLAUDE CERNUSCHI

All in all, I think I will make out well here in Germany.

—Edvard Munch

I possess the cold joy of power now that Germany has been
conquered for my art and that, at least away from home,
there is an interest in it. —Edvard Munch

I. INTRODUCTION

89

In 1982, the German painter Georg Baselitz paid a direct homage to his Expressionist predecessor, the Norwegian Edvard Munch, by entitling one of his own canvases *Man with Sailboat—Munch* (fig. **89**). For Baselitz, referencing Munch in the title of his work must have been both generally and topically appropriate. Generally, because Baselitz became widely known, not only for painting figures or landscapes upside-down, but also for being at the forefront of what is now referred to as Neo-Expressionism, a movement that began percolating in Germany as early as the 1960s, and receiving international recognition in the 1980s. The significance of Neo-Expressionism, as its name implies, lay in its deliberate resurrection of an artistic idiom believed to be specifically, if not indigenously, Germanic. The sudden recuperation of this "national" style drew keen critical attention because, after World War II, the dominant tendency in art, both in the United States and Europe, was abstraction. Initially, German artists were only too happy to join this tendency. Widely seen as an international movement, abstraction was construed as transcending geographical and national boundaries, as politically and philosophically neutral, and as steering clear of anything reminiscent of the ideological excesses of the Nazi regime. By the 1970s and 1980s, however, younger German artists began to resent this deliberate repression (even if it was self-imposed). Avoiding all references to things Germanic struck them as arbitrary at best, and, at worst, comparable to the denials of what transpired in Germany from 1933 to 1945. Reacting against this unspoken mandate, artists such as Baselitz, Anselm Kiefer, and Markus Lüpertz not only adopted a conspicuously Neo-Expressionist style, but also began treating specifically German themes. This controversial shift was not, however, an attempt to glorify—but to come to terms with—the burden and guilt of a traumatic past. It was incumbent upon artists, so they reasoned, to expose this history—not to hide it from public view.

The resurrection of the Expressionist style was integral to this strategy. Ever since its emergence in Germany before World War I, historians have described Expressionism as a highly personal, emotive, and self-revelatory aesthetic, one whose use of exaggeration and distortion, immediacy and looseness of execution, allowed artists to translate subjective states of mind on canvas with as little mediation

89
Georg Baselitz, *Man with Sailboat-Munch*, 1982. Staatsgalerie Stuttgart.

as possible. But Expressionism was appealing for another reason. Although frequently represented as typically Nordic or Germanic, Expressionism's visual distortions and blatant disregard for aesthetic idealization drew fierce condemnation from the Nazis. Ironically, the very formal and philosophical characteristics that, for many aestheticians, endowed Expressionism with its emotional power and German character, were, for the Nazis, the indices of foreign, degenerate, and Jewish influences. In 1937, the Nazis organized an exhibition of "Degenerate Art" in Munich where Expressionist artists took center stage. For Baselitz, then, re-engaging the Expressionist style had significant general and topical implications. In direct opposition to the cerebral detachment of Pop Art, Minimalism, and Conceptual art, Expressionism allowed for the reintroduction of personal subjectivity, and, in opposition to the international dominance of abstraction after World War II, Expressionism allowed that reintroduction to dovetail with the resurrection of a lost national tradition. And although the former West Germany distrusted any hints of nationalism—practicing a kind of political correctness *avant la lettre*—the revival of Expressionism managed to steer clear of any such accusation because of the ruthless suppression of that tradition by the Nazis. Since Munch is by most accounts considered the father of the Expressionist movement, then Baselitz, by paying homage to him, made his own artistic allegiances perfectly clear.

In the present intellectual and cultural climate, however, Neo-Expressionism could not completely avoid the accusation of reengendering German nationalism, or of pandering to the ideological interests of the powerful. Critics on the Left have interpreted the return to subjectivity in painting—and, more specifically, the return to figuration typical of the Neo-Expressionistic work of Baselitz—as an aesthetically conservative and politically reactionary move. Benjamin Buchloh, for one, declared that the "rediscovery and recapitulation" of "modes of figurative representation in present-day European painting . . . cynically generate a cultural climate of authoritarianism." Totalitarian governments, he argues, abjure the difficulty of modernist abstraction and hope to contravene its transgressive nature by encouraging a more comforting and easily accessible realistic style: i.e., one whose very intelligibility helps uphold and sustain the established order. For Buchloh, there is an "actual system of interaction between protofascism and reactionary art practices."[1] This argument comes dangerously close to oversimplifying the complex nature of aesthetics and politics, and obfuscates the remarkable subtlety with which these two forces potentially interact—after all, modernist abstraction is no more inherently progressive than figuration is inherently repressive. But although Buchloh's account is less than persuasive, he nonetheless raises an important and often neglected question about the political implications of Expressionism. Expressionism is frequently represented as a personal and subjective art form whose primary purpose is to provide the recalcitrant, alienated artist with a vehicle for direct expression and communication. But just as Baselitz had nationalistic reasons for re-invoking the Expressionist style, Munch explored certain themes in his work that reinforced the agendas of nineteenth- and twentieth-century German nationalistic movements. These movements, in turn, espoused an ideology that was eventually to have a disastrous impact on both European and world history.

Intriguingly, although Munch's first exhibition in Germany was a disastrous affair, he found a receptive audience in Germany well before he found one in his native Norway. Especially receptive were the artists who were later to spearhead the Expressionist movement in the first decade of the twentieth century, a movement that—even now—is often touted as quintessentially Germanic. (When the Guggenheim Museum in New York organized an exhibition of Expressionist work in 1980, it subtitled the show: "A German Intuition.")[2] As will be argued below, Munch not only exerted a decisive influence upon the development of German Expressionism, but, paradoxically, the ideological edge of his work, as well as that of his Expressionist followers, often echoed the worldview of intellectuals in Germany

whose political inclinations anticipated those of the Nazi regime—the very regime that, ironically enough, was later to reject Expressionism as "degenerate." This, of course, is not to argue (as Buchloh came close to doing with Baselitz) that Munch's work was fascist in any way. But it is to explore the curious ways in which Expressionism found itself at the crossroads of multiple and sometimes contradictory intellectual and political forces in the early twentieth century. By using the scope and nature of Munch's influence on German Expressionism as a springboard for such an investigation, this essay will endeavor to make the nature and implications of these connections more intelligible.

Before these connections can be made to emerge in sharper relief, however, it is imperative to sketch out the historical sequence of Munch's influence on the Expressionist movement. Munch's first impact on German art predates Baselitz's painting by nearly a century. And although this impact is frequently mentioned in the literature and the history of Munch's visits to Germany and his interactions with artists and intellectuals there is amply documented, the extent of that influence in formal, iconographic, and ideological terms has received less attention than it deserves.[3] Our story begins in 1892 when Munch, already a controversial figure in his native Norway, was unexpectedly invited to exhibit in Berlin by its most prestigious aesthetic organization: the *Verein Berliner Künstler* (Association of Berlin Artists). The exhibition so scandalized the public (not to mention the very artists who had invited Munch without any foreknowledge of his work) that it was closed within a week of its opening. According to Walter Leistikow, a *Verein* member, his conservative colleagues were so infuriated over Munch's work as to have exclaimed: "Oh misery, misery! Why, it's entirely different from the way we paint. It is new, foreign, disgusting, common! Get rid of the paintings, throw them out!"[4] The show was an organizational fiasco, but it also gave Munch instant notoriety. The German artist Lovis Corinth even stated that Munch had, in fact, "won the greatest victory. Overnight he became the most famous man in Germany; his show immediately moved to Munich, and from there to other German cities."[5] Indeed, soon thereafter, Munch was invited to exhibit in Cologne and Düsseldorf.

Given the consequences, the motivation of the *Verein* to invite Munch in the first place has intrigued art historians. The original invitation came from Adelsteen Normann, a compatriot of Munch famous for painting Northern seascapes and sailing scenes highly popular with the German public. Yet his uncontroversial style had nothing in common with Munch's. Some scholars have therefore speculated that members of the German art establishment held no genuine interest in Munch, but had ulterior motives for engineering a scandal.[6] Since long-standing disagreements were reaching a fever pitch among members of the *Verein,* the invitation was extended because certain members sought a pretext to provoke a final, irreparable rift among the organization's warring factions. Exhibiting Munch's work, they must have reasoned, would surely do the trick. After all, even Impressionism was still considered radical in Berlin at the time and was rarely shown in the German capital (perhaps because of its foreign—i.e., French—origin). As the conservative members marshaled their forces, others retorted (irrespective of their loyalty to Munch) that closing the exhibition was an inappropriate way of treating an invited guest. After bitter discussions, the conservative members prevailed by a vote of 120 to 103. Some 70 members then stormed out of the hall in protest. The "Munch Affair"—as it was called in the press—thus provided the dissenting members with the perfect excuse to establish a new group: the *Freie Vereinigung Berliner Künstler* (or Free Association of Berlin Artists). Unwittingly, Munch had thus been ensnared in Berlin artistic politics. And appropriately, Max Liebermann, one of the Free Association's most forward-looking members, would, after establishing the Berlin Secession in 1898, reinvite Munch in 1902 to exhibit in the very city that had first been so scandalized by his work. Whether the scandal of 1892 had been pre-calculated or not, it made Munch an overnight sensation in Germany. It is there that his work would eventually have its most immediate and lasting impact, especially on a

group of younger artists whose artistic and philosophical motivations were remarkably similar to those of Baselitz a century later.

What proved so influential (and controversial) about Munch's work on a formal level was his introduction of radical distortions in the realm of anatomical form and local color, as well as his rough physical execution and exaggerations of spatial perspective. On a philosophical level, Munch also rejected empiricism — the central premise of the two most important artistic movements of the time: Realism and Impressionism — and insisted on art's responsibility, not to record visual sensation passively, but to translate subjective psychological states. Observation, he posited, is never dispassionate or objective, but always predicated on an individual's state of mind. "One perceives everything quite differently," he declared, "when one is warm than when one is cold. And it is precisely this, this and this alone, that gives art a deeper meaning. It is the person, life, one must bring out. . . . It isn't the chair which is to be painted, but that which a man has felt by seeing it."[7] Munch further dismissed Naturalism as mere "craft," insisting that "salvation" would only come from Symbolism, i.e., from an art form that, in his own words, "places mood and thought above everything and only uses reality as a symbol."[8] Munch's decision to take "leave of Impressionism and Realism"[9] was underscored in his Saint-Cloud Manifesto, notes that summed up his philosophy of art as an attempt to capture the range of experiences that comprise a person's inner life. "There ought no longer to be painted interiors, people who read and women knitting," Munch wrote, "They ought to be living human beings who breathe and feel, suffer and love."[10]

For younger German artists maturing during the first decade of the twentieth century, and who were later to spearhead the Expressionist movement, Munch's example (in concert with that of van Gogh and Matisse) provided the very stimulus that Munch would later provide for Baselitz. A pivotal event in the development of Expressionism was the founding of the artistic group *Brücke* (Bridge) in 1905 by four architectural students in Dresden: Ernst Ludwig Kirchner, Erich Heckel, Fritz Bleyl, and Karl Schmidt (who later added his birthplace, Rottluff, to his name). Max Pechstein, Otto Mueller, and Emil Nolde, among others, also joined the group before internal strife and disagreement caused it to disband in 1913. *Brücke* did not have a specific program except an exaltation of youth and a rejection of conventions, be they artistic or societal. Impressionism, even as it came to be accepted in Germany, struck these younger artists, as it did Munch, as scientifically objective, emotionally neutral, and ultimately superficial. "How things appear to us," Kirchner wrote, "is what intrigues us in nature, not the objective form and configuration. And it is around appearance that art revolves, not around the actual objective form."[11] Analogously, Nolde admitted that the "techniques of Impressionism suggested to me only a means, but no satisfactory end. Conscientious and exact imitation of nature does not create a work of art. . . A work becomes a work of art when one re-evaluates the values of nature and adds one's own spirituality."[12] Whether any art form (even Impressionism) can actually achieve an "exact imitation of nature" is, of course, a problematic assertion. But it is not a question with which the Expressionists were unduly concerned. Munch provided them not only with a formal example to follow, but also with a powerful rhetorical tool to legitimize their formal distortions on the basis of the psychological insights those very distortions allegedly revealed.

These links and similarities notwithstanding, it is imperative to note that many of the Expressionists later denied having been influenced by Munch, or claimed to have seen Munch's work only *after* having already invented their mature styles. While writing his pioneering study of German Expressionism, the art historian Peter Selz corresponded with some of the aging but key figures of the movement to set the record straight. He quotes (not without suspicion) Heckel's insistence that he first came across paintings by Munch only around 1908 or 1909.[13] In a later interview, Heckel maintained that had he and his colleagues been aware of Munch during their formative years they would surely have invited

him to participate in their exhibitions. Selz also quotes Schmidt-Rottluff's recollection that although works by van Gogh and Munch were readily available in Dresden around 1906, he "was not able to do much with them at the time."[14] Selz even relates that Kirchner would ostensibly fly into a rage at the very mention of Munch's name.[15] Yet Selz warns that these accounts should not be accepted at face value. Pechstein and Nolde never denied seeing Munch's work in their early years; and *Brücke* is known to have indeed invited Munch to participate in an exhibition as early as 1906, although how or even whether Munch answered is unknown.[16] Many Expressionist artists, in fact, have become infamous for backdating their works, presumably to give the impression that their styles had matured independently of external influences.[17] Denying Munch's impact was simply part of the same strategy.

Munch is equally important for having sensitized the Expressionists to earlier tendencies in Northern art that circumvented the idealization associated with the measured and restrained Classicism of Antiquity. Since Classicism was increasingly seen as foreign to German culture and incapable of reflecting contemporary conditions, the Expressionists' attention turned to German art of the Middle Ages and early Renaissance — e.g., the works of Lucas Cranach and Matthias Grünewald — and, most notably, to German fifteenth- and sixteenth-century woodcuts. Not only was this aesthetic tradition an indigenous one, but its formal exaggerations also anticipated the very experiments the Expressionists were themselves making. Since those distortions were believed to exacerbate the emotional and communicative power (rather than the purely descriptive function) of art, then Munch's call to reject the passive transcription of appearances in favor of evoking psychological states could have struck his Expressionist followers as typical of a specifically Nordic or Germanic worldview.

On this account, art splintered along various geographical, chronological, as well as cultural and philosophical fault lines: North/South, antique/medieval, Classical/Romantic, rational/emotional, idealized/distorted, Apollonian/Dionysian, material/spiritual, and so on. Given the Expressionists' disillusionment with the empiricism of Realism and Impressionism, it is therefore hardly surprising that the alternative approach evidenced in German medieval art (and its alleged ability to suggest subjective experience) would have been particularly appealing. On one level, of course, the prototypes artists chose to emulate may simply reveal their own idiosyncratic likes and dislikes. But at the time the Expressionists were painting, many art theorists and critics were also pondering how artistic styles reflect the specific characteristics of a nation, people, or race. The German nationalist critic Arthur Moeller van den Bruck, for example, an acquaintance and great admirer of Munch, drew a marked distinction between French and German art. French art, he wrote, is "objective, precise, real" on account of a French "skeptical" turn of mind. Conversely, it "continues to be Germanic," he adds, "to have an inner eye for the inner being, to understand the universe not critically but to feel it fantastically — and nowhere was this power more strongly preserved than there where the Germanic essence was most strongly preserved, in the North, in Scandinavia."[18] Yet Moeller's distinction was more prescriptive than descriptive. If he admired Munch, it was, arguably, because the Norwegian's celebration of subjectivity intersected his own nationalistic interpretation of art. No less importantly, a similar mentality was strongly entrenched among the artists of the Expressionist movement. The "recognition" of "the division of foreign and German," according to Emil Nolde, was "the first decisive step towards a new spiritual order."[19] Expressionism, therefore, was not simply an artistic attempt to convey the intangible realm of emotion and psychological states, it was also part and parcel of a broader strategy of drawing artistic and philosophical distinctions on the basis of national character. Yet those distinctions did not describe "objective" properties of works of art; on the contrary, those distinctions were inextricable from, and direct reflections of, the biased, patriotic sentiment of the persons making them.

Reinforcing the importance of these divisions was the philosophy of Friedrich Nietzsche. To be sure, Nietzsche was no German patriot, and all forms of nationalism were anathema to him. But this

did not prevent German nationalists like Moeller from claiming him as one of their own. For the Expressionists in particular, Nietzsche's rejection of deductive reasoning and penchant for making categorical declarations bolstered their own celebration of instinct and intuition. Nietzsche's call for Dionysian "agitation" and "intoxication," which he proclaimed "indispensable" for "any sort of aesthetic activity or perception,"[20] made an equally powerful impression. Like Moeller, Munch was also a great admirer of Nietzsche, and executed several posthumous portraits of the German philosopher (fig. **90**) at the request of the Swedish banker Ernst Thiel, who was translating some of Nietzsche's works into Swedish, and helped found the Nietzsche Archives in Weimar.[21] Nietzsche played so important a role in Munch's worldview that Michael Strawser and others have persuasively argued that Nietzsche's "philosophy of art and psychology" provides a key "hermeneutical hypothesis to better explain" Munch's artistic production.[22] Munch had probably been exposed to Nietzsche's ideas as a result of his association with the cultural critic Hans Jaeger and other bohemian intellectuals in his native Kristiania (now Oslo). For young intellectuals staking a position at the margins of society and critical of what they saw as the humdrum monotony and hypocrisy of bourgeois existence, the German philosopher's exultation of the *Übermensch* (an individual who is not the product of his culture, but overcomes its limitations and restrictions) must have been especially attractive. The Kristiania Bohemians' rejection of strict moral codes (and of all aspects of Christian teaching) also mirror Nietzsche's severe philosophical criticisms of Christianity and desire to move beyond the confines of conventional morality. In addition, Nietzsche's claim that *Übermenschen* were most likely artists, saints, or philosophers would have provided artists who, like Munch, were first rejected by peers and misunderstood by their public,[23] with the fortitude to persevere. Nietzschean ideas about the superiority of the *Übermensch,* in fact, even emboldened artists to attribute any dismay over their art—conveniently—to the "inferiority" of their audience.

This disdain was likewise fed by Nietzsche's view that freedom was achieved only at the cost of great emotional suffering. Analogously, Munch claimed his personal isolation to be a prerequisite for, if not the source of, his ability to create—a highly Nietzschean point of view. Along similar lines, Munch's first biographer, Curt Glaser, wrote that "the isolation that he needs is the greatest luxury Munch permits himself."[24] Ragnar Hoppe even recalls Munch having said the following: "With the passing of the years, I have become more and more unsuited to the company of my fellow men . . . for six years I haven't been to a single party, or even a guest at the homes of my best friends."[25] Separateness from society may result in alienation, but it also provides, according to Nietzsche, a privileged point of insight from which to evaluate that society more incisively. Munch, of course, may not have been quite as isolated and unappreciated as the image of the misunderstood genius he wanted to project. Many of Munch's early supporters and biographers, as Patricia Berman has recently remarked, have stressed "the gulf between Munch's production and the work of his contemporaries by virtue of psychological complexity and alienation."[26] But this account may be more fiction than fact. The creation of this image—what Berman calls the "mythic Munch"—can be attributed, at least in part, to attempts by Munch's supporters to paint the artist as a kind of Nietzschean *Übermensch.* In a particularly hyperbolic example, for instance, Gösta Svenaeus went so far as to claim that "one can without reservation characterize Munch as a Nietzschean overman."[27] This is not, of course, to say that Munch did not think of himself in these terms. But acknowledging Nietzsche's influence does not necessarily imply that the philosopher's ideas should be accepted uncritically. Nietzsche was as influential as he was, arguably, because his concepts could be construed as valorizing many of the artist's own visual experiments, and, no less importantly, because those same concepts could be used to turn public criticism into unintended praise. Not surprisingly, Nietzsche also held a strong fascination for the members of *Brücke,* who like Munch also executed posthumous portraits of the philosopher (fig. **91**). When Kirchner first met Heckel, the latter was allegedly declaiming entire passages from *Thus Spoke Zarathustra.*[28] And it is a

90
Edvard Munch, *Portrait of Nietzsche,* 1906. Private Collection.

91
Erich Heckel, *Portrait of Nietzsche,* 1905. Private Collection.

common assumption in the literature on German Expressionism (although some scholars are in disagreement)[29] that the very title *Brücke* was borrowed from the following line in *Zarathustra:* "What is great in man is that he is a bridge and not a goal."[30] Nietzsche used this metaphor to stress that the contrast between *Mensch* and *Übermensch* ("man" and "overman") was equivalent to that between ape and man. The members of *Brücke,* given their own rejection of academic conventions, and desire to establish a new society based on youthful principles, must have taken to Nietzsche's pronouncements like ducks to water. "Living apart and shy," wrote Nolde, "in ascetic self-denial, brooding and alone—this was my lot."[31] Like Munch, they fashioned their self-image after Nietzsche's views that art lies not at the margins of cultural concerns but at their very core, that art plays a crucial role in renewing a person's inner life, and, most notably, that great artists qualify as *Übermenschen.*

Nietzsche's exultation of genius (artistic as well as philosophical), and his unceremonious disdain of those he called "incurably mediocre" and "the mob," thus encouraged artists to cultivate their individual personalities at the expense of what connected them to a broader social fabric. As a result, art was seen in highly individualistic, even self-confessional terms. Echoing Nietzsche's famous dictum that one "should write with blood," Munch proclaimed that "All art, literature and music must be born in your heart's blood."[32] He also told Ludvig Ravensberg: "My pictures are my diaries."[33] Among the themes most amenable to this purpose is, of course, the self-portrait, a recurring thematic obsession among the Expressionists. We will turn our attention to this theme shortly, but, before we do, it is also instructive to stress that, for Munch and the Expressionists, individuality could be also be communicated by formal means.

It was a common assumption among these painters that an artist's psychological and emotional state could be directly translatable through the artist's bodily movements while working on the canvas. Individual and idiosyncratic, physical activity was believed to be so closely reflective of an artist's mental condition as to be unimitatible and unrepeatable. To be sure, Munch's looseness of execution, his proclivity to scratch and lacerate the surface of his paintings, and to allow multiple corrections to remain visible in the final work, were construed as signs of ineptitude by hostile critics. But for artists sensitive to the idiosyncrasies of an artist's individual touch, these were clear manifestations of the artist's emotional as well as technical involvement in his work. For the German Expressionists, spontaneity and impulsiveness were the only means of circumventing traditional modes of execution and heeding Nietzsche's call for "intoxication," "extreme agitation," and a "discharging of emotions."[34] In a letter to a patron, Emil Nolde admitted to employing a "certain amount of carefree playfulness" in his pieces. Yet if he "were to 'correct,' in the academic sense" traces of his mistakes, or changes of mind, then "this effect would not even be vaguely approached."[35] Similarly, Erich Heckel proclaimed that "everything programmatic is to be rejected."[36]

Of course, thick applications of paint and deliberate looseness of execution were as much indebted to Vincent van Gogh and Henri Matisse as to Munch. But Munch's example in print-making along with that of Paul Gauguin and lesser-known figures such as Joseph Sattler and Paul Herman became particularly influential for rekindling an interest in the expressive possibilities of the woodcut. Munch's prints were widely known in Germany, mostly due to the efforts of Gustav Schiefler, who, in 1906, compiled and published the first volume of what was to become the standard catalog of Munch's graphic work. In addition to championing Munch's cause in Germany, Schiefler also had close ties with *Brücke* artists, and even introduced Munch to Nolde. In Munch's treatment of the wood, the Expressionists must have recognized an attitude strikingly similar to their own. First, unlike etchings or engravings (which Munch and the Expressionists also practiced), woodcuts allowed the grain to be visible to great effect in the final product (see *The Kiss,* no. **31**); and, second, because wood cutting is a subtractive process,

the entire task becomes an arduous operation. As a result, the physical strain of the process can be made into an integral part of the work's final appearance (see Munch's *Self-Portrait* of 1911; no. **4**). The marks on the surface of the print, in other words, tend to be read not as the disembodied effects of the artist's hand moving effortlessly on a smooth surface, but as direct traces of the artist's laborious cutting and gouging into the rougher wood. Looking at a woodcut, therefore—especially when the artist has left the surface irregular and unpolished, with protuberances and indents clearly visible—becomes a form of vicarious physical experience. Spectators, on one level, are encouraged to reconstruct, in their imagination, the stress and strain of the very activity that they assume made the work possible. As Schiefler put it "One feels the pulse of an artist when one contemplates his graphic work. . . . The needle, the crayon, the cutting knife are simpler and therefore more penetrating means of expression than brush and color."[37] Every visual aspect of a work, then—e.g., the texture of the surface, the direction of the marks, the depth of the cuts—can be scrutinized and construed as an indexical record of the artist's working process. And the more physical this process became, the more of the artist's individual psychology and emotional force was, in grand Nietzschean fashion, thought to be embodied in the final work. "The artist's personality," for Kirchner, "is more intimately represented when he constructs the incisions by hand than when etching with acid."[38] Similarly, Pechstein stated that so subtle a feature as the "depth of the knifecut" could be so expressive as to reveal "either the agitation or composure of the worker."[39]

The recovery of the woodcut medium by Munch and the members of *Brücke* also coincided with an important debate in art theory between Gottfried Semper and Alois Reigl. This debate (on the relevance of materials in artistic creation) is too complex to be given adequate treatment here. But its implications are so pertinent to the subject at hand that even a cursory account will reveal its relevance to the Expressionist infatuation with the woodcut. Semper insisted that the role of materials was decisive. If materials possessed inherent properties, then these properties would invariably predetermine the final form and purpose any material would take. Reacting against Semper—or, more accurately, against the more extreme views of his followers—Riegl argued that it was not the material, but the artistic impulse or will (which he called *Kunstwollen*) that would dictate a work's final form. Clearly, in Riegl's view, the will (as it was for Schopenhauer and Nietzsche) was construed as a powerful force that overcomes resistance. In art, the will overcomes—rather than submits to—the resistance provided by the inherent properties of materials. For Riegl, the entire history of art can be understood as a "continuous struggle with material; it is not the tool . . . [or] technique . . . [it is] the artistically creative idea that strives to expand its creative realm and increase its formal potential."[40] This view would have struck a sympathetic chord among the Expressionists, who were intoxicated with Nietzsche's idea that the artist "transforms things until they mirror his power—until they are reflections of his perfection."[41]

Thus, even if Munch or the members of Brücke were unaware of Riegl at the time they employed the woodcut technique, the parallel between their worldviews is so striking as to confirm the opinion, held by many art historians, that these artists and aestheticians were thinking along similar lines. Indeed, within a Rieglian mindset, art could be construed as a kind of Nietzschean struggle, an activity that requires the full physical participation as well as psychological involvement on the part of the artist. But our story does not end here.

Although the concepts of struggle and self-determination were primarily aesthetic and psychological for Riegl and Nietzsche, nationalist thinkers like Moeller endowed them with a clearly chauvinistic spin. "Fighting," he proclaimed, "is magnificent and more worthy of man than self-indulgence in smug comfort. Battle gives us, when it is of spirits and passions, our greatest kings and best heroes . . . Eternal peace would be insupportable—it would be boredom, a yawning that would give us merely the philistine."[42] It is therefore crucial to reiterate that the aesthetic connotations surrounding the use of

the woodcut had specifically nationalistic rather than simply aesthetic or technical connotations. German medieval woodcuts, after all, displayed some of the same formal characteristics exploited by the Expressionists: schematized anatomy, large angular planes, an absence of linear perspective, and a simplification of space to the point of denying three-dimensional volume. Since these formal devices were construed as especially expressive, they were increasingly touted as specifically Germanic. That the physicality of the technique also dovetailed with Nietzschean ideas on individuality and genius, and that Munch, a Nordic artist, pioneered the recuperation of the woodcut as a potential means of expression, could only have enhanced its appeal among the Expressionists.

II. SEX AND PSYCHE

But Munch was influential on Expressionism in very specific ways, not only in broad, ideational terms. He hoped, in fact, that these larger philosophical concerns could be directly communicated through the visual motifs and iconographical themes explored in his work. These concerns, he must have reasoned, could be made manifest if the artist made the self into a continual object of investigation. Munch's decision to paint over seventy self-portraits, following the lead of artists such as Rembrandt or van Gogh, is inextricable from his view that art is not a vehicle for recording visual sensation, but an avenue towards self-investigation and self-knowledge. In line with Nietzsche's contrarian stance, however, Munch circumvented conventional portrait formulae where the sitter is portrayed as a member of a group, profession, or social class. Munch's proclivity, rather, was to portray himself as an estranged figure. The *Self-Portrait with Skeleton Arm* (1895; no. **2**), for example, places the artist before an undefined black field, with no context or architectural setting to localize the sitter or identify his rank, standing, or function in society. His eyes are fixed upon the spectator, but his expression is impassive. And, in a parody of conventional Renaissance modes of portraiture, where sitters would rest their arms on ledges before the spectator to provide a sense of immediacy and reinforce the illusionism of the image, Munch substitutes his own decomposed, skeletal arm for the conventional ledge or parapet. In this way, a device originally used to divide the space of the sitter from that of the spectator now becomes a divider between life and death—a *memento mori* (a reminder of death).

Death is a frequent motif in Munch's self-representations. Munch experienced the death of family members at an early age—his mother died when he was five and his older sister, with whom he was especially close, died when he was twelve. He was himself physically fragile and frequently ill, a condition later exacerbated by tobacco and alcohol abuse. These experiences made him so sensitive to the fragility of existence as to feel himself haunted by the memory of deceased loved ones and haunted by premonitions of an early death. Reflecting on death, Munch once remarked, "I am living with the dead—my mother, my sister, my grandfather and, above all, with my father,"[43] and at another time made the famous comment, "Sickness and insanity and death were the black angels that hovered over my cradle and have since followed me throughout my life."[44] Not surprisingly, the inscription and date above the artist's head in the *Self-Portrait with Skeleton Arm* recall that of a tombstone; and Munch at times signed examples of this lithograph on the skeleton arm itself, tending to reinforce how personally the artist took the threat of mortality.

The visual device of separating the head from the body in the *Self-Portrait with Skeleton Arm* was, of course, frequently used by Symbolist artists (e.g., Gustave Moreau, Odilon Redon, and Aubrey Beardsley) to suggest the perpetual tension between the irreconcilable realms of life and death, the physical and the spiritual. Munch, however, allows the separate realms of life and death to interact as conflict-

ing forces within a single body—thus suggesting that the living individual is *already* in a state of decomposition. Intriguingly, Rolf Stenersen recalled the following exchange with Munch while perusing one of his works: "Do you get a feeling of Sickness?" "What do you mean?" "Don't you recognize the smell?" "The Smell?" "Yes, can't you sense that I am beginning to decay?"[45] In this sense, the skeleton arm can be construed as a statement on the permeability between the states of life and death. But the image is so ambiguous and polyvalent as to frustrate any single interpretation and generate a multiplicity of readings. For example, because Munch's torso is indistinguishable from the background, the arm seems unconnected to the rest of the body; Munch's head simply levitates above it, oblivious to the skeletal state in which the limb has fallen. From this vantage point, the dichotomy between head and arm could also be read as suggesting a flight of the imagination. Munch once told K. E. Schreiner that he "lived the whole of his life partly in a dream world, partly in reality. People have realized this and have attacked my defenceless body like ravening wild animals, whilst my soul was wandering far away."[46] The separation of the head and arm may also represent Munch's eventual overcoming of death through the ability of his art to outlast the confines of his physical body. In which case, the arm may not belong to Munch's actual physical person, but serves as a generic symbol of the ultimate barrier: the barrier that separates Munch from the beyond, from the deceased members of his family, and also from his audience. Yet if Munch raises countless questions with *Self-Portrait with Skeleton Arm,* he also offers no precise answers: this self-portrait remains, at the same time, one of his most simple and most enigmatic images.

Munch continues his musings on the theme of death in his *Self-Portrait in Hell* of 1903 (no. **3**). Instead of suggesting the *physical* threat of death, Munch now gives visual form to the ways in which religious beliefs compel the pious to intuit life *after* death as contingent upon their disposition or conduct during *this* life. But if these will indeed be the measures according to which an individual will be tested, Munch predicts his failure in no uncertain terms. The artist depicts himself in the guise of a damned sinner, half-length and in the nude, perhaps as an allegorical commentary on his own difficult relationship with his pious father, whose faith Munch, to the former's great regret, could not share. As in the portrait with skeleton arm, this is not an empirical portrayal of death, but a projection into the future. It is not death itself, but its anticipation, not its finality, but the way it encroaches upon the living, that is the theme of these self-portraits.

Especially intriguing about the *Self-Portrait in Hell* is how Munch allowed an area around his head to remain lighter than the ambient atmosphere. It may be difficult, if not impossible, to interpret the meaning of this area with any kind of certainty, and, admittedly, the difference in tone may simply indicate Munch's desire to highlight his darkened head more dramatically by placing it against a lighter background. But the yellowish area around the head could also be interpreted (albeit tentatively) as a halo. This reading would not be altogether far-fetched since Munch did portray himself as Christ in *Golgotha* (1900, fig. **37**) and as John the Baptist in *Salome Paraphrase* (1898). It was hardly unusual, in fact, for artists to depict themselves as Christ or as religious figures in the late nineteenth and early twentieth centuries. Lacking a supportive system of patronage, and enduring derision and alienation from an uncomprehending public, many avant-garde artists at the turn of the century portrayed themselves in the guise of Christ or of a martyred saint (e.g., Vincent van Gogh, Paul Gauguin, James Ensor, Oskar Kokoschka, Egon Schiele, among others).

In *Self-Portrait in Hell,* Munch uncannily combines signs of sainthood (the halo) and signs of moral transgression (the fires of hell). This may indeed seem too incongruous a combination, yet it was also not unusual for Munch to introduce halos in places where they would otherwise prove inappropriate. In *Madonna* of 1895 (nos. **54** and **55**), for example, Munch depicted a woman from the vantage

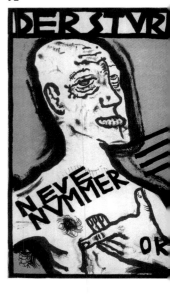

point of her lover during sexual intercourse, but framed her head with a halo-like shape to suggest the sanctity of a moment by which the cycle of life joins all the generations of humanity to each other. In the *Self-Portrait in Hell,* however, the presence of the halo could also provide a way for Munch to express current ideas on the duality and contradictory nature of the psyche. In the late nineteenth and early twentieth centuries, psychologists, philosophers, as well as a host of literary figures were stressing the complexity and conflicted nature of human mentation—a point best summarized by Freud's immortal line: "The Ego is not a master in its own house."[47] Especially pertinent to Munch's self-portrait is the following passage from Arthur Schopenhauer's *World as Will and Representation,* where the philosopher intimates that "religious teaching regards every individual, on the one hand, as identical with Adam, with the representation of the affirmation of life, and to this extent as fallen into sin (original sin), suffering, and death. On the other hand, knowledge of the Idea also shows it every individual as identical with the Saviour . . . as partaking of his self-sacrifice, redeemed by his merit, and rescued from the bonds of sin and death."[48] To construe the human personality as a site of psychic fragmentation and perpetual contradiction, as did Schopenhauer and Freud, is relevant not only because of Munch's use of contradictory signals, but because this reconceptualization of the psyche also set a reevaluation of ethics into motion. If the human mind was construed as a battleground where conflicting and contradictory wishes, desires, and impulses struggled for control, then labels such as "virtuous" and "nonvirtuous" became equally problematic. Just as the Ego, to use Freudian terminology, was said to be continually disturbed by the Id, the difference between virtue and vice was no longer thought of as fixed or permanent. This very point, in fact, was made by August Strindberg (who had made Munch's acquaintance in Berlin) in his "Author's Foreword" to his play *Miss Julie.* "I do not believe," Strindberg writes, ". . . in simple stage characters; and the summary judgments of authors—this man is stupid, that one brutal, this jealous, that stingy, and so forth—should be challenged by the Naturalists who know the richness of the soul-complex and realise that vice has a reverse side very much like virtue."[49]

Paul Gauguin already employed contradictory messages in his *Self-Portrait with Halo* (1889), where the artist combined seemingly incongruous suggestions of sainthood (the halo) with those of sin (a snake and an apple). Oskar Kokoschka, moreover, a Viennese Expressionist whose work was strongly marked by Munch's example, evoked an analogous polarity in his 1909 self-portrait advertising the German avant-garde periodical *Der Sturm* (fig. **92**). In this poster, the artist portrays himself pointing, Christ-like, to a gash on his right side; but the shaven head, an obvious marker of criminality, was Kokoschka's way of commenting—ironically—on the hostility with which he was treated by the Viennese public.[50] Munch's ability to manipulate mixed signals, therefore, even if used to convey a very private and personal message, was not purely idiosyncratic. It was, rather, directly reflective of broader artistic and intellectual currents. Yet it is also possible that Munch was less concerned with contemporary views of the mind than with commenting on what he saw as the tragedy of existence. "When I embarked on the voyage of life," he once stated, "I felt like a boat made of old, rotten wood, whose builder had launched it on an angry sea with these words: 'If you go under, it will be your own fault and you will be consumed by the everlasting fires of hell.'"[51] If *Self-Portrait in Hell* were interpreted in light of this statement, then the artist's placement in hell would represent, not an anticipation of his punishment for leading an immoral life, or even the visualization of feelings of guilt, but an expression of defiance against an existence, the meanings and injustices of which he could not fully comprehend. In this case, the halo (if it is indeed a halo around his head) would sanctify the personal plight of the artist and raise his emotional suffering to the level of that of a saint or martyr.

Many avant-garde artists felt such an acute degree of alienation that their identification with the marginal and the excluded extended, not simply to saints, martyrs, sinners, and criminals, but also to

92
Oskar Kokoschka, Poster for *Der Sturm,* 1909. Private Collection.

the insane. In the nineteenth century, it was even hypothesized by philosophers and criminologists (such as Cesare Lombroso) that genius was nothing but another side of madness.[52] That Munch wrote "could only have been painted by a madman" in the sky of his seminal image *The Scream* of 1893 testifies to the seriousness with which even artists took this dubious association. Munch even claimed marriage to have been an impossible prospect for him on account of the inheritance he believed himself to be carrying. "Because of the tendency towards insanity inherited from my mother and father," he confessed, "I have always felt that it would be a crime for me to embark on marriage."[53] Yet the identification with the insane, whether real or imagined, was not entirely unwelcome. Given that such luminaries as van Gogh and Nietzsche had lost their reason, and given Lombroso's proclivity to associate madness with genius, suggestions of insanity provided Munch and artists like him with a effective rhetorical tool to justify the extreme nature of their visual experiments. These experiments may reflect the extreme psychological states of their makers, but those states, the artists could retort, were hardly aberrant *per se,* only perceived that way by a public unable to grasp the importance of artistic statements made by individuals ahead of their time.

But an image like *The Scream* (no. **7**) does not work simply on the level of self-identification. Understressed in the literature about this famous work, is the extent to which Munch, a great admirer of Ibsen, may have been inspired by a passage in *Peer Gynt* where the hero (or perhaps, more appropriately, the anti-hero) is told by one of the inmates in an insane asylum:

If we would express our feelings,
it must be by using language!
This constraint applies to all men,
Portuguese and Malabaris,
Dutchmen and the half-caste people —
everybody suffers from it.
I have struggled to promote our
true primeval forest speech —
tried to resurrect its body,
championed man's right to shriek —
shrieked myself, and shown how needful
shrieking is in all our folk-songs.[54]

On this account, Munch's exploration of insanity in *The Scream* could be said to represent a calculated attempt to recover a primal mode of expression functioning independently of codified systems of communication such as language. If one accepts the line of thought expressed in the Ibsen passage, then such forms of expression were believed to have been either lost or stifled in civilizations where the dictates of reason had managed to repress any vestiges of instinct and impulse. The emission of screams would ostensibly tap humanity's primeval nature, and permit even contemporary individuals to convey emotional and psychological states outside the prescribed boundaries of civilized behavior. For Munch, then, exploring the wide range of human psychological states including insanity was not just an aspiration to the condition of artistic frenzy encouraged by Nietzsche. It was also an aspiration to rediscover humanity's original condition, to come to terms more fully and honestly with the wide range of human emotive states, and to yield insights about the human condition unrealizable in conventional art. It should hardly be surprising, therefore, that *The Scream* instigated a strong interest in exaggerated physiognomy, and was echoed in many self-portraits by Expressionist artists, including those

of Erich Heckel (fig. **93**), Max Beckmann (fig. **94**) and Oskar Kokoschka (fig. **95**).

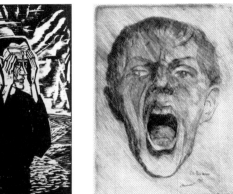

What any analysis of *The Scream* reveals, moreover, since sketches for the work and Munch's own diary entries confirm its status as a self-portrait, is how intimately connected Munch's self-representations are with the rest of his production. Self-portraiture, for example, intersects, not just with the theme of death, but also with that of sexuality. In the *Dance of Death* of 1915 (no. **5**), for instance, Munch portrays himself in close proximity with the conventional Western symbol of death: the skeleton. But although the figure of death is commonly represented as threatening, Munch displays a marked propensity to introduce a sexual component in his portrayals of mortality. Another notable example is *Death and the Maiden* (no. **53**) of 1894, where a nude woman embraces death with unknowing erotic abandon. The connection between mortality and sexuality is seen even in the above mentioned *Madonna*, not only because of the presence of the oddly decrepit fetus in its frame, but also because Munch wrote of the female figure as having the "smile of a corpse."[55] Given the real—as well as imagined—threat of syphilis and other venereal diseases,[56] Munch, like many intellectuals at the turn of the century, closely associated sexuality with death. Another artist, no doubt influenced by Munch, who exemplified this tendency is Lovis Corinth (see his *Death and the Woman* of 1922, fig. **96**). This association of death and sexuality also was highlighted in the increasing study of sexuality in *fin-de-siècle* European culture, of which Sigmund Freud, Richard von Kraft-Ebbing, and Havelock Ellis are but the most famous examples. Their studies went hand in hand with an increasing recognition of the complexity of sexual desire. Freud, arguably, went the farthest with his radical postulation of the death instinct, which, in his view, was inextricable from the sexual drive. Since death existed prior to life and implies—*per force*—a state of non-excitation, Freud posited that all organisms inevitably strive to return to that primordial state. Since every living thing, he writes, "dies for internal reasons—becomes inorganic once again—then we shall be compelled to say that 'the aim of all life is death' and, looking backwards, that 'inanimate things existed before living ones'."[57] Freud's position is that death represents "the most universal endeavor of all living substance—namely to return to the quiescence of the inorganic world."[58]

This, however, is not to suggest that the sexual manner in which death interacts with the figures in either Munch or Corinth's work was at all influenced by Freud. Although it is often assumed that artists reflect the intellectual and scientific mindset of their culture (once that mindset has entered everyday discourse), Bram Dijkstra has persuasively argued that the intellectual presuppositions of late nineteenth- and early twentieth-century psychologists were themselves so contaminated by the art and literature of their time that the reverse could actually have been the case.[59] By his account, the argument could be made that a psychologist like Freud may have postulated the idea of the death instinct less from the direct study of his patients' behavior than from his own subliminal response to works of art—especially works (like Munch's and Corinth's) where death and sexuality were so closely associated as to become inextricable.

Another reference (although an implied one) to sexuality is also discernable in the *Self-Portrait under the Mask of a Woman* (no. **1**), where Munch again portrays himself in an undefined architectural setting, but with a female mask hovering, almost menacingly, above his head. The work is an obvious study in visual contrasts: male/female, animate/inanimate, living/artificial, passive/aggressive, dominating/dominated, etc. The hovering mask, arguably, could be read as a metaphorical way of visualizing Munch's constant sense of foreboding, of being stalked by forces beyond his control. The mask, however, could also have broader social implications. The same motif, in fact, often appears in nineteenth-

93
Erich Heckel, *Man in the Plain (Self-Portrait)*, 1917. Private Collection.

94
Max Beckmann, *Self-Portrait*, 1901. Private Collection.

95
Oskar Kokoschka, *The Warrior*, 1909. Museum of Fine Arts, Boston.

96
Lovis Corinth, *Death and the Woman*, 1922. Private Collection.

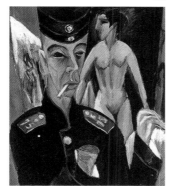

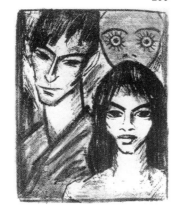

century literature and philosophy as a symbol of delusion and hypocrisy. In the philosophy of Søren Kierkegaard, for instance—which Munch may not have known this early in his career, but which he later acknowledged to have an important kinship with his own work—the mask is used as a reference to the artifice and contrived nature of middle class behavior.[60] Munch was strongly influenced by the anti-bourgeois sentiments of the intellectual circle around Hans Jaeger in Kristiania. Without necessarily having known Kierkegaard's work, Munch could easily have used the mask in an analogous way. That the mask is female may also be significant insofar as Munch had a number of unhappy relationships with women, and often saw them as impediments to his art. On a formal level, the *Self-Portrait under the Mask of a Woman* is also reflective of a frequent proclivity in Munch's work to juxtapose male and female heads in close proximity (see also *Man in Woman's Hair* of 1896–97, no. **37**). And in an earlier version of the *Portrait of August Strindberg* (fig. **97**) than the one on view in the current exhibition (no. **67**), Munch, highly conscious of Strindberg's hostility to women—and to the irritation of his sitter—juxtaposed his head with a schematized female body. Given Munch's own ambivalence towards women, and considering the prevalence of *fin-de-siècle* prejudices against the female sex, the intent, arguably, was to reinforce the cliché of the cerebral male versus the physical female.

The range of motifs in Munch's self-portraits explored thus far, i.e., the suggestions of death, the presence of masks, and the proximity of the male head with either the female head or body, reappear with pointed frequency in the work of *Brücke*. The first direct contact between Munch and *Brücke,* as stated above, probably occurred in 1906 when its members invited Munch to exhibit with (and presumably eventually join) the group. Guarding his own individuality closely, and sometimes even shocked by the work of *Brücke* (in much the same way, ironically, that Munch had himself shocked his own audiences), Munch kept *Brücke* at arm's length. But this did not deter him from eventually exhibiting with its members, or his art from exercising a tremendous influence on theirs. Munch laid the aesthetic groundwork for many of the themes, techniques, media, and even ideological edge of much Expressionist work. Like Munch, the members of *Brücke* made self-representation one of the keynotes of their movement. In his *Self-Portrait as a Soldier* (1915; fig. **98**), for example, Kirchner records his reactions to being drafted in the German army during World War I: "The military," he wrote to a friend in 1916, "has broken me."[61] Kirchner was suicidal, and was obliged to visit several sanatoria to recuperate from psychological trauma and recurring physical symptoms such as lameness in his arms and legs. The lameness was at times so severe as to prevent him from writing and placed his ability to paint in serious jeopardy. Especially pertinent for our purposes, however, is the way Kirchner's depiction of himself with amputated arm, and the inclusion of a nude woman in such close proximity to his face, were directly borrowed from Munchian prototypes: the truncation of limbs from the *Self-Portrait with Skeleton Arm* and the male head/female body juxtaposition from images like the Strindberg portrait. But this blatant appropriation of Munchian devices was not an isolated example. The same motifs also reappear in Kirchner's *Portrait of Ludwig Schames* (fig. **99**), while the combination of a self-portrait with both a female head and a mask (reminiscent of Munch's *Self-Portrait under the Mask of a Woman*) reappears in Otto Mueller's *Self-Portrait with Model and Mask* of 1921/22 (fig. **100**).

97
Edvard Munch, *Portrait of August Strindberg,* 1896. Private Collection.

98
Ernst Ludwig Kirchner, *Self-Portrait as a Soldier,* 1915. Allen Memorial Art Museum, Oberlin College, Ohio. Charles F. Olney Fund, 1950.

99
Ernst Ludwig *Kirchner, Portrait of Ludwig Schames,* 1918, Private Collection.

100
Otto Mueller, *Self-Portrait with Model and Mask,* 1921/22. Private Collection.

The German Expressionists were equally intrigued with the subject of mortality, and their representations of this topic owe a great deal to the visual precedents established by Munch. Heckel's *The Dead Woman* of 1912 (fig. **101**) and Käthe Kollwitz's *Memorial for Karl Liebnecht* of 1919/20 (fig. **102**) are, despite their different subjects and intentions, clearly indebted to Munch's *The Dead Mother* of 1901 (no. **12**). As Munch before them, Heckel and Kollwitz use the dead figure to create an emphatic horizontal line to suggest lifelessness, to evoke the ground where the figure will eventually be laid to rest, and to create a poignant formal as well as psychological contrast to the verticality of the mourners. Also like Munch, both works stress the psychological effect of death on the living. As Reinhold Heller so aptly put it: "It is the state of mind of the survivors that is depicted, not the mood or specifics of death."[62] What distinguishes Munch's image from Heckel's or Kollwitz's, however, is the physiognomic exaggeration and psychological agitation of the child in *The Dead Mother*. Its pose has even led a number of Munch scholars to connect this image to *The Scream,* which, as stated above, is widely recognized as a self-portrait. Since *The Dead Mother* echoes events in Munch's biography, then the resemblance of the child's body language to the figure in *The Scream* suggests that it could also be construed as a kind of displaced self-portrait.[63]

Munch often played with the idea of memory and projection in his work. "I paint, not what I see," he once declared, "but what I saw."[64] The memory of his sister Sophie's death, moreover, is recorded and re-invented after the fact in *Death in the Sickroom* of 1896 (no. **10**) and, most poignantly, of course, in the many versions of *The Sick Child* of 1894 (no. **9**) and 1896, which are the likely sources for Max Pechstein's *Sick Girl* of 1918 (fig. **103**). Munch, in fact, occasionally depicted himself as a child in many drawings, thus reinforcing his propensity to project his various states of mind onto different periods in his life (see Katherine Nahum's essay in the present volume). The ability of the artist to project himself onto a female figure is, of course, more difficult to explain, but Munch did portray himself with female breasts in a later work entitled *Sphinx* of 1926 (fig. **15**), which scholars sometimes subtitle *Self-Portrait as a Woman.* In view of Munch's propensity to rely upon childhood memories to generate images loosely based on past events, and given his willingness to rescramble gender identity, it is highly likely that the child in *The Dead Mother* is, if not a literal self-portrait, then at least another example of Munch's proclivity to use the theme of death to engage in personal projection.

Munch's self-portraits, of course, were not always this oblique, especially when attempting to convey his own acute sense of alienation. One such image is the *Self-Portrait with Wine Bottle* of 1925 (no. **6**), a lithograph after a painting of 1907. Yet however literal the image may be, Munch was not above employing a touch of irony by using a public place, paradoxically, to convey his lack of public contact. The artist's body language also contributes to this effect. By confronting the spectator, the artist turns his back—physically as well as metaphorically—on the very society that had failed to appreciate his art. Munch also accents his facial features to suggest a state of tension and unrest; and, as is usual with him, exacerbates his physical and psychological distance from the figures in the background by an exaggerated use of perspective. As in *The Scream,* perspective lines seem less to recede into the distance than to converge, almost menacingly, upon the spectator. The artist uses a host of formal devices to convey estrangement while, paradoxically, positioning himself in a public setting to emphasize his alienation all the more. The prominent placement of the wine bottle, moreover, a symbol of addiction and desired escape from the world, underlines this point even further—as well as draws attention to Munch's life-long problem with alcohol consumption. Munch's ability to marshal all of these pictorial

101
Erich Heckel, *The Dead Woman,* 1912. Private Collection.

102
Käthe Kollwitz, *Memorial for Karl Liebnecht,* 1919/20. Private Collection.

103
Max Pechstein, *Sick Girl,* 1918. Private Collection.

104
Ernst Ludwig Kirchner, *The Drinker (Self-Portrait),* 1914/15. Germanisches Nationalmuseum, Nürnberg.

105
Edvard Munch, *Self-Portrait with a Cigarette,* 1908. Private Collection.

106
Max Pechstein, *Smoker,* 1916. Private Collection.

107
Max Beckmann, *Self-Portrait with Cigarette*. Private Collection.

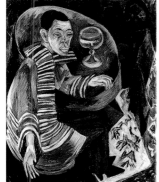

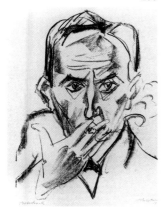

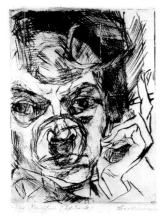

devices and motifs in such a way as to underscore the cleft between artist and society struck a sympathetic chord with Expressionist artists. Indeed, the placement of the alienated artist in a public setting, the use of exaggerated perspective, and the reference to alcoholism in the title recur in Kirchner's *The Drinker (Self-Portrait)* of 1914/15 (fig. **104**). References to addiction and stupor are used here, not as modes of self-deprecation, but as emblems of transgression; while the artist's loss of contact with his surroundings is carefully manipulated to disseminate the image of artist as outsider.

Munch similarly expressed his alienation, bohemian status, and separation from the social fabric in his famous painting of 1895, *Self-Portrait with a Cigarette*. Cigarettes, as Patricia Berman has persuasively argued in her extensive discussion of this painting, had already received a notorious reputation by the late nineteenth century and were frequently connected with illness and alienation. Munch, of course, also employed the cigarette to suggest the brevity of life. Ever since seventeenth-century Dutch genre painting, smoking had been associated with vice and with the ephemeral nature of existence, and, importantly, van Gogh even painted a skeleton smoking as early as 1886. On this account, Munch may have appreciated the way in which the symbolic associations usually attached to the cigarette could have helped him visualize both the artist's obsession with mortality as well as his perceived position as an outcast. Even if the German Expressionists may not have seen Munch's 1895 *Self-Portrait with a Cigarette,* they could have been exposed to his 1908 lithograph of the same subject (fig. **105**), a work ironically meant to celebrate Munch's last cigarette before undergoing a strict regimen of abstention to improve his health. The motif, however, is frequently picked-up by Expressionists such as in Pechstein's *Smoker* of 1916 (fig. **106**) and Beckmann's *Self-Portrait with a Cigarette* (fig. **107**).

The extent of Munch's investigation of the theme of self-portraiture, as well as his admission that his paintings are "his diaries," has led many Munch scholars to claim that his art reflects "the painful honesty of his own questioning of his identity."[65] Given the powerful influence of Nietzsche on Munch and on the members of *Brücke,* it may be natural to construe this fascination with the self as an attempt to explore the hidden realities of the human psyche. No doubt, Munch and the Expressionists thought of their works in precisely these terms. But this does not necessarily mean that *we,* as twenty-first-century observers, should necessarily accept the artists' statements at face value, or that we should endorse the cliché of the suffering, alienated artist often repeated in the artists' own statements (and in the later critical literature as well). Munch, in fact, had a wide number of friends, acquaintances, and patrons, some of whom found him social and even garrulous in conversation. These discrepancies in representation raise intriguing questions. If the image of Munch as a lonesome Zarathustra cultivating his separateness from the world was a partial fiction—one used by the artist and his supporters to project an image of Munch as isolated genius (or "Nietzschean overman")[66]— then perhaps the interpretive implications of his work should be rethought as well. Munch was no doubt sincere when he called his works his diaries; but, by the same token, it should be recognized that all works of art are constructions, and that, as such, they cannot transcribe a person's life without some form of mediation, some form of artifice. Reflecting on the strategies of "borrowing guises and inventing symbolic fictions" in the self-portraiture of Viennese Expressionists like Oskar Kokoschka and Egon Schiele, Kirk Varnedoe has persuasively argued that what is most "modern about these works is not the directness of their communication, but its obliqueness; not the sense of revelation, but the sense of performance."[67] The same, in effect, can be argued about Munch.

If we take his *Self-Portrait in Hell* as a yardstick, the question to ask is: to what extent can that work be said to reveal Munch's inner life? To be sure, the contradiction between the presence of a halo and the artist's location in hell may be reflective of a current view of the human mind as being unharmonious and conflict-ridden. But all the same, it would be unwise to infer too much information from Munch's image, or to interpret it as a transparent view into the artist's psyche. The painting, in fact, *contradicts* the many statements the artist made about the afterlife, and, on this account, is perilous ground upon which to base our understanding of Munch's religious beliefs.

In his statements, Munch suggests that he believed not so much in an afterlife as in the continual transformation of matter and energy. He did declare belief in "immortality" because "the spirit of life lives on after the body is dead." But this was not meant in a conventional Christian sense. When he asked the question: "What becomes of the spirit of life, the power that holds a body together, the power that fosters the growth of physical matter?" his answer was: "Nothing." Yet, for Munch, the "body that dies does not vanish—its substance is transformed, converted. But what happens to the spirit that inhabits it? Nobody can say where it goes to . . . [or] demonstrate how or where that spirit will continue to exist."[68] On the basis of these statements, and of Munch's distance from conventional Christian beliefs, one can legitimately deduce that *Self-Portrait in Hell* is more of an artistic conceit than a necessary revelation of the artist's philosophical or religious worldview. Munch, after all, did not only portray himself as a sinner in hell, but also as Christ, as Saint John the Baptist, as Orpheus, as a woman, and in a number of other guises in various works. It is thus less persuasive to read the multiplicity of these self-representations as transparent glimpses into the artist's inner life, than as reflective of a certain theatricality and inventiveness.

Similar issues will also be raised by Munch's exploration of sexuality, which, like death and self-portraiture, was to become a running theme throughout his work. Since his early discussions with Hans Jaeger and other members of the Kristiania Bohemians, Munch had been exposed to radical ideas about sexuality and free love. In direct opposition to what they saw as a repressive, conventional middle-class code of ethics and old-fashioned expectations about marital fidelity, the Kristiania Bohemians advocated complete freedom in matters sexual. Hans Jaeger, Christian Krohg (an important Norwegian Realist painter who taught and often supported Munch), and Krohg's wife Oda, voluntarily entered into a triangular relationship whose psychological effects on those involved were to be recorded by each in written form. Munch himself entered into sexual relations with a married woman referred to as "Mrs. Heiberg" in his diaries (her real name was Emily "Milly" Ihlen Thaulow, the twenty-four-year-old wife of Munch's cousin, the naval physician, Carl Thaulow).[69] The idea of free love may have been attractive in theory, but it proved emotionally devastating in practice. Attachments began to form in spite of intentions to the contrary and feelings of rivalry caused intense rifts among the group.[70] These were especially difficult for Jappe Nielsen, a friend of Munch who also became involved—unhappily—with Oda Krogh, and whose despondent moments were captured in Munch's various versions of *Melancholy* of 1896 (no. **13**). In his relationship with "Mrs. Heiberg," Munch fared no better. And when he introduced a fellow Norwegian student Dagny Juell to the "Black Piglet" intellectual circle in Berlin, which also ostensibly endorsed the idea of free love, the ensuing contest for her affections caused such bitter strife among the group that its members later dispersed. Munch's *Jealousy* (no. **29**) depicts the emotional effects of Munch and Dagny's relationship on another member of the group, the Polish writer Stanislaw Przybyszewski, who, intriguingly enough, eventually married Dagny.

In view of Munch's own experimentation with the idea of free love, it should be no surprise if his representations of sexuality should also run the gamut of human emotions from affection and sexual satisfaction to aggression and despair. For example, although *The Kiss IV* of 1902 (no. **33**) suggests

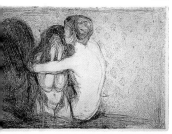

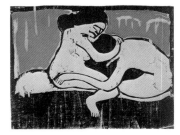

110

selfless absorption and fulfillment, *Man and Woman Kissing* of 1905 (no. **34**) conveys as much friction and repulsion as attraction and desire. *Ashes II* of 1899 (no. **28**), on the other hand, depicts what is left of a relationship once passion and affection have disappeared: "love," Munch declared, is "a flame—because when it is burned out, all that remains is a pile of ashes."[71] It is probably the extent of this emotional range, in addition to Munch's provocative attention to matters sexual, that attracted the artists of *Brücke*. Munch's *Consolation* of 1894 (fig. **108**), for instance, is a likely source for Heckel's *Couple* of 1910 (fig. **109**); and *The Vampire* of 1895 (nos. **40** and **41**) for Heckel's *Two Lovers* of 1907 (fig. **110**), although Heckel's last print also seems to have anticipated Munch's *The Bite* of 1913 (no. **39**). However compelling the formal similarities between Munch's work and that of *Brücke* may be, it is also important to mention how this cycle, by virtue of the serial nature of its images, becomes a perfect opportunity to study the relationality of meaning. In other words, since all of the works are similar—i.e., related without necessarily comprising an actual series—then any individual piece will tend to be interpreted differently within a group than it would as an isolated unit. Its very meaning, in effect, would also change depending on, and in relation to, the meaning of the other pieces hanging next to and around it. Munch himself recognized this very aspect of interpretation, almost by accident, because he preferred his works to be seen in large numbers, a motivation upon which his entire concept of the Frieze of Life hinges. When attempting to discern the most effective sequence for arranging his works, he was struck by the ways in which "various paintings related to each other in terms of content. When they were hung together, suddenly a single musical note passed through them all. They became completely different to what they had been previously."[72] Munch's statement is an acknowledgement, if only a tacit one, of the relational quality of meaning: the view that works of art do not carry meanings inherently in a fixed or permanent way, but that meaning is an act of construction, an act that is contingent upon a specific frame of reference. In Munch's case, the frame of reference was the quantity, and the sequence, in which particular works would be displayed. Whenever the frame of reference changes, the spectator's interpretation of a given work will tend to change accordingly. To peruse *Man and Woman* (no. **38**) in isolation, for example, is a different experience from perusing it next to *Consolation* (fig. **108**). In one case, human relationships seem hopelessly distant and without affection; in the other, evidence of tenderness still manages to permeate an otherwise hopelessly melancholic image. Since Munch did not provide narrative explanations for his images, the spectator is forced to rely upon facial expression and body language to interpret meaning. Those characteristics, however, will not always be read in the same way, but will tend to be read according to the specific range of images the artist (or the museum curator) decides to supply.

Given the admittedly autobiographical nature of Munch's work, it is also tempting to read these images as transcriptions of specific episodes of the artist's life history. But, as argued above with respect to the artist's self-portraits, one should be wary of interpreting works of art as unmediated, transparent avenues into an artist's personal life. Indeed, Munch's images of sexuality were invariably filtered through his personal disposition, ideological biases, as well as through the general assumptions of his culture about the female sex. The subject of sexuality in Munch's work, therefore, inevitably leads to a discussion of his images of, and feelings towards, women. Since, as indicated above, Munch's relationships with women were notoriously problematic, and because he created such blatantly anti-feminine images as *Vampire (Harpy)* of 1894 (no. **42**) or *Woman in Three Stages (The Sphinx)* of 1899 (no. **30**), it has become a near ubiquitous cliché of the Munch literature to label the artist a misogynist. This is

108
Edvard Munch, *Consolation*,
1894. Private Collection.

109
Erich Heckel, *Couple*, 1910.
Private Collection.

110
Erich Heckel, *Two Lovers*, 1907.
Private Collection.

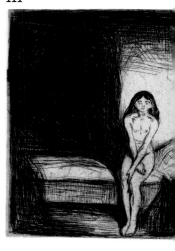

not without reason. In addition to the images mentioned above, Munch himself made several derogatory remarks about women, declaring: "Often, I felt that women would stand in the way of my art."[73] Strindberg expressed a similar idea when he wrote that an individual had to chose "between the laurel wreath of immortality gained through art, or the alternative in *voluptas*, sensuality and depravity."[74] The anti-feminine ideas of Strindberg and of other intellectuals such as Przybyszewski must have had a significant impact on Munch's worldview, and may, in numerous ways, have reinforced the already ambivalent feelings the artist was developing towards women as a result of his personal experiences. In late 1903 or early 1904, for example, Munch told the composer Frederick Delius that, unlike him, he (Munch) remained "a free man," enjoying "perpetual springtime with the enemy—woman."[75] More recently, however, even critics with strong feminist inclinations, such as Patricia Berman, have been willing to reconsider Munch's attitude to the female sex and acknowledge the wide diversity of Munch's images of femininity.[76] And although it is difficult to gainsay that *Vampire (Harpy)* conveys a profoundly negative interpretation of women, other images can indeed be said to represent a wider range of attitudes. In *The Alley (Carmen)* (no. **46**) and *Hands* (no. **49**), for example, Munch portrays the powerful force and disquieting effects of male sexual desire. Yet it remains an open question as to whether the male figures are themselves the victims or the perpetrators of the extreme sexual tension conveyed in both images. Intriguingly, one can read these works in at least one of two ways: as the female self-consciously and malevolently brandishing her power over men by intentionally arousing their lust, or, conversely, as woman being perpetually stalked by the forceful desire she inadvertently and perhaps uncontrollably triggers. *In Man's Brain* of 1897 (no. **36**), moreover, puts the onus of male desire purely on men, suggesting that women are entirely blameless if the content of men's thoughts obsessively revolves around them.

The image that most effectively dispels Munch's reputation as a misogynist, however, is *Puberty* (fig. **111**). No doubt borrowed, as is frequently mentioned in the literature, from Félicien Rops's depiction of a nude woman frightened by a dominating Don Juan figure, Munch's image is an unusually sensitive portrayal of an adolescent girl facing a time of portentous physical and psychological change. Hardly a temptress, Munch's figure is made uncomfortable by the spectator's unwelcome intrusion into her private space, and is forced to hide as well as come to terms with irrevocable changes in her body. These changes, in turn, arouse a number of conflicting emotions. The sensitivity of the image, in fact, is unusual, not only in Munch's work, which is densely populated by vampires and temptresses, but also in *fin-de-siècle* art in general. Its unconventionality lies in the way the image circumvents the extremes of innocence or malevolence which were typical of representations of women in late nineteenth-century art: the saint or the prostitute, the *femme fatale* or the *femme fragile*, the *femme honête* or the *femme publique,* and so on.

Munch, in general, was highly influenced by these characterizations. He described *The Sphinx* as conveying how "woman in her many-sidedness is a mystery to man—woman who simultaneously is a saint, a whore and an unhappy person abandoned."[77] But if Munch's images of women often conform to such reductive forms of categorization, *Puberty* is a conspicuous exception. The figure appears neither unrealistically innocent nor unredeemably corrupted. It could even be hypothesized that her anxiety stems less from being surprised by the spectator, or even from feelings of shame, than from the growing realization that a irreconcilable tension exists between her body's natural inclinations and a society whose codes of behavior prohibit the exploration of those same inclinations. One could make the case, in other words, that *Puberty,* like the conflations of death and sexuality covered above, again provides a close analogy to works of Sigmund Freud. Even if there is no evidence to suggest Munch ever read Freud, and it would have been next to impossible for Munch to have read his works in the

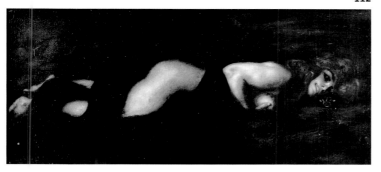

1890s, the parallels are nonetheless so striking as to be well worth exploring. After all, Freud posited that neuroses are almost invariably caused by repressed sexual desire. Since our social expectations and protocols often prohibit the satisfaction of sexual wishes and fantasies, then civilization, in Freud's view, forces its own members to enter into conflict with themselves. If these conflicts become too severe, then Freud posits that we repress the content of our own wishes into the unconscious. But relief is only temporary because the very fact of repressing wishes that still long to be fulfilled ultimately causes neurosis. Although Freud did not advocate unbridled sexuality and the full satisfaction of repressed wishes, his cognizance of psychological problems led him to posit that psychic health was predicated upon human individuals at least recognizing the reality of their own mental lives. To do so, however, required an honest acknowledgement of the very drives that lie hidden behind the façade of reason and propriety.

Thus, even if the adolescent in *Puberty* may not (at least not yet) be repressing her desires, the argument could be made that Munch's work also addresses the nefarious consequences of one's natural wishes being incompatible with the behavioral expectations of one's culture. Interestingly enough, when Przybyszewski wrote about Munch, he described his work in a highly Freudian manner: "Edvard Munch is the first to undertake the representation of the soul's finest and most intense processes, precisely as they appear spontaneously, totally independent of every mental activity, in the pure consciousness of individuality. His paintings are virtually chemical preparations of the soul created during that moment when all reason has become silent, when every conceptual process has ceased to operate: preparations of the animalistic, reason-less soul as it winds and curls upward in wildest storms. . . ."[78] That Munch chose a young girl both to embody and explore the psychological implications of such tensions bespeaks the artist's complex view of (and sensitivity to) the feminine condition—a far more nuanced view of women than the categorical label of misogynist would warrant.

Yet the exceptional nature of *Puberty* may signal another layer of meaning. Without disputing that Munch's images of women convey a plurality of often complex and nuanced meanings, it is also undeniable that many of these same images were profoundly inflected by the misogynist stereotypes of *fin-de-siècle* culture. *Woman with Snake* (no. **45**) from the *Alpha and Omega* series of 1908/09, for example, is an illustration of a lurid narrative (written by Munch himself) about a male, Alpha, whose wife, Omega, deceives him by mating with all of the animals within her reach. Upon discovering Omega's infidelity, Alpha, distraught and furious, kills her by drowning. Her offspring, however, half-human, half-beast, revenge their mother by tearing Alpha to shreds. On its face, this tale may be construed as a private, cathartic release of negative emotions pent up during a difficult personal experience. But the comparison of women to animals was, in fact, a frequent leitmotif of turn-of-the-century misogynist literature. Carl Vogt, for example, used all forms of Darwinian scientific evidence such as cranial measurements to declare that "We may be sure that, whenever we perceive an approach to the animal type, the female is nearer to it than the male, hence we should discover a greater simious resemblance if we were to take the female as our standard."[79] Although such approaches have, needless to say, long been completely discredited, at the turn of the century they were awarded the status of scientific truth. Literary and artistic traditions also contributed to the persuasive power of this analogy: Munch's illustrations, in fact, were most likely inspired by paintings such as Franz von Stuck's *Sin* (fig. **112**), an image where female and animal, almost indistinguishable from each other, also intertwine in a highly sexu-

112
Franz von Stuck, *Sin*, 1899.
Wallraf-Richartz Museum,
Cologne.

ally charged embrace. The impression is not that the woman is under threat, but that she and the snake are comparable creatures: earthy, slippery, and, of course, dangerous. Stuck, in fact, made an entire series of images entitled *Sin* that may, in turn, have motivated Munch to create his own version of the theme in 1901 (no. **44**). The connection between women and animals was thus continually used in *fin-de-siècle* art and science to convey the alleged inferiority of women. And given the authority awarded to Darwinian theory during the late nineteenth century, this nefarious analogy also helped cement the view that women, closer to animals than men, were underdeveloped physically, emotionally, and intellectually. These ideas, in turn, had an insidious, but important, effect on contemporary politics. At a time when women were demanding the vote, as well as greater political and economic autonomy, the comparisons between women and animals went a long way to reinforce the view that women, inherently bestial and carnal, were unworthy of the vote, and undeserving of the very autonomy and freedoms they were themselves requesting.

Munch's *Alpha and Omega* series falls firmly within this context, and it is therefore unlikely, contemporary revisionist readings notwithstanding, that Munch's work can be completely absolved of the charge of misogyny that is often laid at its doorstep. Indeed, in an intriguing essay on Munch's images of women, Kristie Jayne argues that Munch's stress on the reproductive function of women in images such as *Madonna* (nos. **54** and **55**), and the cyclical structure according to which he represents the evolution of women in *Woman in Three Stages (The Sphinx)* (no. **30**) indicates that "in style and subject matter his art depicts women as slaves to the dictates of their reproductive physiologies." A plausible case could be made, she continues, for the influence of Darwinian and post-Darwinian theories on Munch "by examining the artist's fundamentally materialistic and physiologically based view of human life as expressed in his art and his writings."[80] This interpretation has remarkable force. After all, Munch's curvilinear, biomorphic formal vocabulary, replete with flowing, amoeba shapes enclosing and entrapping figures, gives his works a quasi-biological quality, a quality that, by association, tends to endow his paintings with a scientific "look" or "feel." That scientific aura, in turn, tends to add legitimacy to Munch's interpretations of female sexuality, and gives greater credence to the ostensible inevitability of the three stages through which he postulates women must pass. In other words, Munch's style (by vaguely reflecting the biological functions valorized by Darwin) and content (by suggesting Darwin's evolutionary determinism) complement and mutually reinforce each other perfectly. In this way, the scientific authority of Darwinian theory could be misappropriated by a patriarchal culture to deny equal rights to women as a group, and to justify any personal misgivings about women as individuals. Thus, if the term "misogyny" is used in this essay, it is not meant to refer to individual attitudes or emotions, but to the ways in which these same attitudes and emotions interlocked with wider cultural, scientific, and political attitudes. These attitudes, in effect, provided Munch with a frame of reference within which his personal apprehension was no longer seen as private or idiosyncratic, but as another reflection (and confirmation) of what was already being argued by the most prominent cultural and scientific figures of his time. In his highly informative book, *Idols of Perversity: Fantasies of Feminine Evil in Fin-de-Siècle Culture,* Bram Dijkstra has provided an extensive survey of the ways by which anti-feminine beliefs permeated the art, science, and culture of turn-of-the-century Europe. Through his friendships with Strindberg and Przybyszewski, Munch was readily exposed to these beliefs. In Strindberg's plays, women are frequently portrayed as duplicitous, deceitful, and malevolent, and the relationship between the sexes as one of continuous strife and confrontation. And in his novel *Overboard,* Przybyszewski also spoke of "that vertigo-producing abysmal gulf, the great struggle of the sexes, the eternal hatred between them."[81] That Munch's own ideas were not altogether different can be gauged from his own remark that his works of the 1890s "represent one aspect of the battle between men and women, called love."[82]

If we return to the issue of Munch's impact on the Expressionist generation, then it is striking to note the extent to which the presence of deadly hatred among the sexes, and the approximation of women to animals, also appear in Oskar Kokoschka's play *Murderer, Hope of Women* (1909). Like *Alpha and Omega, Murderer, Hope of Women* is also a figment of the artist's own imagination, and, also like *Alpha and Omega, Murderer, Hope of Women* portrays a woman's murder at the hands of a man. Without entering into a detailed discussion of *Murderer's* plot, it is significant to mention that the narrative describes a violent battle for supremacy among the sexes. The female protagonist stabs the male, prods his wound as he lies trapped in a cage, and ultimately revives him. Regaining his strength, the male takes revenge, strikes back, and kills all remaining figures on stage (fig. **113**). What is common to *Alpha and Omega* and *Murderer* is that, given woman's implied brutal and animalistic behavior, as well as her transgressions of male expectations, the violence perpetrated upon her is presented in such as way as to seem justified (as clearly indicated in the title of Kokoschka's play). It is also a refrain of the misogynist literature at the turn of the century that women not only deserved, but also desired, to be treated cruelly. In his *Psychopathia Sexualis* of 1886, for instance, Richard von Krafft-Ebing argued that women's "voluntary subjection to the opposite sex is a physiological phenomenon . . . ideas of subjection are, in woman, normally connected to the idea of sexual relations." It is therefore natural, he continues, that women have "an instinctive inclination to voluntary subordination to man."[83] August Forel, whose portrait had been painted by Kokoschka at the instigation of his friend, the architect Adolf Loos, took this same line of argumentation even further: "it is notorious," he writes, "that many women like to be beaten by their husbands, and are not content unless this is done."[84] And one of the characters in Oscar Wilde's *The Picture of Dorian Gray,* reflects the same idea: "I'm afraid that women appreciate cruelty, downright cruelty, more than anything else. They have wonderfully primitive instincts. We have emancipated them, but they remain slaves looking for their masters, all the same. They love being dominated."[85] Violence was thus deemed an appropriate way of treating women, not simply because women were often portrayed as bestial and unruly, but also because their alleged wish to be treated violently conveniently shifted blame from the perpetrators to the victims of the violence committed.

This, of course, is not to say that all of Munch's images of women are automatically negative; after all, misogyny, like all forms of prejudice, is an emotion, and emotions are not entirely rational or consistent. Munch would hardly have seen any conflict in endorsing a negative view of women in general, while still making tender images of his mother, sisters, friends, or patrons (see the *Portrait of the Painter Aase Nørregaard* and *Lady in a Green Blouse,* nos. **64** and **66**). On this point, one is reminded of Peer Gynt's exclamation at the outset of act two: "the devil take all women . . . all but one."[86]

Reconsidering *Puberty* from this vantage point further underscores how exceptional that image actually is. Perhaps the unconventionality of the piece may be explained if the work were read, not just as a sympathetic portrayal of a youngster facing the physical and psychological changes of adolescence, but as a kind of displaced self-portrait. This interpretation may seem counterintuitive, and, admittedly, it is presented here only as mere conjecture. But if Munch scholars have been amenable to construing the child in *The Dead Mother* as a displaced self-portrait, then there is no reason why Munch's propensity to portray himself as a child, and to engage in gender reversals, could not be applicable to *Puberty* as well. In addition, some of Przybyszewski's comments on Munch's work, believed by many scholars to be actually reflective of Munch's own beliefs, tend to reinforce the view that Munch often projected his own personal emotional states onto the figures he represented. Describing *The Voice (Summer Night),* 1893 (no. **16**), for instance, Przybyszewski writes: "This is the longing of becoming and beginning, the entire painful longing of growing up . . . the fear of tense expectation: the intense listening-into-yourself, half horror, half pleasure in the sensual subterranean areas of sexual arousal." After quoting

Oskar Kokoschka, Illustration for *Murderer, Hope of Women,* 1910. Page 163 of *Der Sturm,* no. 21, July 21, 1910.

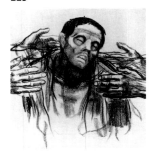

this passage, Heller proposes convincingly that this "description incorporates aspects of *Puberty*," and can, on this basis, be applied to that painting.[87] It would not be farfetched to propose that these representations of fright and anxiety are, in fact, projections of Munch's own conflicted feelings, and that a female figure provided the artist with a visually immediate, but also personally oblique, way of portraying them on canvas.

Whether *Puberty* is a displaced self-portrait or not, Munch's approach to the subject of adolescent sexuality was too provocative to have escaped the attention of *Brücke* artists like Kirchner, Heckel, and Schmidt-Rottluff, who themselves befriended and made numerous portraits of adolescents in sexually suggestive poses. Heckel's print *Marcella* (fig. **114**), after a painting by Kirchner, echoes Munch's *Puberty* quite closely, which is not surprising given the extent of *Brücke*'s debt to Munch. But the common interest in sexuality, and the frequency with which *Brücke* artists appropriated motifs from Munch, should not detract from the widely different implications of their images. In fact, *Brücke* artists often reversed the meanings and connotations of the very sources from which they were borrowing. If *Puberty* could be said to visualize an adolescent's psychological tension and sexual anxiety, Kirchner's *Marcella* conveys no trace of such emotions. Like the members of the Kristiania Bohemia, the members of *Brücke* also sought to circumvent what they saw as the repressive and hypocritical moral codes of middle-class behavior. And like Freud, they also blamed modern civilization for making sexual satisfaction incompatible with the dictates of bourgeois social expectations. But unlike Munch's *Puberty*, the strong sexual overtones of Kirchner or Heckel's depictions of female adolescents display few suggestions of fear or apprehension, only an aggressive and uninhibited acknowledgement of physicality. It should be said, if only parenthetically, that it was not unusual for Munch's work to have inspired formal borrowings from artists who, in the end, turned the meanings of their sources on their head. Just as Kirchner and Heckel transformed suggestions of anxiety and apprehension into more unabashed, confrontational, and down-to-earth interpretations of sexuality, Käthe Kollwitz, similarly borrowed compositional motifs from Munch to widely different effects. Munch's use of disembodied hands to convey the force and aggression of male sexual desire (no. **49**), for example, was transformed by Kollwitz (an artist with very strong socialist sympathies) into a gesture of sympathy and solicitation for famine sufferers in Russia (see her *Help Russia* lithograph of 1921; fig. **115**).

III. NATURE AND NURTURE

But these isolated examples should not give the impression that Munch and the Expressionist generation were always ideologically at odds. For the most part, the philosophical connotations of Munch's works were perfectly aligned with those of *Brücke*. The themes of human alienation and sexuality, in fact, dovetail with the proclivity of Munch and the Expressionists to bifurcate modern life into opposite poles: town and country, urban and rural, nature and nurture, and so on. Analogously, Munch's oeuvre is replete with scenes of urban alienation. *The Scream* (no. **7**), *Spring Evening on Karl Johan Street* (1892), or *Anxiety* (no. **8**, 1894), for instance, were meant to communicate the loss of individuality and intense psychological unease the artist felt in the midst of an impersonal and congested urban environment. The exaggerated perspective found in all these images, a device already encountered in the *Self-*

114
Erich Heckel, *Marcella (after Kirchner)*, 1910. Private Collection.

115
Käthe Kollwitz, *Help Russia*, 1921. Private Collection.

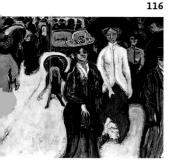

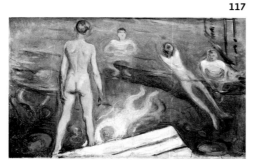

Portrait with Wine Bottle, was, as Kirk Varnedoe has argued, borrowed from the Parisian street scenes of the French Impressionist Gustave Caillebotte.[88] Reversing the original intent of linear perspective, i.e., to provide a persuasive illusion of three dimensions on a two-dimensional surface, Caillebotte used rapidly receding orthogonals to suggest the rush, speed, exhilaration—but also alienation—of modern life. Munch pushes this point even further. The near vertigo-inducing diagonals collapse onto the figures, creating a feeling of claustrophobia commensurate with the subject. These visual exaggerations were deemed so severe as to have encouraged scholars to hypothesize, although without firm evidence, that Munch actually suffered from agoraphobia.[89] Needless to say, diagnosing an artist after the fact—on the basis of stylistic devices alone, and without having had an opportunity to examine him first-hand or to review his medical records—is a highly questionable enterprise. But regardless of what may or may not have been his own psychological state, there is little doubt among scholars that Munch sought to depict the city as a site of estrangement and disaffection. Munch exacerbates this point by generalizing the facial features of his figures to such an extent as to deny them the very individuality he sought to stress in his self-portraits.

This proclivity to see the city as a locus of emotional dislocation, and the crowd as a threat to the individual, was to resonate very powerfully among the members of *Brücke*. Munch's *Anxiety* and *Spring Evening on Karl Johan Street*, in fact, are the most likely prototypes for Kirchner's *The Street (Dresden)* of 1907 (fig. **116**). The exaggerated perspective, dissonant color juxtapositions, organic contours, and distorted, de-individualized figures unmistakably echo formal precedents already established by Munch. Like Munch, Kirchner also arranges his figures frontally across the picture plane and has them make direct eye contact with the spectator. The point, arguably, is to induce in the spectator the same uncomfortable sensations of unease and constriction one feels in the midst of a crowd. The space is so congested that, while scanning the picture, the spectator is provided few paths of escape. Kirchner and his fellow *Brücke* members felt a profound aversion to the impersonality of urban centers like Berlin, and one can interpret Kirchner's work, like Munch's, as an attempt to portray the urban environment as emblematic of the contradictions between the individual and the collective, and between physical proximity and psychological remoteness. "My work," Kirchner wrote, "derives from the yearning of loneliness. I have always been alone; the more I mingled with people, the more I felt my loneliness, felt banished although no one had banished me."[90]

But if large urban centers were construed as *loci* of alienation and artificiality, the antidote was to seek solace and spiritual renewal in nature. In fragile physical and psychological health himself, Munch sought refuge from the dangers of city life (including excessive alcohol and tobacco consumption) in 1908 by visiting the beaches at Warnemünde on the German Baltic coast. At the seashore, he had the opportunity not only to renew his contact with the natural environment but also to explore its implications in his art. Munch revisited the theme of male bathers that had occupied him before in Aasgaardstrand, a village near Kristiania (see *Bathing Men* of 1904, fig. **117**). These representations have been read quite persuasively as glorifications of masculine vitality and physical health. And although academic representations of the nude are physically idealized and dehistoricized (i.e., made to stand outside of time and place), Munch, neither idealizes his figures nor erases the obvious contrast between the paleness of their bodies and their tanned heads and hands. In so doing, Munch emphasizes the realistic rather than idyllic properties of his figures, figures that, in the end, seem more *naked* than nude.[91] The

116
Ernst Ludwig Kirchner,
The Street (Dresden), 1907.
Museum of Modern Art,
New York. Purchase.

117
Edvard Munch, *Bathing Men*,
1904. Munch Museum, Oslo.

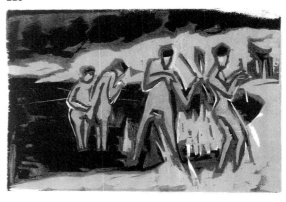

distinction is usually applied to differentiate *nudity,* the permanent and idealized condition of a god or goddess, from *nakedness,* the condition of contemporary individuals who have just removed their garments. The shedding of clothing may also have played a particularly symbolic role in this instance. Just as the clothing of civilization is cast off and bodies find themselves in a more natural state, it is intriguing to note that the more distant the bathers are from the shore, the less human they appear—as if to suggest that the further one moves from civilization, the less inhibited and the more "natural" one becomes. Commenting on Munch's bathers, Robert Rosenblum astutely noticed: "As the nude figures become more deeply immersed in the clear blue waters, they take on bizarre anatomical configurations that recall frog-like swimming creatures with green flesh, flattened featureless heads, and amphibian legs."[92]

Predictably, just as Munch's images of the modern city played a crucial role in the development of *Brücke* subject matter, so did the theme of the human figure in nature. As a foil to the plight of urban artifice and alienation, closeness to nature became a cardinal component of Expressionist philosophy. "I learned," Kirchner wrote, "to depict the ultimate unity of man and nature."[93] Like Munch, the members of *Brücke* sought refuge from crowded metropolitan centers by visiting remote sites, such as the lakes at Moritzburg, where they too disrobed and sought to cast off what they saw as the debilitating effects of civilization by seeking communion with nature. Depictions of bathers not only abound in the work of *Brücke* artists, but even more than in Munch's work, these scenes take on specifically sexual connotations. In Kirchner's *Bathers* of 1910 (fig. **118**), for example, the male figure at the center is conspicuously depicted with erect genitalia, thus allowing an unabashed and aggressive display of sexual desire to remain visible without the conspicuous traces of conflict or anxiety found in works such as Munch's *Puberty*. Indeed, although the sexual implications of Munch's bathing men has been the source of much speculation among scholars, it is intriguing to note that while Munch executed representations of female as well as male bathers, he did not allow the two to intermix. *Brücke*'s images, on the contrary, not only violate the idealization, timelessness, and decorum of classical prototypes, they also provide a context where the natural state of nakedness permits unrestricted interaction across gender lines. Like Freud, the Expressionists felt that they had come close to discovering humanity's original state of being, i.e., a state unconstrained by modern social conditioning and prescribed modes of behavior. For the Expressionists, moreover, frank portrayals of sexuality functioned, as they did for Freud, as pivots upon which the keys to human nature would hinge. If only human beings would again live according to natural law, then the symptoms of anxiety endemic to the modern metropolis would be reduced, and psychic health would dispel the nefarious effects of a repressive and artificial modern life. In this way, the theme of sexuality took on the broader connotation of social critique for *Brücke* artists. After all, humanity's original state would be in no need of recovery if modernity had not first forced human beings to live in a ways inimical to their very nature.

Artists, however, were not the only ones to engage in such critique. In fact, the opposition between nature and nurture provides a kind of interpretive nexus where Expressionist ideology coincides with that of the German Youth movement. The non-programmatic program of *Brücke,* for example, reads: "With a belief in continuing evolution, in a new generation of creators as well as appreciators, we call together all youth. And as youth that is carrying the future, we intend to obtain freedom of movement and of life for ourselves in opposition to older well-established powers. Whoever renders directly and authentically that which impels him to create is one of us."[94] That 1906 statement is striking in its similarity, as Reinhold Heller has noted, to the 1913 summary of the Youth Movement's philosophy: "Now

118
Ernst Ludwig Kirchner, *Bathers,* 1910. Private Collection.

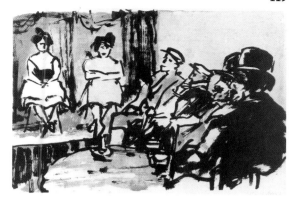

Germany has a movement for youth. . . . Previously only an appendage of the older generation, excluded from public life and limited to a passive existence, youth now begins to be aware and conscious of itself. Independent of the laws of convention, it is attempting to form its own life itself. It strives for a way of life that corresponds to the essence of youth . . . according to its own demands with its own responsibility and according to its own inner truth."[95] The resemblance to *Brücke's* program is clear, and such correspondences were acknowledged by some of the artists themselves: Emil Nolde conceded that his "course of attack found a parallel in the establishment of the German-Volkish student organizations."[96] The Youth Movement started in 1901 as a hiker's club, and soon spread throughout Germany. Its members became widely known as the *Wandervögel* (wandering birds). As with the members of *Brücke*, the *Wandervögel* rejected the bourgeois culture of their parents and sought to reconnect with nature by practicing a simpler, more authentic way of life.

In the ideological climate of turn-of-the-century Germany, however, advocating harmony with nature was not free of powerful nationalistic connotations. Admittedly, the *Wandervögel* despised the political machinery of modern Germany, but George Mosse has persuasively argued that although many disseminators of Germanic ideology claimed an apolitical status, their ideas nonetheless laid the intellectual groundwork for fascist politics.[97] As William Bradley has observed, it was common for scholars of the period to combine "direct observation with historical evidence" into a "patriotic panegyric."[98] A cursory look at *Wandervögel* publications, for instance, makes the nationalistic nature of their endeavors emphatically clear: "Because the landscape which inspires is the landscape of the German *Heimat*, such love awakens love for *Volk* and fatherland . . . a national-Germanic background for all their culture and style of life."[99] To embrace nature, then, was not simply a rejection of materialism and artificiality; it was also an implicitly patriotic celebration of one's native soil, and, in turn, an indictment of urban life. Major cities, which were already thought to be exceedingly large and disconnected from nature, gained a reputation for being international and cosmopolitan — i.e., for being divorced from a country's indigenous population *(Volk).* "Cities," according to the *Volkish* writer Nathaniel Jünger, "are the tombs of Germanism."[100] Similarly, Julius Langbehn declared that "Spiritually and politically, the provinces should be maneuvered and marshaled against the capital."[101] And for Otto Gmelin, "The theater, the cabaret, popular hit songs, fashions, modern dances — all that is international . . . not individual and not *Volk*-oriented."[102]

Not surprisingly, Munch and many of the Expressionists depicted the entertainment and night life of the metropolis, both fascinated and repelled by its decadence and artifice (no. **47** and fig. **119**). And they also saw the agrarian, natural landscape as reflective of the very national spirit that was being increasingly threatened by the rampant mechanization of urban life. The Expressionist stress on personal subjectivity,[103] moreover, echoed the ways in which German thinkers made the idea of nature into a matter of personal projection and even national sentiment. The landscape, they declared, was an extension of the *Volk,* the very people or race who inhabit and draw sustenance from it. According to Otto Gmelin, "For each people and each race a countryside thus becomes its own peculiar landscape."[104] The idea that "Every landscape has its own *Volk*"[105] was widely disseminated in Germany; Emil Nolde even claimed to have learned nothing from a trip to Italy: "faced with a landscape that was alien to me, I found myself incapable of work."[106] One's origin, therefore, defined one's identity. Nolde was born Emil Hansen, but changed his name to Nolde after the village where he was born, just as Karl Schmidt added his birth-place, Rottluff, to his own name. Modernization and industrialization, therefore, were

119
Emil Nolde, *Music Hall III,*
1915. Private Collection.

decried because they altered the landscape and, in turn, the *Volk*'s relationship to it, and, no less importantly, because they encouraged materialism at the expense of a deeper, spiritual relationship with nature. As a result, German *Volkish* thinkers projected that longed-for relationship onto a mythical, pre-industrial past, a myth sustained by unrealistic beliefs in the nobility of an unspoiled rural population, and a landscape assumed to be both national and spiritual.

Munch was himself profoundly affected by such attitudes, which mirrored similar developments in Norway. Munch could project upon nature the spiritual values and the sense of connection he had ostensibly failed to find in human relationships.[107] Fascinated by the theme of metabolism, Munch expressed the view that humanity and nature are forever linked in an indissoluble cycle of life, death, and rebirth. "Nothing," he wrote, "ceases to exist; there is no example of it in nature. The body that dies does not disappear. Its components separate one from the other and are transformed."[108] Analogously, his representation of *The Sun* of 1912/13 (no. **81**), a preparatory study for the Aula of Oslo University (fig. **120**), reflected this same pantheistic view: "To me," Munch wrote, "it seemed as if becoming united with this life would be a raptuous delight, to be with the earth at all times fermenting, always warmed by the sun."[109] Yet given the importance of its location, the image was also a celebration of the more particular properties and life-giving sustenance of the Norwegian landscape. When Munch was recovering from nervous exhaustion and alcoholism in a clinic in Copenhagen in 1909, he expressed his feelings for his homeland this way: "Norway, where one day I must return since nature certainly is important to my art."[110] The image of the sun, then, was the centerpiece of a complex ode to the Norwegian nation—which had received its independence from Sweden only in 1905, a fact that filled Munch with such joy that he wrote on the back of one of his own paintings: "Painted under a feeling of freedom during the election of the King, summer 1905."[111] Receiving a national commission such as the decoration of the University's Aula must have struck a note of personal as well as national vindication for Munch. Norway had been under Danish control from the fourteenth century and then ceded to Sweden in 1814. The survival and maintenance of a traditional culture was an issue of exceptional importance for many Norwegian intellectuals, including, as Patricia Berman has pointed out, Munch's famous uncle, the historian Peter Andreas Munch.[112] Not surprisingly, *The Sun* was flanked by monumental allegories with conspicuously nationalistic overtones: *History,* depicting a old man recounting tales to a young boy beneath a massive tree, and *Alma Mater,* a woman surrounded by infants in the midst of a fertile landscape. At either side of *The Sun,* however, were smaller panels portraying nude figures absorbing the ostensibly salutary effects of solar radiance. The Aula paintings, Munch wrote, were meant to represent "humanity as it strives towards the light, the sun, revelation, light in times of darkness."[113]

Intriguingly, Munch's biographer, Rolf Stenersen, wrote that although Munch saw life as a "constant quest for a non-existent happiness," the "only possible source of anything divine [for him] was the sun and the light."[114] For the German Expressionists, no less than for Munch, the landscape was used as a way to merge nationalistic sentiment with feelings of co-identity with the forces of nature. A study for Munch's central panel was also exhibited in 1913 at the Free Secession in Berlin, and triggered a response in the form of Schmidt-Rottluff's *The Sun!* of 1914 (fig. **121**), a similarly pantheistic image of human beings treating the solar disk as a quasi-divine apparition. Nolde also refers to the healing power of sun in his own autobiography, especially at times of illness: "The sun shone so brightly and beautifully. On the incline of a canal, its ground warmed by the sun's rays, I lay down for many hours and days, seeking renewed strength, nursing."[115] The recurrence of this image during this period was no coincidence.

120
Edvard Munch, *The Sun*, 1916.
Aula, Oslo University.

121
Karl Schmidt-Rottluff, *The Sun!*,
1914. Private Collection.

Extrapolated from old Germanic legends and pagan customs, sun-worship became increasingly popular in Germany and other Northern countries. Advertisements meant to encourage nudism and sun-worship at the time would read: "The sun will brown your skin and cleanse your blood."[116] The Germans in particular—because of the alleged absence of light in their dark and misty forests—often referred to themselves as *Lichtmenschen,* i.e., seekers of light and knowledge. Emil Nolde, for one, wrote: "the nordic people are always drawn south toward the sun."[117] It is very much against this kind of interpretive backdrop that Munch and the Expressionists' images need to be construed. Indeed, Reinhold Heller has already persuasively written that Munch's image can be read as reflective of a "highly popular quasi-religious conception of the time that recognized the sun as the source of all health; particularly in Germany and Scandinavia, a cult of the sun had emerged that had resulted in much-publicized nudist bathhouses, campsites and beaches such as the one at Warnemünde. In Germany, many of the artists and writers whom Munch knew were advocates of the cult, associating it with a politically conservative 'return to nature' which rejected the modern metropolis and yearned for the hardened, sun-drenched bodies of warriors living free in the land."[118] These cults were also religious in an unconventional sense. They saw nature as the repository of religious feeling but without necessarily seeing it through traditional Christian eyes. Julius Langbehn, for example, expressed the view that "God, man and world are concepts, which are contained each within the other."[119] And along similar lines, the *Volkish* thinker Eugen Diederichs proclaimed: "my view of God is this, that I regard the sun as source of all life."[120]

And just as the image of nature could be manipulated to buttress certain political agendas, so was the image of the very people whom *Volkish* thinkers construed as closest to nature. Since the landscape was thought to reflect the very national and indigenous characteristics under threat by industrialization, then those human beings enjoying the most intimate relationship with nature were increasingly portrayed as the bedrock of the German national spirit. Unlike overly intellectualized academics or urban businessmen, simple peasants were seen as embodying the very same properties that were being projected onto the natural landscape. Intriguingly, when representations of peasants and manual laborers appeared in the middle of the nineteenth century in France in the paintings of, say, Jean-François Millet and Gustave Courbet, these works were interpreted as politically inflammatory and provocative. This is unsurprising in view of the numbers of revolutions that swept Western and central Europe in 1848. By the end of the nineteenth century, however, these same representations had lost their radical edge; the emphasis on simple working people, on their connection to the earth, and on the uninterrupted continuity of their folk traditions, costumes, and crafts, became associated with strongly nationalist, and often conservative, political beliefs. So long as no references were made to oppression or poverty, images of peasants could generate nostalgia for a preindustrial past that stood uncontaminated by the values of modernity and international capital. The German nationalist thinker Paul de Lagarde, interestingly enough, merged such nationalistic sentiments with a markedly Nietzschean rhetoric: "Better to split wood than to continue this contemptible life of civilization and education; we must return to the sources, on lonely mountain peaks, where we are ancestors, not heirs."[121]

Munch's *Urmensch* of 1905 (no. **71**, translated awkwardly as *Primitive Man*) and his *Streetworkers* of 1920 (no. **72**) fall comfortably within this context. Given the way Norway's newly gained independence from Sweden affected him, it is obvious that nationalistic fervor was not a feeling from which Munch was completely exempt. And since he was acquainted with Moeller, Munch must have been exposed to some of the basic tenets of *Volkish* philosophy. His own celebration of simple folk and indigenous traditions in the murals for Oslo University were, in fact, read in the same spirit by Norwegian nationalists whose ideology was not altogether different from that of Lagarde. Indeed, in a 1911 lecture held in the very hall where Munch's works were to be displayed, Frederick Stang declared the

importance of the Aula for Norwegian culture and referred, in no uncertain terms, to the invaluable contribution of the peasantry to the national spirit: "[Here] our history, our language, our folk poetry, was retrieved from oblivion. . . . While the farmers conquered the Parliament meeting hall, the culture of our farmer-tradition had become a river flowing through our new art and science scholarship."[122]

On this point, Patricia Berman hits the nail right on the head when she writes that "Due to the efforts of the intelligentsia, the peasants had been reinvented as a metonym for the nation: living in rural areas, peasants were understood to have escaped the taint of foreign culture absorbed by the cities during Danish colonization. They were thus understood to provide Norway's link with its lost past."[123] Working difficult terrain, those peasants were also admired for their physical endurance, ability to endure hardship, and spiritual connection with the land. Their alleged independence from foreign influence and adherence to age-old traditions made them the ideal receptacles for the projections of *Volkish* ideology — an act of projection in which artists themselves fully participated. On this account, Munch's iconography was not only informed by, but also an indirect instrument of, the current nationalistic discourse that was putting this particular ideological spin on the peasantry. The national status ascribed to the peasant was, of course, less fact than fiction, since few intellectuals had extensive contacts with the very peasants whose virtues they were extolling in their writings. But these ideas had become so widely disseminated by the early twentieth century, and had such an appeal to young artists, that they affected the thematic interests of *Brücke* no less than those of Munch. Indeed, echoes of *Urmensch* of 1905 appear in Max Pechstein's *Head of a Fisherman II* of 1921 (fig. **122**), or in Heckel's *The Caretaker* of 1907 (fig. **123**). Pechstein's images were probably the result of a 1909 trip to the east Prussian fishing town of Nidden. In reading the artist's commentary on the trip, the convergence between German Expressionist and *Volkish* philosophy is again striking: "I was as joyful and hopeful as an explorer on the way to discover a new land. And I found it. A remarkable landscape inhabited by a hardy, rugged breed of people."[124] Indeed, to reconnect with nature, according to the writer Friedrich Ratzel, was a sign "of the increased reacquaintance with our country, that is to say, with ourselves as a *Volk*. For how could you divorce from the very being [of nature] a *Volk* which for half a thousand years has worked, lived, and suffered on the same soil."[125]

IV. CONCLUSION: THE IDEOLOGY OF EXPRESSIONISM: THE PERSONAL AND THE POLITICAL, THE PAST AND THE PRESENT

Despite the numerous similarities between Expressionist and *Volkish* ideology, it still remains perplexing that alienated avant-garde artists, who prided themselves on their intellectual independence and radical individualism, would find themselves aligned with a right-wing populism that anticipated (and was later acknowledged as an inspiration by the leaders of) the Third Reich. Yet these similarities did not go unnoticed, even by the defenders of Expressionism. For example, Moeller's appreciation of Expressionism in general, and of Munch in particular, was consistent, as discussed above, with his demarcation of French from German art along nationalistic lines. "Nowhere," he proclaimed was the "power" of German art "more strongly preserved than there where the Germanic essence was most strongly preserved, in the North, in Scandinavia."[126] Moeller, who knew Munch personally, and spent

122
Max Pechstein, *Head of a Fisherman II*, 1921. Private Collection.

123
Erich Heckel, *The Caretaker*, 1907. Private Collection.

time at the *Schwarze Ferkel* in Berlin, saw him as embodying the very Nordic, subjective qualities he was championing in his writings. "Munch," he proclaimed, "has returned to the essential truths of life, accepting them in their entire simplicity but also in their imminent power. . . . through the mysticism of his race, which lives on in him undiminished, he is attached subterraneously to the glowing chain of things . . . And the power with which this is shown, the power and strength of this Scandinavian rooted in the peasant but nonetheless aristocratic, this power seems to add: Now be strong and endure."[127]

According to Reinhold Heller, Moeller's kind of "ideology appealed to Munch."[128] Munch, in fact, supported Germany during World War I. And although Ragna Stang writes "while all his friends were German, France was the country he was really most fond of,"[129] Heller cites the following words Munch wrote to his German friend and patron Max Linde: "How remarkable are the power, effort and sacrifice I see revealed now by Germany! . . . so much greatness and magnificence absorbs all your thoughts. It must be uplifting!"[130]

This, of course, is not to claim that Expressionist art and German ideology are at all identical; after all, there are profound tensions and differences dividing them as well. Although Munch had drawn his support in Norway from marginalized Bohemians, Heller points out that Moeller's followers were "patrons who moved freely in royal and Imperial courts and were the very pillars of social and economic success. It is ironic that it was precisely they who most intensely joined Van den Bruck in expressing the conservative revolutionary ethic antagonistic to the materialistic well-being of the German Empire."[131] In pondering the ideological relationship between Munch and the German Expressionists, the blatant tension between the two parts of the present essay is equally ironic. In "Sex and Psyche," Munch and the artists of the Expressionist movement were described as transgressive individuals, exploring provocative issues such as sexuality and endorsing the Nietzschean belief that, in order to create, artists must separate themselves from society and the materialistic concerns of the average bourgeois. In "Nature and Nurture," however, these same alienated artists were shown to have endorsed ideas in tune with the nationalistic and conservative agendas of *Volkish* thought. This contradiction is difficult to resolve. Similar tensions, in fact, are also discernible in the Munch literature. In her insightful essay on Munch's *Self-Portrait with a Cigarette* of 1895, for example, Patricia Berman argued that the cigarette was "an emblem of Bohemian and Decadent culture," and that Munch used the cigarette "as a programmatic assertion of his affiliation with the European Decadent community."[132] As with many artists and intellectuals of his generation, Berman continues, Munch "considered illness a paradigm for creativity. Illness suggested a condition in which the aesthetic imagination could exceed the constraints imposed by the rational mind, and provided a space within which the artist's creative faculties could operate."[133] Since the dangers of tobacco were well publicized even in the nineteenth century, Munch's posing with the cigarette was, for Berman, a sign of his transgression of conventional social codes, and embrace of the bohemian cult of illness and deviancy. Yet this mindset contrasts rather markedly with Munch's depiction of male bathers, which Berman herself describes as being "in their maturity and muscularity, emblems of virile male authority."[134] Berman even acknowledges that the later male nudes, renewed by an unmediated contact with nature, visualize "a collective, public return to a natural state as the precondition for national cultural health."[135]

But how is this polarity to be resolved? Was Munch to align himself with illness or health, nation or self, culture or decadence? For Munch, perhaps the dichotomy may not have been so marked. "When I paint illness and vice," he declared, it is "a healthy release. It is a healthy reaction from which I can learn and live."[136] On this account, the polarity between sickness and health, transgression and collectivity, should perhaps be seen as two sides of the same coin. Pushing this point a little further, one may hypothesize that the cultivation of alienation and the desire to belong to a collective group, or to serve

a larger cause, may also have functioned in reciprocal ways. As a result, perhaps the nationalistic currents of the time provided the perfect antidote to the plight of the alienated, Nietzschean artist. In *The Politics of Cultural Despair,* Fritz Stern wrote that many of the German intellectuals who, like Lagarde, Langbehn, and Moeller, established a conservative ideology that "not only resembles national socialism, but which the National Socialists themselves acknowledged as an essential part of their legacy"[137] forged their worldview out of "a resentment of loneliness."[138] It is here, arguably, that contradictions between the two sections of this essay could perhaps be reconciled and made intelligible. To those artists, for whom the idea of individuality was integral to their self-image, but whose alienation was profoundly oppressive, the opportunity to lend one's art to a noble cause, or to a greater purpose, could have meant their reintegration into the nation and an end to their marginalization.[139]

Yet at the core of any similarities between Expressionism and *Volkish* ideology are also profound contradictions—contradictions that ultimately cannot be reconciled. First, if non-Germans (e.g., Munch) could be construed as reflecting a German spirit, then that very possibility contradicts the basic premises of *Volkish* thought: namely, that an indissoluble connection exists between person and landscape, nation and spirit. And, second, in the entirety of *Volkish* thought, the concepts of individual and *Volk* are held in such precarious balance as to border on the contradictory. Indeed, despite its alleged attention to individuality, the *Volkish* movement was, in fact, ruthlessly anti-democratic. Individuality was valorized in theory, but, in practice, individuals could only assert themselves in conformity with the collective will of the *Volk.* Fritz Stern has already remarked that the "German critics praised individuality as the highest good, as the most characteristically German attribute, while, less explicitly believing in a rigid determinism. The individualism of the German critics was a slippery notion, as it had to be in order to avoid the political conclusions of liberalism and democracy. The real source of individuality was the *Volk* or the community."[140] It is in the snare of this contradiction that the artists of the Expressionist movement were ultimately trapped. Reconnecting with the *Volk* and the nation may have promised an end to their alienated state, but their refusal to relinquish their individuality ultimately made them unacceptable to a Germanic ideology that professed, but in actuality could not tolerate, dissent.

Expressionism and nationalism, therefore, despite their occasional intersections, always worked at cross-purposes: the personal and the political never found common ground. Moeller's view of Munch was not shared by the majority of *Volkish* thinkers, and even Nolde, who (as an exception among the Expressionists) went as far as joining the Nazi party, found himself ostracized and forbidden to paint. Undeterred, Nolde wrote to Joseph Goebbels insisting, to no avail, that his work had been misunderstood. His art, he declared, "was German, strong, austere, and sincere."[141] But although many members of the youth movement, and of the Nazi party as well, thought hard and pondered the possibility of endorsing Expressionism, in the end, any potential alliance misfired. According to Mosse: "The attraction that Expressionism exerted on the *Volkish* movement was based on a misunderstanding. The attempt to plumb the depths of the soul seemed to link them together. But that which divided them proved to be more important. *Volkish* thought could not accept the chaotic individualism which characterized so much of Expressionist art and literature. The soul was tamed and integrated into the *Volk.* No wonder that Volkish thought only 'flirted' with Expressionism, that it always ended up by rejecting it."[142]

Because the individual and the collective, the personal and the political, were incapable of being reconciled, Expressionism and the totalitarian nationalism that took hold in Germany in 1933 were fundamentally incompatible. Although the Expressionists' rejection of the status quo and their need to reconnect with nature paralleled some aspects of fascist ideology, to read the ideological edge of Expressionism backwards (i.e., in light of subsequent historical events), is as risky as seeing the present purely

in light of the past. Writing in 1974, for example, Fritz Stern feared that the very rise of German ideology instigated by the *Wandervögel* (their youthful rejection of modernity and middle-class modes of behavior, and their attempts to reconnect with nature) was being replayed in the American counter-cultural movement of the 1960s.[143] But his fears proved unwarranted: history does not always repeat itself, and American hippies were no Hitler *Jugend*. It is this very same aspect of history, arguably, that Buchloh, in his condemnation of Neo-Expressionism, has overlooked. Most historians and artists read the past in terms of the present: for the Neo-Platonists of the Renaissance, the birth of Venus was a prefiguration of the Virgin birth; for the Expressionists, the visual distortions of German Medieval art reinforced their own views of art as the repository of subjective experience; and for Baselitz, Munch meant resurrecting a lost tradition that the both the Nazis and later international artistic tendencies such as abstraction had expunged. But Stern and Buchloh did the opposite. By interpreting the counter-cultural movement of the 1960's or the Neo-Expressionism of Baselitz as an example of the very antimodernism the Nazis had practiced, they relied on a different, but equally problematic approach: they read the present in terms of the past. And although Buchloh was right to point to the ideological and political content of Expressionism, both Expressionism and Neo-Expressionism escape the interpretive net he has cast over them. The wide scope and extent of Munch's influence on German Expressionism and Neo-Expressionism reveals how remarkably complex, ideologically varied, and often contradictory that movement turned out to be.

I would like to thank my colleague, Jeffery Howe, editor of this catalog, for his great help and valuable advice during the preparation of this essay; as well as Nancy Netzer, Director, McMullen Museum of Art, Boston College, for her generosity and invitation to participate in this project.

1 Benjamin Buchloh, "Figures of Authority, Ciphers of Regression: Notes on the Return of Representation in European Painting," in Brian Wallis, editor, *Art after Modernism: Rethinking Representation*, Boston: David R. Godine, 1984, p. 108.

2 *Expressionism: A German Intuition 1905–1920*, New York: Solomon R. Guggenheim Foundation, 1980.

3 The key exceptions are Marit Werenskiold, "Die Brücke und Edvard Munch," *Zeitschrift des Deutschen Vereins fur Kunstwissenschaft* 28, 1974, pp. 140–52, Arne Eggum and Sissel Bjørnstad, *Die Brücke—Edvard Munch*, Oslo: Munch Museum, 1978, and Carla Lathe, "Munch and Modernism in Berlin 1892–1903," in Mara-Helen Wood, editor, *Edvard Munch: The Frieze of Life*, London: National Gallery Publications, 1992, p. 38ff.

4 Walter Selber [pseudonym for Walter Leistikow], "Die Affäre Munch," *Freie Bühne* 3, 1892, p. 1297.

5 Lovis Corinth, *Das Leben Walter Leistikows*, Berlin: Paul Cassirer, 1910, pp. 48–50, quoted in Peter Paret, *The Berlin Secession: Modernism and Its Enemies in Imperial Germany*, Cambridge, MA: Harvard University Press, 1980, p. 54.

6 See Paret, *The Berlin Succession*, p. 51.

7 Edvard Munch, Manuscript T 2761 (EM I, typescript, p. 30, c. 1891–92), quoted in Arne Eggum, "The Theme of Death," in Eggum, *Edvard Munch: Symbols and Images*, Washington, DC: National Gallery, 1978, p. 154.

8 "Kamerat Kunst," Kjøbenhavn, February 8, 1892, quoted in Trygve Nergaard, "Despair," in Eggum, *Edvard Munch: Symbols and Images*, p. 131.

9 Edvard Munch, *Livsfrisen tilblivelse*, Oslo: c. 1929, p. 10;

see Reinhold Heller, *Munch: His Life and Work*, Chicago: University of Chicago Press, 1984, p. 38.

10 See Gerd Woll, "The Tree of Knowledge of Good and Evil," in Eggum, *Edvard Munch: Symbols and Images*, p. 231.

11 Ernst Ludwig Kirchner, "Die Arbeit E. L. Kirchners," in Eberhard W. Kornfeld, *Ernst Ludwig Kirchner, Nachzeichnung seines Lebens*, Bern: Stämpfli, 1979, p. 339.

12 Emil Nolde, quoted in William S. Bradley, *Emil Nolde and German Expressionism: A Prophet in His Own Land*, Ann Arbor, MI: UMI Research Press, 1986, p. 64.

13 Erich Heckel, letter to Peter Selz, July 16, 1952, in Peter Selz, *German Expressionist Painting*, Berkeley and Los Angeles: University of California Press, 1974, p. 81.

14 Karl Schmidt-Rottluff, letter to Peter Selz, July 11, 1952, in Selz, *German Expressionist Painting*, p. 81. For other remarks made by Karl Schmidt-Rottluff and Erich Heckel, see also Ragna Stang, *Edvard Munch*, New York: Abbeville Press, 1977, p. 278.

15 Selz, *German Expressionist Painting*, p. 81.

16 See Werenskiold, "Die Brücke und Edvard Munch," p. 140.

17 See Donald Gordon, "Kirchner in Dresden," *The Art Bulletin* 48, 1966, pp. 335–66.

18 Arthur Moeller van den Bruck, "Munch," *Die Zeitgenossen*, Munich: 1906, p. 217; see Heller, *Munch: His Life and Work*, p. 184.

19 Emil Nolde, *Jahre der Kämpfe, 1902–1914*, Berlin: Rembrandt Verlag, 1934, p. 159.

20 Friedrich Nietzsche, *Twilight of the Idols*, translated by R. J. Hollingdale, New York: Penguin, 1978, p. 71.

21 See Stang, *Edvard Munch*, p. 187.

22 Michael J. Strawser II, "Dionysian Painting: A Nietzschean Interpretation of Munch," *Konsthistorik Tidskrift* 61, 1992, p. 161.

23 See Friedrich Nietzsche, *Schopenhauer as Educator*, translated by James W. Hillesheim and Malcolm R. Simpson, South Bend, IN: Regnery/Gateway, Inc., 1965, p. 54.

24 Curt Glaser, *Edvard Munch*, Berlin: Cassirer, 1922, p. 12.

25 Munch quoted in Stang, *Edvard Munch*, p. 24.

26 Patricia G. Berman, "(Re-)Reading Edvard Munch: Trends in the Current Literature," *Scandinavian Studies* 66, Winter 1994, p. 48.

27 Gösta Svenaeus, *Idé och Innehaall I Edvard Munchs Konst*, Oslo: Gydendal Norsk Forlag, 1953, p. 36; see Strawser II, "Dionysian Painting: A Nietzschean Interpretation of Munch."

28 Lucius Grisebach, *Ernst Ludwig Kirchner*, Cologne: Taschen, 1999, p. 11.

29 See Reinhold Heller, *Brücke: German Expressionist Prints from the Granvil and Marcia Specks Collection*, Evanston, IL: Mary and Leigh Block Gallery, Northwestern University, 1988, p. 11, note 16.

30 Friedrich Nietzsche, *Thus Spoke Zarathustra*, translated by R. J. Hollingdale, New York: Penguin, 1977, p. 44.

31 *Jahre der Kämpfe, 1902–1914*, Berlin: Rembrandt Verlag, 1934, p. 234.

32 Quoted in Heller, *Munch: His Life and Work*, p. 86.

33 Quoted in Stang, *Edvard Munch*, p. 11.

34 Nietzsche, *Twilight of the Idols*, pp. 71, 72, 73.

35 Emil Nolde, letter to a patron dated October 20, 1906, quoted in Heller, *German Expressionist Prints from the Granvil and Marcia Specks Collection*, p. 15.

36 Erich Heckel, letter to Alfred Hentzen, c. 1953, quoted in Heller, *German Expressionist Prints from the Granvil and Marcia Specks Collection*, p. 17.

37 Gustav Schiefler," Erich Heckels graphisches Werk," *Das Kunstblatt* 1, 1918, pp. 283–84.

38 Ernst Ludwig Kirchner, "Concerning Graphics," 1913, quoted in Heller, *German Expressionist Prints from the Granvil and Marcia Specks Collection*, p. 17.

39 Max Pechstein, statement on his graphic work, 1912, quoted in Heller, *German Expressionist Prints from the Granvil and Marcia Specks Collection*, p. 18.

40 Alois Riegl, *Problems of Style: Foundations for a History of Ornament*, translated by Evelyn Kain, Princeton, NJ: Princeton University Press, 1992, p. 33.

41 Nietzsche, *Twilight of the Idols*, p. 72.

42 Arthur Moeller van den Bruck, *Die Moderne Literatur*, Berlin and Leipzig: Schuster & Loeffler, 1902, p. 608.

43 Munch quoted in Stang, *Edvard Munch*, p. 67.

44 Munch quoted in Stang, *Edvard Munch*, p. 31.

45 Munch quoted in Stang, *Edvard Munch*, p. 20.

46 Munch quoted in Stang, *Edvard Munch*, p. 19.

47 Sigmund Freud, *Introductory Lectures on Psychoanalysis*, translated by James Stratchey, New York: Norton, 1966, p. 285.

48 Arthur Schopenhauer, *The World as Will and Representation*, translated by E. F. J. Payne, New York: Dover, 1958, vol. I, p. 329.

49 August Strindberg, "Author's Foreword," in *Six Plays of August Strindberg*, translated by Elizabeth Sprigge, New York: Anchor Books, 1955, p. 65.

50 See Claude Cernuschi, "Artist as Christ/Artist as Criminal: Oskar Kokoschka's Self-Portrait for *Der Sturm*, Myth, and the Construction of Identity in Vienna 1900," *Religion and the Arts*, vol. 1, no. 2, 1997, pp. 93–127.

51 Munch quoted in Stang, *Edvard Munch*, p. 15.

52 Cesare Lombroso, *The Man of Genius*, London: Walter Scott, 1891.

53 Munch quoted in Stang, *Edvard Munch*, p. 174.

54 Henrik Ibsen, *Peer Gynt*, translated by Peter Watts, New York: Penguin, 1966, p. 159.

55 Manuscript T 2547, p. 24, see Heller, *Munch: His Life and Work*, p. 128.

56 See Sander Gilman, *Disease and Representation: Images of Illness from Madness to Aids*, Ithaca: Cornell University Press, 1988, p. 255.

57 Sigmund Freud, *Beyond the Pleasure Principle*, translated by James Strachey, New York: Norton, 1961, p. 46.

58 Freud, *Beyond the Pleasure Principle*, p. 76.

59 Bram Dijkstra, *Idols of Perversity: Fantasies of Feminine Evil in Fin-de-Siècle Culture*, New York: Oxford University Press, 1986, p. 146.

60 Søren Kierkegaard, *Either/Or*, vol. II, translated by Walter Lowrie, Princeton, NJ: Princeton University Press, 1974, p. 164: "Do you not know," the philosopher asks, "that there comes a midnight hour when everyone has to throw off his mask? . . . I have seen men in real life who so long have deceived others that at last their true nature could not reveal itself. . . . In every man there is something which to a certain degree prevents him from becoming perfectly transparent to himself."

61 Ernst Ludwig Kirchner, letter to Carl Hagemann, 1916, quoted in Heller, *German Expressionist Prints from the Granvil and Marcia Specks Collection*, p. 142.

62 Heller, *Munch: His Life and Work*, p. 116.

63 See Arne Eggum, "The Theme of Death," in Eggum, *Edvard Munch: Symbols and Images*, pp. 169–70.

64 Edvard Munch, *Livsfrisens tilblivelse*, Oslo: c. 1929, quoted in Heller, *Munch: His Life and Work*, p. 42.

65 Charles Hagen, "Dark Mirror: The Photographs of Edvard Munch," *Aperture* 145, Fall 1996, p. 17.

66 Gösta Svenaeus, *Idé och Innehaall I Edvard Munchs Konst*, p. 36; see Michael J. Strawser II, "Dionysian Painting: A Nietzschean Interpretation of Munch," pp. 161–72.

67 Kirk Varnedoe, *Vienna 1900*, New York: Museum of Modern Art, 1986, pp. 171–174.

68 Quoted in Stang, *Edvard Munch*, p. 120.

69 Heller, *Munch: His Life and Work*, p. 34.

70 See Heller, *Munch: His Life and Work*, p. 47.

71 Munch quoted in Stang, *Edvard Munch*, p. 111.

72 Edvard Munch, draft of a letter to Jens Thiis (?), c. 1932, quoted in Heller, *Munch: His Life and Work*, p. 103.

73 Munch quoted in Stang, *Edvard Munch*, p. 174.

74 August Strindberg, *Inferno, Alone, and Other Writings*, translated by Evert Sprinchorn, Garden City, NJ: 1968, pp. 180–81.

75 Munch quoted in Bente Torjusen, "The Mirror," in Eggum, *Edvard Munch: Symbols and Images*, p. 207.

76 See Patricia G. Berman, "Edvard Munch: Women, 'Woman,' and the Genesis of an Artist's Myth," in *Munch and Women, Image and Myth*, Alexandria, VA: Art Services International, 1997, pp. 11–40.

77 Edvard Munch, Manuscript N30. See Heller, *Munch: His Life and Work*, p. 140.

78 Stanislaw Przybyszewski, "Psychischer Naturalismus," in *Das Werk des Edvard Munch: Vier Beiträge*, Berlin, 1894, pp. 16–17; quoted in Heller, *Munch: His Life and Work*, p. 106.

79 Carl Vogt, *Lectures on Man: His Place in Creation, and in the History of the Earth*, London: Longman, Green, and Roberts, 1864, p. 180.

80 Kristie Jayne, "The Cultural Roots of Edvard Munch's Images of Women," *Woman's Art Journal* 10, Spring/Summer 1989, p. 30.

81 Stanislaw Przybyszewski, *Overboard*, in *Homo Sapiens: A Novel in Three Parts*, translated by T. Seltzer, New York: A. A. Knopf, 1915, p. 33.

82 Edvard Munch, Manuscript N30, c. 1895, quoted in Heller, *Munch: His Life and Work*, p. 106.

83 Richard von Krafft-Ebing, *Psychopathia Sexualis*, translated by F. S. Klaf, New York: Special Books, 1965, p. 130.

84 August Forel, *The Sexual Question; A Scientific, Psychological, Hygienic and Sociological Study* [1906], translated by C. F. Marshall, New York: Physicians and Surgeons Book Company, 1925, p. 239.

85 Oscar Wilde, *The Picture of Dorian Gray*, New York: New American Library, 1962, p. 116.

86 Ibsen, *Peer Gynt*, p. 55.

87 Heller, *Munch: His Life and Work*, p. 122.

88 See Kirk Varnedoe, "Christian Krohg and Edvard Munch," *Arts Magazine* 53, April 1979, pp. 88–95.

89 Anne McElroy Bowen, "Munch and Agoraphobia: His Art and His Illness," *Revue d'art Canadienne* 15, 1988, pp. 23–50.

90 Ernst Ludwig Kirchner quoted in *Ernst Ludwig Kirchner 1880–1938*, Berlin: Nationalgalerie Berlin, Staatliche Museen, 1979, p. 79.

91 See Patricia G. Berman's fascinating essay "Body and Body Politic in Edvard Munch's *Bathing Men*," in Kathleen Adler and Marcia Pointon, editors, *The Body Imaged: The Human Form and Visual Culture since the Renaissance*, New York: Cambridge University Press, 1993, p. 71ff.

92 Robert Rosenblum, *Modern Painting and the Northern Romantic Tradition: Friedrich to Rothko*, New York: Harper and Row, 1975, p. 114.

93 Ernst Ludwig Kirchner, "Die Arbeit E. L. Kirchners," quoted in Heller, *German Expressionist Prints from the Granvil and Marcia Specks Collection*, p. 136.

94 Heller's translation in *German Expressionist Prints from the Granvil and Marcia Specks Collection*, p. 5.

95 Gustav Wyneken, "Was ist 'Jugendkultur'?" in Werner Kindt, editor, *Grundschriften der deutschen Jugendbewegung*, Düsseldorf and Cologne: E. Diedrich, 1963, p. 116, quoted by Heller in *German Expressionist Prints from the Granvil and Marcia Specks Collection*, p. 6.

96 Emil Nolde, *Jahre der Kämpfe, 1902–1914*, Berlin: Rembrandt Verlag, 1934, p. 160.

97 George Mosse, *The Crisis of German Ideology: Intellectual Origins of the Third Reich*, New York: Howard Fertig, 1998, p. 2.

98 William S. Bradley, *Emil Nolde and German Expressionism: A Prophet in His Own Land*, Ann Arbor, MI: UMI Research Press, 1986, p. 17.

99 *Der Sämann* 12, 1914, pp. 431–32.

100 Nathaniel Jünger, *Volk in Gefahr*, Mecklenburg: Wismar & Hinstorff, 1921, pp. 352–53.

101 Julius Langbehn, *Rembrandt als Erzieher. Von einem Deutschen*, Leipzig: Hirschfeld, 1891, p. 133.

102 Otto Gmelin, "Landschaft und Seele," *Die Tat* 17, April 1925, p. 39.

103 Ernst Ludwig Kirchner, "Die Arbeit E. L. Kirchners," in Eberhard W. Kornfeld, *Ernst Ludwig Kirchner, Nachzeichnung seines Lebens*, p. 339.

104 Otto Gmelin, "Landschaft und Seele," p. 32.

105 Claus Harms, editor, *Schleswig-Holsteinischer Gnomon: Ein allgemeines Lesebuch*, Kiel: Schwer'sche Buchhandlung, 1843, p. 141.

106 Emil Nolde, *Jahre der Kämpfe, 1902–1914*, Cologne: DuMont Schauberg, 1967, p. 61.

107 See Stang, *Edvard Munch*, p. 174.

108 Edvard Munch, Manuscript T 2760, Violet Book, typescript pp. 40–1, entry of January 8, 1892, quoted in Heller, *Munch: His Life and Work*, p. 62.

109 Quoted in Heller, *Munch: His Life and Work*, p. 63.

110 Letter to Jappe Nilssen, February 3, 1909, quoted in Heller, *Munch: His Life and Work*, p. 204.

111 See Patricia G. Berman "Edvard Munch's Peasants and the Invention of Norwegian Culture," in Berit I. Brown, editor, *Nordic Experiences: Exploration of Scandinavian Cultures*, Westport, CT: Greenwood Press, 1997, p. 213.

112 Berman, "Edvard Munch's Peasants and the Invention of Norwegian Culture," p. 221.

113 Quoted in Heller, *Munch: His Life and Work*, p. 209.

114 Rolf Stenersen, *Edvard Munch: Close-up of a Genius*, Oslo: Gyldendal, 1969, p. 15.

115 Emil Nolde, *Das Eigene Leben. 1876–1902*, Flensburg: Christian Wolff, 1949, p. 100.

116 *Der Weltkampf* 4, 1927, p. 432.

117 Emil Nolde, *Reisen. Ächtung. Befreiung. 1919–1946*, Cologne: DuMont Schauberg, 1967, p. 57.

118 Heller, *Munch: His Life and Work*, p. 206.

119 Langbehn, *Rembrandt*, p. 91.

120 Eugen Diederichs, *Leben und Werke*, Lulu von Strauss und Torney, editor, Jena: E. Diederichs Verlag, 1936, p. 267.

121 Paul de Lagarde, "Die Reorganisation des Adels," *Deutsche Schriften*, third edition, Munich: J. F. Lehmann, 1937, p. 334.

122 Quoted in Berman, "Edvard Munch's Peasants and the Invention of Norwegian Culture," pp. 221–22.

123 Berman, "Edvard Munch's Peasants and the Invention of Norwegian Culture," p. 222.

124 Max Pechstein, *Erinnerungen*, Wisbaden: Limes Verlag, 1960, p. 35.

125 Friedrich Ratzel, "Die Deutsche Landschaft," *Deutsche Rundschau* 88, July/September 1896, p. 347.

126 Arthur Moeller van den Bruck, "Munch," *Die Zeitgenossen*, Munich: 1906, p. 217; see Heller, *Munch: His Life and Work*, p. 184.

127 Arthur Moeller van den Bruck, *Die moderne Literatur in Gruppen- und Einzeldarstellungen*, Berlin and Leipzig, 1902, pp. 222–223; see Heller, *Munch: His Life and Work*, p. 186.

128 Heller, *Munch: His Life and Work*, p. 186.

129 Stang, *Edvard Munch*, p. 257.

130 Letter to Max Linde, c. September 1914, quoted in Heller, *Munch: His Life and Work*, pp. 213–14.

131 Heller, *Munch: His Life and Work*, p. 186.

132 Patricia G. Berman, "Edvard Munch's *Self-Portrait with Cigarette*: Smoking and the Bohemian Persona," *The Art Bulletin* 75, December 1993, p. 627.

133 Berman, "Edvard Munch's *Self-Portrait with Cigarette*: Smoking and the Bohemian Persona," p. 629.

134 Berman, "Body and Body Politic in Edvard Munch's *Bathing Men*," p. 72.

135 Berman, "Body and Body Politic in Edvard Munch's *Bathing Men*," p. 83.

136 Bente Torjusen, *Words and Images of Edvard Munch*, Chelsea, VT: Chelsea Green Publishing Company, 1986, p. 52.

137 Stern, *The Politics of Cultural Despair*, p. xiv.

138 Stern, *The Politics of Cultural Despair*, p. xii.

139 See also Walter H. Sockel's *The Writer in Extremis; Expressionism in Twentieth-Century German Literature*, Stanford: Stanford University Press, 1959, esp. chapters 4–6.

140 Stern, *The Politics of Cultural Despair*, p. 138.

141 Victor Miesel, editor, *Voices of German Expressionism*, Englewood Cliffs, NJ: Prentice Hall, 1970, p. 210.

142 Mosse, *The Crisis*, p. 187.

143 See Stern, *The Politics of Cultural Despair*, p. ix.

EDVARD MUNCH:
A BIOGRAPHICAL CHRONOLOGY

DANIEL BRUNET

1863

DECEMBER 12: Born the second of five children of Christian Munch, an Army Medical Corps Doctor, and Laura Catherine, née Bjølstad; at Engelhaugen Farm in Løten, Norway.

1864

Family moves to Kristiania (or Christiania), now called Oslo.

1868

Karen Bjølstad, Munch's aunt, takes over the household when his mother dies of tuberculosis.

1877

Sophie, Munch's sister, dies of tuberculosis at the age of fifteen.

1879

Begins the study of engineering at the Technical College.

1880

JANUARY: Paints a copy of the portrait made by Peder Aadnes of his great-grandfather. MAY: Begins to paint seriously, producing sketches of Kristiania and its surroundings. NOVEMBER: Leaves the Technical College and begins to paint seriously. DECEMBER: Begins to study art history.

1881

Studies freehand drawing and modeling under the sculptor Julius Middlethun at the School of Design. Sells two pictures at an auction, receiving 26.5 kroner.

1882

Munch rents a studio with six fellow artists near the *Storting* (Parliament) in Oslo. Their work is supervised by Christian Krohg.

1883

JUNE: Receives a favorable review from Gunnar Heiberg as part of a group exhibition, Munch's first, in Oslo. AUTUMN: Attends the open air academy of Frits Thaulow in Modum.

1884

Earns the first of many grants for continued studies; associates with the avant-garde set of Norwegian contemporary Naturalistic writers and painters.

1885

MAY: Travels to Paris on a scholarship from Frits Thaulow, stays for three weeks. Visits both the Louvre and the Salon, is very impressed with Edvard Manet. After spending the summer at Borre, Munch returns to Oslo and begins three of his major works: *Puberty, The Sick Child,* and *The Morning After.*

1886

Completes the first version of *The Sick Child.* The anarchist Hans Jaeger publishes his controversial novel, *From the Kristiania Bohemia,* for which he is subsquently imprisoned.

1887

Spends summer at Veierland.

1888

Visits Aasgaardstrand for the first time. SUMMER: Exhibits three paintings in Copenhagen.

1889

APRIL: First one-man exhibition, at Oslo. Several artists recommend Munch for a state scholarship. SUMMER: Rents a house for the summer in Aasgaardstrand. OCTOBER: Enrolls in Léon Bonnat's art school in Paris. NOVEMBER: Munch's father dies.

1890

Associates chiefly with Norwegian poets, artists, and writers; continues to study at Bonnat's art school. Spends summer in Aasgaardstrand and Oslo. The state renews his scholarship. NOVEMBER: Sails for France but is hospitalized for two months in Le Havre with rheumatic fever. DECEMBER: A fire destroys five of his paintings in Oslo.

1891

JANUARY–APRIL: Convalesces in Nice, then travels to Paris. Summers in Norway. Returns to Paris after his scholarship is renewed for the third time. DECEMBER: Travels to Nice. Commissioned to design a vignette for *Alruner,* a collection of poems by Emanuel Goldstein.

1892

SEPTEMBER: Arranges a large one-man exhibition at Oslo. OCTOBER 4: *Verein Berliner Künstler* invites Munch to exhibit in Berlin. The exhibit closes after only one week due to violent protest. A number of German artists who support Munch, led by Max Liebermann, withdraw from the *Verein.* Later, the exhibition is shown at Düsseldorf and Cologne, returns to Berlin, then travels to Copenhagen, Breslau, Dresden, and Munich. Munch paints August Strindberg's portrait.

1893

From now until 1908, Munch will spend most of his time in Germany , taking summer trips to Paris and Norway. Socializes with Strindberg, Richard Dehmel, Gunnar Heiberg, Julius Meier-Graefe, and Polish poet Stanislaw Przybyszewski, all of whom are associated with the periodical *Pan.* Exhibits frequently in Germany, Paris, and Scandinavia. Completes *The Scream, Madonna, Vampire,* and *Death and the Maiden.* Begins work on the Frieze of Life.

1894

Now living in Berlin, Munch produces his first etchings and his first lithographs. JULY: *Das Werk des Edvard Munch,* the first monograph of his work, is published by Przybyszewski, Meier-Graefe, Franz Servaes, and Willy Pastor. Munch meets Count Prozor, Ibsen's translator, and Aurélian Lugné-Poë, the director of the Théâtre de l'Oeuvre.

1895

JUNE: Travels from Berlin to Paris and then to Norway via Amsterdam. Spends summer in Aasgaardstrand. Meier-Graefe publishes a portfolio of eight Munch etchings. SEPTEMBER: Returns to Paris, and then travels to Oslo for an exhibition. NOVEMBER: Thadée Natanson's review of the Oslo exhibition is

published in *La Revue Blanche*. DECEMBER: The lithograph of *The Scream* is reproduced in *La Revue Blanche*. Andreas, Munch's brother, dies.

1896
FEBRUARY: Travels to Paris from Berlin. His social circle now includes Frederick Delius, Meier-Graefe, Stéphane Mallarmé, Strindberg, and Thadée Natanson. At the Parisian printer Clot's, he creates his first color lithographs and his first woodcuts. Makes a lithograph for Théâtre de l'Oeuvre's production of Ibsen's *Peer Gynt*. His lithograph, *Anxiety*, is included in Vollard's *Album des peintres graveures*. APRIL–MAY: Ten of his paintings are displayed at the Salon des Indépendants; creates illustrations for Baudelaire's *Les Fleurs du Mal*. JUNE: Strindberg reviews Munch's one-man show at Siegfried Bing's gallery L'Art Nouveau in *La Revue Blanche*. JULY: Travels to Norway. AUGUST: Goes to Belgium. AUTUMN: Returns to Paris.

1897
Ten paintings from the Frieze of Life are exhibited at the Salon des Indépendants in Paris. He designs programs for the Théâtre de l'Oeuvre's production of Ibsen's *John Gabriel Borkman*. Buys a house in Aasgaardstrand and spends summer there. SEPTEMBER: Travels to Oslo.

1898
Travels extensively. MARCH: Travels to Copenhagen for an exhibition and then moves on to Berlin. MAY: Exhibited again in the Salon des Indépendants. JUNE: Travels to Oslo, then Aasgaardstrand. AUTUMN: Returns to Oslo.

1899
Continues travel. APRIL: To Florence, via Berlin, Paris, and Nice. MAY: To Rome, then Aasgaardstrand, to Norstrand, and back to Aasgaardstrand. AUTUMN AND WINTER: Convalesces in the Kornhaug sanatorium, in Faaberg, Gudbrandsdalen.

1900
Paints *Golgotha*, leaves the sanatorium. MARCH: Travels to Berlin, Florence, and Rome. Enters a sanatorium in Switzerland. JULY: Spent in Como, Italy. AUTUMN AND WINTER: Spent in Norway. Finishes *The Dance of Life*.

1901
Travels between Norway and Germany; spends summer in Aasgaardstrand.

1902
WINTER AND SPRING: Stays in Berlin. Meets his future patron, Dr. Max Linde. Linde purchases *Fertility* and writes a book about Munch. JUNE: Travels to Norway; spends summer in Aasgaardstrand. Loses the joint of a finger on his left hand from a gunshot wound while trying to end a regretted liaison with Tulla Larsen. Linde commissions a portfolio of sixteen prints *(Linde Portfolio)*; Munch visits Linde at Lübeck. DECEMBER: Travels to Berlin, meets Gustav Schiefler, who begins a catalogue raisonné of Munch's prints and buys several more for his personal collection. Twenty-two works from the Frieze of Life are exhibited at the Berlin Secession.

1903
Exhibits at the Salon des Indépendants in Paris. Visits Lübeck three times to work on portraits of Dr. Linde and his four sons. Stays in Berlin several times, visits Delius, spends summer in Aasgaardstrand.

1904

Gains sole rights to sale of his paintings and prints in Germany from the Berlin dealer Bruno Cassirer and the Hamburg dealer Commeter. Formally joins the Berlin Secession; Max Beckmann, Emil Nolde, and Wassily Kandinsky join the next year. Travels in Germany and Scandinavia; spends summer in Aasgaardstrand. Writes "The City of Free Love."

1905

Continues to travel in Germany and Scandinavia. SPRING: Quarrels violently with an artist friend, Ludvig Karsten and returns to Aasgaardstrand. The quarrel is one of many during this period. It is believed that the incident inspired the 1935 paintings *The Fight* and *The Uninvited Guest*. Has a significant exhibition in Prague, at the "Mánes" Gallery.

1906

Spends time at several German spas and makes a short trip to Berlin. SUMMER: Drafts a scenic design for a production of Henrik Ibsen's *Ghosts,* directed by Max Reinhardt, which opens the Kammerspiele at the Deutsches Theater; the first performance is on November 8. At the request of Ernest Thiel, a Swedish banker, he paints a portrait of Friedrich Nietzsche.

1907

WINTER: Spent in Berlin working on the design for *Hedda Gabler* and decorations for the foyer at Reinhardt's Kammerspiele. APRIL: Travels to Stockholm, paints a portrait of Thiel. Thiel begins to buy a large number of paintings.

1908

WINTER: In Berlin. FEBRUARY: Exhibits briefly in Paris. The National Gallery in Oslo purchases a number of works at the urging of its director, Jens Thiis, despite strong internal opposition. AUTUMN: Travels to Hamburg and Stockholm, exhibits in Copenhagen. OCTOBER 1: Suffers a nervous breakdown while in Copenhagen and enters Dr. Daniel Jacobson's clinic. Made a Knight of the Royal Norwegian Order of Saint Olav.

1909

Writes a prose-poem entitled *Alpha and Omega* while at the clinic and illustrates it with sixteen lithographs. MAY: Leaves the clinic and returns to Norway. JUNE: Exhibits in Bergen; Rasmus Meyer purchases a number of his works. Enters the competition to decorate the Assembly Hall of the Olso University. His entry will become the Aula murals. MARCH: Significant exhibition in Oslo at Blomqvist's comprising one hundred oils and two hundred graphics. Continues to travel. Paints life-size male portraits and landscapes.

1910

WINTER AND SPRING: Stays in Kragerø. Works on the Aula decorations. To gain more work space, buys the Ramme estate at Hvitsten on the Oslo Fjord.

1911

Makes a brief visit to Germany but primarily lives at Hvitsten. AUTUMN AND WINTER: At Kragerø. AUGUST: Wins the Aula competition and continues to work on the design.

1912

Named an "honorary guest" at the Sonderbund in Cologne and given a room to himself. His predeces-

sors include Paul Cézanne, Vincent van Gogh, and Paul Gauguin. DECEMBER: Participates in exhibition sponsored by the American-Scandinavian Society of New York City showcasing contemporary Scandinavian art, believed to be the first American showing of his work. The exhibition includes: *The Sick Child, Starry Night,* and *In the Orchard (Adam and Eve under the Apple Tree).* WINTER: Spent at Kragerø. Travels to Copenhagen, exhibits in Paris and at the Sonderbund in Cologne, travels to Hvitsten. SEPTEMBER: Returns to Cologne. Continues work on the Aula design.

1913
Lends eight prints to the Armory Show in New York City, priced at $200 each: versions of *Vampire, Moonlight, The Lonely Ones, Madonna,* and *Nude with Red Hair (Sin).* Receives many tributes on the occasion of his fiftieth birthday. In search of even more work space, rents Grimsrød Manor in Jeløya. Travels extensively: Berlin, Frankfurt, Cologne, Paris, London, Stockholm, Hamburg, Lübeck, and Copenhagen. AUTUMN: Spends time in Kragerø, Hvitsten, and Jeløya. OCTOBER: Exhibits in Berlin.

1914
Makes several short trips to Paris and Germany. Spring: Returns to Norway. MAY 29: Aula murals are formally accepted by Oslo University.

1915
Exhibits ten oils and wins a gold medal for graphics at the *Panama-Pacific International Exposition* in San Francisco, his third American show. Begins to aid young German artists financially. Confines his travel to Scandinavia.

1916
JANUARY: Buys the Ekely house in Skøyen where he will spend most of his time for the remainder of his life. SEPTEMBER 19: The Aula murals are publicly unveiled.

1917
Edvard Munch, a book by Curt Glaser, is published in Berlin.

1918
The Frieze of Life is exhibited at Blomqvist's in Oslo; Munch writes the brochure. Works more on the motifs of the Aula murals and the Frieze of Life.

1919
Sick with the Spanish Influenza.

1922
The Kunsthaus, Zurich, gives a retrospective exhibition of seventy-three oils and three hundred eighty-nine graphics. Paints twelve murals for display in the workers' dining room of Oslo's Freia Chocolate Factory.

1923–1925
Travels less and less, but still makes brief trips throughout Scandinavia and Germany.

1926
Laura, his sister, dies. Continues to give financial support to German artists.

1927
The National Gallery in Berlin hosts Munch's most comprehensive show, including two hundred and twenty-three oils. This exhibition is enlarged and then displayed at the National Gallery, Oslo.

1928

Begins work on mural designs for Central Hall of Oslo City Hall, a project that is later abandoned.

1929

Builds a "winter studio" in Ekely. The National Museum of Stockholm hosts a major exhibition of Munch's graphics.

1930

First instance of the eye trouble that will recur throughout the rest of his life.

1931

His aunt, Karen Bjølstad, dies. She had taken over the Munch household in 1868, after the death of his mother.

1933

Munch's seventieth birthday inspires many honors and tributes. Books about him by Jens Thiis and Pola Gauguin are published. Made a Knight Grand Cross of the Order of Saint Olav. Begins to work on new designs for the *Alma Mater* in the Aula.

1937

Eighty-two of his works located in German museums are confiscated after being branded "degenerate". Later, these works are sold in Norway. Rejects proposal from Jens Thiis to build a Munch Museum in Tullinløkka, Oslo.

1940–1944

Continues painting and printmaking during the German occupation of Norway, living quietly and refusing all contact with the Nazi invaders and their supporters and collaborators. His last print is a lithograph of Hans Jaeger.

1944

JANUARY 23: Munch dies peacefully at Ekely little more than a month after his eightieth birthday. He is interred in the Court of Honor of Our Savior's Cemetery, not far from Henrik Ibsen's final resting place. Munch bequeaths all of his work to the city of Oslo: over 1,000 paintings, 15,400 prints, 4,500 drawings and watercolors, and six sculptures.

1963

The Munch Museum opens in Oslo.

Self-Portrait under the Mask of a Woman
1891–92, oil on canvas, 69 × 43.5 cm
Munch Museum, Oslo
MM M 229

1

Self-Portrait with Skeleton Arm
1895, lithograph, 45.3 × 31.5 cm
Fram Trust

2

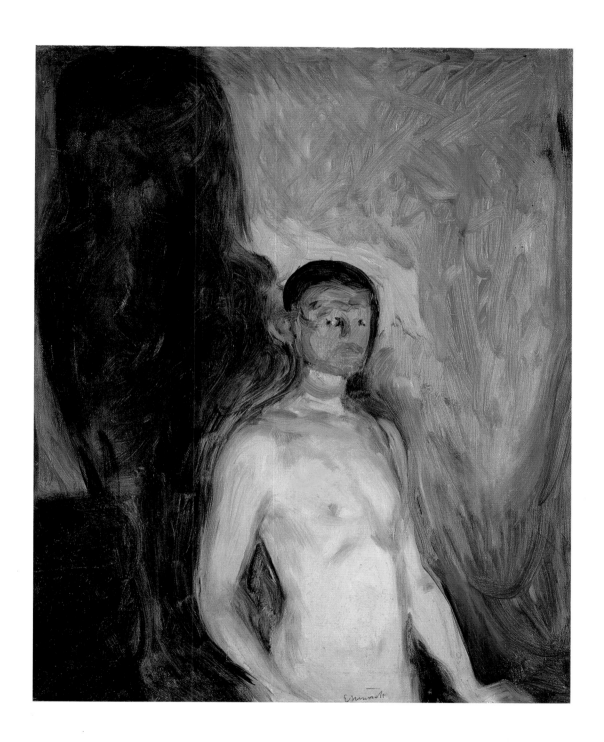

Self-Portrait in Hell
1903, oil on canvas, 82 × 66 cm
Munch Museum, Oslo
MM M 591

3

Self-Portrait
1911, woodcut, 55.3 × 34.2 cm
Munch Museum, Oslo
MM G 627-2

4

Dance of Death
1915, lithograph, 50 × 28.5 cm
Munch Museum, Oslo
MM G 381-7

5

Self-Portrait with Wine Bottle
1925, lithograph, 49.8 × 62.7 cm
Fram Trust

6

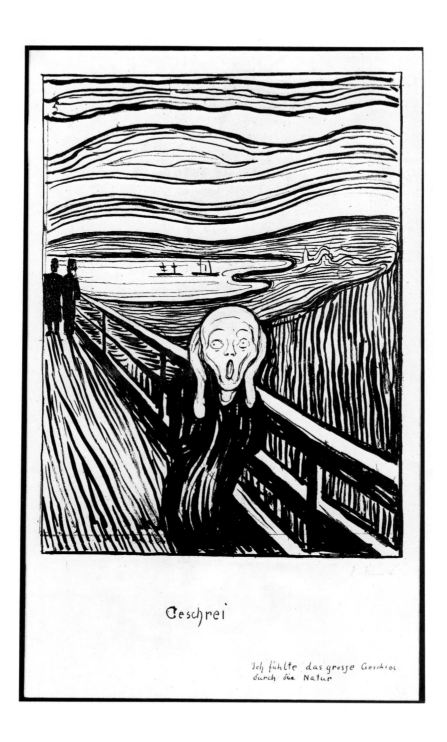

Geschrei

Ich fühlte das grosse Geschrei
durch die Natur

The Scream
1895, lithograph, 71 × 56 cm
The Metropolitan Museum of Art, New York
Bequest of Scofield Thayer, 1982
1984.1203.1

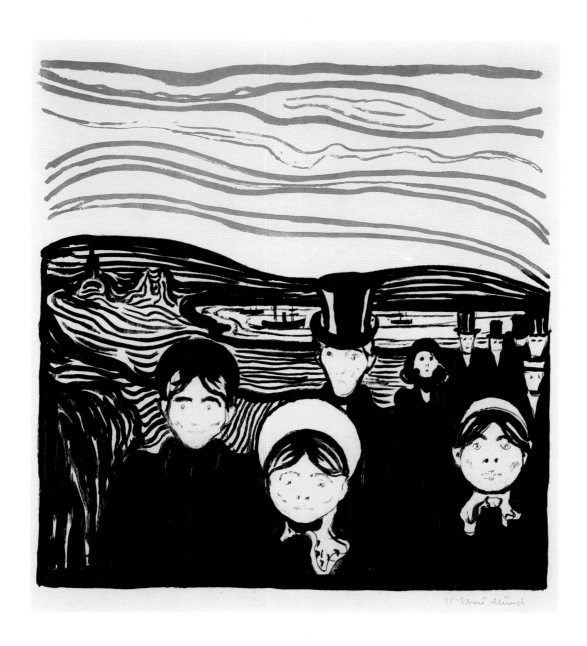

Anxiety
1896, lithograph, 41.3 × 38.8 cm
Fram Trust

8

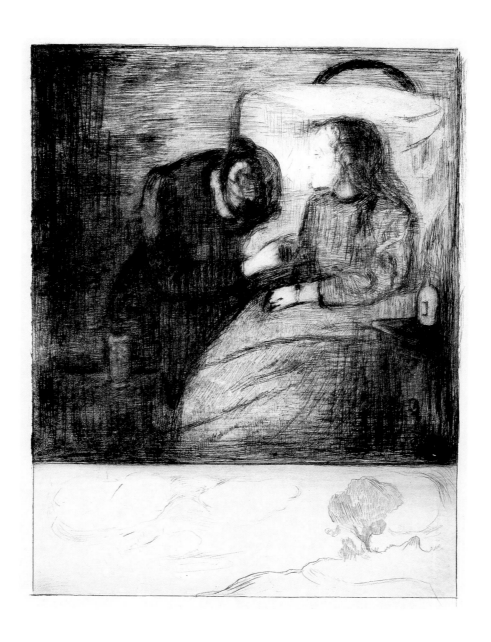

The Sick Child
1894, drypoint and roulette, 35.7 × 27.1 cm
Fram Trust

Death in the Sickroom
1896, lithograph, 47.2 × 63 cm
Museum of Fine Arts, Boston
Lee M. Friedman Fund
69.1235

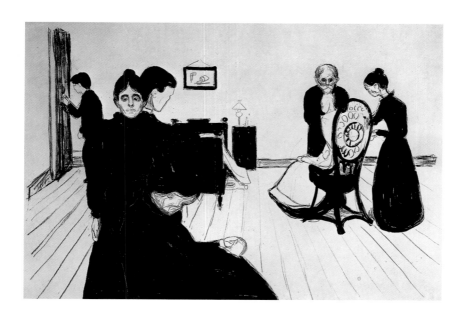

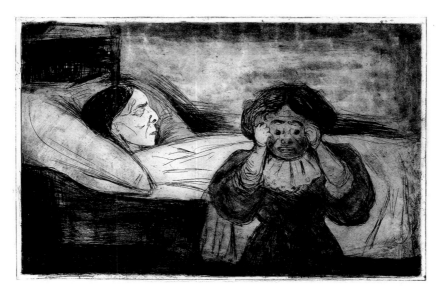

The Dead Mother
1901, etching, 32.2 × 49.4 cm
Museum of Fine Arts, Boston
William Francis Warden Fund
57.354

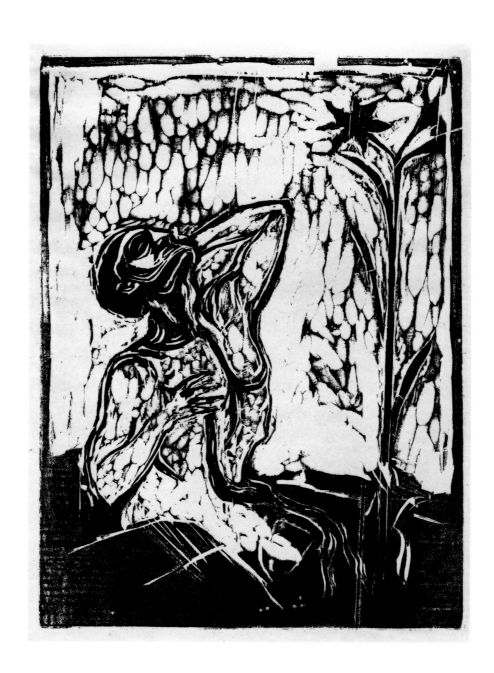

The Flower of Pain
1898, woodcut, 45.7 × 32.7 cm
Fogg Art Museum, Harvard University Art Museums
Gift of Lynn and Philip A. Straus, class of 1937
M21544

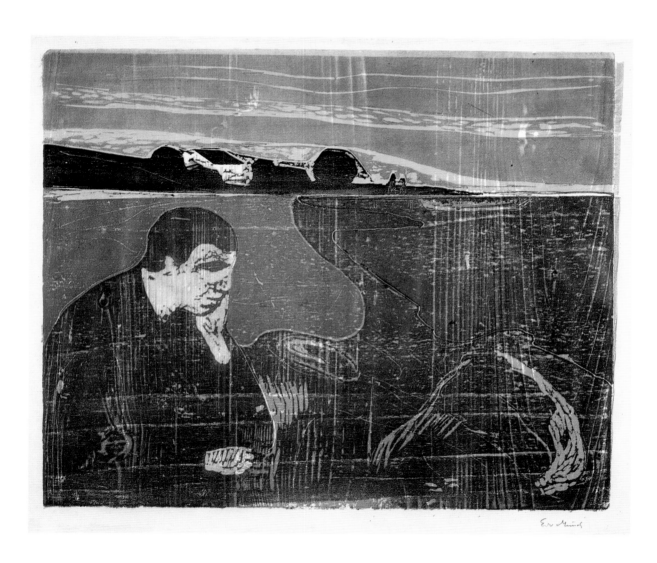

Melancholy
1896, woodcut, 37.5 × 45.4 cm
Museum of Fine Arts, Boston
William Francis Warden Fund
57.356

Melancholy (Woman on the Shore)
1898, woodcut, 33.3 × 42.2 cm
Munch Museum, Oslo
MM G 588-3

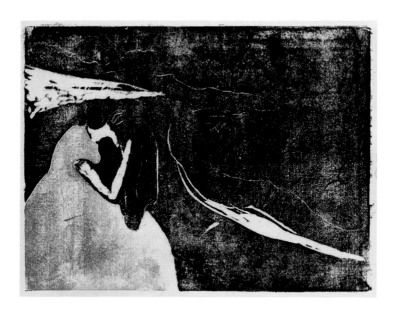

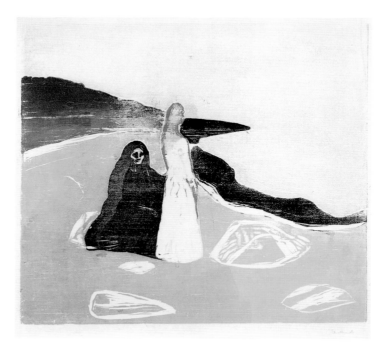

Women on the Shore
1898, woodcut, 44.8 × 51 cm
Fram Trust

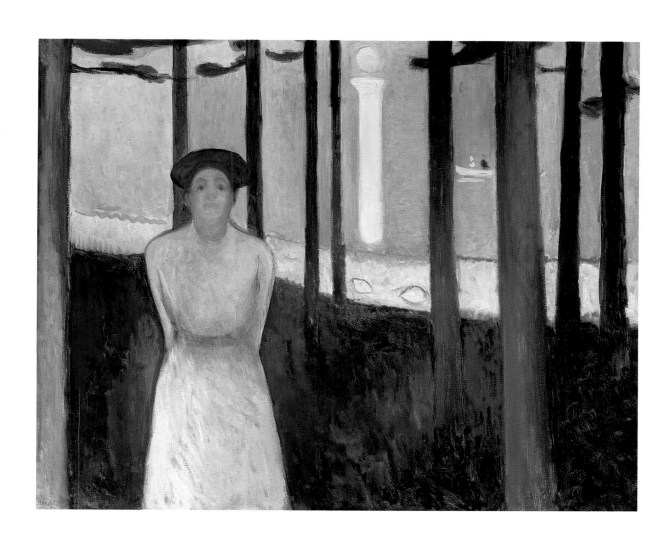

The Voice (Summer Night)
1893, oil on canvas, 87.8 × 108 cm
Museum of Fine Arts, Boston
Edward Wadsworth Longfellow Fund
59.301

16

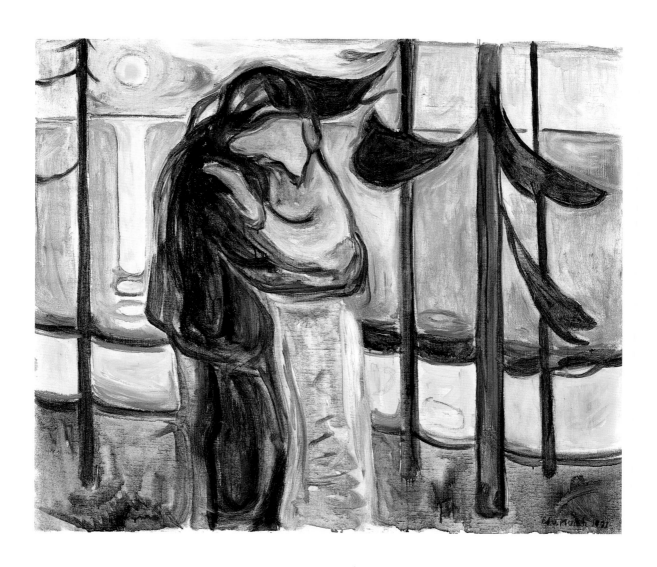

The Kiss on the Shore
1921, oil on canvas, 89 × 101.5 cm
Sarah Campbell Blaffer Foundation, Houston, Texas
1968.1

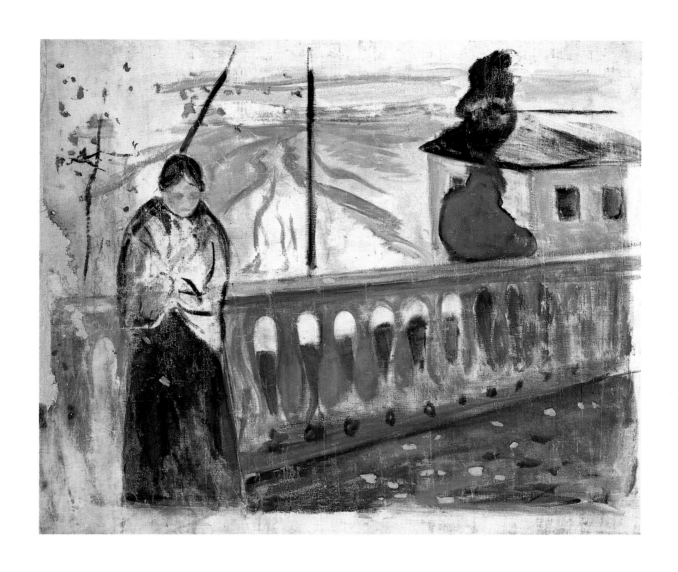

View from Balcony, Aasgaardstrand
c. 1900, oil on canvas, 90 × 103 cm
Borre Kommune, Norway

18A

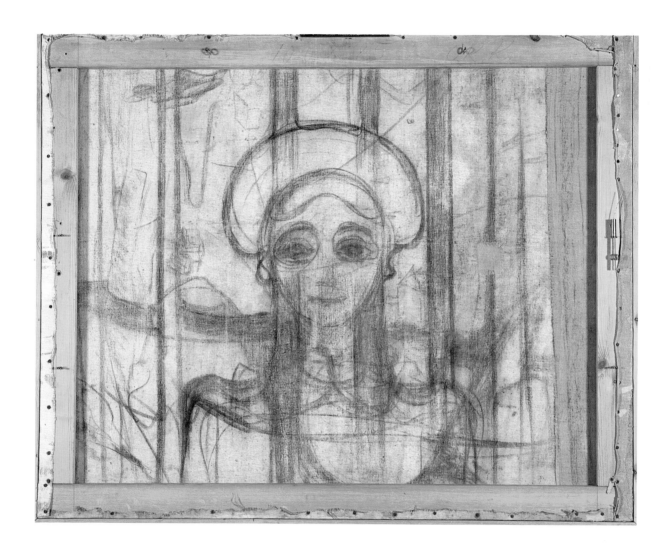

Study for The Voice (Summer Night)

18B [reverse]

The Voice (Summer Night)
1894, intaglio, 23.7 × 31.4 cm
Munch Museum, Oslo
MM G 18-3

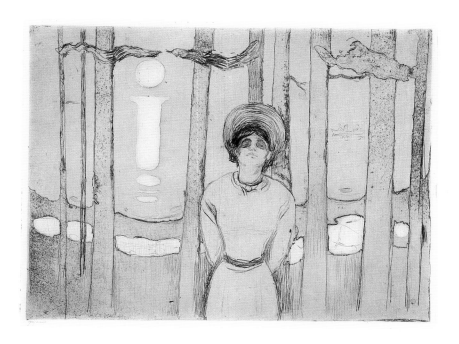

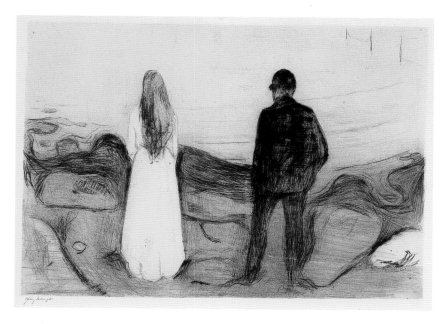

The Lonely Ones
1895, drypoint, 15.5 × 21.3 cm
Fram Trust

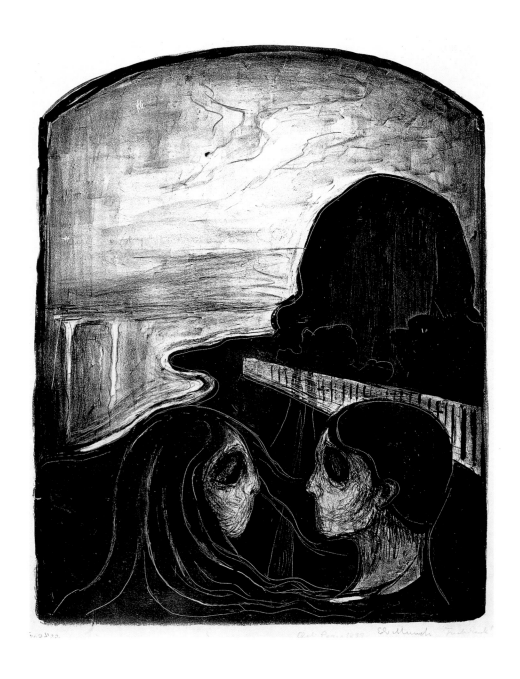

Attraction I
1896, lithograph, 47 × 35.5 cm
Fram Trust

Attraction II
1895, lithograph, 35.5 × 45.7 cm
Fram Trust

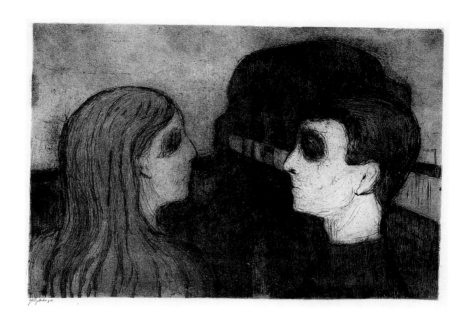

Attraction
1896, lithograph, 38.3 × 60.4 cm
Fogg Art Museum, Harvard University Art Museums
Gift of Lynn and Philip A. Straus, class of 1937
M20223

Separation II
1896, lithograph, 41.4 × 64.3 cm
Fram Trust

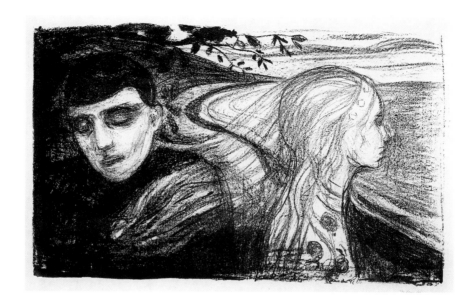

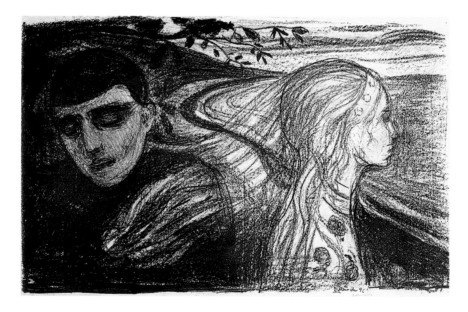

Separation II
1896, lithograph, 57 × 87 cm
Anne-Ruth and Jan Klein, Norway

26

Separation I
1896, lithograph, 50.5 × 65.2 cm
Museum of Fine Arts, Boston
William Francis Warden Fund
57.367

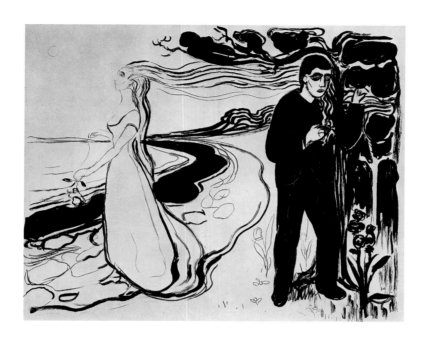

To the Forest
1897, woodcut, 50 × 64.5 cm
Ian Mackenzie Fine Art, London

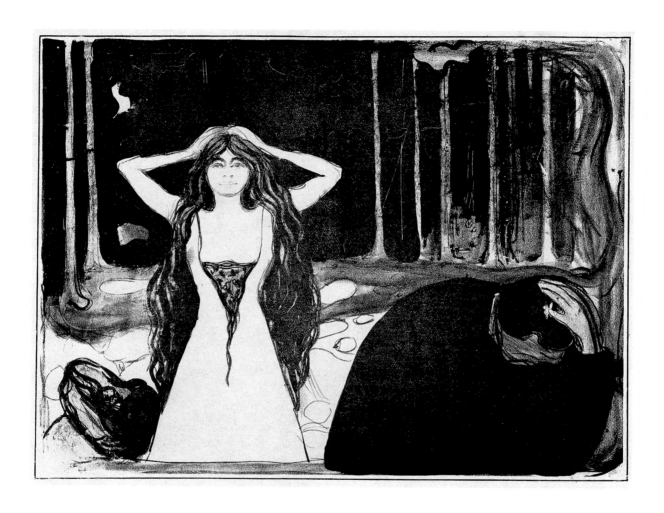

Ashes II
1899, lithograph, 35.3 × 45.4 cm
Fram Trust

28

Jealousy II
1896, lithograph, 47.6 × 57.8 cm
Epstein Family Collection
EFC 053.1

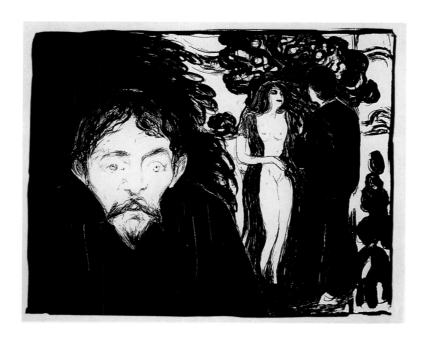

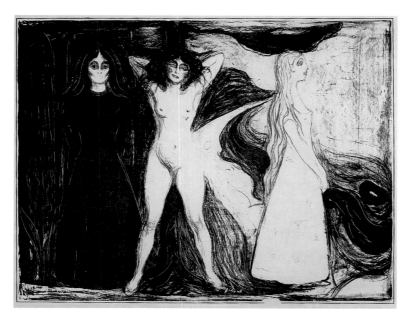

Woman in Three Stages (The Sphinx)
1899, lithograph, 44.8 × 59.4 cm
Fram Trust

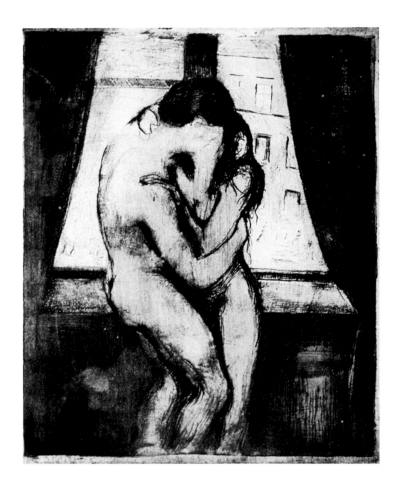

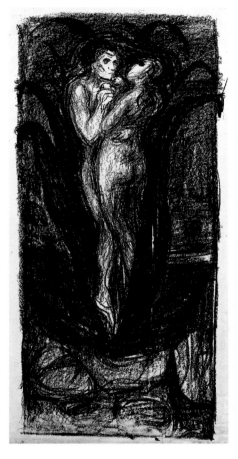

The Flower of Love
1896, lithograph, 62.3 × 28.4 cm
Fogg Art Museum, Harvard University Art Museums
Gray Collection of Engravings Fund
G8427

The Kiss
1896, etching, 38 × 32 cm
Private collection, Norway

31

32

The Kiss IV
1902, woodcut, 44.7 × 44.7 cm
Munch Museum, Oslo
MM G 580-28

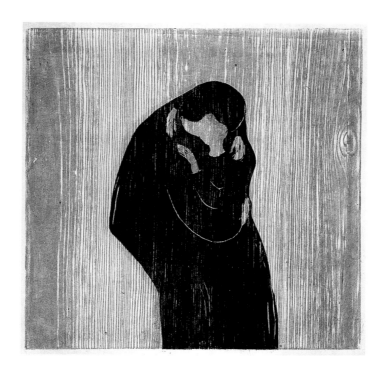

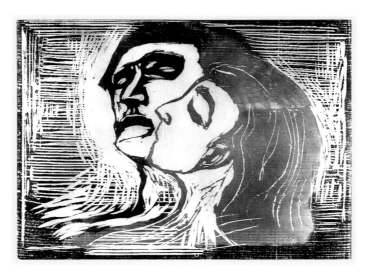

Man and Woman Kissing
1905, woodcut, 39.8 × 54 cm
Fogg Art Museum, Harvard University Art Museums
Gift of Joseph Pulitzer, Jr. in memory of Frederick B. Deknatel
M 15341

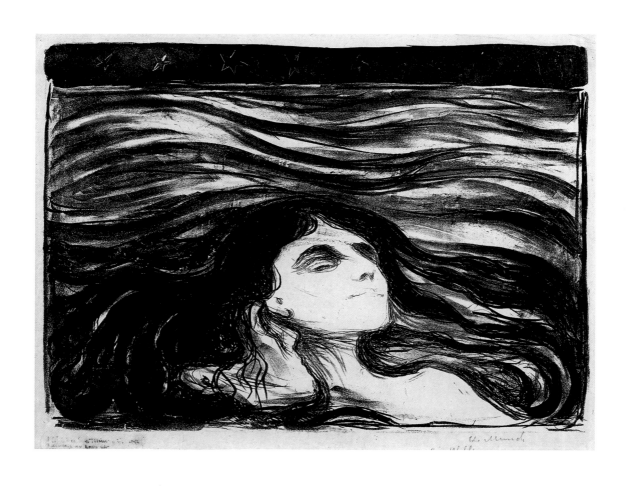

Lovers in the Waves
1896, lithograph, 31 × 42 cm
Fram Trust

35

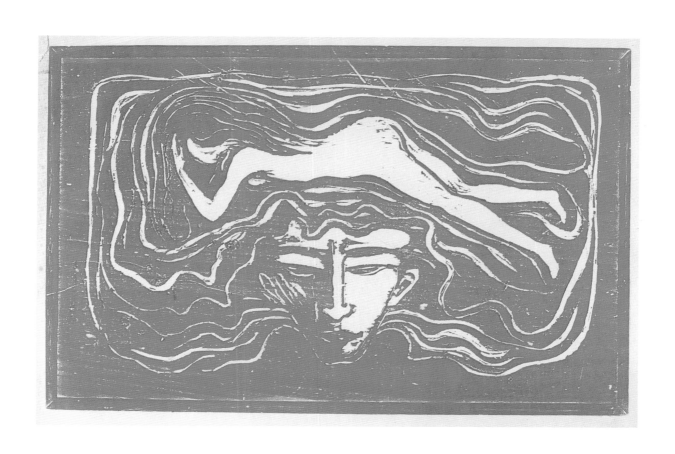

In Man's Brain
1897, woodcut, 37.3 × 56.7 cm
Munch Museum, Oslo
MM G 573-12

36

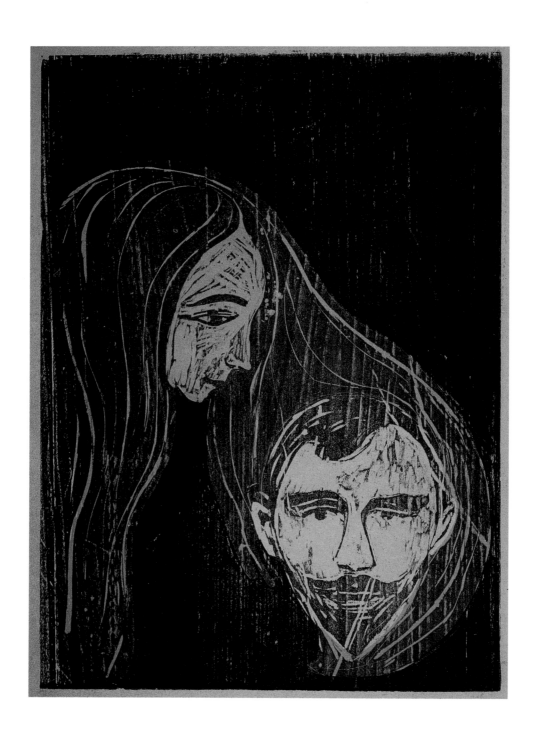

Man in Woman's Hair
1896, woodcut, 54.6 × 38.1 cm
Museum of Fine Arts, Boston
George Peabody Gardner Fund
41.728

Man and Woman
1899, woodcut, 42 × 51 cm
Munch Museum, Oslo
MM G 600-7

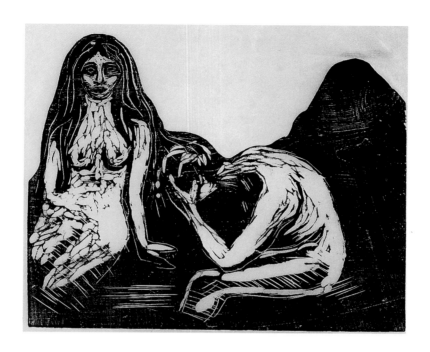

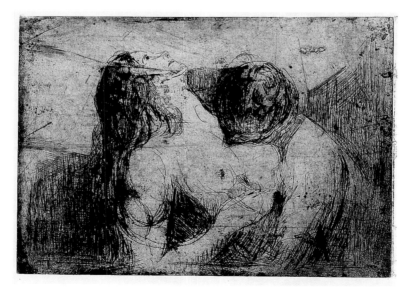

The Bite
1913, intaglio, 24 × 31.5 cm
Munch Museum, Oslo
MM G 142-2

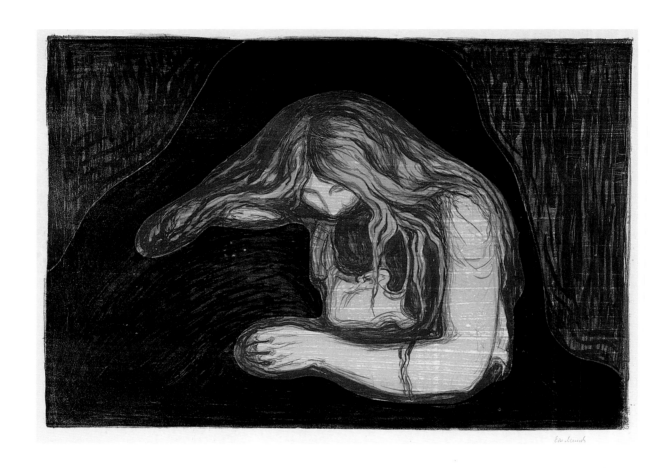

Vampire
1895/1902, lithograph over woodcut, 34.3 × 55.5 cm
Private Collection

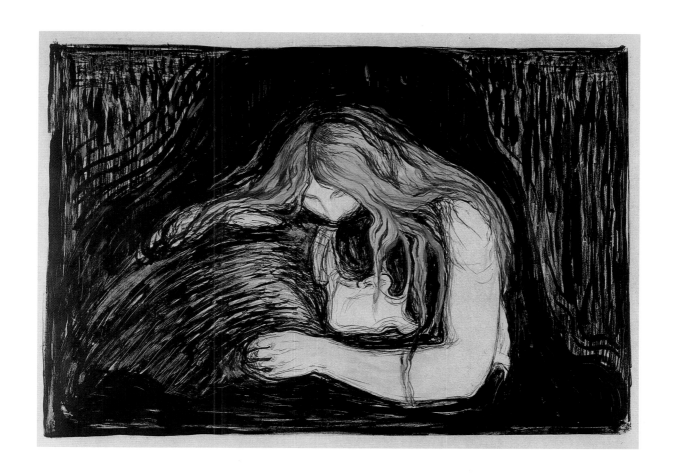

Vampire
1895, hand-colored lithograph, 47.5 × 61 cm
Fram Trust

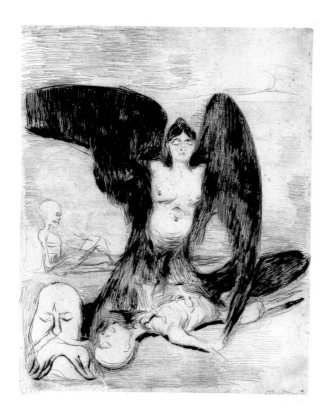

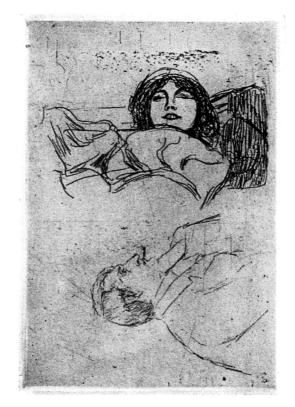

Vampire (Harpy)
1894, drypoint, 36.7 × 27.5 cm
Museum of Fine Arts, Boston
William Francis Warden Fund
57.348

42

Self-Portrait with Model
1897, etching, 22.7 × 14.8 cm
Fram Trust

43

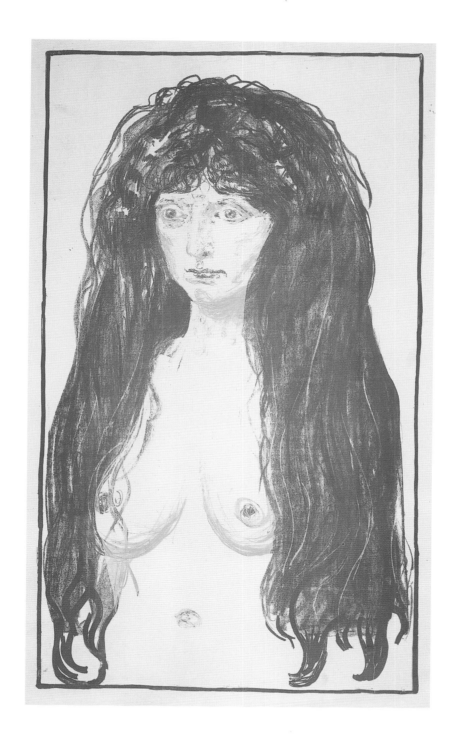

Sin
1901, lithograph, 70.2 × 40.5 cm
Museum of Fine Arts, Boston
William Francis Warden Fund
57.371

44

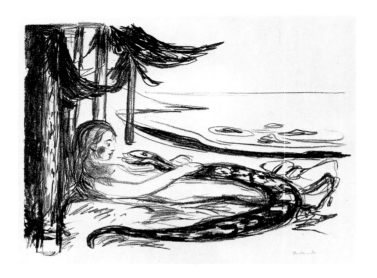

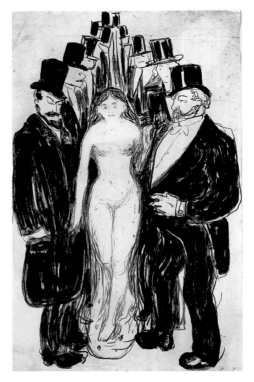

Woman with Snake
from Alpha and Omega Series
1908–09, lithograph, 35.2 × 48 cm
Museum of Fine Arts, Boston
William Francis Warden Fund
57·373

The Alley (Carmen)
1895, lithograph, 43.2 × 26.7 cm
Fram Trust

45

46

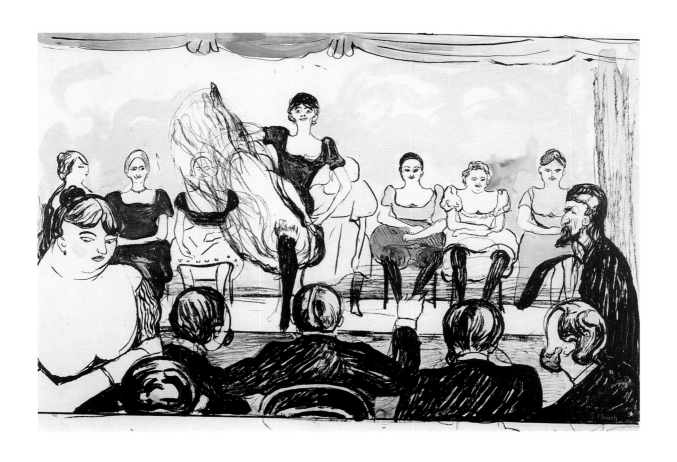

Tingel-Tangel (Can-Can)
1895, hand-colored lithograph, 40.6 × 61.6 cm
Fram Trust

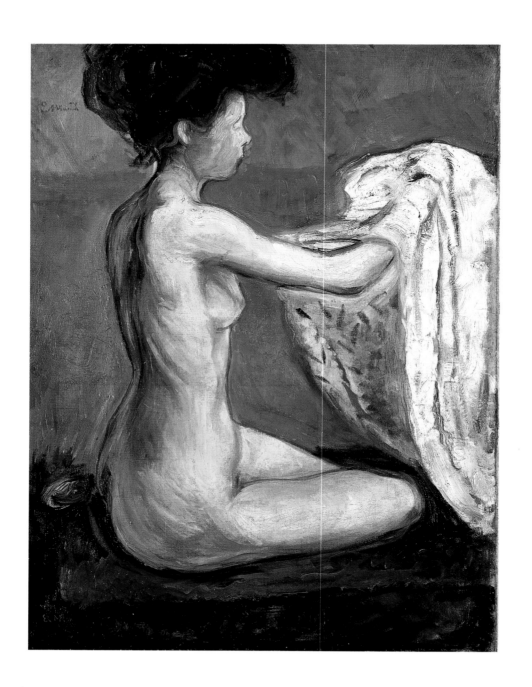

Parisian Model
1896, oil on canvas, 80 × 60 cm
National Gallery of Norway, Oslo
NG.M.02816

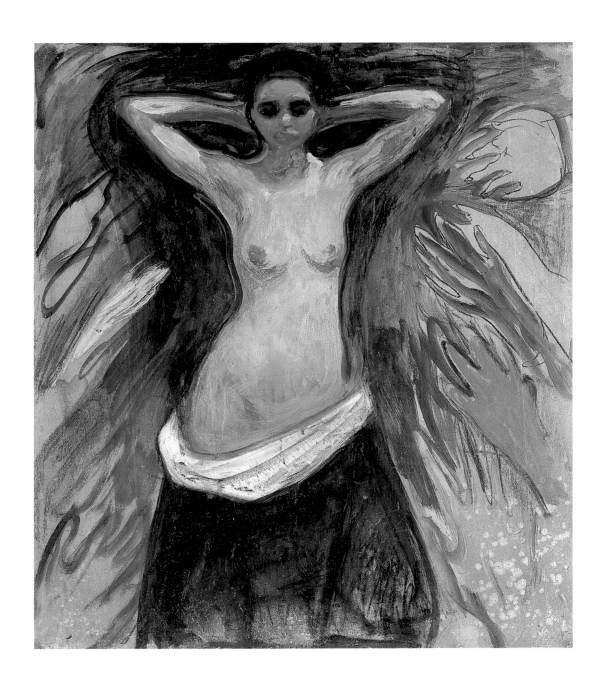

Hands
1893, oil and crayon on cardboard, 91 × 77 cm
Munch Museum, Oslo
MM M 646

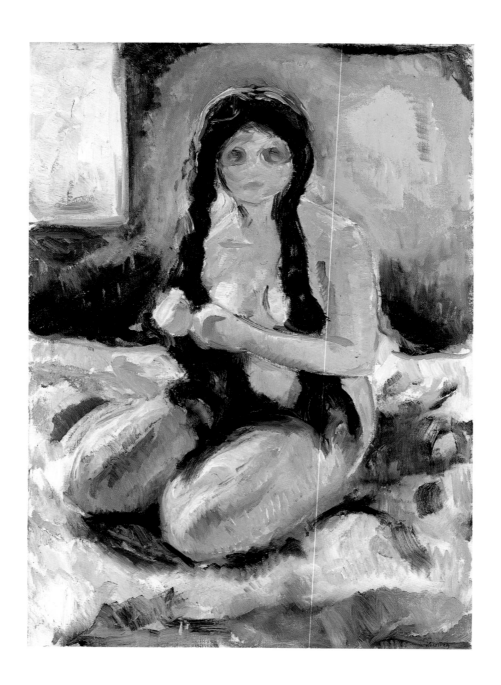

Kneeling Woman
1913, oil on canvas, 103 × 72.5 cm
National Gallery of Norway, Oslo
NG.M.02818

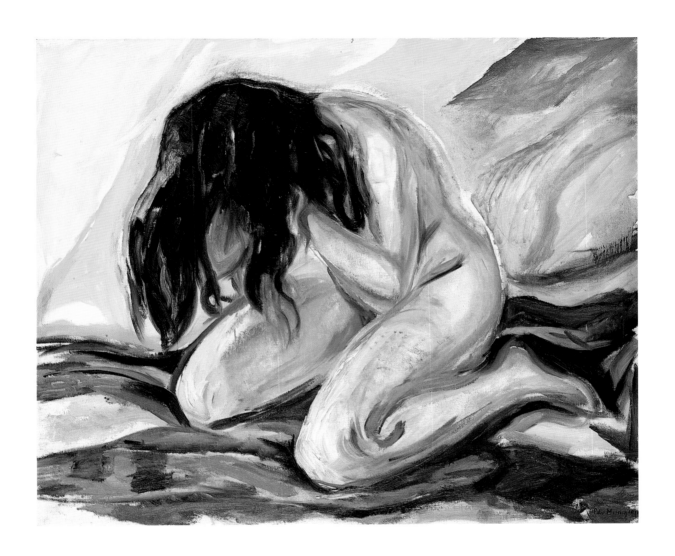

Kneeling Female Nude
1919, oil on canvas, 120 × 100 cm
Sarah Campbell Blaffer Foundation, Houston, Texas
1969.1

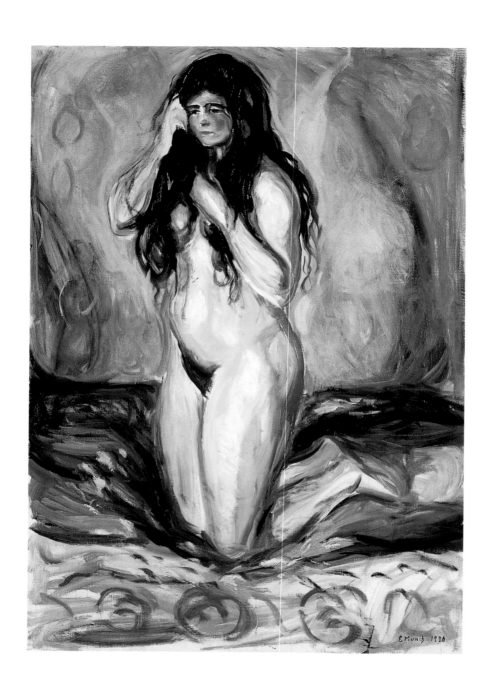

Female Nude (Anna)
1920, oil on canvas, 105.4 × 150 cm
Sarah Campbell Blaffer Foundation, Houston, Texas
1974.4

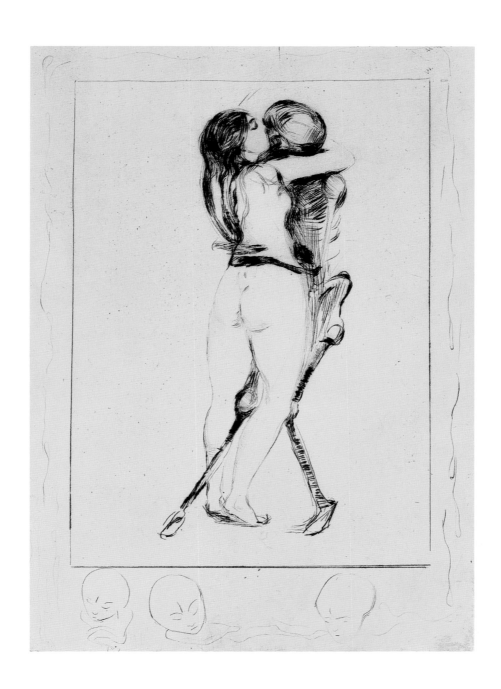

Death and the Maiden
1894, drypoint, 30.3 × 22 cm
Fram Trust

53

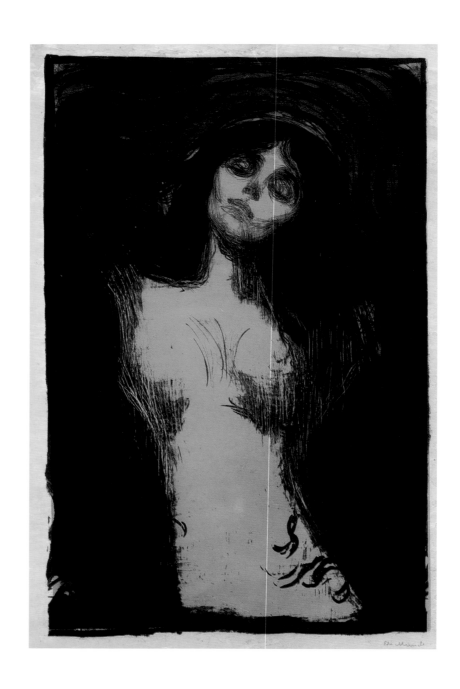

Madonna
1895, lithograph, 67 × 45 cm
Private collection, Norway

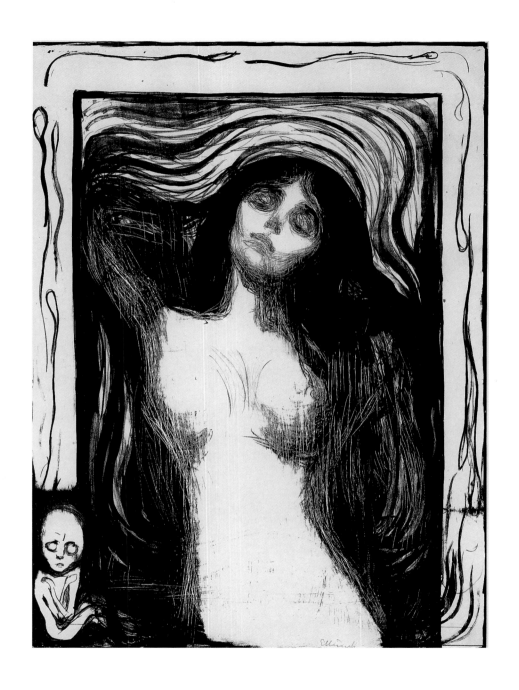

Madonna
1896, lithograph, 58.4 × 44.5 cm
Fram Trust

55

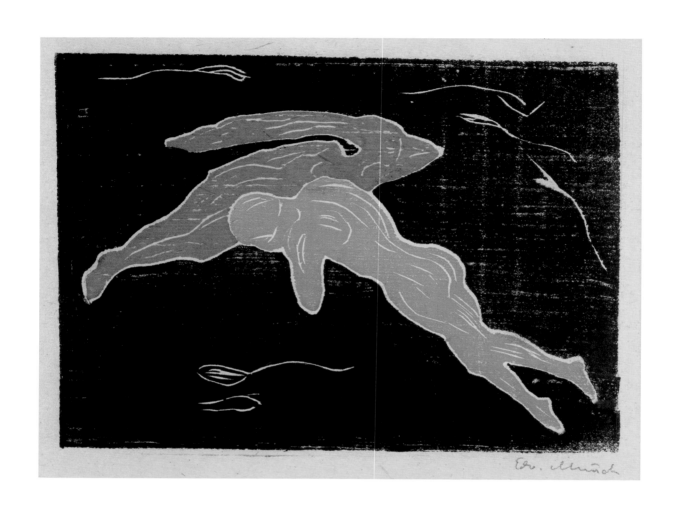

Encounter in Space
1899, woodcut, 18.1 × 25.1 cm
Fram Trust

56

Poster for exhibition at Hollaender Garden
1902, lithograph, 83 × 66 cm
Museum of Fine Arts, Boston
William Francis Warden Fund
57.380

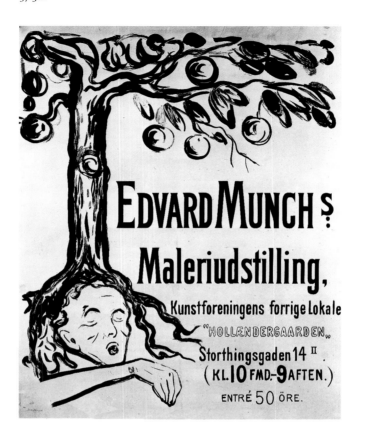

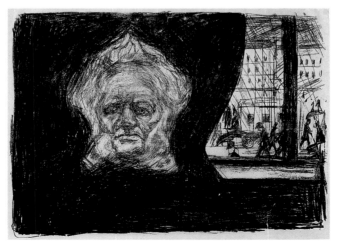

Henrik Ibsen at the Grand Café
1902, lithograph, 43.1 × 59.4 cm
Munch Museum, Oslo
MM G 244-3

Stage Set Design for *Ghosts*:
Mrs. Alving, Osvald, and Regine
1906, tempera on unprepared canvas, 60 × 102.5 cm
Munch Museum, Oslo
MM M 65

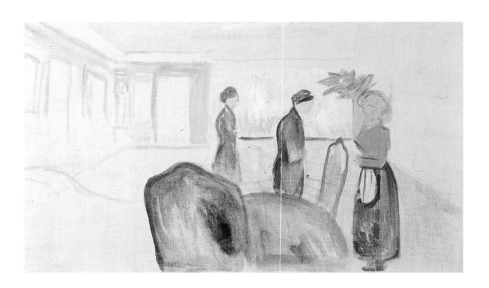

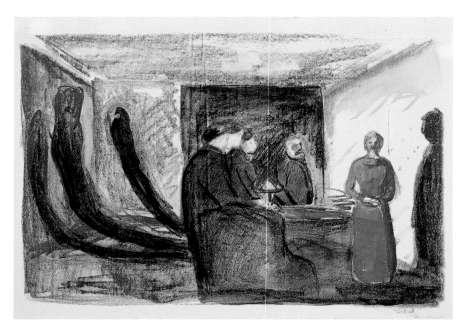

Scene from Ibsen's *Ghosts*
1920, lithograph, 39.7 × 50 cm
Fram Trust

61

Stage Set Design for *Ghosts:*
Osvald and Mrs. Alving
1906, oil on board, 47.5 × 68 cm
Munch Museum, Oslo
MM M 1037

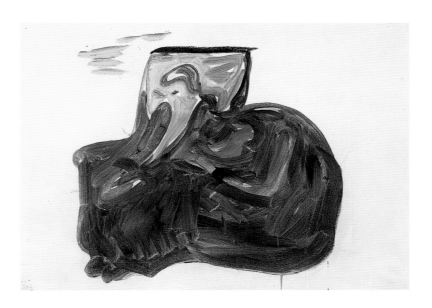

Osvald *(Ghosts)*
1919, lithograph, 39 × 50 cm
Munch Museum, Oslo
MM G 421-6

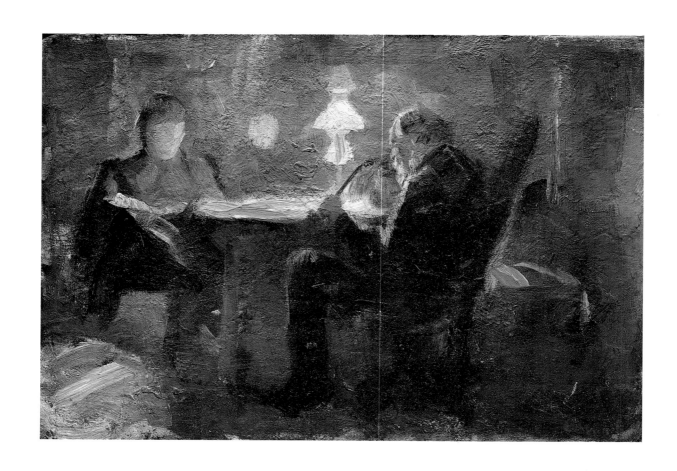

Interior with the Artist's Father and Sister
1884–85, oil on wood panel, 27 × 39.5 cm
National Gallery of Norway, Oslo
NG.M.02811

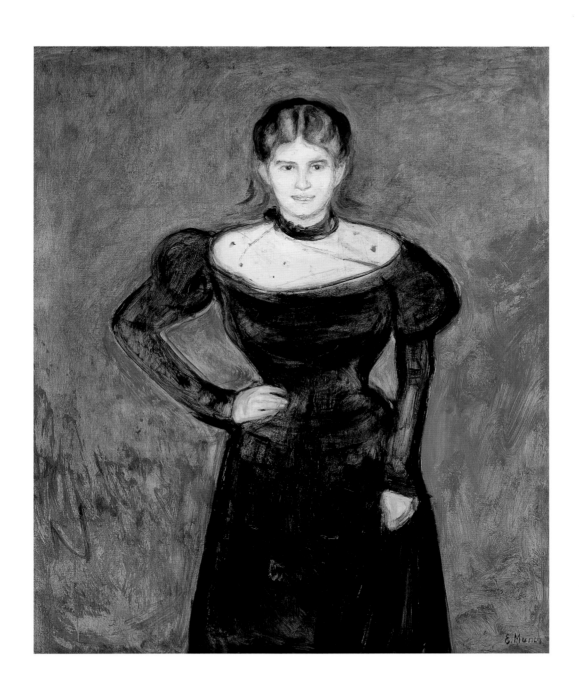

Portrait of the Painter Aase Nørregaard
1895, oil on canvas, 131 × 109 cm
National Gallery of Norway, Oslo
NG.M.01793

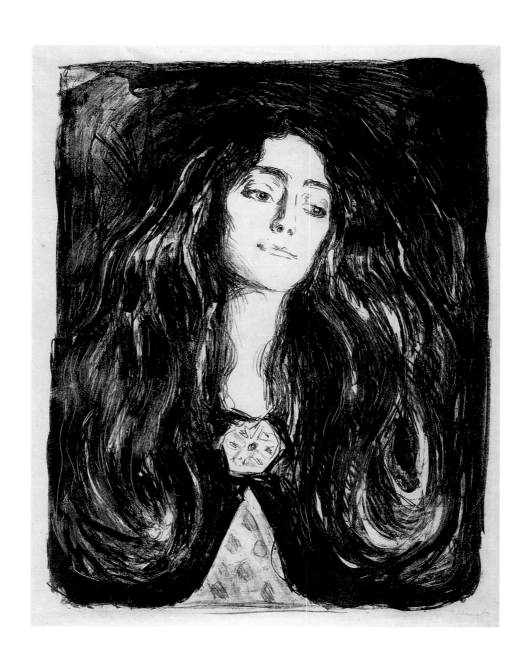

The Brooch (Eva Mudocci)
1903, lithograph, 59.7 × 45.7 cm
Fram Trust

65

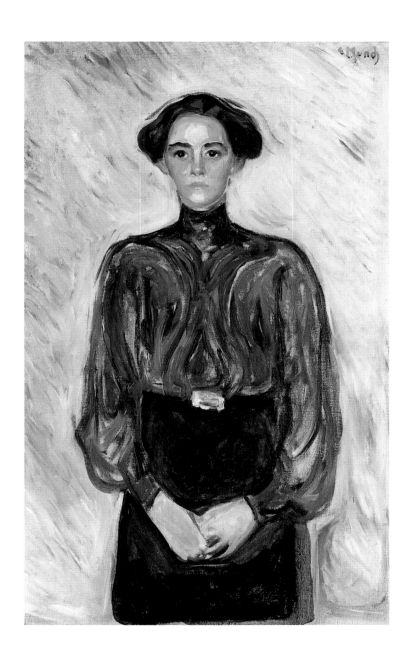

Lady in a Green Blouse
1905, oil on canvas, 99.5 × 60.5 cm
National Gallery of Norway, Oslo
NG.M.02817

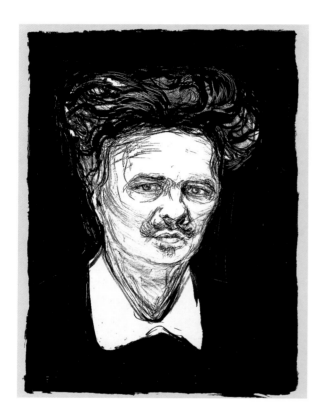

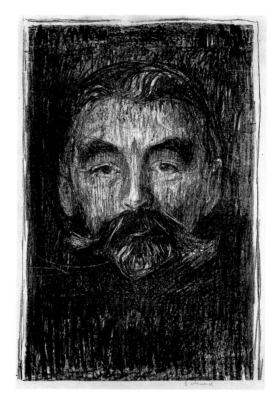

Portrait of August Strindberg
1896, lithograph, 50.5 × 36.7 cm
Fogg Art Museum, Harvard University Art Museums
Gray Collection of Engravings Fund
G8687

67

Portrait of Stéphane Mallarmé
1896, lithograph, 50.6 × 35 cm
Museum of Fine Arts, Boston
William Francis Warden Fund
57.669

68

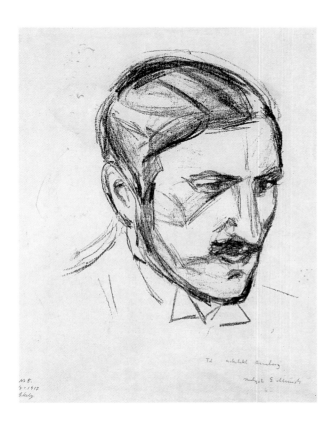

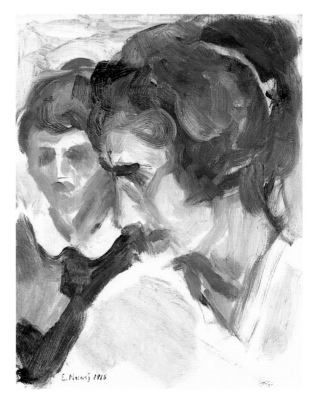

Portrait of Arnstein Arneberg
1917, lithograph, 45.7 × 35.5 cm
Fram Trust

69

Two Women
1919, oil on canvas, 28 × 35.5 cm
Fram Trust

70

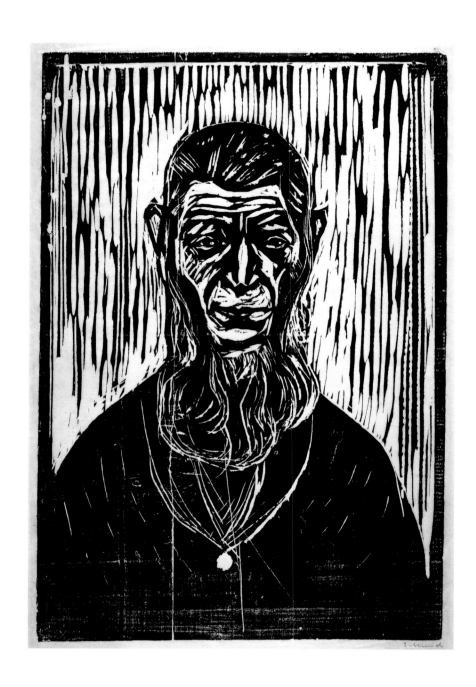

Primitive Man
1905, woodcut, 68.5 × 45.5 cm
Fogg Art Museum, Harvard University Art Museums
Gift of Lynn and Philip A. Straus, class of 1937
M21543

Streetworkers
1920, lithograph, 44 × 47 cm
Fram Trust

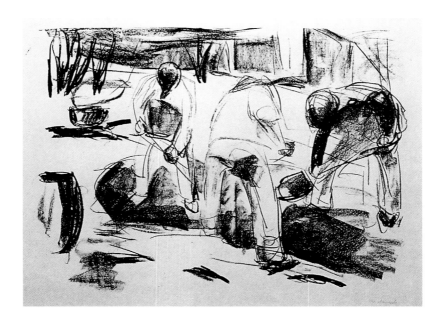

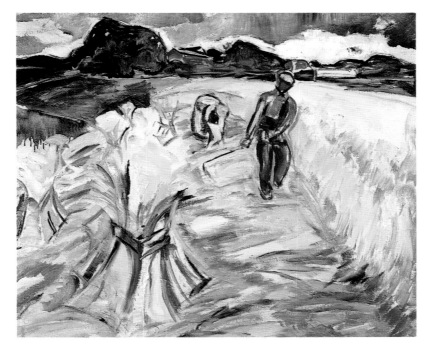

Harvesting the Crop
1923, oil on canvas, 100 × 120 cm
Fram Trust

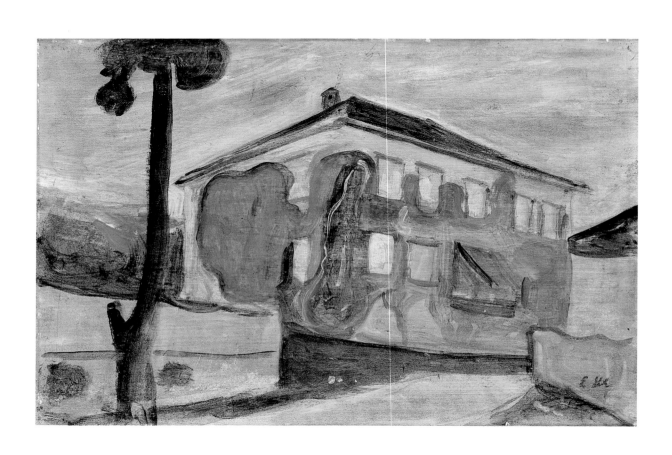

Red Virginia Creeper
1900, oil on wood panel, 32.5 × 48 cm
National Gallery of Norway, Oslo
NG.M.01894

The White Horse
1919, oil on canvas, 95.3 × 125.5 cm
Fram Trust

Fra Hvitsten:
Landscape with Oslo Fjord
1912–15, oil on canvas, 54 × 82 cm
Fram Trust

76

Coastal Landscape
1914, oil on canvas, 87.5 × 66 cm
Fram Trust

77

Three Girls on a Bridge
1920, woodcut, 50.2 × 42.5 cm
Fram Trust

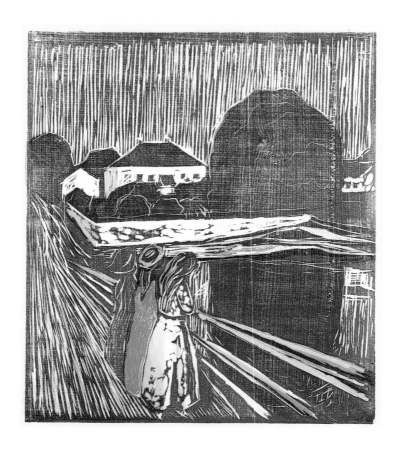

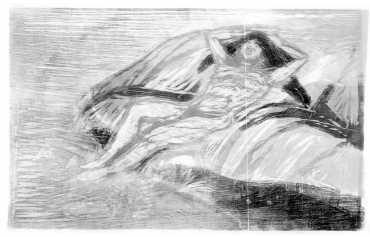

**Sunbath: Nude Figure
Lounging on Rock**
1915, woodcut, 61 × 41 cm
Fram Trust

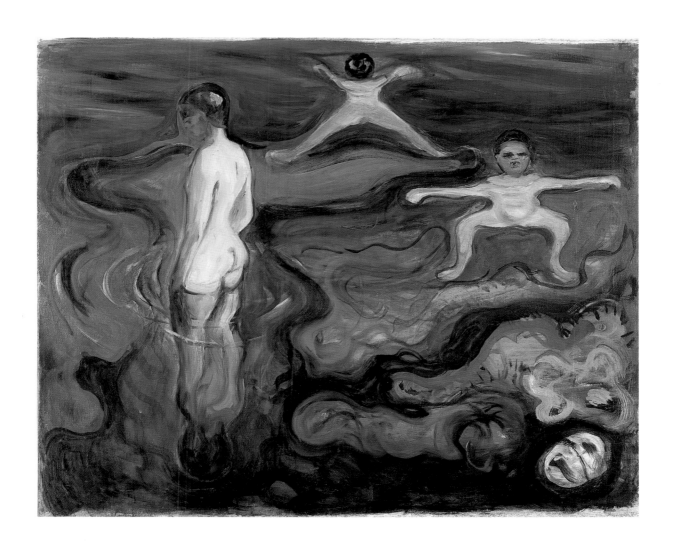

Bathing Boys
1902, oil on canvas, 83.5 × 100 cm
Munch Museum, Oslo
MM M 462

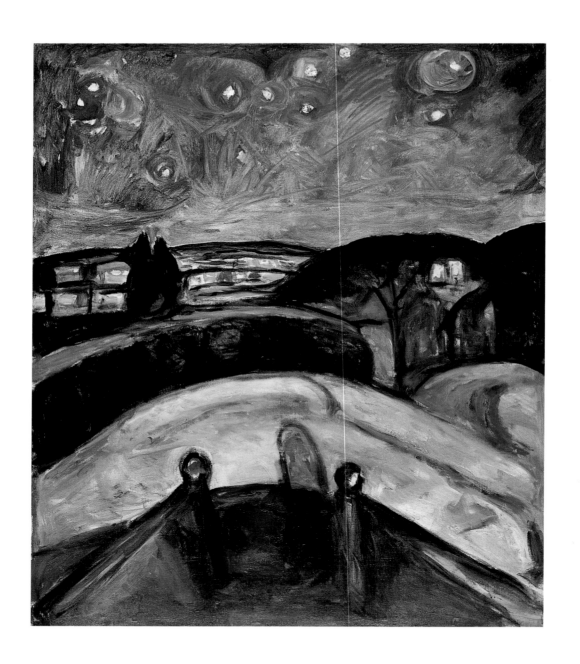

Starry Night
1922–24, oil on canvas, 139.5 × 119 cm
Munch Museum, Oslo
MM M 9

81

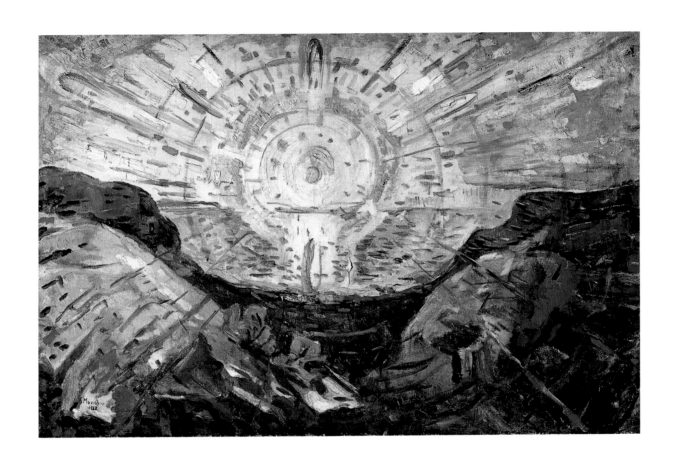

The Sun
1912, oil on canvas, 123 × 176.5 cm
Munch Museum, Oslo
MM M 822

Winter Landscape, Ekely
1919, oil on canvas, 54.5 × 81.5 cm
Fram Trust

83